THE **DIGITAL PRINT**

Preparing Images in Lightroom and Photoshop for Pri

JEFF **SCHEWE**

Dedicated to the lasting memory and substantial contributions of Bruce Fraser.

Thanks Bruce, from all of us.

THE DIGITAL PRINT
PREPARING IMAGES IN LIGHTROOM AND PHOTOSHOP FOR PRINTING
Jeff Schewe

Peachpit Press
www.peachpit.com

To report errors, please send a note to: errata@peachpit.com
Peachpit Press is a division of Pearson Education.

Copyright © 2014 by Jeff Schewe

Acquisitions and Project Editor: Rebecca Gulick
Production Editor: Lisa Brazieal
Contributing Writer and Development Editor: Brie Gyncild
Copy Editor: Patricia Pane
Compositor: Kim Scott/Bumpy Design
Proofreader: Kim Saccio-Kent
Indexer: Valerie Haynes Perry
Cover and Interior Designer: Mimi Heft

ISBN-13: 978-0-321-90845-2
ISBN-10: 0-321-90845-7

9 8 7 6 5 4 3 2

Printed and bound in the United States of America

TABLE OF CONTENTS

PREPARING IMAGES FOR PRINTING 79

■ CHAPTER 5

ATTRIBUTES OF A PERFECT PRINT 245

DEVELOPING A PRINTING WORKFLOW 295

INTRODUCTION

This book is about optimizing and printing your digital images using Lightroom and Photoshop. *The Digital Print* details what it takes to set up color management and how to optimize your images using soft proofing and the proper use of the print driver. It's also about what makes a truly great print and how to develop a fine art printing workflow to make printing more efficient and more fun!

I drill down on the tone, color, image sharpening, and noise reduction you need to apply to your images prior to printing. I outline the importance of image resolution and how it affects your printed image. I extensively cover converting color images to excellent black-and-white images and how to make great black-and-white prints. I also cover topics such as paper choices and deal with issues surrounding print permanence.

I wrote this book because there didn't seem to be an optimal source of information that suitably covered the main topics without being relegated to covering everything about a single application. The world doesn't need yet another Lightroom or Photoshop book, but the world does need a current book about the essence of image optimization for printing, regardless of the imaging application. I set out to write a book about cross-application integration that addressed the needs of photographers who want to optimize their images for the best-possible fine art print.

I called the book *The Digital Print* for a reason. In my formative years as a young photographer, I read a series of books by Ansel Adams that formed the genesis of my infatuation with and addiction to photography. Ansel's books—*The Camera*, *The Negative*, and *The Print*—had a huge impact and greatly helped advance my knowledge of photography. This book is the companion to my previous book, *The Digital Negative*, which details what makes for a really good digital negative and how to harness the massive power of Lightroom and Camera Raw to extract the best-possible raw rendering of that digital negative. With *The Digital Print*, I pick up where *The Digital Negative* left off and also add scans from film into the mix.

Who am I and why should I write this book? Well, I'm a graduate of Rochester Institute of Technology (RIT), with two degrees in photography. I was a commercial advertising photographer in Chicago for over 25 years (yeah, I won a few awards). I was an early adopter of digital imaging—my first photo assignment that was manipulated on a computer was in 1984 (the year the first Macintosh computer shipped). I didn't do the digital imaging—a pioneering company called Digital Transparencies, Inc., in Huston, Texas, did the imaging.

I started doing my own Photoshop digital imaging in 1992 using Photoshop 2.0. I was one of the first off-site Photoshop alpha testers (*alpha* meaning way before any sort of final coding is done and before the software is really usable). I got to know and work with many of the Photoshop engineers because of this testing. When I mention names like Thomas Knoll (the co-author of Photoshop) or Mark Hamburg (the number-two Photoshop engineer and founding engineer of Lightroom), it's not to drop names but because these guys are friends of mine. I've worked with them a lot over the years. I want people to know their names and give them the credit they deserve.

I was significantly involved in the early development of both Camera Raw and Lightroom—not because Adobe was paying me tons of money (alpha testers work for free), but for the selfish motive of advancing and improving the tools I personally wanted to use.

I've also had the good fortune to meet a lot of the leading experts in the field, and I want to express my sincere appreciation of one dearly departed friend, Bruce Fraser, noted author and educator, for taking me under his wing. I had the honor of joining Bruce and some other friends in forming a company named PixelGenius, which develops Photoshop plug-ins.

By way of disclosure, let me just say that I am not and never have been an employee of Adobe (even though over the years I've worked with Adobe on software development). I don't have any contracts or testimonials with any camera companies. In the book, I frequently mention specific cameras and lenses I used for image captures. I do so to provide a provenance of how and with what gear an image was captured, not to promote any specific camera. I used those cameras because, well, those are the cameras I bought and paid for (although I've gotten some really good deals).

I have had a long-standing relationship with Epson and personally own four Epson printers: a Stylus Photo R3000, a Stylus Pro 3880, a Stylus Pro 4900, and a Stylus Pro 9900. Yes, I am a printer junky! However, I arranged the loan of a Canon printer imagePROGRAF iPF6400 so I could write about printing from a more neutral position. I want to thank Canon for its support. I was impressed with the image output from the Canon and can honestly say that both Epson and Canon make great printers, so you really can't go wrong with either brand.

I owe a large debt of gratitude to many people, and since it's my book, I'll take the time to mention them. First, we all owe a huge debt of gratitude to two brothers, John and Thomas Knoll, who really started this whole digital image revolution by co-authoring Photoshop. I also send sincere thanks to Mark Hamburg, for his willingness to put up with my quirky ways and sometimes actually listen to me when I told him what he should do. There are many people at Adobe to thank: Russell Preston Brown for being a co-conspirator, Chris Cox for a lot of sneaky things he put into Photoshop, Russell Williams for striving for Photoshop excellence, and John Nack and Bryan Hughes for being Photoshop product managers who really care about the end user. On the Camera Raw team, special thanks go to Eric Chan, who will always listen and do the right thing (even if it's a pain), and the gone but not forgotten Zalman Stern (he didn't die—he just went to work for Facebook).

I also thank my good friends and partners at PixelGenius—Martin Evening, Mac Holbert, Mike Keppel, Seth Resnick, and Andrew Rodney—and our gone but not forgotten members, Mike Skurski and Bruce Fraser. We all miss them and so does the industry. I'll also give a shout out to the Pixel Mafia—you know who you are.

I want to thank the Peachpit "Dream Team" (that's what Bruce used to call them, and I wholeheartedly agree): Rebecca Gulick, who was the acquisitions and project editor (which means she had to put up with my foolishness and tardy submissions); my production editor, Lisa Brazieal, who conspired with me to allow me to do what I thought was best; and my development editor Brie Gyncild, who helped me sound like I have half a clue. Thanks also to the book's compositor, Kim Scott of Bumpy Design, who did an excellent job of laying out the book and making my figures work. Thanks to my copy editor, Patricia J. Pane, for catching all the small stuff, and to my indexer, Valerie Haynes Perry, for making stuff easy to find. Big thanks also go to Mimi Heft for the cover and interior design excellence (and for putting up with my histrionics)—seriously, I never would've picked *those* images for the covers of both books, but they really work!

I also owe a huge debt of gratitude and massive appreciation to my long-suffering wife, Rebecca (Becky), who is always the first person to read the drivel I write (and tell me how to make it sound intelligible, which always makes me look good to my copy editor). She stoically puts up with all my inattention and bad habits when I'm writing and seems to genuinely love me in spite of myself. Thanks also to my loving daughter, Erica, who suffers the loss of her dad while I'm under deadline. She gets back at me by being one my harshest critics, which, I think, makes us even.

My thanks also go to you, the reader, for taking the time to at least get this far. I hope you'll find this book beneficial in advancing your printing excellence.

—Jeff Schewe, June 2013

NOTE You can find additional information on the book's companion Web site at www.thedigitalnegativebook.com.

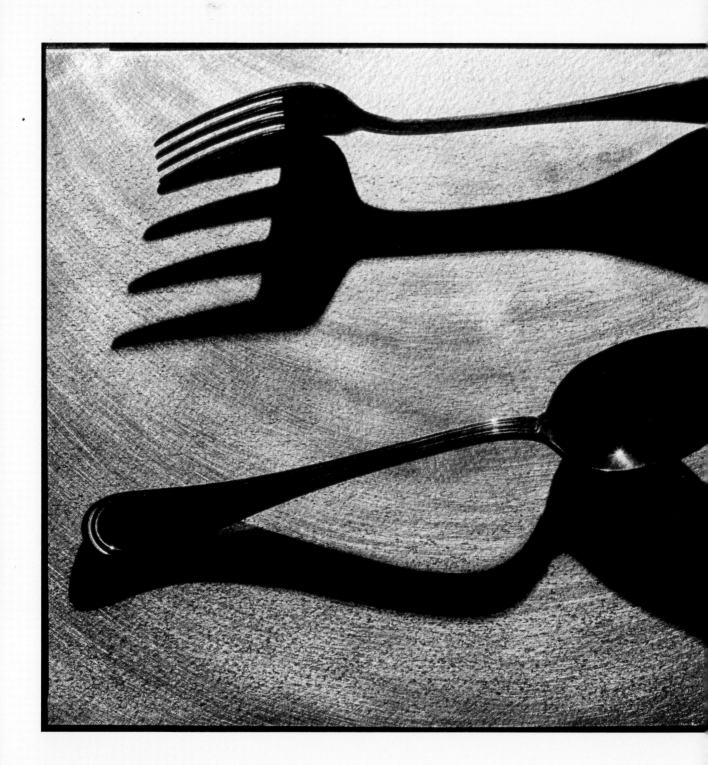

■ CHAPTER 1

A DIGITAL PRINTING PRIMER

Digital printing has come a long way in a relatively short time. Today with digital printers, you can create high-quality fine art prints that meet or exceed traditional analog darkroom prints. It is helpful to know a little about the various digital printing technologies, and about the printing options available to you. This chapter is a quick printer primer.

This image started off as a Van Dyke Brown print on hand–coated watercolor paper from an 8x10 black–and–white negative shot on an 8x10 Sinar using a 240mm lens. The resulting print was copied on 8x10 Ektachrome transparency, and that was scanned on an Epson Perfection V750 scanner. The scan was corrected in Lightroom 5.

A BRIEF HISTORY OF DIGITAL PRINTING

Canon claims to have invented what it calls *bubble jet technology* in 1977, when a researcher accidentally touched an ink-filled syringe with a hot soldering iron, forcing the ink to expand and releasing a droplet of ink from the needle of the syringe.

Inkjet printers were developed in the early 1980s. The HP Thinkjet, released in 1984, and the Canon BJ-80, released in 1985, were originally used to print documents. In the late 1980s, Hewlett-Packard introduced a color printer that could print in four colors (CMYK), but it wasn't really considered a photo printer.

In 1994 Epson released the first high-resolution inkjet printer that could print photographs. The Epson Stylus Color (model P860A) could print black, cyan, magenta, and yellow at 720 DPI. While the Epson could print business graphics just fine, it didn't do so well on high-resolution color photographs. It wasn't until 1997 that Epson released the Epson Stylus Photo printer, which printed with six colors: black, cyan, magenta, yellow, light cyan, and light magenta. The Epson Stylus Photo produced good continuous-tone photographic output.

The printer that really launched fine art digital printing was the Iris printer. Originally created by Iris Graphics in 1985, the Iris printer was designed as a graphic arts proofing printer. It printed with CMYK inks and with enough resolution (an apparent resolution of 1,800 DPI or 12 pixels/mm) to produce sharp details and fine gradations. The Iris had four very small crystal-stimulated piezoelectric, glass capillary nozzles. The paper was mounted on a big drum capable of printing at 34 x 46.8 inches, which then spun, and the ink was jetted out of the nozzles in a continuous stream onto the paper. The droplets were given a charge, and unneeded droplets were deflected away from the spinning drum electrostatically. It wasn't really designed for fine art printing. To make that leap required an evolution. It was a rock star with a hacksaw who jump-started fine art digital printing.

A ROCK STAR AND A HACKSAW

Graham Nash of Crosby, Stills, Nash (and sometimes Young) is an avid photographer in addition to being a famous rock star. Graham, of course, had a ton of great images of all the rock and roll bands of the time. An art director was working on a show of photographs of Joni Mitchell and asked Graham to submit some photographs. Unfortunately, Graham sent a book of original negatives of Joni Mitchell to this art director, who proceeded to lose them. Consequently, Graham lost two years of photographic work; all he had were contact sheets. Graham was devastated by the loss

of so many of his original negatives and tried to devise a way of using the contact sheets to make prints for a major exhibition in 1990 at the Parco Gallery in Tokyo, Japan. The show was to include 35 celebrity portraits, each 3 feet x 5 feet, in groups of 50. Unfortunately, taking a contact sheet and enlarging it in the darkroom would not produce a very good image, so Graham turned to others to solve this problem.

Crosby, Stills, and Nash's tour manager, R. Mac Holbert (the R stands for Roy), who had set up accounting and scheduling for the band, was also interested in computers. More importantly, Mac had played around with a very early digital scanner, called *ThunderScan*, but that scanner couldn't scan from Nash's contact sheets. Mac sought the expertise of some other tech-savvy people, in particular Dave Coons from the Walt Disney Company, who had designed and built a high-resolution scanner for Disney. Mac and Graham sent the contact sheets to Dave Coons, who was able to make high-resolution scans from them.

Once they had the scans, they needed to print the images. Coons made a preliminary print off the contact sheets using an Iris 3047. Graham was impressed. He wasn't satisfied yet, but he was impressed by the potential. Graham and Mac continued to work with Coons to improve the potential output of this Iris inkjet printer—which was really designed for proofing, not fine art printing. The prints were finally made, and the show in Japan was a huge success. In fact, it was so successful that the photographs were reprinted for a show at the Simon Lowinsky Gallery in New York City and yet another show at the G Raw Hawkins gallery in Los Angeles.

Because of the success of the shows and the print sales, Graham decided to purchase an Iris printer in the winter of 1989. These are very expensive machines; he signed the papers to purchase the Iris 3047 for $126,000, and bought a coach house in Manhattan Beach, California, to house the printer.

The Iris printer was originally designed for producing proofs on graphic art paper. When Graham uncrated the printer and tried to mount watercolor paper to it, he couldn't get the paper to fit underneath the print head. So he took a hacksaw to this expensive machine and sawed off the print head so that it could be remounted farther away from the paper to allow the use of thicker watercolor paper. That of course voided the warranty, but it also ushered in a new era of fine art printing.

Dave, Graham, and Mac proceeded to make prints for shows, which were great successes. Mac and Graham decided that they wanted to make these prints available to other photographers and artists, so they started Nash Editions, a high-end print atelier.

The problem with the Iris printer is that it took over an hour, sometimes a couple of hours, each morning, just to get the printer online and working. It took from 20 to 30 minutes to actually make a print—all in all a very tedious process. Also, the Iris

> **NOTE** In the interest of disclosure, Mac Holbert is both a good friend and also a business partner. After Bruce Fraser passed away, we needed somebody to join PixelGenius to take over product management for our PhotoKit Sharpener plug-in. Mac joined PG as a partner and worked to improve the PhotoKit Sharpener 2 plug-in.

inks were not very lightfast. These issues forced Mac and Graham to look for new printers that would be easier to maintain and provide a more efficient workflow.

In 1999, an Epson representative walked into Nash Editions and asked if they would be interested in looking at Epson's new large-format digital printer, the Epson Stylus Pro 9500. Nash Editions got an early test machine. The first black-and-white prints looked "awful," according to Mac. Graham primarily created black-and-white prints because he was a black-and-white photographer. Working back and forth with Epson, Nash Editions was finally able to get really good output from the Epson Stylus Pro 9500. That was the beginning of the end of the use of Iris printers, and the beginning of Epson printers used for fine art printing. Ultimately, Mac arranged for the donation of Nash Edition's original Iris printer to the permanent Smithsonian's National Museum of American History.

JON CONE AND PIEZOGRAPHY

While Nash Editions and Epson were teaming up on the West Coast, Jon Cone was doing his own innovating on the East Coast. Jon Cone started his company, Cone Editions, in the early 1980s in New York City as a collaborative printmaking atelier. Cone Editions did serigraphy, woodcut, etchings, monotyping, and photogravure. In 1989, Cone moved to a small rural Vermont village and started creating digital output, also with an Iris 3047 printer. He was directly involved with the development and marketing of the Iris printer for the fine art market. He helped advance long-life, or fade-resistant, inks and ink formulation.

Like Nash, Cone also started to switch over to Epson printers in about 1999. He developed a line of inks for Epson printers, and he developed Piezography, a term he coined. Piezography is a unique approach that involves replacing colored inks with different shades and hues of gray inks to produce excellent black-and-white prints. The inks that Cone developed are still available today.

ADOPTION OF INKJET FOR FINE ART PRINTING

Graham, Mac, and Nash Editions were pretty successful in promoting digital inkjet printing for the fine art market, but there was an enormous amount of resistance. Most people didn't know or understand what an inkjet printer was. In the early 1990s, inkjet printers were thought of as document printers, not photographic printers.

In an attempt to give fine art inkjet printing an air of mystery or distinction, Jack Duganne (one of the first people hired at Nash Editions) coined the term *giclée*, based on the French word *gicleur*, which means "nozzle." The corresponding French verb is *gicler*, which literally means "to squirt or spray." A lot of people started using the

term *giclée* to mean a fine art digital print that was somehow better than an inkjet print or computer-generated print. Neither Mac nor Graham liked the term, and Mac wishes that Jack had never come up with it.

Epson worked hard to promote its printers for fine art photography. One of the earliest shows of fine art inkjet printing was called "America in Detail," and was sponsored by Epson in honor of the new millennium. The photographer Stephen Wilkes went on a 52-day odyssey that resulted in a critically acclaimed exhibition that traveled to New York, Chicago, Los Angeles, and San Francisco in 2001. Mac Holbert of Nash Editions produced all the proofs and final prints for the traveling show.

The early winner in fine art digital printing was Epson. One reason was the ecosphere: the Epson printer became a platform for a lot of third-party development of paper and inks, such as Jon Cone's Piezography inks. There was a synergy between Epson, digital printers, and photographers that helped Epson become the leading platform for fine art digital printing. It was only later, when Canon and HP developed improved ink sets and printers, that Epson had any competition.

Now the battle over the perception of inkjet printing as legitimate for fine art printing has been won. The term *giclée* is now used only by the uninitiated. Dealers or galleries still occasionally use it, but it's mostly fallen out of favor.

The term that I prefer and use is *digital pigment print*. It accurately describes producing prints digitally but with pigment inks on paper.

NASH EDITIONS AND MAC HOLBERT'S DEPARTURE

I was shocked when Mac left Nash Editions and moved to Ashland, Oregon. I wanted to write about the split, but rather than try to characterize Mac's departure, I asked Mac to write a few words.

The 2008 recession hit Nash Editions hard and Nash's son Will was assigned the task of reinvigorating the business. While I supported his efforts, it became clear that we didn't share much in common when it came to the Nash Editions "mission." I saw the writing on the wall and took the opportunity to move my family north to Ashland, Oregon, where I collaborated with several friends to start a new digital printing company, The Image Collective, focused on providing print-on-demand services to the cultural heritage world (i.e., museums and libraries). We currently represent more than 20 museum and library collections, including The J. Paul Getty Museum and the National Gallery in England.

−R. Mac Holbert, June 2013

AHEAD: EVOLUTION, NOT REVOLUTION

The earliest Epson pigment printers entered the market just over a decade ago. Digital printing advances exploded at the time that digital cameras took off. There was a revolution in digital printing because there was a lot of demand.

At this point, the cameras are getting only evolutionary changes, subtle improvements. The same is true for digital printing. Both Canon and Epson have reached some of the limits of physics, chemistry, and mechanical engineering. My guess is there won't be a lot of revolutionary change in the future of the fine art printing industry; moving forward, there are going to be minor advancements that represent an evolution.

TYPES OF DIGITAL PRINTERS

Digital printers differ primarily in their print-head design and ink types for inkjet printing, or the manner of ink transference in the case of dye-sublimation printers. A third type of printer uses lasers or LED lights to expose photosensitive paper, which is then chemically processed. I'll start with the inkjet printers.

PIEZOELECTRIC VS. THERMAL PRINT HEADS

As the early leader in digital fine art printing, Epson developed a technology called *piezoelectric print heads*. Though Canon and Hewlett-Packard had developed thermal print heads, they couldn't provide the same kind of resolution early on that the piezoelectric print heads could. Piezoelectrical print heads use an electrical charge to change the shape of a piezo crystal. The change in the shape forces a droplet out of the print-head nozzle.

The current Epson print heads for the Pro Printers have 360 nozzles per inch that squirt tiny droplets of ink, down to about 1.5 picoliters. A picoliter is 1 trillionth, or a millionth of a millionth, of a liter. The physical size of a picoliter is approximately 50 microns.

Thermal print heads, also known by the Canon brandname *Bubble Jet printers*, use a small heating element that heats up a chamber; the droplet is then ejected onto the paper. Once the heating element goes off, because of the vacuum, the chamber receives the ink again, so that the next time the heating element heats up, it squirts out another droplet of ink.

In Chapter 4, I discuss the resolution that thermal and piezoelectric print heads can print. Basically, though, the reported resolution of the operating system for Epson printers is 360 DPI. For Canon and HP, the basic resolution is 300 DPI.

There are some important differences between the two print-head technologies. For example, piezoelectric print heads are very expensive and have no user-serviceable parts. If the print head goes bad, the entire part needs to be replaced by a service technician, and is considerably expensive. Piezoelectric print heads also tend to suffer from nozzle clogs. Anyone who has owned an Epson printer will attest to the fact that if you don't use the printer a lot, you'll encounter a lot of clogged nozzles and spend a lot of ink cleaning the nozzles. That's just due to the design of the piezoelectric print heads.

Thermal print heads include a lot of extra nozzles. If the printer detects a blocked nozzle, it masks that nozzle out and starts using a new one. So Canon and HP printers are less likely to produce nozzle clogs—but, eventually, you run out of unused nozzles. When there are no more fresh nozzles, you have to replace the print head. The upside is that you can replace the print head yourself, so it doesn't require a service call.

As to which printer produces the best prints, it's reached the point where, at the date of this writing, it's six of one, half a dozen of the other. Both Canon and Epson printers are capable of producing really great prints. At this stage, Canon and Epson are the only real players. Sadly, HP has fallen out of the fine art printing market.

Pigment vs. dye inks

The early inkjet printers all used organic dyes. They were colorful. They could produce a big gamut of color. (To learn about color gamut, see Chapter 2.) Unfortunately, they had relatively poor lightfastness and didn't necessarily last long. The move from dye inks to pigment inks substantially improved the lightfastness and the longevity of prints. Initially, however, those improvements were made at the expense of the color gamut, which was noticeably smaller than that of dye inks. (You'll learn more about lightfastness in the "Print Longevity" section of Chapter 5.)

Both Epson and Canon—and to a degree HP—have worked to advance the color gamut of pigment inks. Pigment inks now rival the gamut of dye inks.

Note that what I'm referring to as *pigment* is literally microencapsulated pigment that is suspended in an aqueous medium. The pigment particles have to be small enough to go through those tiny little nozzles.

Solvent inks

A recent release of Epson printers that use solvent-based inks that are set by heat, are coming onto the market. Solvent printers have some benefit—the prints are very durable and are highly resistant to fading and water. That makes solvent-based printers useful for outside signage or vehicle decals and decoration. Solvent-based printers can also print on canvas without the requirement of overcoating for protection.

In the past, solvent-based printers were not really good at photo printing. Epson has released a series of solvent-based printers. Epson SureColor printers are 64–inches wide and use Epson UltraChrome GS2 inks. One model (S30670) uses an 8-channel, 4-color (CMYK) ink set, while the top-of-the-line model (S70670) has dual 10-channel, 10-color ink sets that can print with optional white or metallic inks. The ability to print white ink as a base layer for the subsequent color inks means that you are no longer tied to printing on white materials. These are huge and expensive production printers that are unlikely to be used by many fine art printers, but the substantial improvement in photo printing with solvent inks makes them interesting for somebody looking to produce unusual printed material.

DYE SUBLIMATION

Dye-sublimation printers use dye-based ink that is exposed to a heating element: the dye is melted off of the ink film and onto the receiving paper. Unfortunately, a special paper is required to receive the dye sublimation. Unlike the organic dyes used in dye inks, dye-sublimation inks are very robust and have a good lightfastness.

Dye-sublimation printers were expensive. I say "were" because in general, dye-sublimation printers have fallen out of favor for fine art printing. There are still a few printer companies that use them for special purposes, such as iron-on transfers for T-shirt printing and printing patterns on fabric, but not really for fine art printing.

BUILT LIKE A TANK, FOR A TANK

The early Kodak XL7700 printer that I first started getting service bureau prints from was built like a tank. In fact, it was actually designed for a tank. Under contract for the government, Kodak created the XL7700 as a map printer for the Abrams M1A1/2 tank. It came with a rack mount so it could be mounted in the tank itself and so tank commanders could send maps of enemy positions. Kodak decided to sell it in the consumer market—and for a period of time, it was pretty successful.

DIGITAL CHROMOGENIC

When Kodak first produced color print material back in the 1950s, Kodak took the name chromogenic and shortened it to C-prints. The early color printing material was chromogenic dyes and processed in chemicals to produce a color print from a color negative.

Early on, some of the best digital photographs were made using digital chromogenic printers. One of the earliest digital chromogenic printers was the LightJet from Cymbolic Sciences, Inc. It used silver halide color photographic paper. Red, green, and blue digitally controlled lasers exposed the photosensitive emulsion on the paper medium. The print material was processed using a traditional photochemical process. Another popular digital chromogenic printer was a Durst Lambda. Both the LightJet and the Lambda were very popular in large Pro Photo labs. Some are still running. Sadly, neither printer is still being made, though they are still being supported, and the paper and chemicals are still available.

Digital minilabs, the sort that make prints at drugstores or photo stores, generally use either the Fujifilm Frontier or the Noritsu. Sometimes both may be in the same photo lab. The chromogenic printers are somewhat limited in size, with a standard width of 24 inches. The Noritsu and the Frontier are still being manufactured. They're often used by wedding photographers because the number of prints they can produce per hour makes the cost per print very competitive compared to pigment inkjet prints.

Because the digital chromogenic process uses traditional photosensitive silver halide photo print material, the lightfastness and longevity of chromogenic prints is limited to that of the chemical processing. Even if you use the best Fuji Crystal Archive paper, the longevity is about 60 years, which is on the low end of the longevity of inkjet pigment prints.

In addition to digital chromogenic printing, many photo labs offer inkjet pigment prints.

ONLINE PRINT SERVICES

Several online photo labs can make prints for you. In the United States, consumer-oriented sites such as Shutterfly.com, Snapfish.com, and Mpix.com are doing pretty good work.

Online professional labs include Burrell Imaging (burrellcolourimaging.com), Miller's Professional Imaging (www.millerslab.com), and Digital Precision Imaging, Inc. (ProDPI.com).

If you're outside of the United States, I suggest using an Internet search engine if you want to find an online print service that will work for you.

DIGITAL HALFTONE

Traditional commercial printers print with four four-color plates on large web presses; that's how they print magazines, for example. The print magazine industry seems to be going away, but short-run halftone reproduction is kind of exploding. HP produces the Indigo digital offset printing presses, which can print up to seven inline colors.

One of the early digital halftone short-run printers is Blurb (blurb.com). Blurb uses an HP Indigo printer, which uses toner ink, but acts like an inkjet printer on steroids.

With short-run reproduction, you can buy as many or as few printed items as you like. Many consumer and pro photo labs offer short-run printing, and they're generally all using HP Indigo printers. You can order books, note cards, greeting cards, calendars, and many other consumer products. To prepare images, you have to soft proof for CMYK reproduction, which I discuss in Chapter 4, and optimize the image for digital halftone output.

PICKING A PRINTER

Buying a printer is a lot like buying a new car. You can choose from a wide array of different models with different specifications and price points. The first decision to make is which class of printer and which size you need.

CONSUMER GRADE

There are a myriad of consumer-level printers, and I couldn't begin to discuss them all. Generally, consumer-grade printers are short-lived and require very expensive ink. In fact, buying a new set of ink can be almost as expensive as buying the printer.

Consumer-grade printers are a disposable commodity, rather than precision machines. They're not expected to last long; the ink cartridges are very small; and the mechanical engineering is very low end.

I know a lot about printing, and I'm not even sure how to pick a consumer-level model. Recently, my daughter wanted to buy a new printer. She and I went to the local computer warehouse, walked the aisles, looked at printers, tried to compare different features and specifications, and between the two of us, we couldn't figure out what to get. She finally decided that she wanted to get the highest-rated printer available at the Apple Store, and that's how she picked her printer. She's actually quite pleased with it. It's an HP Photosmart 6520 e-All-in-One printer with scan, copy, and print functions. She can print to her printer from her computer, her iPad, and her iPhone, and it prints 4 x 6-inch photos that are "okay" for her. Most of the consumer-grade printers are capable of printing only 8.5-inch-wide paper.

My favorite consumer-level photo printer is the Epson PictureMate, which looks like a small-sized boombox and can even print on location using batteries. I've taken a PictureMate with me on three separate Antarctic photo expeditions so workshop attendees could make and share prints.

THE COST OF INK

A consumer-grade inkjet cartridge (for an Epson R2880) may contain about 11.4 milliliters of ink and cost about $13.50, or $1.18/milliliter. That works out to $34.90/oz, or more than $4,400 per gallon. Compare that to the cost of human blood (about $17.27/oz) or Grey Goose Vodka (about $1.10/oz) or gasoline (about $.04/oz), and you'll quickly figure out ink is really expensive!

As you move up the ladder of inkjet printers, you'll find the cost per milliliter goes way down. An inkjet cartridge for an Epson Stylus Pro 3880 costs about $63 but contains 80 milliliters, so the cost goes down to about $.79/milliliter; for the Epson 9900 you can buy a 700-milliliter cartridge for $279.95 and the cost goes down to $.40/milliliter. So, in terms of ink costs, the larger cartridges are more cost effective.

You might be tempted to buy lower-priced ink to save money, but I would caution against this for a couple reasons. First, most third-party inks are not tested for longevity and lightfastness, so the print you make may not last nearly as long as when using the manufacturers' inks. Second, third-party inks may be more likely to clog and may destroy your print heads. I call that penny wise but pound foolish.

There are some continuous ink systems (CIS) that allow you to take ink out of large, less-expensive ink cartridges and refill smaller ink cartridges. This process generally requires chip resetting on the ink cartridges and can be a messy proposition.

Some third-party ink systems can provide special solutions, such as Jon Cone's Piezography black-and-white inks. These are not cheap knockoff inks but are special-purpose inks that allow you to do a type of printing you can't achieve with normal color inks.

PROSUMER GRADE

Moving up, but still below professional grade, is what I call *prosumer-grade* printers. These are more likely to be dedicated photo printers as opposed to multiuse printers.

In the prosumer grade, there are many fewer models to choose from. Both Canon and Epson have a good range of models, with carriages that are 8.5 inches, 13 inches, or 17 inches wide. I like two prosumer-grade printers that I own: the Epson Stylus

Pro R3000 (13 inches) and the Epson Stylus Pro 3880 (17 inches). Canon makes some equivalent models, such as the Canon PIXMA iP7220 8.5-inch printer and the PIXMA Pro9500 Mark II 13-inch printer.

One of the characteristics of prosumer models is that they'll often have larger ink cartridges so that you don't have to replace them so frequently. The cost per milliliter drops considerably.

PROFESSIONAL GRADE

There are even fewer professional-grade digital printers available, and Canon and Epson are really the only manufacturers making them. Canon makes the image-PROGRAF iPF6400 (24 inches wide) and iPF8400 (44 inches wide). These printers use 12 LUCIA pigment inks, with eight colors and four black or gray inks. Canon also has the imagePROGRAF iPF9400, a 60–inch-wide printer, and the iPF5100, a 17–inch-wide printer that is arguably a desktop printer, but it hasn't been revved in a couple of years.

It could be argued that the Epson Stylus Pro 3880 falls under the Pro series, though it's more of a prosumer printer. Epson also has a professional 17-inch-wide printer, the 4900. There are two additional current printers: the 7900 (24 inches) and the 9900 (44 inches), and those use the Epson UltraChrome HDR inks, which include ten colors with an optional matte black.

You can purchase an Epson printer with a spectrophotometer, the Epson Spectro-Proofer, but that is primarily useful for service bureaus. If you want a spectrophotometer, I recommend that you get a package from X-Rite, which I'll talk about in Chapter 2.

The Epson Stylus Pro 11880 is a wide-format printer that uses Epson UltraChrome K3 inks, a slightly different ink set with vivid magenta. Epson also offers the 7890 (24 inches) and 8890 (44 inches) versions of the printer with the Epson UltraChrome K3 ink set.

While I have no problem with buying consumer-grade or even prosumer-grade printers over the Internet, I don't think that's a good idea for a professional-quality printer. These are expensive investments, and you don't want to make decisions on a whim. You can do research on the Internet, but find a good local dealer who can help you set up the printer, train you to use it, and work on your behalf to deal with the printer manufacturer if there are any problems or warranty issues. I also highly suggest getting extended warranties where offered. With a professional-grade printer, if something does go wrong, you're going to want to have the printer serviced.

Throughout the book, I'll be talking about making high-end prints, and I'll assume people are working with prosumer or professional-grade printers. As I mentioned, I've got an Epson R3000, Epson 4900, and Epson 9900, and a Canon iPF6400 in-house. Those are the printers that I've used throughout the book.

NOTE One advantage to working with Canon printers is that all the inks are always loaded so you don't have to swap inks. On Epson printers, the main black ink channel is shared by both photo black and matte black inks and you have to switch between them if you switch from photo paper to watercolor paper, which of course uses ink.

PRINTING IN-HOUSE VS. A SERVICE BUREAU OR PHOTO LAB

If you're a hands-on person who likes to have total control, printing in-house might be your cup of tea. When you make the print yourself, you get the chance to get ink on your fingers—especially if you have a leaky ink cartridge, which has happened to me. You also get the headaches of owning and maintaining the equipment. When you're the one doing the printing, you end up paying for all of your own mistakes; you have to buy the ink and the paper; and no matter how much soft proofing you do, the final print either makes or breaks the image. You'll probably end up making multiple prints to get the ultimate print from your image.

If you hire a service bureau or photo lab to make your print, they're the ones with the headaches and the cost, and you pay only a per-print price. Particularly if you're using a consumer-grade or prosumer-grade printer, you'd be hard-pressed to make prints as cheaply as you can get them online or even from your local drug store.

The question comes down to your aesthetic and your desire for control versus dealing with the headaches of ownership.

One other thing to factor in is the time it takes you to get your print. When you're printing in-house, you can load the paper and make the print immediately. With a service bureau or photo lab, there is some turnaround time. That's not to say that a service bureau or photo lab doesn't screw up, so if you're in a time crunch and you need to have it right, relying on a photo lab can lead to disappointment and problems.

If you are reading this book, I suspect you may fall under the category of being a *hands-on* person. So, I might suggest a mix of making your own smaller-sized prints and sending out for large prints. A prosumer or pro printer capable of printing on 13-inch or 17-inch-wide paper would cover medium-sized prints and smaller, and you could use it to proof for larger 24-inch or 44-inch-wide prints from a photo lab or service bureau.

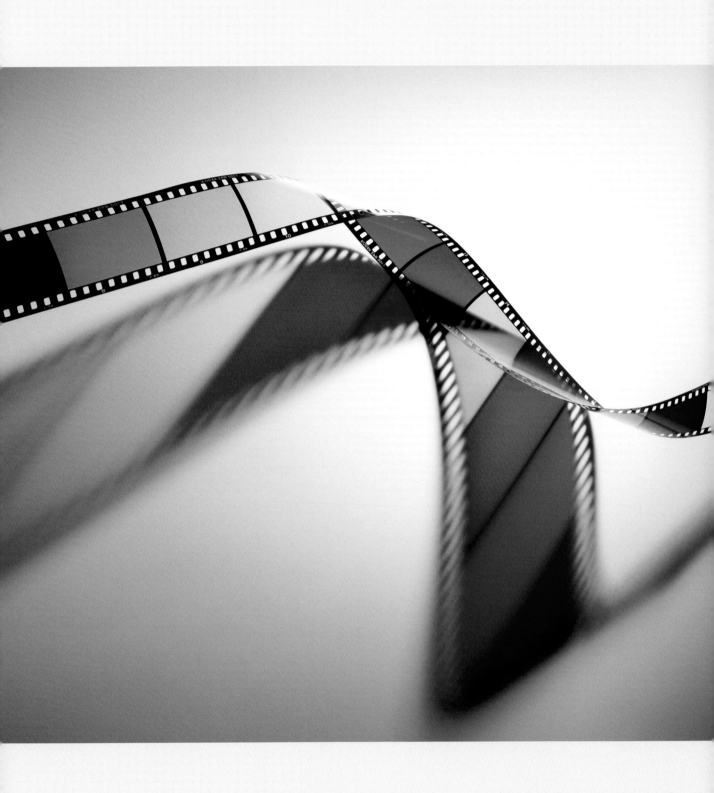

■ CHAPTER 2

COLOR MANAGEMENT

At this point, color management for digital imaging is a mature and efficient system for maintaining color appearance across multiple devices. It works really well—well, most of the time. There are the occasional hiccups when a new operating system or imaging application is released, but for the most part these are short-lived bumps on the road to color nirvana, assuming you have a fundamental grasp of the technology and employ color management correctly. That's what this chapter is all about—using color management correctly!

The image of film on film was shot on 8x10 Ektachrome with a Sinar 8x10 camera with a 300mm lens under studio strobe lighting. The film roll was shot on 35mm Ektachrome shooting through colored filters with a Nikon 35mm camera and a macro lens. The transparency was scanned on an Epson Perfection V750 Scanner.

UNDERSTANDING THE COLOR OF COLOR MANAGEMENT

You don't need to be a color scientist to understand and use color management (although that wouldn't hurt). I am not, by any means, a color scientist—believe me. Over the years, however, I've learned a bit about color (or colour if you are from outside the United States). The human eye is an interesting organ, and our ability to see has been a major part of our evolutionary success. But when it comes to seeing color, the topic can be confusing. What is color?

WHAT IS COLOR AND HOW DO YOU SEE IT?

Is color a property of light or a property of an object you see? Or is color something a person perceives? Yes! Color is a mix of these, but as my good friend and colleague Bruce Fraser used to say, color is actually an *event* that occurs because of three things: a light source, an object, and an observer. The color event is the perception that is evoked by an observer caused by the wavelengths of light produced by a light source and modified by reflectance from the surface of an object. Whether that object is a red apple, a green leaf, or a pair of fancy blue suede shoes, the color you "see" is dictated by the light falling on the object, which wavelengths of light are reflected (or transmitted) by an object, and how they are perceived by your eyes. Change any of those three aspects of a color event and the color will be different. Let's look at the three parts of the *color event*. But before you read on, let me give you a bit of a warning; this material can sometimes get geeky. Whenever possible I've put the really geeky information in a note or sidebar. If you are already well versed in color science (or really don't want to expose yourself to it), you can skip to the section "Fundamentals of Color Management" later in this chapter. If you *are* a color scientist, go easy on me. I'm still learning this stuff!

Light

Is light a wave or a particle? Sir Isaac Newton (1642–1727), the English physicist and mathematician, described light as a particle, whereas other scientists, such as Dutch mathematician Christian Huygens (1629–1695), thought of light as a wave. It took quantum physicists, such as Max Plank and Albert Einstein, to reconcile the wave-particle duality and call light a "wavicle" or photon, which is an entity that has characteristic properties of both waves and particles. A photon is a pulsating packet of energy that travels through space (and time). Photons have a constant speed (the

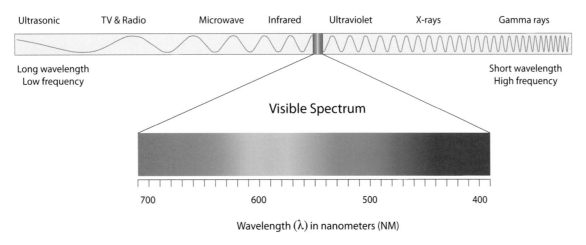

Electromagnetic Spectrum

Ultrasonic TV & Radio Microwave Infrared Ultraviolet X-rays Gamma rays

Long wavelength
Low frequency

Short wavelength
High frequency

Visible Spectrum

700 600 500 400

Wavelength (λ) in nanometers (NM)

FIGURE 2.1 The Electromagnetic Spectrum highlighting the portion of the spectrum visible to the human eye.

speed of light) but can have different energy levels. The energy level dictates the speed of the pulsation. Higher energy photons pulse at shorter wavelengths and higher frequencies, whereas lower energy photons pulse at longer wavelengths and lower frequencies. **Figure 2.1** shows the electromagnetic spectrum and the tiny portion visible to humans.

As you can "see," the human eye can see only a small section of the spectrum that ranges from about 700 nm to about 380 nm. A nanometer is one billionth of a meter, which is pretty darn small! The color sensations produced by the different wavelengths dictate the colors you see. Longer and lower frequencies appear red; shorter wavelengths with higher frequencies appear blue.

In color management you're primarily concerned about the visible light; however, as photographers and printmakers, you need to understand the impact of near-visible light as well. Digital cameras are very sensitive to infrared (IR) light and require IR cut-off filters to help eliminate false color sensitivity. Ultraviolet (UV) light can have an impact on printmaking because optical brightening agents (OBAs) can change UV light to visible light and change the appearance of a print. OBAs can also have a negative impact on print longevity, which I'll discuss in more detail in Chapter 5, "Attributes of a Perfect Print."

The spectral properties of a light source have an impact on the color you see when viewing an object. Daylight (CIE Standard Illuminate D) has relatively even spectral power distributions (SPDs). Tungsten light has more long wavelengths and

WHAT IS THE COLOR OF WHITE?

Different light sources have different spectral properties that can influence the color you see. For photography, the primary measurement of "white light" is determined by how many degrees the light measures in a *Kelvin* scale, named after the Glasgow University physicist William Thompson, the first Baron Kelvin (Lord Kelvin). The Kelvin scale is an absolute, thermodynamic temperature scale using as its null point absolute zero (approximately –273.15 Celsius).

All matter emits electromagnetic radiation when it has a temperature above absolute zero. The radiation represents a conversion of a body's thermal energy into electromagnetic energy and is therefore called *thermal radiation*. When the radiation is high and hot enough, you see light. When used to measure light, the degrees Kelvin (°K) refers to the temperature it would take to heat a theoretical black-body radiator to emit visible light. A black-body at room temperature would radiate only a small amount of infrared radiation. If the black-body was heated to 1500–2000° K, the radiation and light would appear similar to candlelight, with a dull red color. A tungsten lightbulb has a color temperature of about 3200° K and contains a bit more orange and yellow but is still little blue light. At 5000° K the black-body emission levels out and includes more short wavelength radiation. At 9000° K and above the light is considerably bluer with predominately short wavelengths and relatively few longer wavelengths. **Figure 2.2** shows the approximate spectral curves of a black-body at various temperatures.

The normal standard for photography is considered 5000° K, which is daylight. However, it should be noted that 5000° K is not D50, because the black-body temperature path (also called the *Planckian locus*) follows a generally red/amber/yellow/blue progression. The designation of specific light color, such as D50, needs a different axis of color called *Tint* in Camera Raw and Adobe Lightroom. The tint is a range of color perpendicular to the Planckian locus and is generally green or magenta.

I've used the term *color temperature* to describe the color of light. Purists would call it a *correlated color temperature* because most emissive light sources, such as daylight, tungsten, fluorescent, and computer displays, are not true black-body radiators. So it's actually the closest apparent correlated black-body temperature.

FIGURE 2.2 Color temperature of light.

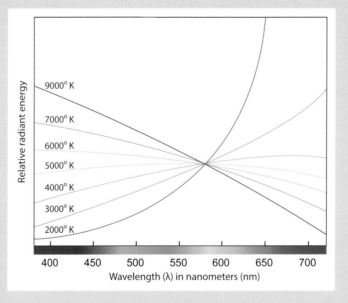

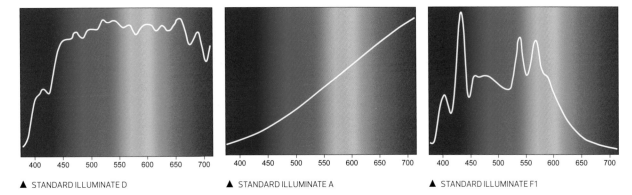

▲ STANDARD ILLUMINATE D	▲ STANDARD ILLUMINATE A	▲ STANDARD ILLUMINATE F1

FIGURE 2.3 Spectral power distributions of Standard Illuminate D (daylight), Standard Illuminate A, and Standard Illuminate F1. Note that the ranges of the nanometers in this figure are reversed from Figure 2.1. It really doesn't matter from which end of the visible spectrum you chart the visible colors, as long as you understand the wavelengths and the frequencies (the colors) involved.

low frequencies (reds/yellows), whereas other light sources, such as a cool-white fluorescent bulb, have very spiky spectral power distributions that can seriously change color appearance. **Figure 2.3** shows the spectral power distributions of CIE Standard Illuminate D (daylight), CIE Standard Illuminate A (2856° Kelvin, approximately the same as tungsten), and CIE Standard Illuminate F1 (cool-white fluorescent).

Although the spectral power distribution can have a substantial effect on the color the eye can see and perceive, a factor in human vision can mitigate the differences in color perception.

Color constancy is an example of chromatic adaptation and a feature of the human color perception system, which ensures that the perceived color of objects remains relatively constant under varying illumination conditions. Photographic film and digital sensors do not have this ability and respond differently to light with different spectral illumination and color temperature.

Color

The next component of the *color event* is the color of the object. Whether the object is animate or inanimate, solid or translucent, the color an object may appear is dictated by what colors the object may reflect or absorb (transmit or filter out in the case of light passing through a translucent material). It's pretty simple really: The color of an object when viewed with a full spectrum of light is the color that is *not* absorbed. Take a look at **Figure 2.4**. The rose is red, the leaves are green, and the ribbon is blue. The image was shot with a Canon EOS 1Ds MIII camera with a 100mm macro lens.

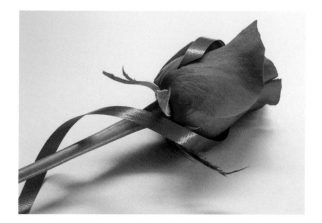

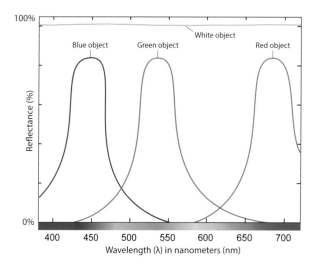

FIGURE 2.5 Spectral curves showing a representational curve for the blue, green, and red objects of the image shown in Figure 2.4. Note that an additional curve has been added to show the curve for a "white object" (such as the background).

The scene was lit with a full-spectrum, daylight fluorescent bulb (a GE Chroma 50 bulb) that does not produce an overly spiky spectral power distribution, which is a good thing. The rose reflected the red component of the white light and absorbed all of the green and blue colored light. The leaves and stalk reflected the green (and a bit of yellow) while absorbing the red and blue light. The blue ribbon reflected the blue (and a touch of cyan) while absorbing the green and red. This image shows how a full-spectrum white light falling on an object produces a visible color by reflecting certain components while absorbing others. **Figure 2.5** shows spectral curves of the blue, green, red, and a curve for a white (or light gray) object.

The Eye

The eye is the final component of the *color event*. I won't try to explain *exactly* how the human eye works. This is my short and concise version.

The human eye responds to light based on three colors of light. This response is called *trichromacy* and breaks down to photoreceptors called *rods* and *cones*. Rod receptors are mainly receptive to luminance, and the cones are sensitive to color (which is why you have far less color vision in low-light levels). Trichromacy—red, green and blue sensitivity—is concentrated in the fovea centralis (commonly called the fovea), which represents about 2° of the retina. This is the basis of the CIE 1931 2° Standard Observer (see the sidebar "The CIE 1931 2° Standard Observer").

There are three types of cones, which are sensitive to different wavelengths of light. Although it would be convenient to think of them as red, green, and blue cones, in actuality it's better to think of them as cones sensitive to short, medium, and long wavelengths, as shown in **Figure 2.6**.

THE CIE 1931 2° STANDARD OBSERVER

Due to the distribution of cones in the eye, the tristimulus values depend on the observer's field of view. To eliminate this variable, the CIE defined the "standard colorimetric observer" based on work by Wright [1928] and by Guild [1931]. This theoretical observer was derived after extensive testing of the ability of a wide variety of people to see and match colors. This "observer" represented the chromatic response of the average human viewing through a 2° angle due to the color-sensitive cones residing within a 2° arc of the fovea. As a result, the CIE 1931 Standard Observer is also known as the CIE 1931 2° Standard Observer. Another more modern alternative is the CIE 1964 10° Standard Observer, which is derived from the work of Stiles, Burch, and Speranskaya but is less often used.

In recent years, the concept of an Expert Color Observer has been introduced. With training, the human ability to see and distinguish colors can be increased. People who deal with color on an extensive basis, such as artists, designers, and color scientists, can actually exhibit superior color vision.

Unfortunately, the flip side of the coin is color blindness or color vision deficiency, which is the inability or decreased ability to see certain colors or perceive color differences under normal lighting conditions. The two major types of color blindness include those who have difficulty distinguishing between red and green, and those who have difficulty distinguishing between blue and yellow. Color blindness can be inherited or caused by damage to the retina because of accidents or over exposure to ultraviolet light. About 8 percent of males but only 0.5 percent of females are color blind in some way or another, whether it is one color, a color combination, or another mutation. There's not much in the way of treatment, although mild color blindness can be overcome to a large degree by discovering what sort of color blindness a person has and training to help mitigate the issue. To know how well you see color, get your eyes tested. X-Rite offers a free, online color challenge to see how you score in a color hue test. Google the term "*X-Rite color blindness test*." If you score poorly, visit your eye doctor for more testing.

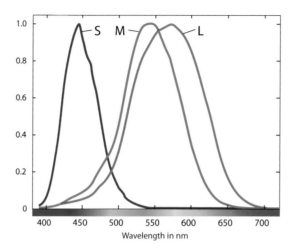

FIGURE 2.6 Peak sensitivities of the S, M, and L cones. The wavelengths of the three cone photoreceptors have peak absorptions at 420 nm, 530 nm, and 565 nm. Rods that are primarily used for lower light and provide little color sensitivity peak around 499 nm.

Trichromacy and *tristimulus* are two related and often-confused terms. Trichromacy (also known as the Young-Helmoltz theory of three-component color named for Thomas Young in 1802 and further work by Hermann von Helmholtz in 1850) is a well-verified theory that color vision is due to the three types of color sensitive cones. Tristimulus refers to experiments and measurements of human color vision involving three-color stimuli. The most comprehensive tristimulus model has been defined by the CIE and is the backbone of modern color management.

Figure 2.7 shows the well-known "horseshoe" plot of the CIE 1931 XYZ color space displayed in Yxy coordinates (see the "Geek Warning" note). The two-dimensional x and y plots exaggerate some colors and downplay others. For this reason, the CIE XYZ color space is not perceptually uniform, although it's useful to use for comparison purposes.

I'll show additional CIE 1931 XYZ gamut plots later in this chapter when I discuss how the color gamut of various devices, such as cameras, scanners, Photoshop working spaces, and printers, can be compared.

It is the trichromatic nature of the human eye that makes it possible to perceive a full spectrum of colors based on just three basic colors of light. These three colors are roughly broken into thirds: red, green, and blue. These three basic colors are called the *additive primary colors* because you can *add* any of the additive primary colors together to achieve virtually any color of the spectrum. If you have three colored light sources with overlapping colors divided roughly into red, green, and blue, any color of light can be produced by mixing the portions of the three colors. If you add equal amounts of red, green, and blue together, the result is white light.

Red plus green produce yellow; red and blue produce magenta; and blue and green produce cyan. The complementary colors to the additive primary colors are called *subtractive primary colors*. **Figure 2.8** shows both sets of colors.

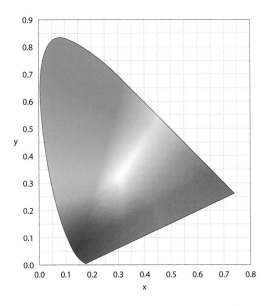

FIGURE 2.7 The CIE XYZ 1931 color space as plotted in Yxy coordinates. The horseshoe shape of colors represents the two-dimensional plotted color gamut of human vision.

FIGURE 2.8 The additive and subtractive primary colors.

▲ ADDITIVE PRIMARIES OF RED, GREEN, AND BLUE

▲ SUBTRACTIVE PRIMARIES OF CYAN, MAGENTA, AND YELLOW

The main differences between the additive and subtractive primary colors are that the RGB primaries are largely associated with photography, whereas the subtractive primaries of CMY are associated with printmaking and inks. Why does CMY almost always need a fourth black ink? Because today's inks, whether for halftone or inkjet printing, cannot achieve a true deep black without adding the extra density provided by the fourth black ink. Figure 2.8 shows the additive and subtractive primaries.

The order of RGB with CMY leads to the creation of a full spectrum of colors for a color wheel, which is red, yellow, green, cyan, blue, and magenta. These are the six main colors you should be concerned about for color correction. If an image has a green cast, you should either add magenta or reduce green. It's the same deal for the other primaries: To add yellow, you can reduce the blue, or to add red, reduce the cyan.

Opponency: The red/green and blue/yellow monkey wrench

Just when you thought you had a handle on all that color encompasses, let me throw in a monkey wrench—an opposite way of thinking about seeing color. Even though Thomas Young proved that by mixing red light and green light you could achieve yellow light, it's tough to imagine a color being both red and green or blue and yellow. This highlights another theory of color called the *Hering Theory* or the *opponent-color theory* based on experiments by Edwald Hering in 1892.

The Hering Theory held that the retina has fundamental components that generate opposite signals depending on wavelength. Hering thought that color components were not independent receptors that have no impact on their neighbors but work as opponent pairs. The opponent pairs are light/dark, red/green, and yellow/blue. **Figure 2.9** shows a visual illusion of successive contrast that indicates Hering had something correct with the *opponent-color theory*.

The debate about opponency and trichromacy went on for many years until it was finally reconciled into yet another theory called the *zone theory of color*. Think of the zone theory as the one ring to rule them all: The three different kinds of cones absorb the light in the receptors and convert it to electrical signals according to Young-Helmholtz (trichromacy). Then the cone signals that are coded into the neural network generate three new signals: one achromatic signal (light/dark) and

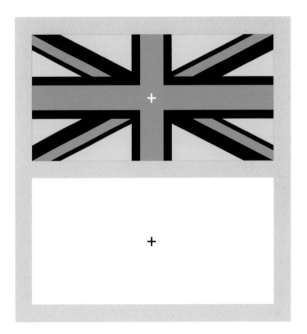

FIGURE 2.9 The visual proof of a form of simultaneous contrast (successive contrast) where the eyes see the opposite colors as an after image.

IF YOU STARE AT THE TOP IMAGE FOR A MINUTE OR SO (LOOK DIRECTLY AT THE WHITE CROSS) AND THEN QUICKLY GLANCE DOWN AT THE BLACK CROSS, WHAT DO YOU SEE? THE UK FLAG? THE COLORS WERE CHOSEN TO DEMONSTRATE COLOR OPPONENCY.

two opponent signals (red/green and yellow/blue) according to Hering (opponency). These two apparently contradictory theories actually combine into a fuller explanation of how you see color. Opponency and trichromancy are essential to understand color management.

The CIE has established several color models used extensively in color management. One is the previously mentioned CIE 1931 XYZ color model based on trichromacy and another that is based on the premise of opponency called CIE L*a*b* (CIELAB). The intention of the LAB color spaces was to create a space that could be computed via simple formulas from the XYZ space but is more perceptually uniform than XYZ, meaning that a given change in value corresponds roughly to the same perceptual difference over any part of the color space.

CIELAB has the opponent colors of light/dark (the L* or lightness part), red/green (the a* part), and yellow/blue (the b* part). This concept of lightness (L*), red/green (a*), and yellow/blue (b*) pretty much covers all colors of the visible spectrum (note that the a* and b* numbers can be either a negative or positive number). Using LAB you can convert trichromatic colors into values in an opponent-color system.

Figure 2.10 shows the CIELAB and how the colors and lightness values are designated. Note that Hering's designated colors of L* (light/dark), a* (red/green), and b* (yellow/blue) remain. This is, of course, "technically" accurate; however, I tend to prefer to think of the +a* as more of a magenta-tinted red and -a* as more of a cyan-tinted green.

NOTE
L*a*b*, LAB, or Lab?
Technically, the LAB color space is based on the CIE 1976 (L*, a*, b*) color space (otherwise known as CIELAB). If you happen to post to any of the online forums where color geeks hang out, you'll probably want to write LAB as L* (star) a*(star) b*(star) or L*a*b*, or you'll get flamed. I have no problem with the technical accuracy of L*a*b*, but I get tired of typing the whole darn thing with the asterisks. From this point forward in the book, when I refer to the CIELAB, I'll call it CIELAB. But if I refer to a more generic LAB space (such as the one in Photoshop, which is CIELAB D50), I'll eliminate the asterisks and simply type LAB. OK?

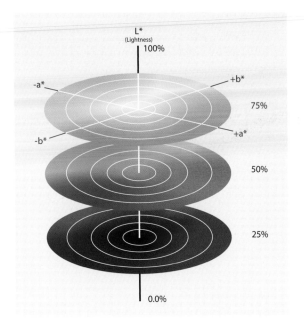

FIGURE 2.10 The L*a*b* color space with the axis of L* (lightness) and the +–a* and +–b* colors with approximate lightness percentages.

NOTE What Is a
Spectrocolorimeter?
Technically, a spectro-
colorimeter is a spec-
trophotometer that can
calculate tristimulus
values, which includes
most spectrophotom-
eters used in color man-
agement. However, the
term is sometimes used
more as a marketing
term for a colorimeter
that has more than the
typical RGB filters in
addition to the three
color sensors. At best,
the term spectrocol-
orimeter is confusing
when applied to color-
imeters simply because
it has more than three
bands. At worst, the
term is intentionally
misleading. The term
multi-band colorimeter
with a designation of the
number of bands mea-
sured would be more
accurate.

MEASURING AND SPECIFYING COLOR

The term *color measurement* is actually a misnomer. As I noted, color is an event with three components: a light source, an object, and an eye. When you measure color, you measure the stimulus entering the eye and deduce the sensation of color that stimulus produces.

Three main types of instruments measure the stimuli the eye will interpret as color. They all work by shining a light with known spectral properties onto or through a surface and then use a detector to measure the light that is reflected or transmitted. The detector is simply a photon counter. Because the detector can't determine the actual wavelengths of the photons it counts, the instrument must filter the light going to the detector. The differences between the three main types of instruments— densitometers, colorimeters, and spectrophotometers—are the number of filters, the type of filters, and the sensitivity and accuracy of the detectors:

- **Densitometers** measure *density*—the degree to which a reflective surface absorbs light or a transparent surface allows light to pass. Densitometers are commonly used in graphic arts and photographic sensitometry. Densitometers are used more often for process control rather than color management purposes.

- **Tristimulus colorimeters** (usually shortened to colorimeter) measure the *tristimulus colorimetric* values or numbers that model the color response of the cones in your eyes. Colorimeters generally have red, green, and blue filtered band measurements but can have additional bands for special purposes and greater accuracy. Colorimeters are commonly used as display profiling devices.

- **Spectrophotometers** measure the spectral properties of a surface and how much light at each wavelength a surface reflects or transmits. Spectrophotometers used for color management purposes measure the visible spectrum between 400–700 nm in bands between 10–20 nm. Some spectrophotometers can also measure light in the nonvisible UV spectrum to determine the presence of fluorescence. Spectrophotometers are commonly used for print profiling devices.

Each type of instrument has its uses, as well as strengths and weakness. The cost of the various instruments can vary significantly as can their accuracy.

Colorimetry

Colorimetry is the science and technology used to measure and specify human color perception, and to be able to predict color matching. The goal of colorimetry is to build a numeric model that can predict when metamerism (a color match) does or does not occur. To be a successful colorimetric model, the model must perform two tasks:

- Where a standard observer sees a color match between two different color samples, the model must represent both samples by the same numeric values.

- Where a standard observer sees a difference between two color samples, the model must represent both samples as different numeric numbers but also be able to compute the color difference number and predict how differently the samples appear to an observer.

The CIE colorimetric models form the backbone of most all color management systems and allow you to numerically represent the color that people with normal color vision see. The two primary models used in color management are the CIE XYZ system shown in Figure 2.7 and the CIE L*a*b* (LAB) system shown in Figure 2.10.

Delta-E (ΔE). Color difference calculations offer a standardized method to compute the differences between two samples. If you measure the two samples in a uniform space, such as XYZ or LAB, and compute the differences between them, the distance will correlate well to the difference a standard observer sees. This difference or delta is called *Delta-E* (abbreviated as ΔE or simply dE) by the CIE. Delta is a Greek letter Δ often used to denote *difference*, and E represents *Empfindung*, which is German for "sensation."

Studies have proposed different ΔE values that have a *just noticeable difference* (JND), but a ΔE of 1.0 is said to be about the threshold of human vision discrimination between two colors that are not touching one another. However, human vision is more sensitive to color differences if the two colors actually touch each other. As a result, a standard observer might be able to see a difference of less than 1 ΔE; however, usually numbers less than 1.0 represent differences between measurements or are limited by the accuracy of the instrument. A ΔE between 3 and 6 is typically considered an acceptable match in commercial reproduction on printing presses. A ΔE of over 6 is considered to be a mismatch of the colors.

Metamerism. In colorimetry, metamerism is the critical color matching of the apparent color of objects with different spectral power distributions (SPDs). Colors that match this way are called metamers, and metamerism is what allows you to produce a print of a red rose and see the red color!

An SPD describes the proportion of total light emitted, transmitted, or reflected by a color sample at every visible wavelength and precisely defines the light from any physical stimulus. However, the human eye contains only three color cone receptors (see Figure 2.6), which means that all colors are reduced to three sensory quantities called the *tristimulus values*. Metamerism occurs because each type of cone responds to the cumulative energy from a broad range of wavelengths, so that different combinations of light across all wavelengths can produce an equivalent response and the same tristimulus values or color sensation.

MODERN COLOR APPEARANCE MODELING: CIECAM02

Resent research has improved color appearance modeling. Published in 2002 by the CIE Technical Committee, the CIECAM02 model was ratified in 2008. The main parts of the model are its chromatic adaptation transform, CIECAT02, and its equations for calculating mathematical correlations for the six technically defined dimensions of color appearance: brightness (luminance), lightness, colorfulness, chroma, saturation, and hue.

CIECAM02 has been used in Windows Color System (WCS) starting with Windows Vista. However, CIECAM02 is not directly interchangeable with Windows Image Color Management (ICM) and has not been widely adopted by major color management companies or software developers in professional use. It's fertile ground for the future, just not very useful yet.

NOTE

What Is CIELUV?

The CIE 1976 (L* u* v*) color space, commonly abbreviated as CIELUV, is another color space adopted by the CIE as a simple-to-compute transformation of the CIE 1931 XYZ color space but attempts to provide better perceptual uniformity. CIELUV and CIELAB were adopted simultaneously by the CIE because no clear consensus could be formed to support only one or the other of these two color spaces. CIELUV is used less than CIELAB in color management.

Metamerism is often mistakenly confused with the broader term *metameric failure* or sometimes called a *metameric mismatch*. **Figure 2.11** shows an illuminant metameric match and a metameric failure (mismatch). This sort of metameric failure is most common in color management scenarios.

Because objects can reflect only those wavelengths that are present in the light source, the different light sources in Figure 2.11 can contribute to the metameric failure of the two color samples. Light source A contains more long wavelength (red) than light source B, which contains more short wavelength (blue). However, it's the nature of the two color samples exhibiting different SPDs that result in the metameric failure.

There are several methods of measuring metamerism. The best-known method is called the *Color Rendering Index (CRI)*, defined by the CIE as the effect of an illuminant on the color appearance of an object by conscious or subconscious comparison with its color appearance under a reference illuminant. A newer method for daylight simulation is the CIE Metamerism Index (MI), which is derived by calculating the mean color difference of eight (or more) metamers with five in the visible spectrum and three in the ultraviolet range in CIELAB or CIELUV I. The main difference between CRI and MI is the color space used to calculate the color difference. When evaluating color matching in color management, it's critical that the viewing lights have a good CRI or MI, which is why viewing booths can be so expensive.

Gray balance failure. A common problem with printing, which is often referred to mistakenly as metamerism, is actually not related to metamerism. The inks used to create printed output are generally made up of various flavors of cyan, magenta, yellow,

▲ COLOR SAMPLE 1

▲ VIEWED UNDER A LIGHT SOURCE A BY...

▲ THIS IS A *METAMERIC MATCH* IF THE SAMPLES RESULT IN THE SAME COLOR EXPERIENCE

▲ COLOR SAMPLE 2

▲ ...A STANDARD OBSERVER

▲ COLOR SAMPLE 1

▲ VIEWED UNDER A LIGHT SOURCE A BY...

▲ THIS IS A *METAMERIC FAILURE* (MISMATCH) IF THE SAMPLES RESULT IN A DIFFERENT COLOR EXPERIENCE

▲ COLOR SAMPLE 2

▲ ...A STANDARD OBSERVER

FIGURE 2.11 Metameric match and failures (mismatch) of two color samples under two light sources with different spectral power distributions.

and black (CMYK). To produce a neutral gray, some combination of CMYK is mixed. When printers are profiled, the gray balance to achieve a ramp from black to white is based on a viewing standard, which is generally D50. However, that same gray balance may not remain visually neutral under different SPDs, such as tungsten, fluorescent, or cooler skylight. The changes to the gray balance are not really a metameric failure because it is the same print that looks different under different lights, not two color samples that appear differently. Steve Upton of CHROMIX (www.chromix.com) has coined the term *Gray Balance Failure (GBF)* to explain this problem.

A prime example of GBF was found in the early pigment printers released by Epson and Canon. The pigment inks in these printers made gray balancing impossible under different viewing lights. If you had a print that looked good under D50 (daylight) and then viewed the print under tungsten light, the print would exhibit a very strong pink/magenta cast. If you took it outside and viewed it under skylight (D75), the print would look greenish. Color management could not really fix the problem, but subsequent ink and printer design has pretty much eliminated the GBF problems. **Figure 2.12** shows a simulation of the GBF you could expect to see with the 2000P printer. I refer to this as a simulation because, well, I never bought one of those printers, not after finding out how bad the GBF was with that ink set. But this is a reasonable facsimile of what it could look like (based on what I've seen). Just remember that GBF is not "metamerism," nor is it a result of metameric failure!

Color specification. The science of colorimetry is all about color appearance, color measurement, and color matching. Somewhere along the line, though, the specification of color comes into play. Color specifications in XYZ and LAB have specific quantifiable meaning. They are considered *device independent color* measurements. The measurement or specifications of colors in either XYZ or LAB coordinates don't vary depending on external factors (with the exception of CIELAB requiring the specification of a *reference white* point, such as D50 or D65). The numbers are set and have unambiguous meaning. This makes these color models very useful for color management because you can transform into and out of them very accurately.

FIGURE 2.12 A simulation of gray balance failure in early pigment inkjet printers.

▲ PRINT VIEWED UNDER D50 (DAYLIGHT)

▲ PRINT VIEWED UNDER 3200°K TUNGSTEN LIGHT

▲ PRINT VIEWED UNDER D75 (NORTHERN SKYLIGHT)

FIGURE 2.13 The Photoshop Eyedropper tool and options.

▲ THE EYEDROPPER SAMPLE SIZE AND SAMPLE OPTIONS. BOTH DROP-DOWN MENUS ARE SHOWN FOR BREVITY; NORMALLY, YOU WOULD SEE ONLY ONE OF THE DROP-DOWN MENUS AT ONCE

▲ THE EYEDROPPER TOOL FLYOUT MENU

In Photoshop or Lightroom, additional methods of specifying a color are called *device dependent color* measurements. This is important because the numbers of various colors change based on the color space you are using to specify those numbers.

Photoshop color measurement and specification. In Photoshop you can measure or specify a color using a variety of device dependent colors and one device independent color—LAB. Photoshop's LAB color uses a D50 white point coordinate. Photoshop also has the ability to specify colors in Hue, Saturation, and Brightness (HSB) as well as RGB (0–255) and CMYK (0–100%). The measurement or specification of a color in RGB, HSB, or CMYK depends on the color space you have set in the Photoshop Color Settings dialog and the color space of your image (more about this later in the section "Color Management in Photoshop"). For more information about the HSB color space, check out the sidebar "HSB, HSV, or HSL Color?"

Color measurement in Photoshop uses the Eyedropper tool, and how it behaves depends on the tool's settings and options. Note that **Figure 2.13** shows the Eyedropper tool as well as the Color Sampler tool. The Color Sampler tool allows you to place persistent sampler readouts in the Info panel.

The Eyedropper tool has readouts that display on the Info panel with options for the color space, as shown in **Figure 2.14**. You can change what the readouts display by clicking the small Eyedropper icon on the panel. Note that you have separate options for two different color readouts on the left and right side of the Info panel for comparison purposes.

Being able to read out the color measurements of various color spaces is very useful when comparing colors. The Color Sampler tool allows you to place persistent color readouts in a document. Although Photoshop is limited to only four samples, Camera Raw allows the placement of up to nine samples. Unfortunately, at this time, Lightroom has only a single color readout and no option for persistent sample readouts. **Figure 2.15** shows the readouts of four Color Sampler points and the location of the points in an example image. Note that I've changed each of the sample points to read out in a different color space.

RGB AND HSB READOUTS

FIGURE 2.14 The Eyedropper tool readout drop-down menu and various color readouts of the color red.

▲ THE EYEDROPPER OPTION MENU OF THE SECOND COLOR READOUT

RGB AND LAB READOUTS

RGB AND CMYK READOUTS

FIGURE 2.15 Multiple Color Sampler Info panel readouts.

▲ INFO PANEL READOUTS

▲ COLOR SAMPLER SAMPLE POINTS

The specification of colors in Photoshop offers the same basic options as color measurements: RGB, HSB, CMYK, and Lab sliders in two places—the Color panel and the Color Picker. **Figure 2.16** shows the options in the Color panel, and **Figure 2.17** shows the options in the Color Picker (accessed by clicking a color swatch in the Color panel or the main toolbar).

Color measurement and selection in Lightroom, on the other hand, is very primitive (some may say crude, and I wouldn't completely disagree!). The only place to measure color in Lightroom is in the Develop module. Only a single nonpersistent color sampler is available, and the readout is always 0–100% RGB. The only places to select colors are in the Color Sampler tool in the Adjustment Brush and Graduated Filter, and also the Split Toning panel. **Figure 2.18** shows the Lightroom color measurement readout and the Color Picker.

FIGURE 2.16 The Color panel in Photoshop showing the flyout menu with the color selection options.

▲ COLOR PICKER WITH THE R (RED) BUTTON SELECTED

FIGURE 2.17 The Color Picker in Photoshop. Depending on the radio button selected, the color preview display changes to reflect the color space and color aspect.

▲ THE LIGHTROOM COLOR MEASURE TOOL
READING OUT R 100%, G 0%, AND B 0%

▲ THE LIGHTROOM COLOR SELECTION TOOL

FIGURE 2.18 The Lightroom color measurement and picker tools.

The Color Sampler tool in Camera Raw is actually a model I wish Photoshop and Lightroom would follow. It allows up to nine persistent color readouts, which is five more than Photoshop and eight more than Lightroom. More is better! **Figure 2.19** shows Camera Raw's Color Sampler and Color Picker.

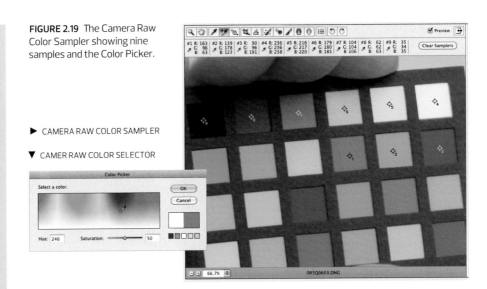

FIGURE 2.19 The Camera Raw Color Sampler showing nine samples and the Color Picker.

▶ CAMERA RAW COLOR SAMPLER

▼ CAMER RAW COLOR SELECTOR

NOTE

Lightroom's Color Readouts Lightroom's color sampling readouts are not in a "normal" color space. Because the Develop module works in Lightroom's internal color space (which is ProPhoto RGB primaries but a linear gamma), the color readouts in Light-room do not adhere to a 0–255 RGB color space. Instead, Lightroom's color readout is 0–100% RGB. Some people call Lightroom's internal color space Melissa RGB (after Mellissa Gaul, a former Lightroom QE manager). Actually, the readouts are in Melissa RGB, but instead of Lightroom's internal linear gamma, the read-outs represent an sRGB tone curve. You can get 0–255 RGB but only when you soft proof in a specific RGB color space profile. You'll learn more about color spaces later in the chapter, but for now just remember that the internal color space is ProPhoto RGB with a linear gamma and the readouts and histogram display are in Melissa RGB.

When colorimetric models fail

Although the CIE colorimetric models of human vision work very well as a basis for color matching, there are some areas of color perception where the models don't work. The models were originally designed to predict how well two different color samples might match when viewed in a prescribed manner under specific illumination. There are times when colorimetric-based color measurement doesn't work because *accurate* color isn't always what is desired; sometimes you just want the *right* color. The right color is often a matter of the color you see within the context of that color.

Color constancy. Color constancy is an important factor in human vision; however, it sometimes gets in the way of seeing the right color. **Figure 2.22** shows an example of color constancy related to simultaneous contrast where the surrounding colors influences the color you see in an object. I used a color fill layer (set to a Color blend mode) in Photoshop to create the color tints. The area of the flowers were masked out using a layer mask. The flowers' colors in both images are exactly the same, but in the warm tint the flowers look darker and less saturated than the flowers in the cool-tinted image. Colorimetric models simply can't (at this time) address this simultaneous contrast effect of human vision.

Color constancy lets your eyes adapt to different illumination. It's what allows you to see a red rose in daylight or under tungsten illumination and perceive the color red. **Figure 2.23** shows an X-Rite ColorChecker Passport target. The image on the left shows what the target looks like under daylight (shot with strobe lighting).

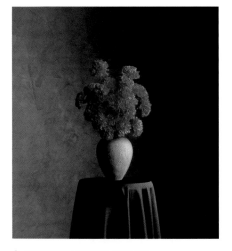

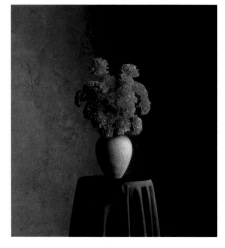

FIGURE 2.22 The simultaneous contrast effect of color constancy. Look at the flowers in both shots; do the colors appear the same to your eyes?

▲ WARM TINT IN THE BACKGROUND

▲ COOL TINT IN THE BACKGROUND

▲ PASSPORT TARGET COLORS AS PERCEIVED UNDER DAYLIGHT ILLUMINATION

▲ PASSPORT TARGET COLORS AS PERCEIVED UNDER TUNGSTEN LIGHT WITH WHITE BALANCE CORRECTED

▲ PASSPORT TARGET AS SEEN BY A CAMERA SENSOR UNDER TUNGSTEN LIGHT UNCORRECTED

FIGURE 2.23 Color constancy of human perception and lack of constancy in a camera.

The middle image is what a target shot under tungsten lighting would *look* like to your eyes. It was shot under tungsten illumination but corrected for white balance because a camera doesn't have color constancy. The image on the right is the uncorrected target under tungsten lighting.

Another aspect of color constancy is that the appearance of color can be impacted by the SPD of the illumination and the illumination levels. For color constancy to work, the illumination must contain a full spectrum of wavelengths and be bright

enough that the cones of your eyes are being used. Spiky narrow bands of illumination, as might be seen if an object were lit with colored neon signs, will not allow for normal color constancy.

Additionally, as the illumination dims, the rods of your eyes overtake the cones because rods outside of the fovea become more important under lower-light levels. As illumination output is reduced, your eyes become less sensitive to color. The lower the illumination level, the more the rods come into play. The retina contains about 120 million rods, whereas only about 6 million cones are concentrated in the fovea. The rods are sensitive to wavelengths of light at about 500 nm, which is in the cyan/green regions of the spectrum. The illumination level is not really factored into the CIE colorimetric models, which is limited to the cones in the fovea. This can have an impact in print viewing environments. A print under dim illumination will look cooler/bluer than a print under a brighter illumination.

Color psychology and memory colors. Color psychology and memory colors bring up another set of issues when you're discussing human color vision. The psychology of color is beyond the scope of color appearance models (and thus beyond the scope of this book). But you need to be aware of the psychological impact of color and realize that color is a very subjective and complicated subject.

Memory colors have been useful for the success of human evolution. You can judge the ripeness of an apple based on your perception of the color of the apple. That's a useful ability if you are hungry! Color appearance models can't address the issue of memory colors. However, as a photographer or artist, memory colors can help you take control and override the *accurate* results of color management, and get the color *right*. **Figure 2.24** shows an image with various pieces of fruit. Can you accurately identify the individual fruit, even though the colors are all wrong?

FIGURE 2.24 Fruit with wrong memory colors.

Without the correct memory colors, it might be difficult to figure out what some of the fruit actually is. I have a hard time and I shot the image! In the figure is a plum, an apricot, three cherries (one redder than the others), and a peach. **Figure 2.25** shows the correct color of the fruit.

Colorimetry isn't about color perception; it's simply the basis for the quantification of the color you can see. Colorimetry is, however, very useful for the mathematical models used for the management of color. This will become more apparent when I explain the differences between a perceptional rendering of color versus a colorimetric rendering of color when using color management.

FIGURE 2.25 Fruit with the correct memory colors.

PLUM APRICOT CHERRIES PEACH

UNDERSTANDING THE MANAGEMENT OF COLOR MANAGEMENT

Now that you know a bit about the *color* of color management, turn your attention to the *management*. Color management is the process of managing the appearance of color across a variety of devices, such as digital cameras, scanners, computer displays, and output devices—such as printers, halftone presses, or multimedia screens. The goal is to achieve a good color match from the original input device to the digital processing software and then to the final output regardless of what output you choose.

THE BASICS OF COLOR MANAGEMENT

The basics of color management are very simple: It's all about the three C's: calibration, characterization, and conversion. With the current Macintosh and Windows operating systems, color management can pretty much take place under the hood in

FIGURE 2.26 The basic
principles of color management.

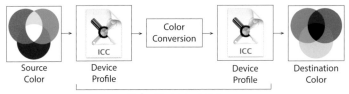

the computer. All you need are some profiles, a color management savvy application, and some sort of output that is *consistent* and *repeatable*. Color management won't work with moving targets! **Figure 2.26** shows a chart that represents the most basic color management principles and how color management works.

Color management in a nutshell takes place as follows: The source color data is characterized in a profile of the device. The source color is converted to the destination color based on the profile for the destination. Of course, in reality it's a bit more complicated. Presuming that the color management is based on the underlying ICC Color Management technology, there are defined methods of creating profiles and accomplishing the color conversions. That's where the process gets a tiny bit more complicated.

THE INTERNATIONAL COLOR CONSORTIUM

The International Color Consortium (ICC) is a group created to "promote the use and adoption of open, vender-neutral, cross-platform color management systems." The ICC was formed in 1993 by eight industry leading vendors: Adobe, Agfa, Apple, Kodak, Microsoft, Silicon Graphics, Sun Microsystems, and Taligent. Apple was first to incorporate an operating system (OS) level of ICC-based color management with the introduction of ColorSync. Microsoft added OS level ICC color management in 1997. Sun Microsystems, Silicon Graphics, and Taligent have left the ICC, and many other firms have become members, including but not limited to, Canon, Fuji, Fujitsu, Hewlett-Packard, Lexmark, Sun Chemical, and X-Rite. The full list of members, now more than 50, and other ICC color management information is available at www.color.org.

ICC-based color management

Prior to the formation of the ICC, other color management solutions were available. Unfortunately, they tended to be expensive and proprietary, and were anything but open, vender-neutral, and cross-platform. What the ICC developed was a series of

standardized device profiles and a method to convert from one device to another while maintaining the same (or really similar) color appearance. There are three basic types of ICC color profiles:

- **Input Profiles** characterize digital capture devices, such as scanners or digital cameras. The profile contains the color that the device can represent as well as a color conversion from that device color to a *standard color space*, such as CIE XYZ or CIELAB. The standard color space is called a *Profile Connection Space (PCS)*. An input profile is a one-way profile from the device color to the PCS, traditionally labeled as a data set "A" to data set "B" conversion. Input profiles can be matrix-based values with linearization curves (usually a 3x3 color matrix with tone response curves for each RGB color) or Look-up table (LUT) based. All of the scanner or camera profiles I've ever seen have been RGB input profiles. The table-based values tend to have greater accuracy potential because multiple tables (data sets) can be employed in LUT-based profiles, but the profile sizes are larger.

- **Display Profiles and Working Space Profiles** are essentially the same but a bit different in use. The practical difference is that a Display Profile is the result of the calibration and characterization of a unique computer display or LCD projector, which is device specific. A Working Space Profile is an idealized (and normalized) color space profile that is standardized across digital imaging applications, such as Photoshop or Lightroom. Although the color space is not truly a *device independent color space* like XYZ or LAB, there are agreed upon standards, so I consider Working Spaces to be semi-device independent standardized color spaces. You are probably familiar with Photoshop's various Working Spaces, such as sRGB, Adobe RGB (1998), and ProPhoto RGB. Some of those spaces were modeled after actual computer displays and have the same sort of color primaries, white points, and gamma curves as specific display profiles would have. ProPhoto RGB is a huge color space that contains theoretical colors that are beyond the human visible spectrum. I'll cover this color space in greater detail in "Color Management in Photoshop." Display/Working Space profiles can be either matrix or LUT based, and unlike Input Profiles are bidirectional (data set A > B and data set B > A conversions), which means you can convert into and out of these profile color spaces. The PCS can be either XYZ or LAB, although the Working Space Profiles are generally based on CIE XYZ.

- **Output Profiles** were originally designed to profile CMYK output devices, although RGB output devices can also be profiled. Output Profiles are always LUT-based data sets, not matrix based. Most Output Profiles use LAB as the PCS and establish a relationship between at least two sets of data, such as a CMYK data set *to* a LAB data set and a LAB data set *to* CMYK and/or RGB data sets. In

> **NOTE**
> **What's a Gamut?**
> In color management, the term color "gamut" refers to that portion of the color space that can be represented or reproduced by a device. The color gamut is generally specified in the two dimensions (2D) of hue and saturation. If you plot a color gamut in three dimensions (3D), you can see hue, saturation, and luminance axes to better visualize the gamut size, shape, and volume of color a device can represent. The term "out of gamut" refers to a situation where the gamut size, shape, or volume of an image source exceeds the gamut of a device or color space. The ICC offers a variety of Rendering Intents to control how out-of-gamut colors are mapped to an output color space.

addition to containing the PCS, output profiles contain *Rendering Intents,* which control how colors that are outside of the color gamut of one device are mapped to the output device color gamut. Because the color gamut of Input Profiles and Device/Working Space Profiles may be considerably different and usually larger in volume than Output Profiles, the Rendering Intent dictates how those out-of-gamut colors are handled. See the note titled *What's a Gamut?*

ICC profiles for Input, Display/Working Space, and Output are remarkable and contain a lot of critical data, such as color transform models, chromatic adaptation models, color appearance models, and gamut mapping algorithms. All are important to maintain the color appearance as images move through a color managed workflow. But there are inherent limitations of profiles. One limitation is that in order to keep the file sizes of profiles reasonable, the LUTs undergo subsampling, which means that not every color a device can represent will be stored in the profile LUTs.

Color Matching Method (CMM). CMM is the name for the algorithms that use the source profile colors and render the destination profile colors. How a CMM behaves is dictated by ICC standards, but there is wiggle room and different CMMs can have different results—sometimes better, sometimes just different, and occasionally worse.

Photoshop and Lightroom use the *Adobe Color Engine (ACE)* color-matching module. Actually, Thomas Knoll (who wrote Photoshop and Camera Raw) was the principal engineer for ACE and made a few additions that are not part of the ICC specification. Instead of performing the color transforms in 8-bit or 16-bit precision, Thomas uses 20-bits of precision in color conversions for better accuracy. Additionally, although the ICC specifies a method of mapping the source profile's white point to the destination profile's white point, ACE also includes a mapping for the source profile's black point to the destination profile's black point.

Apple has its own CMM called *Apple CMM* as part of ColorSync, and Microsoft uses a different CMM called *Image Color Management (ICM)*, which was originally written by Heidelberg. Which is the best CMM? Well, I tend to defer to Thomas Knoll on color science and management issues, so I'm predisposed to use his CMM. If you are not so predisposed and you want to go down the rabbit hole of testing various CMMs, go right ahead; I won't stop you. **Figure 2.27** shows the basics of an ICC color management workflow.

Figure 2.26 shows only the basics of an ICC workflow going from an Input Profile to a Working Space in an application, such as Photoshop, using the Display Profile to view the image and then a transform to the Output Profile. Note that from the Working Space to the Output Profile, the Output Profile is bidirectional; if you turned on soft proofing in Photoshop, it would display how the destination color would look before actually doing the final color conversion. Also not shown is the impact of the profile's Rendering Intent on the color conversion.

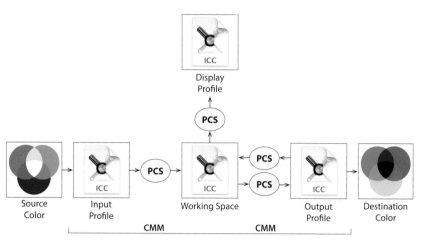

ICC Color Management Workflow

FIGURE 2.27 Flowchart of a basic ICC color management workflow.

Rendering Intents. Contained in ICC profiles are Rendering Intents, which are how a profile maps out-of-gamut colors from one profile to another. Three basic Rendering Intents are specified by the ICC with one additional variant, giving four potential ways of handling out-of-gamut colors. Each is a compromise in certain aspects; which is best for a given image needs to be tested visually by soft proofing in Photoshop or Lightroom:

■ **Perceptual Intent** either compresses or expands the full gamut of the color data from the source profile to fit the destination profile. Gray balance is usually preserved, but colorimetric accuracy is *not* preserved because Perceptual rendering generally requires a shift of all colors away from colorimetric accuracy. The Perceptual Intent usually includes contrast enhancing distortions to the L* values and may also include saturation or chroma enhancing distortions. The general goal is to produce an output rendering where the color relationships are maintained and is pleasing to the viewer, and colorimetric accuracy is sacrificed to achieve that goal. Using a Perceptual rendering alters colors that are already in the destination profile's gamut to maintain the perceptual color relationships. Extensive research has been done in the pursuit of optimization of Perceptual rendering algorithms, and most companies treat these algorithms as trade secrets. The ICC has few restrictions on the Perceptual Intent to allow companies the freedom to implement their proprietary algorithms. As a result, there is wide variation in the results of Perceptual Intents from different vendors using some pretty exotic algorithms to adapt and maintain the color appearance.

TIP

Choosing the Best Rendering Intent If saturated colors and the relationship of various colors to each other are the most important aesthetic in the image, the odds are that the Perceptual Intent might do the best job. But if the tonal values of lights to darks are more important than the color (as would be the case in B&W), the odds are that the Relative Colorimetric Intent might be the best. However, the only way to know for sure is to first use soft proofing. If that doesn't work, make a side-by-side print (hard copy) proof of the image. The best Rendering Intent is the one that renders the image the best to your eyes!

■ **Relative Colorimetric Intent** (also called *media-relative colorimetric*) preserves the colorimetry of in-gamut colors and clips out-of-gamut colors. Most natural colors that have not been enhanced by software will fit into the output gamut of an inkjet printer. Because the Relative Colorimetric Intent preserves colorimetric accuracy, there is no reduction in color saturation for in-gamut colors. For this reason, the Relative Colorimetric Intent generally delivers higher color saturation in the output rendering than the Perceptual Intent. (The exception is when the Perceptual Intent has saturation or chroma enhancing adjustments incorporated in the Perceptual Intent algorithm.) For photographic images that retain natural colors, the Relative Colorimetric Intent is often a good choice. The only way to know which intent is best to use for a given image is to soft proof with both.

■ **Saturation Intent** is another vendor-specific rendering that usually sacrifices the hue and lightness to maintain the saturation of the pure colors. Generally, this is most useful in printing items like charts or graphs where the exact hue and lightness of a color is less important than maintaining the maximum saturation in the print. The exact gamut mapping is up to the vendor and can be as simple or exotic as the vendor desires. Some vendors use the Saturation Rendering as an alternative to Perceptual Rendering in effect providing a different flavor of Perceptual Rendering. However, because this intent is vendor specific, how the Saturation Rendering behaves depends on the vendor's whim.

■ **Absolute Colorimetric Rendering Intent** is similar to Relative Colorimetric Intent and is actually based on the data in the Relative Colorimetric Intent. The CMM takes the data in the Relative Colorimetric Intent and uses the media white point data to calculate the absolute colorimetric data. As a result, if an Output Profile has a dingy, yellow white point, which represents the color of the print media, the rendered print will have that dingy yellow appearance. Absolute Colorimetric is mostly useful when you're attempting to do cross-rendered proofing where a whiter paper and a larger output gamut is used in the proofing system (e.g., inkjet printer), but the proof should simulate the dingy white of typical paper and smaller gamut inks used for commercial printing. Cross-rendered proofing can be remarkably accurate for predicting what your images will look like coming off a printing press and is very useful for preparing images for halftone repro—as long as you have good CMYK press profiles (which can be a challenge to find or make).

The Rendering Intent you use to convert from the source profile to the destination profile can have a dramatic effect on the way out-of-gamut colors are mapped. I cannot stress enough how important it is to soft proof to predict how your image will be rendered and make proper adjustments in the image. Although Photoshop offers

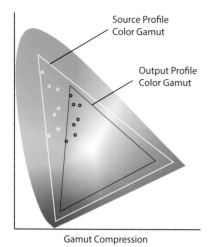

Gamut Compression

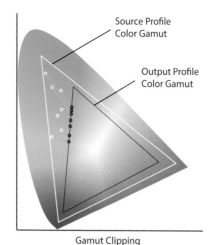

Gamut Clipping

FIGURE 2.28 Comparison of the differences between gamut compression and gamut clipping on source colors to output colors (plotted in two dimensions). Charts are courtesy of Karl Lang. These are simplified representations and do not show the effects of white point mapping.

all four Rendering Intents, Lightroom includes only Perceptual (gamut compression) and Relative Colorimetric (gamut clipping). **Figure 2.28** shows a simplified depiction of the differences between gamut compression and gamut clipping. The white circles represent color samples in the source profile, and the black circles represent where the source colors fall in the output gamut after gamut mapping.

COLOR MANAGEMENT ON MACINTOSH

The previous section on ICC-based color management describes the basic ColorSync color management for the Mac platform with some platform-specific distinctions. My workflow is more or less Mac based, but I do run Windows for testing and to be sure I know how to run on the other platform. Naturally, I have some pretty strong opinions on how well and how poorly color management works on the Mac. In general, color management on Mac and Windows is almost the same except Apple has a tendency of breaking color management with OS updates, whereas Microsoft tends to avoid breaking the important aspects of color management. The Mac side is pretty straightforward: The primary color management controls are for setting your computer display profile and telling the OS which profile to use for your display.

Displays System Preferences

To set your display to the proper ICC profile, click the Apple menu and choose System Preferences. In the main System Preferences window, click the Displays icon and then click on the Color panel. In the Color panel you'll see the display profile being

FIGURE 2.29 The Color panel of the Mac Display dialog window.

used by ColorSync. **Figure 2.29** shows my Display preferences on the Color panel. Note that I have "Show profiles for this display only" selected. This is useful to avoid being overwhelmed by way too many profiles and prevents me from selecting the wrong profile.

Let me make a couple of points regarding Figure 2.29. First, this screen shot is from Mac OS X 10.6.8 but is essentially the same for 10.7.x and 10.8.x. Second, there are three panels to select from: Display, Arrangement, and Color because I have multiple displays connected to my computer. If you have a single display, you would see only Display and Color. Third, by default there will be a display profile available based on the system detecting the display. In Figure 2.29 the default profile is named *LCD3090WQXi* because that's the type and model of the display I use. Fourth, the highlighted display profile is named *LCD3090WQXi-Center_03-15-13* because that's the name I gave it when I profiled my display. I added the *Center* and the *03-15-13* because this display is my "center" display (I have three), and I made the profile on 03-15-13. It's useful to include the date you made a display profile to ensure that you can distinguish between multiple displays.

As far as color management on the Mac, setting the correct display profile is about all you need to worry about other than knowing how to install other ICC profiles. That can be easy or difficult depending on which OS you are running and what sort of printer you are using. Unfortunately, Apple has complicated color management (unnecessarily).

Installing ICC profiles on Macintosh

By default, when you install a printer, the print driver *should* correctly install all the various paper profiles included with the printer. The default system-level location for ICC profiles is in the root-level Library/ColorSync/Profiles location. Navigating to that folder, you should be able to see all of the installed system- level ICC profiles. However, you can also load ICC profiles into the User-level location User *<your user name here>*/Library/ColorSync/Profiles. It doesn't really matter which location you choose if your computer is a single-user machine. If you have multiple users, you can limit which users can access which profiles by installing them into the User-level location. You can add subfolders to the ColorSync/Profiles folder one level deep. The folders won't appear in applications, but it can be useful for organizing loose profiles in the main folder.

The System, Photoshop, and Lightroom can find profiles in either location, but if you are using a recent Epson printer, the driver-installed profiles are, unfortunately, hidden. **Figure 2.30** shows where those hidden profiles live.

Why did Apple tell vendors to do this? I've never gotten a good answer from either Apple or Epson. But if you want to access the driver-installed profiles for some purpose other than for use in Photoshop or Lightroom, you'll have to go hunting to find them.

NOTE **Where Is Your Mac User–level Library?** With the release of OS X 10.7.x and 10.8.x, Apple has done something I really hate: It has made the User–level Library (referred to as ~/ Library) a hidden folder, which means by default you can't even see the User Library. It's terrible and wrong–headed, but there are a couple of measures you can take to circumvent this "mis–take." For a temporary workaround, hold down the Option key, and then click the main Finder's Go menu. In the drop–down list, choose the menu item for Library to access the User–level Library folder. You can add the User Library to your Favorites sidebar. Keep in mind that this is only a temporary fix.

▲ ACCESS THE DIRECTORY PATH ROOT-LEVEL/LIBRARY/PRINTERS/EPSON/ INKJETPRINTER/ICCPROFILES/PRO9900_7900.PROFILES, RIGHT-CLICK, AND CHOOSE SHOW PACKAGE CONTENTS

▶ THE SUBDIRECTORY PATH CONTENTS/RESOURCES SHOWS ALL OF THE DRIVER-LEVEL PROFILES

FIGURE 2.30 The hidden profiles location on Macintosh.

ColorSync Utility

One of Apple's offerings that's very useful is the *ColorSync Utility* application in the Utilities folder within the main Applications folder. If you launch the ColorSync Utility, you can perform some useful tasks, such as running Profile First Aid for fixing problem profiles, examining a profile's information, seeing a LAB gamut plot of the profile, and inspecting the various ICC profile tags contained in a profile. You can use the Calculator pane in ColorSync Utility to convert color values from one color space or profile to another, and to find the color values for any pixel on your screen. **Figure 2.31** shows the main ColorSync Utility dialog window and the details of a profile.

In the Profiles panel you can see a list of all the currently installed ICC profiles in the main ColorSync Profiles folder, the User profiles, and Other. Even the hidden Epson profiles can be found in the Other list. If you click the Profile First Aid button, you'll have the option of doing a Verify or Repair function on all your installed profiles. This will either check or attempt to repair any profiles that do not conform to the ICC profile specification. Note that the utility can fix most tag-related problems but not all possible problems, although using Profile First Aid is a valuable feature, particularly if you've installed a new printer and made your own profiles. If you click the Devices button, the utility will search your system for all ColorSync devices that have ColorSync profiles connected to them. This search can last a while if you have several printers installed.

▲ THE DETAIL WINDOW SHOWING ICC PROFILE TAGS

FIGURE 2.31 The main ColorSync Utility showing the Profiles panel and the profile details panel for the AdobeRGB1998.icc profile.

▲ THE MAIN COLORSYNC UTILITIES PROFILES PANEL

Profile naming

Each ICC profile has two names: the name of the actual profile's file as shown in the Finder and an internal name that is used for display in menus. You can change the external filename by renaming it on the disk, but that won't alter the internal name. **Figure 2.32** shows a ColorSync Utility function for this purpose. To change the name, double-click the profile name and select the 'desc' tag. This will display the current internal name. To change the name, enter the new name in the ASCII Name text field. Generally, you don't need to worry about the UniCode Name because it's not generally used, but for safety's sake I suggest entering the same name in both fields. To be honest, I don't really know what the Mac Script Name field is for, and I don't recall ever seeing a normal ICC profile with anything in that field. In this example, I changed the profile name for my LCD3090WQX1-Center_03-15-13 name.

As an additional note about profile naming, it's best to correctly name a profile when you first make it and use a meaningful name. Obviously, it's important for the name to contain the name of a device and any additional info, such as paper settings for a printer. As mentioned earlier, it's useful to include a date in display profiles so you can check when it was made and redo it if too much time has elapsed. Unfortunately, a free system-level application like the ColorSync Utility is not available for Windows, although there's a free Profile Inspector, which I'll show you in the next section.

NOTE
Be Careful When Renaming Profiles.
If you have recorded actions for Photoshop to perform color space conversions, changing the profile name will break those actions because an action needs to know the exact profile name as it appears in the Photoshop menus. So, if you change the name of the profile, you'll need to edit the action to update to the new profile name.

▲ THE INITIAL 'DESC' ICC PROFILE TAG SHOWING THE ORIGINAL INTERNAL PROFILE NAME

▲ THE EDITED 'DESC' INTERNAL PROFILE NAME

FIGURE 2.32 Changing the internal name of an ICC profile in the ColorSync Utility.

COLOR MANAGEMENT ON WINDOWS

Compared to the way color management works (or sometimes breaks) on the Mac, Microsoft has done a pretty good job of keeping color management consistent and relatively simple to use. As on the Mac, the first thing to do is to make sure your display profile is properly set in the *Color Management Control Panel*.

Color Management Control Panel

The easiest way to check your display profile on Windows is to click the Start menu, choose Control Panels, and then choose Color Management. The Color Management Control Panel is shown in **Figure 2.33**. In the Device drop-down menu, choose your computer display. In my case, it's named Parallels Display Adapter because I'm running Windows 7 on a MacBook Pro running OS X 10.8.2 using Parallels Desktop 7 for Mac.

To be sure your profile is associated as your default display profile, click the Set as Default Profile button in the Devices panel of the Color Management Control Panel. I made this profile running the Windows version of X-Rite's i1Display Pro.

FIGURE 2.33 Setting your default display profile in the Devices panel.

All Profiles and Advanced panels

In the main Color Management dialog window are two additional tabs. All Profiles shows a list of all installed profiles, and the Advanced panel offers the ability to change various system defaults. **Figure 2.34** shows the panels.

▲ ALL PROFILES PANEL ▲ ADVANCED PANEL

FIGURE 2.34 The All Profiles and Advanced panels.

The All Profiles panel offers some limited information regarding the selected profile. In Figure 2.34 I've selected the same display profile shown in Figure 2.33. The profile is noted as a Display class profile, the date created by the PCS, and the profile version. However, the All Profiles panel doesn't offer any detailed look at profile tag information like the ColorSync Utilities does for Mac. It does offer the ability to add new profiles without having to burrow down into your hard drive. By clicking the Add button, you can navigate to the location of a new profile and add it easily. You can also add a profile by right-clicking on the actual profile and choosing Install Profile, as shown in **Figure 2.35**.

You can always manually move a profile into the rather obscure location where .icc and .icm profiles need to be located. The directory path is Local Disk (C)\Windows\System32\spool\drivers\color. Don't worry about memorizing that path, you can always look it up here in this book!

I would be remiss if I didn't say a word (or four) about the Advanced panel in the Windows Color Management Control Panel. Those four words are *don't worry about it*. Although the Advanced panel shows a variety of options for changing many system defaults for profiles, Rendering Intents, and gamut mapping, none of them apply when you're working in Photoshop or Lightroom. I asked a color geek and a Photoshop engineer about this panel, and their responses were that the entire Windows Color System (WCS) is a work in progress and doesn't really apply to a color management workflow when you're using professional applications.

▲ RIGHT-CLICK CONTEXT MENU

▲ DIRECTORY PATH OF THE INSTALLED PROFILE

FIGURE 2.35 Right-clicking on a profile to use the context menu command Install Profile and the directory path for the location of the installed profile.

Windows color management utilities

Although Windows doesn't have a utility along the lines of ColorSync as part of the system, there are some free or paid solutions to inspecting and modifying ICC profiles. You can download the free utility Profile Inspector from the ICC website (www.color.org/profileinspector.xalter). With Profile Inspector (**Figure 2.36**), you can inspect profiles and modify some of the parameters in the profile.

I've hunted and searched (well, OK, I Googled), and unfortunately, I can't find any free utilities for profile renaming for Windows. However, I suggest looking at an application called ColorThink v2 from CHROMIX (www.chromix.com). **Figure 2.37** shows ColorThink's Profile Inspector and the Profile Renamer functions.

> **NOTE Why Is ColorThink in Demo?** You might notice that in the ColorThink main panel the profile shown is named Demo CMYK Profile.icc. The reason the word "demo" is used is because I have a license for both ColorThink and the full version ColorThink Pro (as anybody interested in color geekyness should have). But my licenses for both are for the Mac version, not the Windows version. So, I had to run ColorThink in demo mode to create the figures.

▼ THE HEADER WINDOW SHOWING THE PROFILE HEADER INFORMATION

▲ PROFILE INSPECTOR MAIN WINDOW

FIGURE 2.36 The Profile Inspector main window and the detailed Header window.

▲ PROFILE INSPECTOR

▲ PROFILE RENAMER

FIGURE 2.37 ColorThink's Profile Inspector and Profile Renamer.

COLOR MANAGEMENT IN PHOTOSHOP

Color management in Photoshop can be either very difficult and complicated or easy; it all depends on you. Because I like things easy, that's the way I'll explain Color management in Photoshop to you. It all starts with Photoshop's main Color Settings dialog window, which comes in two flavors: Fewer Options or More Options (which means basic and advanced).

Photoshop Color Settings preferences

The Color Settings preferences live near the bottom of the Edit menu. You can also use a command key to access these settings. Clicking on the menu item Color Settings brings up one of the two dialog windows (depending on whether or not you've already been playing with your color settings and how you left them). **Figure 2.38** shows the basic and advanced dialog windows

▲ FEWER OPTIONS (BASIC)

FIGURE 2.38 The Fewer Options and More Options Color Settings dialog windows in Photoshop.

▲ MORE OPTIONS (ADVANCED)

Both dialogs contain some of the same optional settings, such as the Settings drop-down menu, the Working Spaces, and the Color Management Policies. The main differences between the two are being able to set the Conversion Options and the Advanced Options in the More Settings dialog. I'll concentrate on the More Settings dialog because, well, it's easier!

By default, Photoshop includes the Settings option North American General Purpose 2. If you are in different parts of the world, you may see different options. It doesn't matter which options you see because you don't want to leave these settings at their defaults! It's best to change the RGB Working Space to something *other* than sRGB. I use ProPhoto RGB, and the only other useful choice would be Adobe RGB (1998). I'll explain why in the "Advanced Color Management Considerations" section at the end of this chapter. **Figure 2.39** shows the built-in options for RGB Working Spaces in Photoshop.

▲ SELECTING PROPHOTO RGB

▲ NEVER USE THE MONITOR RGB SETTING

FIGURE 2.39 Changing the RGB Working Spaces option to ProPhoto RGB and avoiding the option that you should never use, Monitor RGB.

You can use any color space as your Photoshop Working Space with the exception of Monitor RGB. Why? Because Monitor RGB is a device-specific color space that is unique to your display and thus not a viable working space if you want to use color management for eventual print output. However, it is useful to look at to confirm that Photoshop correctly identifies the display profile you set at the system level.

When you change your RGB Working Space, consider changing the Gray Working Space. Photoshop's default Gray Working Space is set to Dot Gain 20%, which is fine and dandy if you are preparing grayscale images for halftone reproduction. However, it's less useful when you're working on color images that may be converted to black and white images. The optimal Gray Working Space is a Gray Gamma that matches the same gamma of your RGB Working Space. I've chosen ProPhoto RGB, which

has a gamma of 1.8. If you are using Adobe RGB, select Gray Gamma 2.2. If for some reason you're using sRGB, select Gray Gamma 2.2 because the gamma in sRGB is a tuned tone response curve (TRC) that is a hybrid of gamma 2.2 with some sections of the curve modified (which I'll explain later). **Figure 2.40** shows changing the Gray Working Space to Gray Gamma 1.8.

Notice at the bottom of Figure 2.39 the check boxes for how Photoshop will handle images whose embedded profiles mismatch or are missing. It's best to select the option Ask When Opening in the Missing Profiles section. I'll explain further in the next section.

At this stage, the Working Spaces and Color Management Policies will look like those in **Figure 2.41**. Save your color management settings so you have a named setting that will appear in the top Settings menu. You should do this for two reasons: First, it's useful to have your own saved settings so you can see at a glance if anything has been changed. Second, if you have several saved settings, it becomes a lot easier to switch between different settings. My saved settings include the Photoshop Default, Linear RGB, sRGB-for-web, and a special setting for when I'm working on images for the book. Saved settings also make it easy to record an action to play back so you can be sure what Photoshop's Color Settings are currently set to.

When you click the Save button, a Save dialog appears. Enter a meaningful name (keep it simple). When you click Save in that dialog, another dialog appears that allows you to enter a useful comment.

After saving your settings, the main dialog will look like the one in **Figure 2.42**.

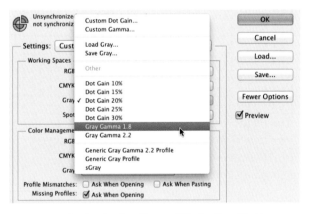

FIGURE 2.40 Setting the Gray Gamma 1.8 in the Gray Working Space menu.

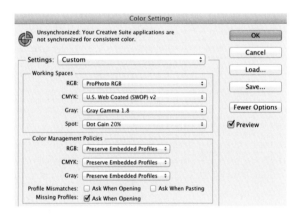

FIGURE 2.41 The custom Settings before saving, the Save settings dialog, and the Color Settings Comments dialog.

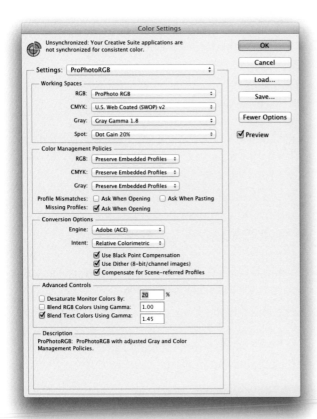

FIGURE 2.42 My saved Color Settings for digital imaging for fine art print output.

Let's discuss a few more important options. I'll keep it easy. See the options in Figure 2.42? Don't change them! I'll explain what the Conversion Options and Advanced Controls do, but the odds of you needing to change them are pretty slim.

Conversion Options. I like to leave these options set at Photoshop's default, and here's why:

- **Engine.** This option allows you to change the CMM that Photoshop will use when making mode changes. You want Adobe (ACE) unless you have a very *good* reason not to use it (and I can't think of any *good* reasons).

- **Intent.** This option allows you to change the Rendering Intent when using a Mode change in the Image menu. I don't bother changing this because, I never change to Mode; I really only use the Convert to Profile command in the Edit menu. Doing a Mode change eliminates too many potential options and can have unintended consequences. I'll explain more in the next section.

- **Use Black Point Compensation.** I've explained that Thomas Knoll extended the ICC CMM specification to include this option. Again, unless you have a very good reason, don't deselect this option.

- **Use Dither (8-bit/channel images).** When you do a Mode change or apply the Convert to Profile command, this preference tells Photoshop to add a very slight amount of noise during the conversion from 16-bit/channel to 8-bit/channel. Doing so is almost always a good idea unless you are doing specific testing and need zero noise in conversions. This option also controls whether or not Photoshop applies a tiny bit of noise when you make a gradient.

- **Compensate for Scene-referred Profiles.** This option is only important if you are round tripping images between Adobe After Effects or Adobe Premiere and Photoshop. If you are a photographer doing some printing, it really doesn't apply to you (or me).

Advanced Controls. The Advanced Controls are what Bruce Fraser used to call big *hurt me* buttons that normal users should never change:

- **Desaturate Monitor Colors by.** This option was a response by Thomas Knoll and Mark Hamburg to address concerns by some people who were using very large color spaces, such as ProPhoto RGB, on very small gamut displays. As it turned out, it was a needless concern, and this option should be removed.

- **Blend RGB Colors Using Gamma.** This option allows the user to change the way Photoshop layers will blend. By default Photoshop uses a gamma 2 power curve, but at times this can lead to unsatisfactory blending results. For certain types of graphics, this option might be useful to change to Gamma 1, but again, this isn't a concern to photographers.

- **Blend Text Colors Using Gamma.** The default is gamma 1.45 and I've never encountered a situation where I felt the need to either deselect this option or change the gamma. If you find one, let me know.

Missing Profile warning

The Photoshop Color Settings, in particular the Color Management Policies, impact the way Photoshop behaves when you're opening images. Preserve Embedded Profiles is the only sane policy for normal use. You have only two other policies: Off and Convert to Working RGB, CMYK, or Grayscale. Off is really a cruel joke with only two possible scenarios: You *always* want to embed RGB profiles to avoid a situation where the color space of the image is unknown. The only exception to not embedding an RGB profile is when you are going to upload images to the Internet for web browsing.

NOTE

Off Is Not Really Off When you select Off, Photoshop just hides the fact that it's still using color management under the hood. If you turn off all color management, Photoshop will still use the various Working Spaces you have set for the creation of new images, and if you open an image whose embedded profile is different than your Working Space profile, Photoshop will strip the profile, which is almost always the wrong thing to do. When you're copying and pasting between images with different profiles (or stripped profiles), Photoshop will preserve the numbers at the expense of the color appearance, which again is almost always the wrong thing to do. The bottom line is don't try to use Off!

The web is essentially hostile to color management because only a few web browsers have color management, and even those don't always behave correctly when images have embedded profiles. Instead, convert RGB images to sRGB, use Save for Web in Photoshop, and strip out the profile. This is one reason I like to select the Ask When Opening check box in the Missing Profiles option, as shown in **Figure 2.43**.

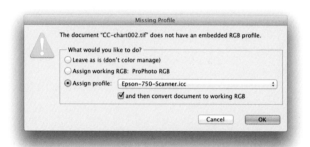

FIGURE 2.43 The Missing Profile warning.

Figure 2.43 shows the warning that the document "CC-chart002.tif" does not have an embedded RGB profile. There's a good reason; this image was a scan from a flatbed scanner that cannot embed custom Input Profiles. So when I do a scan, I need to be sure to heed the warning, assign a profile (the Epson-750.icc profile), and then convert it to the working RGB. If I opened a JPEG with no embedded profile, chances are that the image was prepared for the web, and I would assign sRGB as the profile.

The other situation where you probably don't want to embed profiles is when you are preparing CMYK images for reproduction by printers you don't know. Embedding a CMYK profile in a file for an unknown printer can lead to one of several situations, but only one good outcome. If you embed the profile and the printer doesn't know how to deal with profiles, in all probability the printer will ignore them anyway so it's best not to include the profile. If you do embed a profile, the printer might just think it's necessary to do something because of that profile, such as do a CMYK to CMYK color transform, which is likely the wrong thing to do.

Assign vs. Convert to Profile

Another aspect of the color management policies is how to handle profile mismatches when you're opening an image or pasting between different images. Because I deselect the mismatch warnings, I don't see them as a general rule. **Figure 2.44** shows both warnings.

The biggest problem that arises when you encounter these warnings is that you have the option of changing Photoshop's behavior regarding profile mismatches, but you don't see what the results might be using the different options. In the case

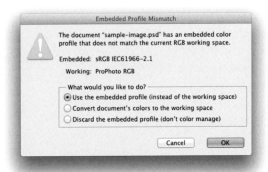

▲ EMBEDDED PROFILE MISMATCH WARNING

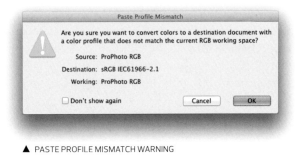

▲ PASTE PROFILE MISMATCH WARNING

FIGURE 2.44 The Embedded Profile Mismatch and Paste Profile Mismatch warnings.

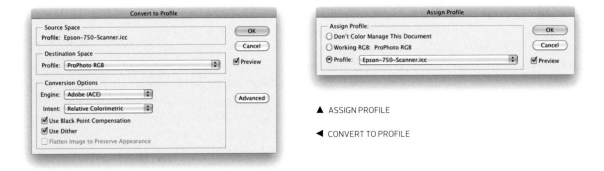

▲ ASSIGN PROFILE

◀ CONVERT TO PROFILE

FIGURE 2.45 The Assign Profile and the Convert to Profile dialogs.

of the Embedded Profile Mismatch warning, chances are you'll want to use the embedded profile anyway. So, why put up with a *nag warning* every time you have a mismatch? Just deselect the warning in the policies. It's the same deal with the Paste Profile Mismatch warning. You'll almost always want to preserve the color appearance by converting the colors from one profile to the other. Again, just deselect this policy option.

The best option is to simply open the image and then use either the Assign Profile or Convert to Profile commands in the Edit menu. **Figure 2.45** shows both dialogs.

The main reason these commands are preferable to the *nag warnings* is that in both cases you have the option of seeing a preview of the open image to evaluate what the different choices will look like before committing to any changes.

There is a fundamental difference between the Assign and the Convert commands. It's pretty simple but can create some issues if these commands are not used correctly:

- **Assign Profile** tells Photoshop that you want to preserve the color *numbers* at the expense of the color *appearance*. This is really only important if an image has no profile (as in the case of a missing scanner profile) or an image's embedded profile is wrong. Believe me when I say that an incorrect embedded profile shouldn't occur in a good color managed working environment, but it can happen. Assigning a different profile is a way to fix that. The advantage of the Convert command is that you can select various profiles and see a preview before committing.

- **Convert to Profile** tells Photoshop you want to preserve the *appearance* of the colors at the expense of the color *numbers*. This command is almost always preferable to Assign Profile because the whole purpose of color management is to preserve the appearance of color across various devices. I use the Convert to Profile command rather than Mode changes because I can preview the changes at the point of conversion and see what the differences will be when using different Rendering Intents while performing the conversion.

As with the Color Settings preferences in Photoshop, there are two options for the Convert to Profile command: Basic or Advanced. **Figure 2.46** shows the Advanced version of Convert to Profile.

The main benefit of using the Advanced version of the dialog is that Photoshop will filter the various Destination Spaces for you. So, if you are doing an RGB to RGB conversion, the only profiles you'll see in the RGB Profile drop-down list are

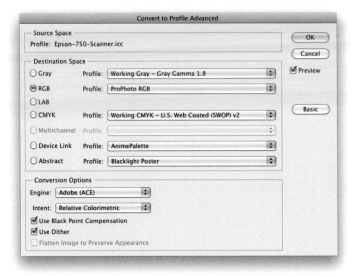

FIGURE 2.46 The Advanced version of Convert to Profile.

RGB profiles. The same is true for the other Destination Spaces. This is very useful because by default the Basic dialog forces the user to scroll through all of the loaded profiles regardless of their color space. In fact, I think the Basic version is harder to use than the Advanced version, even though the Advanced version includes some scary options, like Device Link and Abstract profiles, which I never use.

The Conversion options give you the ability to select the Engine, the Rendering Intent, and whether or not to use Black Point Compensation (you should) and to use Dither (you generally should). The advantage of selecting these options here versus in the main Color Settings is that you can make changes on an image-by-image basis with the benefit of seeing a live preview before committing to the change.

Clearly, this section is not complete because two large chunks of color management implementation in Photoshop have not been addressed: Proof Setup (soft proofing) and the Print command dialog. These two functions are special enough that entire sections have been dedicated to them later in the book. For Proof Setup (soft proofing), refer to Chapter 3, "Preparing Images for Printing." For the Print command dialog, refer to Chapter 4, "Making the Print."

COLOR MANAGEMENT IN LIGHTROOM

In comparison to color management in Photoshop, color management in Lightroom is a breeze! Your choices are limited, and the decisions you must make are few. That's by design. I'll again defer talking about soft proofing and printing to later chapters, but there are really only two places where you need to concern yourself about using color management: the main Lightroom External Editing preferences and the Export command. **Figure 2.47** shows the Color Space options in the External Editing preferences, and **Figure 2.48** shows the Color Spaces options in Export.

When you're in Lightroom, you don't need to worry about color management because Lightroom takes care of that under the hood. The only time you need to think about color management is when you take images outside of Lightroom. If you open an image from Lightroom in Photoshop, the color space Lightroom uses is set in the External Editing preferences shown in Figure 2.47. You have only three choices: ProPhoto RGB, Adobe RGB (1998), or sRGB. Whether you select the Edit In-Photoshop flyout menu from the main Lightroom Photo menu or one of the other options, such as Open as Smart Object, Merge to Panorama, Merge to HDR, or Open as Layers, the color space selected in the External Editing preferences will be applied. Unlike Camera Raw, which also offers ColorMatch RGB, your choices are simple. Choose one of the three (hopefully ProPhoto RGB). If you're editing in ProPhoto RGB, be sure to also select 16-bit instead of 8-bit to avoid potential banding issues when editing in Photoshop. If your Photoshop Color Settings are set to use the embedded profile, there's nothing else you need to do in Photoshop.

FIGURE 2.47 The Color Spaces options in the External Editing panel of the main Lightroom Preferences.

FIGURE 2.48 The Color Spaces in Lightroom's Export command.

The other place where you need to properly choose the correct color space is when you're exporting. Figure 2.48 shows the Color Spaces in the File Settings section of the Lightroom Export command. You have the same three choices plus an option called Other. Lightroom can only use RGB profiles, so you'll usually need to use one of the main three. You might need the Other option if you are sending a file to a third party for printing and want the recipient to receive an already converted file. If you click Other, you can select which profiles appear in the drop-down menus throughout Lightroom.

That's really the extent of color management in Lightroom. It is considerably less complicated than Photoshop.

APPLIED COLOR MANAGEMENT

If you have survived the lengthy discussion of the basics of color management, you might think that applied color management would be daunting. It's not. Once you understand the basics, working with a color management system is actually relatively simple.

In this section, I'll highlight the important components of the implementation and application of color management, but I don't go into detail about all processes you'd use to work with all the different vendors and solutions. Instead, I'll show you how I use specific hardware and software, and then I'll list alternative vendors and solutions for your own investigation.

INPUT PROFILES

Input profiles are the front end of a color management system. Images get into a computer via scanner or digital camera, so those are the primary types of input profiles.

Scanners

For scanners, I use X-Rite i1 Profiler, a software package that works with the i1 Profiler's hardware and includes components for scanners, display calibration, and output profiles.

To create a scanner profile, you need to scan in a standard target. In this case, I'm using a ColorChecker target. Make sure that you have no automatic adjustments or any corrections applied in the scanning software itself, because that would defeat the purpose of creating a profile. I use the Epson stand-alone scanner software to scan the target; I don't like to scan directly into Photoshop. **Figure 2.49** shows the scanning steps.

NOTE When you are using a scanner profile as an input profile, you definitely want to convert that input profile into your working space. An input profile doesn't make for an optimum working space because there's no guarantee that equal amounts of red, green, and blue will be completely neutral. When you edit the scan, edit in the working space.

▲ THE PREVIEW PANEL

◀ THE SCANNER SETTINGS PANEL

FIGURE 2.49 Scanning in a ColorChecker card.

▲ THE COLOR CONFIGURATION DIALOG BOX
SHOWING NO COLOR CORRECTION SELECTED

I scanned the target at 100 percent of its actual size in 48-bit color (16 bits per channel) at a resolution of 200 PPI. The profile-making software does not require really high resolution. After making the scan, I open i1Profiler and load the target. The next step is to load the reference, which is the data describing what the chromaticity for the ColorChecker should be. The last step is to make the profile. As I mentioned earlier in this chapter, I highly recommend using only version 2 ICC profiles, not version 4. **Figure 2.50** shows the ColorChecker reference target and the profile settings.

Then, in Photoshop, I'll load the ColorChecker scan and convert the profile from the Epson 750 scanner ICC profile I created to ProPhoto RGB. The result of the conversion can be seen in **Figure 2.51**.

SCANNER PROFILING SOFTWARE

X–Rite i1Profiler (www.xrite.com)

Profile Prism (Windows only) (www.ddisoftware.com)

LaserSoft Imaging (www.silverfast.com)

TGLC Color Management (www.tglc.com)

basICColor GmbH (www.basiccolor.de)

FIGURE 2.50 Loading the target reference settings to create the profile.

▶ THE MAIN I1PROFILER SCANNER PROFILING WORKFLOW

▼ THE SETTINGS FOR MAKING THE PROFILE

FIGURE 2.51 Opening the image in Photoshop and converting to ProPhoto RGB.

▶ THE ORIGINAL SCANNED COLORCHECKER UNCONVERTED FROM THE SCANNER

▼ THE MISSING PROFILE PHOTOSHOP DIALOG BOX WITH THE ASSIGN PROFILE SET TO THE SCANNER PROFILE AND THE OPTION SET FOR THEN CONVERT TO WORKING SPACE

▲ THE FINAL CONVERTED COLORCHECKER CONVERTED TO PROPHOTO RGB

Digital cameras

Camera Raw and Lightroom use DNG profiles for digital cameras, instead of ICC profiles. If you use Capture One or another third-party raw processing software that uses ICC profiles, you can create ICC profiles using basICColor (www. basiccolor.de) or Argyll CMS (www.argyllcms.com).

DNG profiles are used for the same purposes as ICC profiles, but they are not ICC profiles. They are designed specifically for converting raw captures. I suggest making dual-illuminant DNG profiles, shooting a target under daylight (D50, D55, or D65), and then shooting a second target under tungsten (3200° Kelvin). You load the shots of the target and make a profile that contains DNG dual illuminant, which is optimal for daylight and tungsten. That profile can be used in Camera Raw or Lightroom. **Figure 2.52** shows selecting two images in Lightroom and using the X-Rite export preset.

▲ A DAYLIGHT AND TUNGSTEN CAPTURE SELECTED IN LIGHTROOM ▲ THE X-RITE EXPORT PRESET

FIGURE 2.52 Selecting the Passport shown in Lightroom and exporting.

I use X-Rite Passport, and in this case I'm using the Passport target in the Passport software. By the way, the software is free and can be used on any ColorChecker target, not just a Passport target. X-Rite Passport software is available free as a download from X-Rite. **Figure 2.53** shows both captures loaded into the ColorChecker Passport software. **Figure 2.54** shows using the profile in Lightroom.

▲ THE DAYLIGHT CAPTURE LOADED

▲ THE TUNGSTEN CAPTURE LOADED

▲ SAVING OUT THE DNG PROFILE

FIGURE 2.53 Making a Dual Illuminant DNG profile.

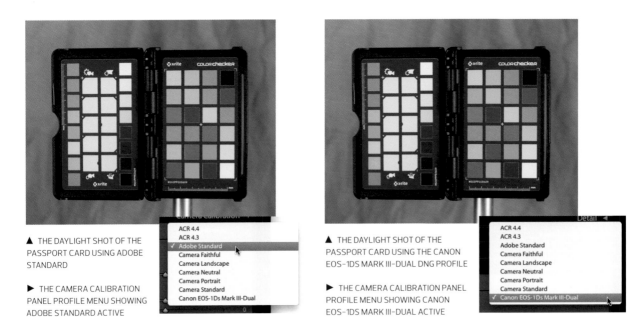

▲ THE DAYLIGHT SHOT OF THE PASSPORT CARD USING ADOBE STANDARD

▶ THE CAMERA CALIBRATION PANEL PROFILE MENU SHOWING ADOBE STANDARD ACTIVE

▲ THE DAYLIGHT SHOT OF THE PASSPORT CARD USING THE CANON EOS-1DS MARK III-DUAL DNG PROFILE

▶ THE CAMERA CALIBRATION PANEL PROFILE MENU SHOWING CANON EOS-1DS MARK III-DUAL ACTIVE

FIGURE 2.54 Comparing the Adobe Standard profile with the DNG profile made by ColorChecker Passport.

You can't edit the colors in a DNG profile using X-Rite Passport, but you can edit them in DNG Profile Editor, which is free from Adobe Labs (labs.adobe.com). In DNG Profile Editor, open the DNG profile, and then do per-color edits to customize how the DNG profile will render colors. This can be useful for situations in which a product needs to have very good color rendering, such as Budweiser red or John Deere green.

You can also use ColorMunki Photo (www.colormunki.com) to create DNG profiles for digital cameras. One additional option, DataColor SpyderCheckr Pro, doesn't actually make either ICC or DNG profiles. Instead, it creates a preset that you can use in either Lightroom or Camera Raw, but I find the use of presets for color calibration to be problematic.

DISPLAY CALIBRATION AND PROFILING

Computer displays are really the bastard child of consumer televisions because all the technology and research and development go toward TV. With displays for the computer, generally you get what you pay for. A high-end display costs more because it has a higher set of specifications and a more expensive set of components that provide greater uniformity and profitability. I would argue that if the camera is the way of capturing the scene, the computer display is the window into viewing your photograph. Using a cheap commodity-priced display is not doing your image evaluation any favors.

Calibrating and profiling a display is a two-step process. You first calibrate the display to a standard. I suggest D65 and a gamma of 2.2, with about 150 cd/m² luminance. High-end displays come with their own profiling hardware and software, but you have to use separate hardware and software for commodity-priced displays.

High-end displays

There are two kinds of high-end displays: wide gamut and sRGB gamut. Wide-gamut displays approach 98 percent of the Adobe RGB color gamut, while an sRGB display can only show the colors in the sRGB gamut. For Photoshop, Camera Raw, and Lightroom, I suggest using a wide-gamut display. Those are available from two vendors: NEC (www.necdisplay.com) and EIZO (www.eizo.com). I use NEC displays. I don't personally use EIZO displays, but I've seen them often enough to know that EIZO is a very good brand.

The Windows display pipeline allows for 10-bit-per-color display output. Photoshop CS5 and later in Windows can use a 10-bit-per-channel display pipeline. (Lightroom for Windows does not support a 10-bit-per-channel display pipeline.) However, Mac OS is still limited to 8 bits per channel. One of the advantages of using an NEC or

NOTE I'm of the opinion that X-Rite has oversold the spawning of multiple profiles for a given camera based upon different lighting sources. You need one profile for daylight and one for tungsten. Both of those are considered continuous light sources, but because of the potential for metameric failure in the way the sensor responds in daylight and tungsten illumination, you need a dual-illuminant profile. However, you don't need to make a profile for overcast conditions of shade or sunset. You can handle all of those conditions with white balance corrections using the daylight DNG profile. The only time you'd want to make special DNG profiles is if you were photographing under a non-full-spectrum light source such as fluorescent or LED. In such cases, making a custom profile for a specific light source would make sense.

FIGURE 2.55 Calibrating and profiling an NEC 3090WQX1 30–inch display using SpectraView II software.

▲ THE MAIN SPECTRAVIEW II DIALOG BOX SHOWING THE CALIBRATION TARGET OF D65, A GAMMA OF 2.2, AN INTENSITY OF 150 CD/M2, AND A CONTRAST RATIO OF 250:1

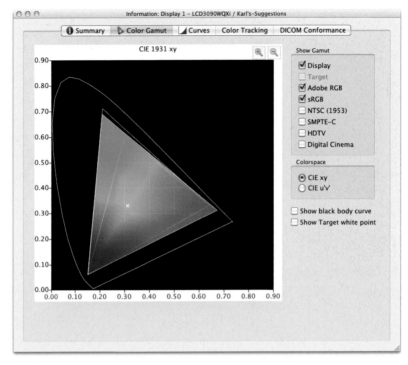

▲ COMPARING THE NEC DISPLAY COLOR GAMUT TO SRGB AND ADOBE RGB

EIZO display is that the software controls the display's internal components and calibrates the display to the intended target in 10-bit-per-channel accuracy. Therefore, you get the benefit of the 10-bit-per-channel calibration even if you're not using a 10-bit-per-channel display pipeline. **Figure 2.55** shows the SpectraView II software for calibrating and profiling an NEC wide-gamut display.

Commodity–priced displays

NOTE The Retina display improves the detail but not the color accuracy on Mac laptop displays. It doesn't provide any bet–ter color management.

If you buy a cheap display, you'll have to get a third-party hardware and software calibration package. I use X-Rite i1 Profiler to calibrate and profile my laptops. I don't make any accurate color determination while I'm in the field on a laptop, but it's still useful to know that the laptop's display screen is calibrated. **Figure 2.56** shows the X-Rite i1Display Pro puck and the i1Profiler application for calibrating and profiling the display.

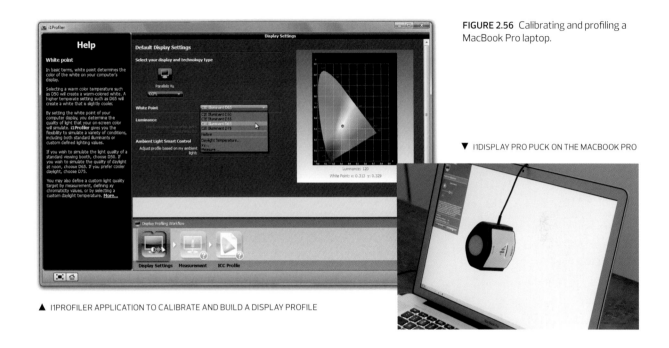

FIGURE 2.56 Calibrating and profiling a MacBook Pro laptop.

FIGURE 2.56 Calibrating and profiling a MacBook Pro laptop.

▼ I1DISPLAY PRO PUCK ON THE MACBOOK PRO

▲ I1PROFILER APPLICATION TO CALIBRATE AND BUILD A DISPLAY PROFILE

PROFILERS FOR COMMODITY-PRICED DISPLAYS

X–Rite i1Profiler	ColorEyes Display Pro
ColorMunki Photo	basiCColor GmbH
Datacolor Spyder	

WORKING-SPACE PROFILES

In *The Digital Negative*, I devoted about two pages to color management for raw image processing. I'll devote even less space here because it's really quite simple. If you are shooting raw and processing in Lightroom or Camera Raw, and then printing to a wide-gamut printer, there's really only one working space that can contain all the colors that the camera can capture and the printer can print. That's ProPhoto RGB. **Figure 2.57** shows that the Canon iPF6400 printer using Hahnemühle Glossy FineArt Baryta can actually print colors outside the gamut of Adobe RGB—let alone sRGB.

Only ProPhoto RGB can contain all the colors a camera (in this case, a Phase One P65+ camera back) can capture and a high-end large-gamut printer can print. Any questions?

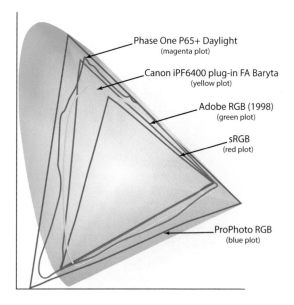

FIGURE 2.57 Comparing 2D gamut plots.

Phase One P65+ Daylight
(magenta plot)

Canon iPF6400 plug-in FA Baryta
(yellow plot)

Adobe RGB (1998)
(green plot)

sRGB
(red plot)

ProPhoto RGB
(blue plot)

PRINTER PROFILES

A printer profile needs to characterize exactly how a printer will render a certain color. There are two components to an output profile: the PCA-to-the-output-device transforms, and the PCA-to-the-display-space transforms. To ensure that what you see in Photoshop or Lightroom is accurate, a well-made profile must have an accurate set of tables for the display and the final output.

If you have a really good profile that works well for soft proofing and final printing, you're good to go. The question is whether your profile is good. The reason to consider having a custom profile made—whether you make it yourself or hire a third party to do so—is to make sure that you have a very accurate fingerprint of your specific printer, which may differ from the profile built into the driver.

Built-in driver profiles

Recently, both Epson and Canon have done a very good job of characterizing and profiling their printers and OEM papers. However, that's generally true only for their papers, not for third-party papers. In other words, if you're using Epson or Canon paper, you can rest assured that the built-in driver profiles will generally be very good.

Paper manufacturer–provided profiles

The major paper manufacturers and distributors have a very good selection of custom profiles that usually work pretty well. In writing this book, I've used the profiles provided by paper manufacturers to make a lot of prints. However, there are still some benefits to making a custom profile. For one thing, you can make a profile for the viewing conditions of the print—one that corrects for daylight or tungsten viewing conditions. Also, if you're using the Canon Print Export plug-in with third-party papers, you'd have to make a custom profile for that.

Third–party custom profiles

For a reasonable charge (between $30 and $150 per paper), there are services that will make a custom profile for you. You print a standard target and mail the print to the vendor, who reads the target and creates a profile for you. That can be successful and should be a consideration if you only need one or two individual custom profiles. For less than a couple of hundred bucks, you can have custom profiles without spending the money to buy an entire color management solution.

Rolling your own

If you like the hands-on approach and want absolute total control, which is how I do things, you'll want to consider making your own profiles. That will require investing in a spectrophotometer and profile-making software, which can be pretty expensive.

Even though inkjet printers may be using various shades of cyan, magenta, yellow, and multiple blacks, they're considered RGB printers for the purposes of the operating system's print pipeline, so you need to create RGB profiles for them.

You can't use the current version of Photoshop to produce the printer profiling targets, because it no longer has an option to print with no color management. Lightroom doesn't have the option either, so you can't use it. You have to use either the profiling software, such as X-Rite i1 Profiler, or Adobe Color Printer Utility (free from labs.adobe.com).

NOTE My good friend and colleague Andrew Rodney (aka The Digital Dog) makes great custom profiles. His Web site is www.digitaldog.net. CHROMiX, the company that develops ColorThink, also makes great profiles (www. chromix.com).

RGB PRINTER PROFILERS

X–Rite i1Profiler	LaserSoft Imaging
ColorMunki Photo	basiCColor GmbH
Datacolor SpyderPRINT	

FIGURE 2.58 A 2,000–patch sample set up and sized for measuring with an iSis XL strip–reading spectrophotometer.

► THE I1PROFILER SHOWING THE TEST CHART PANEL

▼ AN IMAGE (COURTESY OF X–RITE) OF AN ISIS XL STRIP–READING SPECTROPHOTOMETER

NOTE Epson printers stabilize fairly quickly; after about an hour, the change is only detectable by spectro measurements. Canon printers have a slower stabilization period of up to several hours, depending on the printer/paper combination. To be safe, I always print targets the day before and read them the next day.

When you're printing a target, more patches are generally better than fewer patches. You get a smoother profile with more patches, but too many may introduce a degree of inaccuracy. About 2,000 patches is a decent-sized target and can print on a tabloid-size paper. I've got the test patch set to print for an iSis XL spectrophotometer. **Figure 2.58** shows a 2,000 patch target in i1Profiler that will be printed out using an Epson 4900 printer with Hahnemühle Glossy FineArt Baryta paper. I used i1Profiler to print the target. I let the printed target dry overnight to be sure the target colors was stabilized.

Once you print the target, you measure the resulting colors. In this case, I measured it using the iSis XL, which is sized to handle tabloid-size paper.

Once the target has been measured, you can set up for the lighting conditions for the ambient light that the print will be displayed under. I'll select D50. Or you can use the handheld spectro to create a custom sample of a unique lighting condition. **Figure 2.59** shows the Measurement and Lighting panels in i1Profiler.

Under Profile Settings, you select the various options. To be honest, I've tested the various options and I see so little difference that, unless you have a scientific

FIGURE 2.59 Detailed view of the Measurement and Lighting panels in i1Profiler.

▲ THE MEASUREMENT PANEL

▲ THE LIGHTING PANEL

interest (or are a color geek), I'd advise you stick to the defaults. When you're creating the ICC profile, be sure to select version 2, not version 4. **Figure 2.60** shows the Profile Settings panel with the options being set.

The last step is to create and save the profile. At this point, you should give it a meaningful name. Name it carefully. As I mentioned earlier in this chapter, renaming the profile after the fact is fraught with problems. **Figure 2.61** shows the last ICC Profile panel in i1Profiler.

That's basically it. As long as you load the profiles into your appropriate platforms, which I've discussed earlier, the profiles will be available in Photoshop and Lightroom.

I've told you how to create RGB profiles, but I'm not going to go into how to make a CMYK profile. This is an area of graphic arts that few should consider entering. To create a CMYK profile, you need a printer willing to print under the exact printing conditions with the exact same paper you'll be using for a press run to a CMYK target. Then you'd have to measure the target and configure the CMYK profiles

FIGURE 2.60 The profile settings options

▲ THE TABLES MENU SELECTING OPTIMIZE QUALITY

▲ THE PERCEPTUAL MENU SELECTING COLORFUL

▲ THE ADVANCED PANEL SHOWING THE CHROMATIC ADAPTATION SET TO BRADFORD (DEFAULT)

▲ THE ADVANCED PANEL SHOWING ICC PROFILE VERSION (SELECTING VERSION 2)

▲ THE ADVANCED PANEL SHOWING PROFILE WHITE POINT SET TO DEFAULT (RECOMMENDED)

FIGURE 2.61 The final ICC Profile panel in i1Profiler.

correctly, including total ink and dot gain, and GCR or UCR. The odds of a printer being willing to do that are not very high. However, the good news is that, if you do need to print CMYK or do CMYK conversions, the default CMYK working space in Photoshop (SWOP-coated v2 ICC profile) has been widely accepted throughout the industry. Most printers will tell you just to use that profile. If you're outside of the United States, there are different CMYK standards, but the standard profiles for various regions come with Photoshop.

BUYING A COLOR MANAGEMENT SOLUTION

Should you or shouldn't you? If you have any interest in having an accurate view of your image, you really must get a software and hardware package to calibrate and profile your display—that is non-negotiable. If you're trying to look at your photographs in an unprofiled state on your display, you have no idea if the colors you see are actually in your image. But beyond the display calibration and profiling, the question is whether you want to invest in a complete input and output color management solution.

Once again, you get what you pay for. On the low end, ColorMunki Photo offers a pretty sophisticated and yet inexpensive front-to-back solution, but it is somewhat limited in its scope and less flexible and less powerful than X-Rite i1 Profiler. If you move up to i1 Profiler, you can get the software and hardware together or as separate purchases. The X-Rite i1 Pro 2 spectrophotometer, which allows you to make display or output profiles, is more expensive but not hugely expensive.

If you are in a production environment where you need to make a lot of profiles very quickly, you might consider getting an automated strip reader such as the iSis or iSis XL. Otherwise, using the X-Rite i1 Pro solution and having to manually read the strip by dragging the spectro along the strip guide can be frustrating and tedious and slow. However, the automated strip reader is a more costly investment and really only useful in a production environment.

If you successfully use the printer-supplied output profiles or the profiles from the paper manufacturer, then quite honestly, investing in a complete solution doesn't really make a lot of sense. Your return of investment will be somewhat limited. I have the complete system primarily because I'm an equipment junkie and want to have absolute total control over the process, so I'm willing to pay that price.

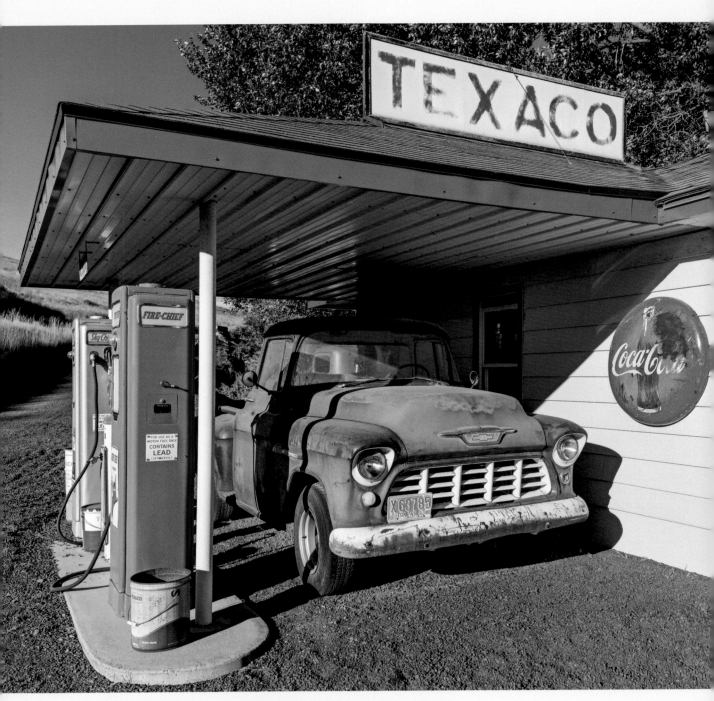

This image is of an old Texaco gas station that's part of a museum for old cars and trucks in the southeast area of Washington State, near Pullman. The image was shot with a Phase One 645DF camera with a 45mm F2.8 lens at F8.5. The camera back was a Phase One P65+ captured at ISO 100.

■ CHAPTER 3

PREPARING IMAGES FOR PRINTING

When you know how and where you're printing your image, you can optimize it for the appropriate resolution, ink colors, and paper type. To get the best results, start with your RGB master image, in which you adjust tone and color, perform capture and creative sharpening, and apply noise reduction. With that image ready, you can pivot in any direction, whether you're printing to a desktop printer, sending a file to a service bureau, or posting an image on the web.

PREPARING THE RGB MASTER IMAGE

In creating an RGB master, you optimize the image as much as possible without doing anything output-specific. You don't want to do anything that limits your options later, and that means preserving as much of the original data as possible. As you're initially applying color and tone correction, you want to be careful not to significantly or unalterably clip shadow or highlight detail; you won't know how much of that detail you'll need until you prepare the image for specific output. That said, some clipping is unavoidable, even with conservative optimization. **Figure 3.1** shows a variety of film scans and digital captures in their original state. **Figure 3.2** shows the results of optimizing for tone and color, as well as some conversions from color to black and white.

FIGURE 3.1 The original images before tone and color correction.

FIGURE 3.2 The RGB master images after tone and color optimization in Lightroom or Photoshop.

When you shoot in the harsh midafternoon sun, you'll have to work to keep important highlight and shadow detail in the final tone curve of the image. For example, in the image of the Texaco station shot in harsh afternoon sunlight, the extreme specular highlights are clipped, and that's okay. The image was captured with a Phase One 645 camera with a 45mm lens and a P65+ 60 MP camera back. Fortunately, the camera is pretty good at capturing scenes with wide dynamic range. **Figure 3.3** shows the original scene at the default settings in Lightroom.

You can make adjustments globally, so that they affect the entire image, or locally, affecting only selected areas. Global adjustments can be beneficial, such as when you're setting the white point. In some cases, however, a global adjustment fixes one area only to ruin another. People often struggle to optimize an image globally, going back and forth, fiddling repeatedly, when it would be more effective to fix an

FIGURE 3.3 The Texaco station at "default."

FIGURE 3.4 This initial scan without corrections shows the cross–curve color cast.

issue locally. The concept of global and local adjustments applies to tone and color correction, image sharpening, and noise reduction.

When you're preparing the RGB master image, I recommend fixing the worst problem first. Once you've done that, other problems tend to become less acute. For example, the image of 35mm film with different colors shown in **Figure 3.4** had a *cross-curve color cast* (the highlights were yellow, while the shadows came out blue). Correcting that color cast first made it easier to address any other issues in the image.

In this chapter, I'll discuss the high-level workflow for creating an RGB master image. If you want to learn more about working with Camera Raw, Lightroom, and Photoshop to make the appropriate adjustments, see *The Digital Negative*, which is all about preparing your RGB master image.

OPTIMIZING TONE AND COLOR

You can adjust tone and color in Photoshop, Camera Raw, or Lightroom. Camera Raw and Lightroom have some advantages that Photoshop doesn't have, especially because they let you work with raw camera data. You can perform global and local adjustments in any of these applications. However, if you need to make a complex color and tone correction, you'll get more accurate results in Photoshop, which provides a greater degree of precision in masking, selection, and layers.

Adjusting tone and color in Camera Raw and Lightroom

Both Camera Raw and Lightroom are set up to walk you through a recommended workflow for tone and color adjustments. Some people may wonder why the controls appear in the order they do. Well, Thomas Knoll, the founding engineer of Camera Raw and co-inventor of Photoshop, thought this was the order you should use, and his opinion is good enough for me.

Some folks eschew the use of the Basic panel. They advocate using the Tone curve to do all tone corrections. There's nothing wrong with doing both. All the tools are there to use, though just because they're there doesn't mean you have to use them. The more you understand the interactions between the various tools, the more likely you'll be able to accomplish what you want. One thing Photoshop, Camera Raw, and Lightroom have in common is that there are multiple ways to do the same or similar things. That can be intimidating for a new user. I say you should just use whichever method gets the result you want in the easiest and most efficient way. For our purposes, though, we're going to trust Knoll's judgment and start with the Basic panel in Camera Raw. Most of what I describe in Camera Raw is the same in Lightroom.

The first step is to arrive at the optimal white balance for an image. Do this before making any other tonal adjustments, because the white balance affects the tone response. Some cameras are very good at detecting the white balance when you set the camera to auto white balance. My camera is not, so when I shoot, I hard-set it at daylight to get it right. In Lightroom or Camera Raw, use the White Balance Selector to select an area to use to set the white balance. For the Texaco image, the initial daylight settings had a temperature of 5500°K and tint of +10; when I used the white balance eyedropper, those values changed to 5650°K and +10. Those values would be technically correct, but being technically correct and aesthetically correct are two different things. Use the technically correct numbers as a starting point for your image, but then adjust the sliders until the image looks right. I adjusted the white balance for this image to a temperature of 6336°K and a tint of +10; the changes don't seem huge, but the image is noticeably warmer on the printed page. **Figure 3.5**

FIGURE 3.5 Using the White Balance Selector tool in Lightroom.

FIGURE 3.6 The result of manually adjusting the white balance to 6336°K

FIGURE 3.7 The histogram in Lightroom.

shows the Lightroom White Balance Selector sampling a neutral target. **Figure 3.6** shows the result of the manual white balance adjustment.

When you hover the color sampler over the white part of the wall, the histogram shows that there isn't really any clipping in that area. **Figure 3.7** shows the histogram indicating no substantial clipping of highlights and only mild clipping of shadows.

However, if you hold down the Alt (Windows) or Option (Mac OS) key, you'll see that there is clipping in the specular highlights; that's a good and natural thing. Why do I say it's a natural thing? If you have a picture of the sun and it's not clipped or burned out, it's going to look pretty weird, because unless it's a solar eclipse, the sun should be the brightest thing in our world. Pressing Alt or Option while you hold down the Blacks slider shows a little clipping in the extreme shadows under the roof of the gas station (**Figure 3.8**).

With the white balance set, you can move on to the other sliders. The Exposure slider is your primary lightening and darkening tool in the Basic panel. If the overall image is too dark, increase the Exposure setting; if it's too light, decrease the Exposure. Adjusting the Exposure controls by 1.0 pretty much equals adjusting one full stop, replicating what it would be like to adjust the f-stop of a camera. Here, I've set it to -25. Exposure is the first tone slider you want to use, but not the last. Continue

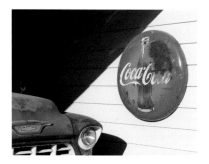

▲ A DETAILED PORTION OF THE SCENE ▲ THE PREVIEW OF HIGHLIGHT CLIPPING IN THE SPECULAR HIGHLIGHTS ▲ THE PREVIEW OF SHADOW CLIPPING

FIGURE 3.8 Using the highlight and shadow clipping display option.

on to the Contrast slider. If you have a high-contrast scene, you should reduce the Contrast value; in a low-contrast scene, increase it. In this case, I set it to -10. None of these are huge differences.

> **NOTE** We know that there is some clipping in the specular highlights, even though it's not indicated in the histogram (Figure 3.7). I was curious about this, so I asked Eric Chan, one of the Camera Raw engineers, what was going on. Eric told me that the histogram is more conservative about reporting clipping than the Alt or Option key when you use the sliders. The Alt or Option key with sliders show you per–channel clipping in the output color space; a channel is considered to be clipped if any pixels have an 8–bit value of 0 or 255. The warning triangles on the histogram also show you per–channel clipping. However, this is based on a histogram calculation. Specifically, a given color channel is considered to clip the shadows if at least 0.1% (i.e., 1/1000) of the pixels in the image have the 8–bit value of 0; highlights are considered clipped if at least 0.1% of the pixels in the image have the 8–bit value of 255. You'll see the triangle warnings on the histogram light up only when you pass that threshold.

Highlights, Shadows, Whites, and Blacks are fine-tuning controls for adjusting the tone mapping. Think of tone mapping as a curve with shadows at the bottom, highlights at the top, and midtones in the middle. While Exposure controls everything including the highlights, midtones, and shadows, the Highlights slider affects only pixels above the middle of the curve, and the Shadows slider affects only those below the middle. Camera Raw and Lightroom have built-in highlight-recovery and shadow-enhancement algorithms that darken highlights and lighten shadows,

NOTE The image-adaptive algorithms were introduced in process version 2012. Images that have been modified in earlier versions of Lightroom or Camera Raw won't use these algorithms. These new algorithms allow Lightroom and Camera Raw to better handle high-contrast scenes with reduced highlight or shadow clipping.

respectively, in an image-adaptive manner. Basically, they use the image data to modify the image itself.

The last two sliders in the Tone area of the Basic panel fine-tune the white point and the black point. Press the Alt or Option key as you move the Whites and Blacks sliders to see the impact of each. Here, I've set the Highlights to -17, increased the Shadows to +40, moved the Whites to +6 (because the whites were getting dingy with the reduction in Exposure and Highlights), and decreased the Blacks to -20 to punch down the deeper shadows. **Figure 3.9** shows the result of the global tone corrections.

After making those global tonal changes, there were two areas of the image I wanted to adjust locally, to darken the whites in one case and lighten some shadows in another. I used the Adjustment Brush in Lightroom with the Auto Mask on to darken the exposure one stop; the Adjustment Brush mask is set to green so that it's clear where I'm applying the adjustment. (You can choose the color. Red is the default, but because the image has so much red in it, the affected areas wouldn't have been obvious.) Then I painted a different area with the Adjustment Brush with the Auto Mask off, using a soft dodging approach to lighten up some of the shadows so it wasn't getting too dark above the car. **Figure 3.10** shows the two local adjustments made with the Adjustment Brush in Lightroom.

The histograms from the original image and the adjusted image don't look terribly different. There's no substantial clipping in either, but you can see that the way in

FIGURE 3.9 The result of the global tone adjustments.

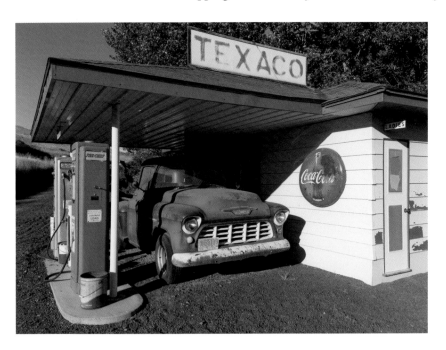

which the image has been adjusted has been optimized for printing. Keep in mind that there's no such thing as a good or bad histogram per se. Basically, a histogram is the graphical representation of the levels in your file. It provides useful information, but you don't really adjust the image by looking at the histogram. **Figure 3.11** shows the final tone- and color-corrected image, and the final histogram.

▲ LOCAL ADJUSTMENT TO DARKEN THE HIGHLIGHTS
−1.00

▲ LOCAL ADJUSTMENT TO LIGHTEN THE EXPOSURE
0.50 AND SHADOWS +40

FIGURE 3.10 The local adjustments.

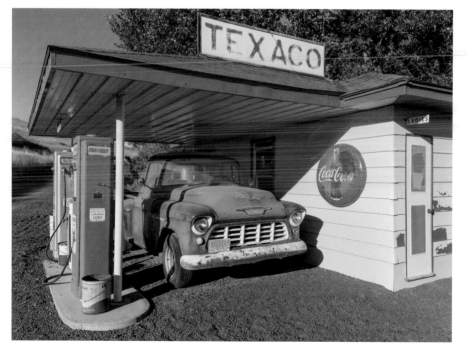

▲ THE FINAL IMAGE

▲ THE FINAL HISTOGRAM

FIGURE 3.11 The final Texaco station tone and color corrections.

When you're working with a high-dynamic range image, you're trying to contain the image tone curve and maximize your highlight and shadow detail using tone mapping (in either the Basic panel or Tone Curve panel). With a low-contrast dynamic range original, you're trying to increase the apparent contrast in the image. The approach to the two are diametrically opposed.

The previous example dealt with toning a high-dynamic range scene that is common when shooting in sunlight. But what about toning a low-dynamic range scene shot in overcast or cloudy conditions? Instead of trying to compress the tone curve, with a low-contrast scene you expand the range.

I've made adjustments to an image of lava rock on the side of a mountain in Iceland. It's pretty bland and boring, typical of a low-contrast scene. It's generally on the dark side, with not a lot of snow or ice or anything like that. The histogram for the image shows a whole bunch of data sitting just left of a traditional bell-shaped curve. The image was shot with a Phase One 645 camera with a 75mm lens and a P65+ camera back. **Figure 3.12** shows the starting image and the original histogram.

To adjust the tone for this image, I didn't do much of anything with the Exposure slider. I increased the Contrast to 25, and then lightened Highlights and darkened Shadows to increase contrast in the midtones. I punched up the Whites to +25 and dropped the Blacks to -20.

FIGURE 3.12 The original image and histogram.

I then made some changes in the Presence area of the Basic panel. Clarity increases contrast in the midtones; it affects middle gray, the area just above it, and the area just below it. Here, I increased the Clarity to +10. Vibrance increases saturation nonlinearly; it increases the saturation of unsaturated colors more than that of fully saturated colors. Saturation, however, increases the saturation of all colors equally. The ability to increase the saturation of desaturated colors more with the Vibrance slider is useful aesthetically. I moved the Vibrance slider to +40.

I also used a tone curve to adjust this image. I used a parametric tone curve to darken the highlights but lighten the lights to increase the contrast of the midtones. (Confusingly, the Highlights in the Tone Curve panel don't relate to Highlights in the Basic panel. They're similar, but a different part of the curve. I try not to think about it too much. Just move the sliders until it looks good. I'm sure the engineers could tell you what the relationship is, but that wouldn't help you make the adjustments.) Still in the Tone Curve panel, I lightened the Darks and darkened the Shadows. **Figure 3.13** shows the tone-adjusted image and the Basic and Tone Curve panels.

▲ THE ADJUSTED IMAGE

▲ THE BASIC PANEL

▲ THE TONE CURVE PANEL

FIGURE 3.13 The result of the Basic and Curves adjustments.

The Basic panel adjustments of Highlights, Shadows, Whites, and Blacks are image-adaptive. Their ranges adapt to be optimal for the image, and they tend to be more conservative in their actual approach, less twiddly and fiddly. Tone Curve is an actual tone-curve mapping with no image-adaptive mapping to alter the behavior. It's a direct application, giving you a little more flexibility but a stronger effect.

After all these global toning adjustments, I applied a local adjustment using a graduated filter. With the tone changes, the top of the image had started to get too bright, so I wanted to darken the top of the image. Rather than fuss and fiddle with global changes, I darkened the Exposures, darkened Highlights, and increased Clarity in just the top portion using the gradient. **Figure 3.14** shows the Graduated Filter pin.

As you can see in the final image, the contrast and vibrance of the image have been punched up. I made the overall white balance temperature a little cooler, but did not make a huge adjustment. If you look at the histogram of the final image, you'll see that the only thing notable is that I did introduce some shadow clipping with the extreme tone-mapping adjustment, but I didn't introduce any highlight clipping. Instead of a narrow bell-shaped curve, it's now an overall rounded top curve. **Figure 3.15** shows the final image and the histogram.

FIGURE 3.14 The Graduated Filter local adjustment.

FIGURE 3.15 The final image and histogram.

DODGING AND BURNING

To photographers who've never worked in a darkroom, the terms *dodging* and *burning* may seem odd. But those of us who remember the way developer smelled like eggs know what they mean. When developing film in a darkroom, you literally moved your hands underneath the negative in the enlarger to affect how the image was projected onto the paper. If the image was too dark, you'd move your hand underneath and cast a shadow on the exposure. You can lighten an area a specific amount by dodging for 5 or 10 seconds. Conversely, if an area was much too light, you'd hold your hands together underneath to cut out the light everywhere except in a small area: burning. To burn an image is to constrain and continue the exposure longer.

Adjusting tone and color in Photoshop

TIP You can process scans in Lightroom and Camera Raw. For Camera Raw, they must be flattened TIFF files. Lightroom can import either TIFF or PSD files, but PSD files must have the Maximum Compatibility option checked when saved. I often use Lightroom for processing scanned images that don't need extensive retouching or masking and selections.

If you've captured photos digitally, you can make tone adjustments on raw data in either Camera Raw or Lightroom and optimize the image pretty well. However, if you're scanning film as TIFF images or if you need to mask beyond the capability of Camera Raw or Lightroom, you'll get better results adjusting the tone in Photoshop. **Figure 3.16** shows the original film scan.

As with making corrections in Camera Raw or Lightroom, when you're working on your RGB master image in Photoshop, you want to make the appropriate corrections while preserving the textural detail that might be useful later. This image (**Figure 3.16**) was scanned from film and has a dingy yellowish highlight that I find unpleasant. The shadows also have a kind of blue-magenta cast. I didn't try to fix this in the scanning software because the only tone and color corrections available are global. So, I scanned somewhat flat and didn't worry about nailing color correction. I started correcting the tone with a Curves adjustment layer in Photoshop (**Figure 3.17**). There are some tricks to using the Curves panel.

FIGURE 3.17 The Curves panel in Photoshop.

FIGURE 3.16 The original film scan opened in Photoshop.

▲ THE HIGHLIGHT COLOR TARGET COLOR PICKER ▲ THE SHADOW COLOR TARGET COLOR PICKER

FIGURE 3.18 Adjusting the white point and black point clipping colors.

First, it's important to know that when you're setting the white point, black point, and gray point in the Tone panel, you'll clip highlights and shadows if you use the default target highlight and target shadow colors. By default, the target highlight color has RGB values of 255, 255, 255, and the target shadow color is set to 0,0,0.

To change the target highlight color, double-click the White Point sampler in the Curves panel; I suggest setting RGB values of 250, 250, 250. With those values you can be conservative and not clip arbitrarily. Double-click the Black Point sampler to change the target shadow color; I suggest 10, 10, 10, so you won't clip shadows. There's no need to change the gray. **Figure 3.18** shows adjusting the white and black color samplers in the curve panel. To access the white and black color settings, double-click on the actual Curves panel eyedropper.

When you click OK in the Color Picker for the target highlight or target shadow color, Photoshop prompts you to save the values as the default. It's a good idea to click Yes, so that those values will always be in place and you won't have to think about it again. Just try to remember you've changed the defaults and alter them when needed.

The other factor that is important to understand is that the sample points for black, white, and gray are controlled by the Sample Size menu for the Eyedropper tool. By default, the sample size is set to Point Sample, which selects an individual pixel. It can give you unpredictable results because you can't control your cursor finely enough to be sure which color you're sampling; you may even end up sampling noise or other artifacts. I recommend choosing 11 by 11 Average or larger from the Sample Size menu. With 11 by 11 Average, Photoshop averages the color in an 11-pixel by 11-pixel area, so you have a much better idea of what you'll be sampling. **Figure 3.19** shows the Eyedropper Sample Size menu.

NOTE The sample size settings for the Eyedropper tool changes the options for all Photoshop tools that use an eyedropper. So, if you change it for one, all other tools will be changed. This isn't really a problem, just something to be aware of as you work.

FIGURE 3.19 The Eyedropper Sample Size dropdown menu.

FIGURE 3.20 The result of the initial tone and color correction using Curves.

Once you've set the target colors and sample size, use the White Point, Black Point, and Gray Point samplers to make adjustments. In this image, I clicked the brightest area to neutralize the color cast in the whites, the darkest area to neutralize the color cast in the blacks, and a gray area to neutralize the middle. Just those three clicks produced a substantial improvement. **Figure 3.20** shows the result of the tone and color correction from using the White Point, Black Point, and Gray Point samplers in the Curves panel.

For this image, adjustments in the full RGB image gave enough correction, and that's often true. However, you can adjust each channel separately. Currently, the red, green, and blue histograms show that I'm just shy of clipping highlights and shadows. But sometimes having an absolutely neutral color cast is aesthetically less useful. For example, you might want to introduce a cast in the highlights for the same reason I introduced warming in the image of the Texaco station. If that's the case, you may want to adjust the curve for each channel separately. The samplers work the same way when you're adjusting separate channels. **Figure 3.21** shows the individual Curves adjustments for red, green, and blue.

FIGURE 3.21 The red, green, and blue channel controls in the Curves panel.

▲ RED CHANNEL ▲ GREEN CHANNEL ▲ BLUE CHANNEL

You can also make changes in the Curves panel using the Targeted Adjustment tool. Instead of clicking and creating a point on the curve, you hover the pointer over the image, and then click and push up or down to make the curve adjustment. The Targeted Adjustment tool lets you watch the image as you're making the adjustment instead of watching the actual curve point.

CURVES OR LEVELS?

Both Curves and Levels adjustments let you adjust the end point and the middle point for input and output, but Curves also lets you perform a per-channel adjustment anywhere along the curve line. Levels gives you control over the end points and the middle points only; the most that you can do with Levels is the adjustment of three points, with no intermediate point adjustments. Curves has greater precision on a per-channel basis. Generally, I encourage people to use Curves. I do use Levels a lot on channels, where I'm trying to lighten, darken, clip, or adjust an overall channel as opposed to an actual image. But the bottom line is that Curves gives you greater precision throughout the entire range.

The Curves adjustment removed much of the initial color cast, but the overall image still has some cast involved that I would have to adjust locally. In lieu of doing that, I've used Color Range to select all the noncolor portions of the image. (Note that whatever you chose from the Sample Size menu in the options bar also applies when you use Color Range.) Here, I clicked and dragged in the midtone and highlight areas of the image. In the Color Range dialog box, all the saturated colors are deselected

or black, and all the neutral colors are selected because they're white. I then used a Hue/Saturation adjustment layer to introduce a global desaturation using the result of the color range as a layer mask. **Figure 3.22** shows the Color Range selection tool.

FIGURE 3.22 The Color Range selection tool.

NOTE I like to keep layers separate in layer groups. For this image, there's a background layer; a layer for spotting, on which I cleaned up dust spots with the Healing Brush; a Basic Tone & Color; a Hue & Sat Adjustments layer for some complex adjustment layers, with multiple layers controlling different colors; and a layer group for additional background toning adjustments. **Figure 3.23** shows the final layer stack. Note that some of the layers groups are shown collapsed.

FIGURE 3.23 The final image layers stack.

▲ REDS ADJUSTMENT

▲ YELLOWS ADJUSTMENT

▲ GREENS ADJUSTMENT

▲ BLUES ADJUSTMENT

▲ MAGENTAS ADJUSTMENT

FIGURE 3.24 The various per-color adjustments in a single Hue/Saturation adjustment layer.

 I added some Hue/Saturation adjustments that are more specific, including one very complex adjustment that performs hue/saturation adjustments by color. I did five iterations of the same layer to control the different colors: magentas, blues, greens, yellows, and reds. In addition to individual adjustments, the saturation has been pumped up and the color lightened in each, making a color adjustment as opposed to a tone adjustment. **Figure 3.24** shows the various per-color adjustments.

 I then added yet another adjustment layer for color, a global Vibrance adjustment layer. I added two pixel layers on top, where I painted in a layer in both green and blue set to a Color blending mode so that I could physically paint color into the image. It's a fine-tuning tweak that is more complex than you may need for most images.

Finally, I performed local gradient curve adjustments in different portions of the image. I darkened the lower right, lightened the center circle with a radial gradient, added a curve to darken the very top of the image, and so on. **Figure 3.25** shows the final tone and color correct image and a detail of the *background toning adjust* layers.

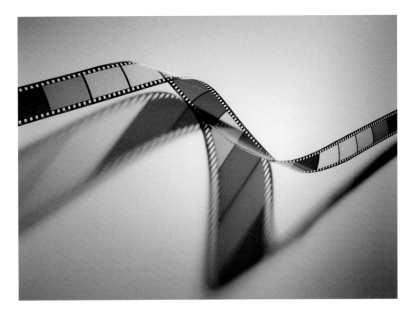

▲ THE FINAL ADJUSTED IMAGE (ALSO SHOWN ON THE OPENING SPREAD OF CHAPTER 2)

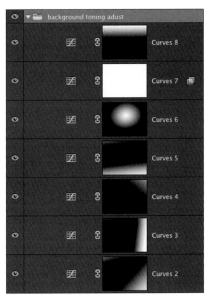

▲ A DETAIL SHOWING THE ADDITIONAL ADJUSTMENTS FOR THE BACKGROUND OF THE IMAGE

FIGURE 3.25 The final adjusted image and a detail of the background toning adjust layers.

NOTE You may be wondering why I've stacked so many different adjustment layers together and whether this would degrade the image quality. Well, since none of the adjustments involve clipping and are only curve adjustments, and coupled with the fact I'm working on a 16-bit image, there's no problem. I do suggest, where possible, to keep the number of individual adjustment layers to a minimum, but you gotta do what you gotta do to get the image just right.

IMAGE SHARPENING AND NOISE REDUCTION

Sharpening is required of any image that has gone from the continuous tone of film or a camera to pixelization. Creating a digital image introduces softness that's not in the original scene. The very act of putting an image onto film and then scanning it softens the image. Digital cameras have aliasing filters that introduce a degree of softness in the resultant digital capture. How much sharpening you need to do depends on the source (kind of camera, lens, and sensor) and the content (whether the image itself is high frequency with lots of textural information or low frequency, such as a person's face).

Image sharpening and noise reduction are two different sides of the same coin. Sharpening an image necessarily enhances noise, so you want to mitigate that as much as possible. Just as with tone and color correction, when you're preparing your RGB master image, you want to optimize sharpening and noise reduction without limiting your possibilities later. And just as with tone and color correction, you can perform sharpening and noise reduction both globally and locally.

A sharpening workflow

My good friend and colleague, the late Bruce Fraser, originally developed the concept of a sharpening workflow. Bruce came up with the idea of including sharpening and noise reduction as part of a larger workflow, rather than an all-in-one operation. In this workflow, capture sharpening, creative sharpening, and output sharpening are three distinct steps. However, in Camera Raw and Lightroom, capture sharpening and creative sharpening happen at the same time. **Figure 3.26** shows a multi-application flowchart of the workflow for image sharpening and noise reduction.

Capture Sharpening. Through capture sharpening, you try to determine the frequency of the edges (that is, whether it's a high- or low-frequency textural image) and apply the proper edge sharpening to recover the apparent sharpness lost in the process of digitizing. This is a conservative approach. You don't want to oversharpen in the beginning, because it's almost impossible to undo oversharpening; sharpening is a destructive process. At this stage, you also need to apply noise reduction because when you sharpen edges, you can sharpen noise or film grain. The intent is to maximize the image detail. In fact, in Photoshop, you should do noise reduction before sharpening, so that you don't sharpen the noise itself. In Lightroom or Camera Raw, there are two discrete algorithmic steps in the same processing pipeline, so it doesn't matter what order you use, as long as you apply both sharpening and noise reduction.

Creative Sharpening. With creative sharpening, you use sharpening to achieve the creative effect you want. For example, you can make one thing look sharper by

NOTE Aliasing filters differ among digital cameras. They're useful because they reduce the risk of moiré patterns, which are interference patterns between the subject texture and the grid array of a digital sensor. However, they decrease image quality. Some cameras have virtually no aliasing filter. Nikon developed the D800E with a much-reduced aliasing filter because everyone was clamoring for it, but of course it increased the risk of moiré patterns and artifacts. If you get a moiré pattern, just about all you can do is introduce blurring after the fact or try to move in or out or rotate the camera to mitigate the interference. I will say, though, that the Moiré slider in Camera Raw and Lightroom's local adjustment tools work pretty well for color moiré!

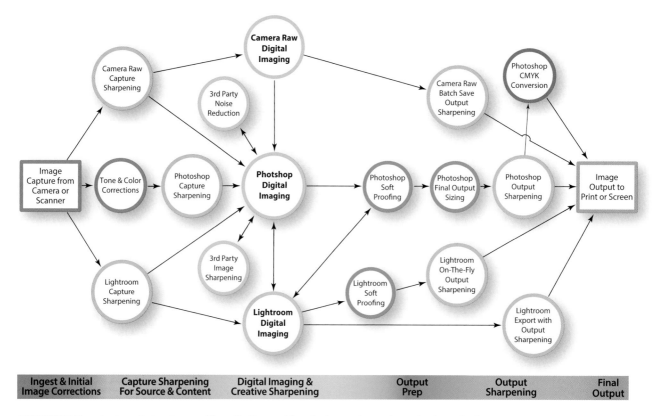

FIGURE 3.26 Flowchart graph showing a multi–application workflow for image sharpening and noise reduction.

applying blur to everything else. Creative sharpening implies localization, or sharpening specific areas of the image. In a portrait, you might sharpen the eyes and lips, and maybe hair and eyelashes, but not skin (unless you're shooting a craggy old sailor); you do that sharpening locally.

Output Sharpening. Output sharpening is the last stage, and it can't be done until you determine the final size and resolution of the final output. The output sharpening required for a glossy paper is different from that for a matte or watercolor paper. Output sharpening is built into Camera Raw and Lightroom as a separate distinct stage when you're making the print or exporting, but it's more difficult in Photoshop.

Capture sharpening in Lightroom and Camera Raw

Capture sharpening in Lightroom and Camera Raw is performed the same way, but make sure you don't do it twice! Don't do it in Camera Raw and then again in Photoshop. You should never apply the same type of sharpening twice. **Figure 3.27**

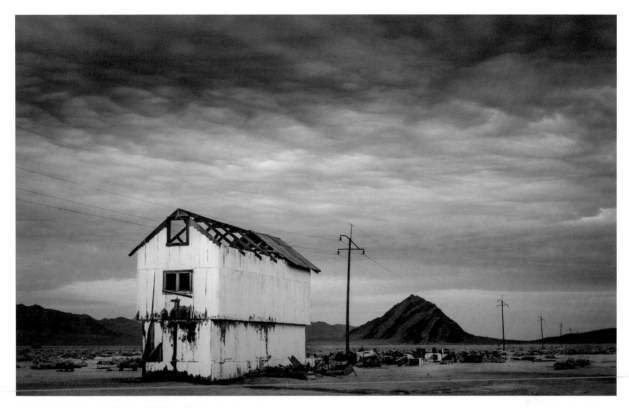

FIGURE 3.27 Just outside Death Valley, California, at sunrise.

shows the image I'll be using to demonstrate capture sharpening in Lightroom. The image was shot with a Phase One 645 with a 75mm lens and a P65+ camera back just outside of Death Valley, California (the town, not the national park).

To perform sharpening in Camera Raw or Lightroom, zoom in to a 1:1 ratio (100%), because it's the only screen ratio in which a single image pixel is equivalent to a single display pixel. That is the only zoom that will accurately show you the impact that you're having on sharpening and noise reduction.

In the Basic panel, you worked from top to bottom, but in the Detail panel, that's not the case. Adjust the Radius slider before you adjust the Amount, Detail, and Masking sliders. The Radius dictates what kind of edge enhancement will be applied to the image. In this image, a high-frequency texture image, I want to use a reduced radius (0.8 in this case). When you're dealing with low-frequency images, such as people's faces, or very soft types of images, use a larger radius. In fact, Lightroom actually has two defaults: Sharpen for Scenic (a reduced radius for high-frequency

> **NOTE** You perform sharpening in the Detail panel, which is broken down between sharpening and noise reduction—opposite sides of the same coin. What you do in one will impact what you have to do in the other.

images, often landscapes) and Sharpen for Faces (a 1.4-radius for low-frequency images). Unfortunately, Camera Raw doesn't include those defaults.

After you've set the radius, adjust the Amount slider. I tend to adjust it aggressively, because things that I'll do later will mitigate that. Often, I have to come back and make fine-tuning adjustments on multiple sliders anyway. **Figure 3.28** shows detailed figures at a screen zoom of 3:1 showing no sharpening, default sharpening, tuned sharpening, and tuned sharpening with luminance noise reduction. I set the Amount to 60 in this case, which is fairly aggressive, with Radius at 0.8, Detail at 90, and Masking at 20. I used a luminance noise reduction of 20 and adjusted the detail slider to 65% to preserve more edge detail.

NOTE Normally, I would do adjustments at 1:1 screen ratio—it's the only screen ratio in which a single image pixel is equivalent to a single display pixel. That is the only zoom that will show you accurately the impact that you're having on sharpening and noise reduction. (Also note that the image is 3:1 for illustration purposes.)

TIP Lightroom ships with two sharpening presets in the Lightroom General Presets folder. They are handy starting points for low-frequency images (Sharpen–Faces) and high-frequency images (Sharpen–Scenic). Although these are only starting points, you can easily modify them for your own images. If you use Camera Raw, however, there are no presets—but you can make your own. The settings for Sharpen–Faces are Amount 35, Radius 1.4, Detail 15, and Masking 60. The settings for Sharpen–Scenic are Amount 40, Radius 0.8, Detail 35, and Masking 0.

In both Lightroom and Camera Raw, you can press Alt (Windows) or Option (Mac OS) while you adjust the slider to visualize what the control is actually doing. When I press Option as I adjust the Amount slider, the image is in grayscale because sharpening is applied to the luminance information, not the color information. You can use the same Alt/Option trick with the Radius, Details, and Masking sliders. **Figure 3.29** shows the various sharpening previews when holding down the Alt or Option keys while adjusting a slider.

The Detail slider is a difficult concept. It is a kind of a stepless interpolation between two different sharpening algorithms. If you run it up, you move toward a deconvolution sharpening, similar to the Smart Sharpen filter you might use in Photoshop to sharpen lens blur. It gives you higher acutance but also increases the risk of halos and noise. In this case, I set it to 90, and that basically applies as much acutance to the sharpening as possible. When you run it down to 0, you reduce the acutance of the sharpening, and you suppress halos. Lightening the light side and darkening the dark side increases the apparent sharpness—that's fundamental to the concept of sharpening. If you're sharpening a face, move it more toward zero, as in the Sharpen for Faces default in Lightroom.

▲ NO SHARPENING

▲ DEFAULT SHARPENING

FIGURE 3.28 Comparing no sharpening, default sharpening, tuned sharpening, and tuned sharpening with luminance noise reduction.

▲ TUNED SHARPENING

▲ TUNED SHARPENING WITH NOISE REDUCTION

FIGURE 3.29 Comparing the various previews available when adjusting the sharpening sliders.

▲ AMOUNT

▲ RADIUS

▲ DETAIL

▲ MASKING

The Masking slider controls edge masking. It's the edge detail you typically want to sharpen; surfaces are areas between the edges. Edge masking cuts back on the sharpening that is applied to surfaces and concentrates it on the edges.

One of the things you'll note particularly with a high Detail value is that as you increase the sharpening, you'll start enhancing the noise. Unless you want it as a special effect, noise interferes with image quality. The default is to have no noise reduction in the luminance data. I think that you should apply some basic noise reduction to virtually every image, because increasing sharpening impacts noise. Even if you have a high-resolution, low-noise, low ISO camera sensor, the very act of sharpening exacerbates noise. It's not on by default because it is very image-sensitive, so you have to figure it out for yourself pretty much on an image-by-image basis.

The next step for sharpening is to adjust the noise reduction. Remember that sharpening is applied to the luminance, not the color information. The Luminance slider effectively attempts to obliterate the noise by applying a type of blur. If you increase the Luminance Detail value, you preserve more image detail, but the image may be noisier; as you reduce the value, you tend to lose some of the actual image detail. The trick is finding the optimal point between blurring the noise and preserving the useful image detail. **Figure 3.30** shows the result of the global sharpening and noise reduction as a screen zoom of 1:1. The aim is to arrive at the optimal sharpening and noise reduction at this zoom without introducing any serious image artifacts due to oversharpening. The problem with global sharpening is that, not unlike global tone and color correction, you can't always fix things globally. If you do see objectionable sharpening artifacts, you can address the issues locally.

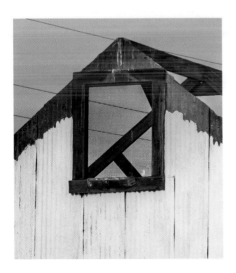

FIGURE 3.30 The final global sharpening and noise reduction at a 1:1 zoom.

FIGURE 3.31 This figure shows the result of using the Adjustment Brush (with Auto Mask turned on) to apply a local minus sharpening and plus noise reduction to the masked area shown in green.

You can use a local adjustment tool to apply local sharpening and noise reduction in Camera Raw or Lightroom. In this image, I've used the Adjustment Brush using Auto Mask to paint the entire sky (the masked area is in green) and then erased the local sharpening and noise reduction that was in the building itself. **Figure 3.31** shows the Adjustment Brush mask for modifying the sharpening and noise reduction in the sky.

Local sharpening and noise reduction uses the same parameters that were applied in the Detail panel itself. The only thing you end up changing is the relative amount. So, if your Amount slider for sharpening is set to 50, you can add +50 sharpness locally to take it to 75. It works as a relationship of percent. One tricky thing to keep in mind is that when you apply a negative sharpening amount between -1 and -50, you reduce the sharpening amount in the Detail panel, but if you apply between -51 and -100, you're actually adding lens blur. **Figure 3.32** shows a comparison of tuned global sharpening, tuned global noise reduction, and the result of the Adjustment Brush reducing sharpening in the sky while increasing the luminance noise reduction. The local adjustments were -25 Sharpness and +50 Noise reduction.

Combining both global and local sharpening and noise reduction is important to maximize the image quality in the RGB master image and will lead to better optimized images for printing. Be sure to examine your image very carefully to make sure you don't introduce sharpening artifacts. It was while I was examining this image that I realized that there was a foreign object in the scene! One of the things I do to examine the effectiveness of sharpening is to look at all areas of image. When I examined one of my photos, I realized there was a photographer in the middle of my scene. One of the problems of doing a workshop with other photographers is that they sometimes end up in your shots. **Figure 3.33** shows a before and after *photographer* removal in Photoshop.

▲ TUNED GLOBAL SHARPENING

▲ TUNED GLOBAL SHARPENING AND LUMINANCE NOISE REDUCTION

▲ LOCAL ADJUSTMENTS FOR SHARPNESS AND NOISE REDUCTION

FIGURE 3.32 Comparing global and local sharpening and noise reduction.

FIGURE 3.33 Now you see him, now you don't—retouching using Photoshop's Healing Brush (because Lightroom's wasn't quite up to the task—I tried!).

▲ UNKNOWN PHOTOGRAPHER IN THE SHOT

▲ NO PHOTOGRAPHER IN THE SHOT

Noise reduction in Lightroom and Camera Raw

When you use a small-format camera with high ISO, you have to be more aggressive with noise reduction. For serious noise reduction in Lightroom and Camera Raw, the principles are the same, in that you want to sharpen the edge detail and reduce the unfortunate noise in the surfaces. I've found that when you're trying to sharpen high ISO, you want to use a slightly larger radius so you don't oversharpen the noise. **Figure 3.34** shows an image shot on an older Canon EOS 10D camera (which I still keep around so I can make really noisy images for demos). The image was shot at ISO 1600, which was pretty noisy for this camera. The full image doesn't look too noisy because it's been downsized so much for the figure, but when it's zoomed in, you see all the real noise!

In this case, I used a radius of 1.3. This is also an example of using a lowered Detail slider to help mitigate the tendency of sharpening to affect the noise. In this case, I ended up using a very strong Luminance noise reduction (75) and pulled back on the Detail slider to reduce noise in the surfaces. As you can see, the noise reduction has really smoothed out the textural noise, but it started to look just a little synthetic. **Figure 3.35** shows a 3:1 zoom of four stages: no noise reduction or sharpening, default sharpening but no noise reduction, tuned sharpening but no noise reduction, and the tuned sharpening and luminance noise reduction applied.

FIGURE 3.34 The full frame of the images used for the noise example.

▲ NO NOISE REDUCTION AND NO SHARPENING

▲ DEFAULT SHARPENING WITH NO NOISE REDUCTION

FIGURE 3.35 Comparing various sharpening and noise-reduction settings.

▲ TUNED SHARPENING WITH AMOUNT 55, RADIUS 1.3, DETAIL 17, MASKING 0, WITH NO NOISE REDUCTION

▲ TUNED SHARPENING WITH NOISE REDUCTION APPLIED WITH LUMINANCE 75, DETAIL 30, AND CONTRAST AT THE DEFAULT 50. THE COLOR AND DETAILS SETTINGS REMAIN AT DEFAULT

After I've reduced the noise, I often add grain in the Effects panel. The trick is to reduce the noise as much as possible and then add in some finer grain to help break up the synthetic appearance. It may make a difference if you're printing a really big image. **Figure 3.36** shows the result of adding grain with the Effects panel.

FIGURE 3.36 Adding grain to mitigate the noise–reduction smoothing.

▲ THE SETTINGS USED IN THE EFFECTS PANEL

▲ THE IMAGE WITH GRAIN ADDED

I realize it may seem counterintuitive to add grain after reducing noise, but the noise-reduction algorithm tends to leave an image with an artificial lack of micro detail. This won't be a problem if the image is downsampled for the web, but it will be noticeable when making larger prints. The addition of the grain gives the final sharpened and noise-reduced image a more "photographic" appearance. **Figure 3.37** shows the final result with a zoom of 1:1, which is the normal zoom range for sharpening and noise reduction.

FIGURE 3.37 Adding grain effect results in a more photographic image, shown here with a 1:1 zoom.

One of the biggest noise-reduction tools in Lightroom and Photoshop is down-sampling. When you downsample, one of the things that is reduced is noise. So, if you're going to make a small print, you probably don't need to worry too much about noise.

Capture sharpening and noise reduction in Photoshop

Before you do any capture sharpening in Photoshop, make sure you've done all your tone and color corrections. Applying sharpening and noise reduction will make adding major adjustments more difficult to integrate into the image.

Photoshop is the grand dame of digital imaging, but a lot of the functionality requires expert knowledge and manual application of functions. And while Photoshop has many ways of doing just about everything, when it comes to sharpening and noise reduction, the built-in tools often need a bit of user intervention. Critical to both sharpening and noise reduction is the ability to deal with edges differently than surfaces (non-edges). Edge masking is built into Camera Raw and Lightroom, but you have to create an edge mask manually in Photoshop. You can use the edge mask for both capture sharpening and noise reduction. **Figure 3.38** is a scan from a sheet of 4 x 5 film shot in my studio. I built the head (based on Michelangelo's

FIGURE 3.38 The original scan from 4 x 5 transparency film. Scanned on a Imacon Flextight 848 scanner with sharpening turned off.

CREATING AN EDGE MASK IN PHOTOSHOP

1. In the Channels panel, click the RGB channel (the individual Red, Green, and Blue channels will be selected, too), and then click the Load Channel As Selection button at the bottom of the Channels panel to load the luminosity information of the RGB channel as an actual selection.

2. Click the Save Selection As Channel button at the bottom of the Channels panel or choose the Save Selection command in the Select menu.

3. Rename the channel (named Alpha 1 by default). I renamed mine *Luminosity* to make it clear that it's the luminosity data.

4. Select the Luminosity channel. The image becomes grayscale.

5. Apply the Find Edges filter (in the Stylize menu). The Find Edges filter looks through the image and creates a result that darkens the edges. The non-edge (surface) area will be light or white.

6. Modify it. I used a Levels adjustment to clip the black side to darken the actual images.

7. Add a Gaussian blur to soften the edges so the edge mask has a soft transition between what's selected and what's not. A gentle 2–4 pixel radius blur is typical.

8. Invert the image so the edges are selected instead of the surfaces.

9. Make another slight modification to the tonality to lighten up the white edges.

You end up with an edge mask that can be applied as a layer mask to the actual sharpened image data.

Figure 3.39 shows the Channels panel with thumbnails illustrating the individual steps as well as the final edge mask. The exact numbers you'll need to use for the different levels' adjustments and blurring will depend on the image and resolution.

▲ THE CHANNELS PANEL SHOWING THE STEPS USED TO MAKE THE EDGE MASK

▲ THE FINAL EDGE MASK

FIGURE 3.39 The steps used to create the edge mask, and the final mask.

David, reversed) and those are my hands in the shot. I used a sound trigger to fire the strobes when I hit the chisel with the hammer. I like to put a little something of myself in my images! This is the image I use to show capture sharpening and noise reduction in Photoshop. To create an edge mask, see the sidebar "Creating an edge mask in Photoshop."

In Photoshop, you want to make sure to apply noise reduction before sharpening. If you reduce noise in surface areas, you can apply more aggressive sharpening to the edges. You can use the edge mask you created as an edge mask for sharpening and as a surface mask for blurring. In this case, I'm using the Reduce Noise filter in Photoshop. The key is to be pretty aggressive with the Strength and Preserve Detail sliders, while remembering you can always modulate how much of the blurring will actually end up occurring in edges because you'll be using your own surface mask on top. To create a new layer to apply the noise reduction to, I've duplicated the background image and named it Reduce Noise. I prefer to work on a separate layer to take advantage of layer blending options. **Figure 3.40** shows the Reduce Noise settings using Advanced mode.

Advanced mode lets you apply asymmetrical amounts of noise reduction per channel. Film traditionally has more noise in the blue channel than in the red or green channel, so apply stronger noise reduction in the blue channel. This is true of digital cameras when shooting under tungsten, too, but the same is not true of digital cameras when shooting in daylight; this is because under tungsten the blue channel is essentially getting only one source of the exposure. There is so little blue light under tungsten that if you correct from tungsten to daylight you get more noise in the blue channel. You'll note that I kept the blue channel strength at 8 but reduced the Preserve Details setting to 50% to allow the blue channel noise reduction to be stronger. This is one area where you have more control in Photoshop. You can't do a per-channel noise reduction in Creative Raw or Lightroom.

In the image, the top layer is named Reduce Noise. Load the edge mask, and when you load the selection, invert it. The inverted edge mask is essentially a surface mask. Next, create the layer mask. The end result is that the reduced noise will be blended in all of the white areas of the layer mask—but not in the darker areas, which are the edges. I've avoided blurring the edges. **Figure 3.41** shows the Load Selection dialog box from the Select main menu with the Edge Mask channel selected and the Invert option checked.

The next step is to actually sharpen the edges. But to do that, I want to create a new layer to apply the sharpening to. To create a new layer for sharpening, I want to use a method of creating a new layer based on a copy of all visible layers. The simple method is to hold the Alt (Windows) or Option (Mac OS) key and select Merge Visible from

TIP If you've arrived at a setting that is useful, save that setting. I've saved a Reduce Noise setting named "4x5 Film" because I have a bunch of images that I scanned from 4x5 transparencies, and they'll probably all need the same starting points for tweaks.

FIGURE 3.40 Using the Reduce Noise filter in Photoshop.

▶ THE MAIN PANEL SETTINGS WITH IMAGE ZOOMED TO 300%

▶ THE PER CHANNEL SETTINGS FOR THE BLUE CHANNEL

FIGURE 3.41 The Load Selection dialog box.

the Layers panel flyout menu. You can use the command Control+Option+Shift+E (Mac OS) or Control+Alt+Shift+E (Windows) if you want to, but I have a rule against remembering four key keyboard shortcuts that require two hands. **Figure 3.42** shows selecting the Merge Visible command (I'm holding down the Option key for this).

Smart Sharpen has been improved in Photoshop CC, which adds more functionality and more accurate algorithms. When I use Smart Sharpen, I set the Amount very high, set the Radius pretty small, and set the noise reduction to 20% (one of the new aspects of the improved Smart Sharpen). I've set it to remove Lens Blur. I don't modify the Shadows and Highlights in the filter dialog box; I use Layer Blending to do that later. **Figure 3.43** shows the settings I've used, which I've saved as a preset named "4x5 Film."

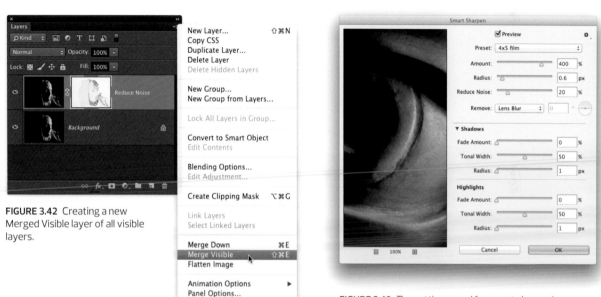

FIGURE 3.42 Creating a new Merged Visible layer of all visible layers.

FIGURE 3.43 The settings used for smart sharpening.

After applying the Smart Sharpen filter, I double-click the layer thumbnail to open the Layer Style dialog box. For Blend Mode, I choose Luminosity because I want to sharpen only the luminance data. I don't want the sharpening to drive textural detail to blown-out white, so I press the Alt or Option key while I move the highlight stops on the Blend If slider to 225 and 250. Then I set the shadows stops at 10 and 35, so that sharpening won't occur there; this creates the kind of roll-off on shadows that

you would otherwise do in the Smart Sharpen dialog box. The advantage to doing it here is that you can fine-tune it for your image. The numbers I've used are useful starting points, but you'll need to adjust them based on your image. **Figure 3.44** shows the Layer Style dialog box that you get by double-clicking on the layer thumbnail in the Layers panel.

FIGURE 3.44 Adjusting the Blend More and Blend If sliders in the Layer Style dialog box.

After applying the Smart Sharpen and the modifications to the Layer Style, I'll reload the Edge Mask selection (not inverted this time) and create a layer mask that will allow the sharpening to apply to the edges only and not to the surfaces. **Figure 3.45** shows a comparison of the before image, the image after noise reduction, and finally, the image with capture sharpening applied.

If you think this is a complicated process for noise reduction and sharpening, you're right. However, this entire process can be automated by recording the steps as an action for application to multiple images. Note, however, the specific settings in the filters will be image and resolution dependent, so it's likely you'll need to create a variety of actions to handle various film types and sizes. The other alternative is to use a third-party plug-in such as PhotoKit Sharpener 2 from PixelGenius (shown in **Figure 3.46**). But that's not the only option; check out the sidebar "Using third-party sharpening and noise-reduction products" for others.

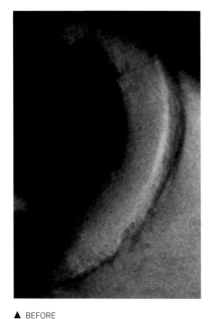 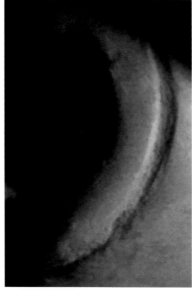

▲ BEFORE ▲ AFTER NOISE REDUCTION ▲ AFTER NOISE REDUCTION AND CAPTURE
 SHARPENING

FIGURE 3.45 Comparing the before image, the image after noise reduction, and the final image, with capture sharpening applied.

FIGURE 3.46 The PhotoKit Sharpener 2 plug-in from PixelGenius.

Creative sharpening in Camera Raw and Lightroom

Creative sharpening is about strategic sharpening and blurring to focus attention to specific areas of the image or to make other changes based on aesthetic preferences. You can make one area of an image appear sharper by blurring the surrounding areas. In Camera Raw and Lightroom you can use any of the local adjustment controls to add sharpness or even blurring. I hope you know that -51 through -100 settings for the Sharpness slider in the local controls actually add a lens blur effect. But if you didn't know it, now you do! **Figure 3.47** shows the original image plus the image with repeated graduated filters using a -100 Sharpness setting.

▲ THE ORIGINAL IMAGE ▲ THE IMAGE WITH GRADUATED BLUR APPLIED

FIGURE 3.47 The image before and after local blurring is applied.

In this image, I used the Graduated Filter tool in Lightroom with a -100 Sharpness value. As I noted before, between -51 and -100, the sharpener actually introduces blur roughly equal to the lens blur in Photoshop, though it's limited in the amount of blurring radius. You can't add a Gaussian or other strong blur in Lightroom or Camera Raw; you'd have to do that in Photoshop. My intent was to make the center appear sharper and to reduce the attention drawn by the leading and receding edge of this boat anchor chain. In Lightroom 5 and Camera Raw 8, you can now duplicate an adjustment by holding down Ctrl+Alt (Windows) or Command+Option (Mac OS) while you drag an adjustment pin. That makes it very easy to add more blurring. In this case, I had to make three different -100 blurs on each side to get the amount of blur that I wanted to show.

When you apply a local blur with a gradient or brush, you can, in effect, erase portions of the blur by adding + amounts of local sharpening. The numbers can get pretty confusing, so, I again turned to Eric Chan for clarification. He said: "The – sharpening in the –1 to –50 range is effectively an interpolation between no sharpening whatsoever (which happens at –50) and global sharpening (which happens at 0). For example, suppose you had global sharpness Amount set to +30. Suppose you used a local brush to paint local Sharpness set at –25 over an area. Since –25 is halfway between 0 and –50, this means that this would be effectively applying a total sharpness Amount of +15 in that painted area (because 15 is halfway between 0 and the global amount of 30)." The blurring of –51 through –100 is also offset if you paint over a blurred area with a + sharpness brush. Let me give you some advice: don't try to understand the numbers, just practice combining local and global sharpening and blurring to get the hang of it."

The gradient I added wasn't all that accurate (because it was a gradient), so I painted +100 sharpness to cancel out the blur I'd added with the gradient where I didn't want blurring to occur. **Figure 3.48** shows two areas of local + Sharpness using an Adjustment Brush to paint it in.

I then added even more sharpening in the center areas than I had applied in the Detail panel. In **Figure 3.49** you can see the result of adding what would be considered a tilt-shift blur kind of effect.

FIGURE 3.48 Local Adjustment Brush masks for removing the blurring gradations and applying additional sharpening to the center of the image.

FIGURE 3.49 A detail of the result of local blurring and sharpening.

Creative sharpening in Photoshop

You can do the same kind of creative sharpening in Photoshop, but with different tools. I usually do an overlay high-pass local sharpening, which I'll show in the context of using it for output sharpening. As for the rest of the huge array of options for creative sharpening in Photoshop, I'll have to take a pass. There's simply too many techniques to even scratch the surface. Somebody should write a book on Photoshop—oh, wait, some people have! A search on Amazon for Photoshop returns 11,795 results. So let me put in a good word for a good friend and colleague, Martin Evening (with whom I even co-authored a Photoshop book). The main concept to grasp is that creative sharpening (and blurring) is an important stage in the sharpening workflow.

FIGURE 3.52 The gumball machine.

To start with, I create a new layer that contains a merged copy of all the visible layers at the top of the layer stack (see Figure 3.42 for the command). Then I "pre-sharpen" using Unsharp Mask. At this point, don't oversharpen. Arguably, it's hard to sharpen visibly, but add a degree of Unsharp Mask before you do the overlay high-pass sharpening. In this case, I used an Amount of 100, Radius 3.6, and Threshold 10. Setting the Threshold to 10 reduces the scope of Unsharp Mask so it's applied only to areas where there is a level difference of 10 or greater; it reduces the amount of sharpening applied to noise. For the Radius, Bruce Fraser suggested applying a sharpening radius that is 1/50th to 1/100th of an inch. That depends on your output resolution. Here, it's 360, so I'd want to apply a sharpening radius that is between 1/50th and 1/100th of an inch. Then choose Edit > Fade Unsharp Mask, and choose Luminosity for the

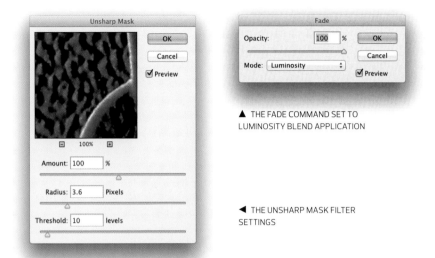

FIGURE 3.53 The Unsharp Mask filter settings and the Fade command.

▲ THE FADE COMMAND SET TO LUMINOSITY BLEND APPLICATION

◄ THE UNSHARP MASK FILTER SETTINGS

Mode so that Unsharp Mask is applied to the luminosity only. **Figure 3.53** shows the Unsharp Mask filter and the Fade command found in the Edit menu.

The next step is to apply an Overlay blending mode. An Overlay blending mode doesn't affect anything that is middle gray, but it whitens the lighter colors and darkens the darker colors. Once the layer is set to Overlay, the next step is to apply a High Pass filter, which is an edge detection filter, so that the Overlay blend mode is applied to the actual edges only. Then, double-click the layer thumbnail, and fine-tune and adjust the Blend If sliders. I'm not applying the sharpening to anything above level 250 or below level 10 because I don't want to plug up shadow detail or clip out highlight detail. Sharpening will be applied at full blend between 50 and 200. You need to adjust these numbers for your own images and goals. As always, season to taste. But, unfortunately, it's really impossible to judge the correct amount of output sharpening on a display; you need to judge it by evaluating the print. **Figure 3.54** shows the High Pass settings (same radius as USM) and the Layer Style blending options.

The result won't look too good onscreen because, well, you can't judge the results onscreen. **Figure 3.55** shows a before and after at a 200% screen zoom in Photoshop with the final figure shown at 100%. At 200% the image looks oversharpened, but in the book's reproduction, the 100% should look pretty well sharpened.

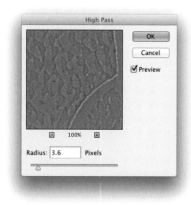

▲ THE HIGH PASS FILTER

FIGURE 3.54 The High Pass filter settings and the Layer Style options.

▲ THE LAYER STYLE SETTINGS

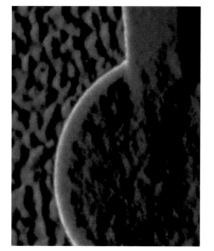

▲ NO OUTPUT SHARPENING AT 200%

▲ WITH OUTPUT SHARPENING AT 200%

▲ WITH OUTPUT SHARPENING AT 100%

FIGURE 3.55 The final output sharpening results compared.

USING A DISPLAY TO JUDGE OUTPUT SHARPENING—YOU CAN'T!

While you can accurately accomplish both capture sharpening and creative sharpening by evaluating the image onscreen at a 100% zoom, you cannot accurately judge output sharpening. Why? Because a computer display simply doesn't have enough resolution. My 30-inch display has about 100 pixels per inch. My image will be printed on a printer capable of outputting 360 PPI. So, at 100% zoom, the image is 3.27 times as large as the final printed size. Yes, I can reduce the zoom down to 33% to see an approximately sized image, but the display is capable of displaying only one-third of the image's final resolution. What to do? Well, trial and error is the only way to determine the correct output sharpening for printing—which is exactly what Bruce Fraser did when he designed PhotoKit Sharpener, and what I did when I consulted with the Lightroom engineers to incorporate PhotoKit Sharpener's sharpening routines into Lightroom and Camera Raw. That's another reason I like to print from Lightroom!

IMAGE AND OUTPUT RESOLUTION

Right off the top, I'll say that many people don't have a clue about resolution. The only resolution that image applications actually care about is the pixel resolution (how many pixels wide by how many pixels tall). The final print size (pixels per inch, or PPI) is a function of unit and size. A digital capture has x number of pixels by x number of pixels but no built-in inches or centimeters or pixels per inch. That's all set by the application. The actual resolution of your image as it relates to printed size depends on the size of the final print. Here's a little test of this theory: one of these images in **Figure 3.56** was shot with a Phase One P65+ 60 MP camera back and the other was shot using an iPhone 4 that captures 8 MP. Which is which? It's really hard to tell when printed smaller here in the book.

FIGURE 3.56 One of these was shot with an 8–megapixel iPhone 4 and the other with a $40K 60–megapixel camera. Can you tell which is which?

▲ CAMERA A

▲ CAMERA B

HOW MUCH RESOLUTION DO YOU NEED?

Simply put, you need enough resolution so that you don't see the pixels in your print. Human vision doesn't relate to pixels per inch naturally. The human eye can see about a 1-minute degree arc. That doesn't translate to printer or camera resolutions easily. Bruce Fraser used trig and did all the calculations that I hate to do (the math is shown in the table on page 129). The actual resolving capability of the eye depends on how close or how far away you are from the object that you're viewing. You need more resolution the closer you hold an image to your eye; from farther away, you need less resolution. When you're viewing a print 8 inches away from your eye, you can resolve about 420 pixels per inch; if you're looking at one from about 24 inches, the eye can resolve only 143 pixels per inch. How much resolution you need depends on how big the print will be and how far from it the viewer will be. Generally speaking, a person will look at a print from about twice the diagonal of the print size. As a result, generally speaking, you can figure out how far away your viewer will be, and therefore what resolution you need. Unfortunately, if photographers are involved in viewing their prints, the viewing distance is limited by the length of the nose, so if you're working for photographers, increase the resolution. Ultimately, you can never have too much resolution.

RESOLVABLE PRINTED RESOLUTION

VIEWING DISTANCE (IN INCHES FROM A PRINT)	RESOLUTION OF THE EYE (DPI)
8	428
10	355
12	286
18	191
24	143

As you can see, the closer the distance, the more resolution the eye can see when expressed as dots per inch (DPI). The normal viewing distance for a print is typically between 1.5 to 2 times the diagonal of a print. So a 3.5 x 5-inch print would normally be viewed from between 10 inches to 12 inches away and the eye could resolve between 355 DPI and 286 DPI. Now, before you get too worked up about this, realize there are a lot of factors involved, such as the illumination on the print and the vision of the viewer. If a person has 20/20/20 vision (by that I mean the 20/20 vision of a 20-year-old), they will see more resolution than somebody who is 50 years old and needs reading glasses. But let's agree to agree on the general principles, OK?

A printer that prints at 360 DPI, such as the Epson line of printers, or 300 DPI, such as the Canon line of printers, would seem to fit the needs of output resolution. Yes, well, that depends on the nature of the viewer and presupposes that they don't walk up to a print and view it from mere inches away. When you're talking about printed billboards seen from a highway, that's a safe bet, but if you are talking about people in a gallery where the prints are well lit, people will tend to walk into a print and view it closer than normal. So, it would seem to behoove somebody who wants his prints to have excellent detail to print at high resolutions.

In the images that were taken with two different cameras, one has 6732 x 8948 pixels and was output to a print size of 18.7 x 24.9 inches at 360 PPI. The iPhone 4 shot looks pretty good next to the expensive shot when printed in this book. However, its pixel dimensions are just 2472 x 3296. If you printed it at 18.7 x 24.9 inches, the resolution comes down to 132 PPI. That's not enough resolution for a reasonable print. **Figure 3.57** shows the answer to the question of which image came from which camera. Camera A was from the 60 MP P65+ camera back and Camera B was the iPhone 4 capture. The P65+ capture is shown in Photoshop at 100% zoom and the iPhone was zoomed to 273% to be the same size in Figure 3.57.

FIGURE 3.57 Comparing the zoomed-in view of the two captures.

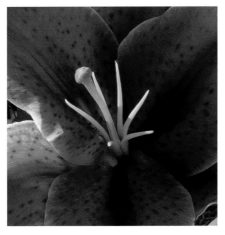 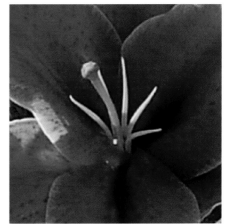

▲ P65+ CAPTURE AT 100% ZOOM ▲ iPHONE 4 CAPTURE ZOOMED TO 273%

IMAGE VS. PRINTER RESOLUTION

NOTE For Epson print-ers, there is a print driver setting that reports a higher resolution to the operating system. If you select Finest Detail in the driver, the Pro series of Epson printers report a resolution of 720 DPI. The Pro series of Canon printers also have a higher resolution option that reports at 600 DPI. I'll cover this in the next chapter when I discuss using the Epson and Canon print drivers.

Confusion about printer resolution has led to a lot of industry myths. In Photoshop and Lightroom, resolution is measured in pixels per inch (PPI). Printers measure dots per inch (DPI), but an inkjet printer (as opposed to a halftone press) deals with two kinds of resolution: the actual droplets per inch that the printer can physically eject and the amount of resolution that the printer reports to the operating system or print pipeline. Inkjet printers work by moving the print head back and forth, with a stepper motor stepping the paper forward to lay down subsequent blocks of ink. Such printers are designated as having a resolution measured in droplets per inch of x number of droplets by x number of droplets. The droplets are very, very small, and they're measured in picoliters, which is a unit of volume rather than dimension. When you're printing something, each discrete droplet gets laid down on the paper. A professional Epson printer physically has 360 nozzles per inch vertically; Canon printers have 300. The droplet resolutions are 1440 x 720 for Epson and 1200 x 600 for Canon and HP. But that's not the resolution you want to send to the printer. The print driver works hand in glove with the operating system's print pipeline. When the printer reports itself, it designates its desired input resolution: for Epson, it's 360 PPI, and for Canon and HP, it's 300 PPI. If the operating system receives something different from the printer's reported resolution, it does an interpolation. This is why setting the proper resolution in Lightroom and Photoshop is critical. The interpola-tion that the print pipeline uses is similar to a nearest-neighbor calculation, which is ugly compared to bicubic or other interpolation algorithms. You want the image you send to the printer to match the resolution as it is reported to the print pipeline.

If you're preparing an image for an output service bureau, ask them what resolution they require. If you're preparing images for halftone reproductions, the amount of resolution you need is dependent on the line screen. The most common line screen is 150 lines per inch, so you'd send an output resolution of 300 PPI. You can get by with as little as 1.4 times the line screen and go up to 2.5 times the line screen, but the best results are two times the line screen. If you're sending a job to an inkjet service bureau or for halftone reproductions, you can't do final output sharpening until the image is in the final resolution because the sharpening is radius-based.

IMAGE SIZING AND INTERPOLATION IN CAMERA RAW AND LIGHTROOM

If you think of pixels as a life form, upsampling and downsampling is a matter of creating life or killing life. When you downsample, you throw away pixels, so pixels you initially captured sacrifice their lives so that the image can be smaller. With that in mind, it's ideal if you can use the native pixels in an image to output the desired resolution. Essentially, if you're printing to an Epson or Canon printer, there are two ways to get to the desired output resolution: resize without resampling or resample. **Figure 3.58** shows an image open in the Lightroom Print module and the Print Job panel with the Resolution currently unchecked—in other words, resizing without resampling.

▲ THE IMAGE LAID OUT TO PRINT AT 21 X 15 INCHES ON 22 X 17–INCH PAPER

FIGURE 3.58 Resizing without resampling in Lightroom.

◄ THE PRINT JOB PANEL SETTINGS IN LIGHTROOM

One tip I use to determine the print size and resolution is to make sure the Dimensions option is checked in the Guides panel. **Figure 3.59** shows the Guides panel with the Dimensions option checked. It also shows the display for print size and the native resolution of the image at that print size.

As I already mentioned, it's not optimal to send nonstandard resolution to the print drivers; it's far better to resample in Lightroom to arrive at the print driver's reported resolution. In this case, at the final print size, the native image's resolution was 326 PPI, so I would change the Resolution setting in the Print Job panel. **Figure 3.60** shows entering 360 PPI in the Resolution text entry and the change in the Dimensions display. Since the image is now being resampled (not just resized), the display shows no resolution.

FIGURE 3.59 The Guides panel and the size and resolution display.

▲ THE GUIDES PANEL WITH DIMENSIONS CHECKED

▲ THE DISPLAY FOR PRINT SIZE AND RESOLUTION

FIGURE 3.60 Entering 360 PPI in the Print Resolution field and the elimination of the print resolution in the size display.

▲ A DETAILED VIEW OF THE PRINT JOB PANEL WITH 360 PPI ENTERED

▲ THE NEW DISPLAY SHOWING ONLY THE PRINT DIMENSIONS AND NO RESOLUTION

You can also resample when exporting from Lightroom or when setting the Workflow Options in Camera Raw. Both use the same resampling algorithms. **Figure 3.61** shows the Image Sizing options in Lightroom and Camera Raw.

The Lightroom resampling algorithm is different from the one in Photoshop. Lightroom automatically uses Bicubic if the resampling is minor. If it upsamples, it uses Bicubic Smoother, and if it downsamples, it uses Bicubic Sharper. The advantage of Lightroom and Camera Raw is that the interpolation is seamless and automatically applies output sharpening based on the resampled size of the image.

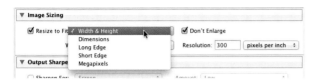

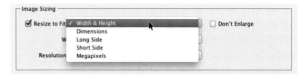

▲ LIGHTROOM'S IMAGE SIZING EXPORT OPTIONS ▲ CAMERA RAW'S IMAGE SIZING OPTIONS

FIGURE 3.61 Resizing and resampling options in Lightroom and Camera Raw.

IMAGE SIZING AND INTERPOLATION IN PHOTOSHOP

To resize without resampling in Photoshop, use the Image Size dialog box: deselect Resample and enter the PPI resolution you want. The width and height change based on the actual pixel dimensions. If you want to make smaller prints using the "native" resolution of the file, increase the resolution and make the width and height smaller; that requires no resampling. However, if you want to print to a specific size, deselecting Resample will give you an intermediate PPI resolution, which may produce poor results. **Figure 3.62** shows the Photoshop CC Image Size dialog box with the P65+ flower capture showing a native pixel dimension of 6732 px x 8984 px and a print size of 18.7 x 24.956 inches. Resizing without resampling could produce an image that would be 37.4 x 49.911 inches at 180 PPI (the lowest output resolution I would suggest ever using) or a print that is 9.35 x 12.478 inches at 720 PPI. All three print sizes are coming from the same original native resolution of the original image. No resampling involved!

If you're printing to an inkjet printer, consider resampling. Use the Image Size dialog box in Photoshop to resample the image to a larger width and height at the proper output pixel resolution, which would be 360 PPI for Epson and 300 PPI for Canon. (Don't try to resample using the Print dialog box; you'll have much better results using the Image Size dialog box.) You can also use third-party image resampling algorithms; some are better and some are worse than the ones in Photoshop.

The Image Size dialog box in Photoshop CC has been improved with a new algorithm for enlargement. The Preserve Details option lets you increase the pixel dimensions while also reducing some noise. As I mentioned before, downsampling removes noise. Likewise, upsampling increases noise, so it's an improvement to have an algorithm that lets you upsample and reduce noise at the same time. In my experience, if you're working with a digital capture with original photographic aspects that are very good (no camera shake and good subject focus), you can almost

NOTE There is a variety of third-party resampling plug-ins available, such as Alien Skin Blow Up, Perfect Resize by onOne Software (formerly Genuine Fractals), and PhotoZoom Pro from BenVista. There are also some more exotic algorithms that are standalone or incorporated into other software, such as Qimage Ultimate for printing (Windows only). I've tested most of the offerings and prefer to stick with Photoshop or Lightroom for upsampling—but that is a decision you should make for yourself after testing the results on your own work.

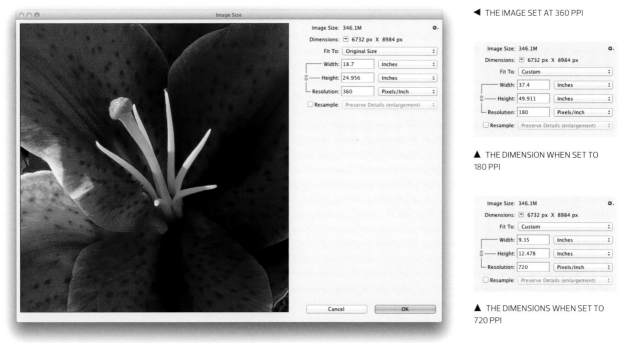

▲ THE DIMENSION WHEN SET TO 180 PPI

▲ THE DIMENSIONS WHEN SET TO 720 PPI

FIGURE 3.62 Comparing the different print sizes capable of being produced at the same original image pixel dimensions without resampling.

always upsample 200%. Depending on the output media, you can possibly go further. If you're printing to watercolor paper with a texture and a tooth, the resolution is more forgiving and you can probably upsample up to 400%. With glossy media that renders fine detail, you're probably limited to 200%. **Figure 3.63** shows resampling the iPhone 4 capture (with native pixel dimensions of 2472 x 3296 pixels) to get to a final print size of 13.733 x 18.311 inches.

The Bicubic Sharper algorithm has some sharpening built into it; generally speaking, that's what you should use for downsampling in Photoshop. Bicubic Smoother was previously the best algorithm for enlargement, but use the new Preserve Detail option if you're enlarging an image significantly. If you're resampling only a small amount, keep the settings automatic and Photoshop will use whatever default you've set in your Photoshop preferences. Those preferences are used for any free transform or image rotation; I recommend leaving the setting at automatic so Photoshop will use the correct interpolation. **Figure 3.64** shows the main General Preferences in Photoshop for setting the default interpolation algorithm.

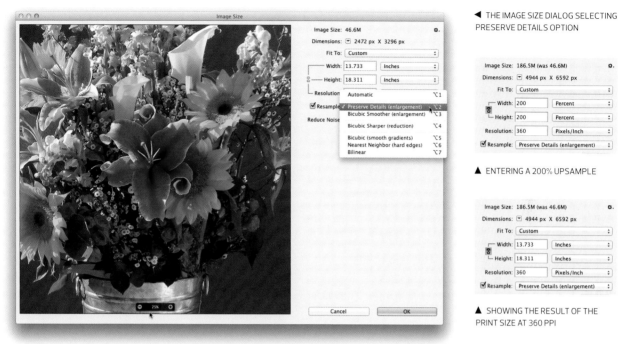

◀ THE IMAGE SIZE DIALOG SELECTING
PRESERVE DETAILS OPTION

▲ ENTERING A 200% UPSAMPLE

▲ SHOWING THE RESULT OF THE
PRINT SIZE AT 360 PPI

FIGURE 3.63 Using the new Image Size command to upsample the image 200%

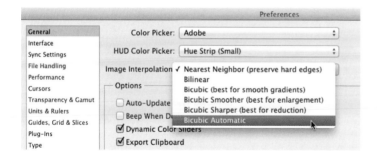

FIGURE 3.64 The General
Preferences for setting the
default Image Interpolation
in Photoshop.

If you downsample a large image for the web in Photoshop, Bicubic Sharpener can oversharpen. Test what you're resampling at the size you'll use. You may just want to use the standard Bicubic option and sharpen as needed. In Lightroom or Camera Raw, you can use the Sharpen for Screen option to prepare an image for the web.

PREPARING A COLOR IMAGE FOR BLACK–AND–WHITE PRINTING

If you're planning to print a color image as black and white, first optimize the color and tone curve. You can easily convert from color to black and white in Lightroom and Camera Raw with a couple of methods, and there are a lot of ways to do it in Photoshop. **Figure 3.65** shows the image I'll use to demonstrate a black-and-white conversion in Lightroom. It was shot in San Miguel de Allende, Mexico, using a LUMIX GH2 camera with a 14–140mm lens at ISO 640.

CONVERTING AN IMAGE IN CAMERA RAW OR LIGHTROOM

One way to convert color to black and white is to simply use the Saturation slider in the Basic panel and set it to -100. That removes all the color from the image, but it's not very flexible. The better way is to use the HSL/Color/B&W panel in Lightroom or Camera Raw. In the old days, black-and-white film had a panchromatic response for red, green, and blue light. You could modify that response with a contrast color.

FIGURE 3.65 The original color image adjusted for tone and color prior to black–and–white conversion.

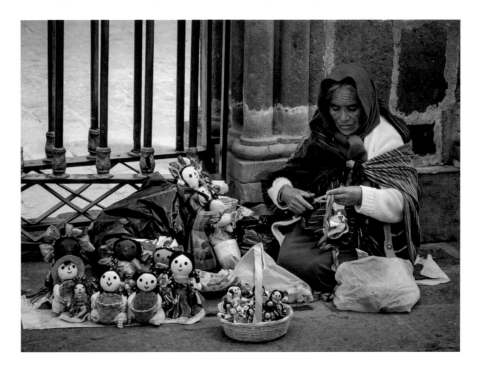

For example, a red filter would pass red and absorb cyan or blue, making skies dark, while a green filter blocks magenta so trees are lighter. The HSL to Black and White conversion is doing the same thing on a per-color basis. If you select Auto, Lightroom or Camera Raw tries to maintain an optimized blend of the different colors to maintain color contrast, so that colors retain their relative tones. The default zeroed-out conversion is almost never useful, but I use Auto most of the time because Lightroom and Camera Raw do a pretty good job. **Figure 3.66** shows standard zeroed B&W sliders and the result of the Auto.

◀ THE RESULT OF ALL SLIDERS AT ZERO

FIGURE 3.66 The result of a zeroed B&W setting and the result of clicking the Auto button.

◀ THE RESULT OF CLICKING ON THE AUTO BUTTON

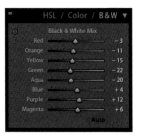

▲ THE RESULTING SLIDERS SET BY AUTO

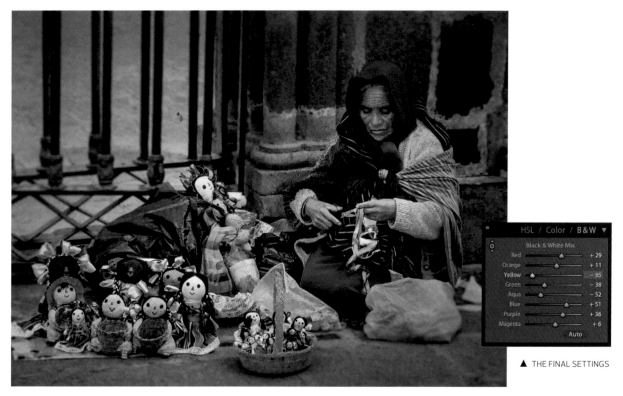

▲ THE FINAL SETTINGS

▲ THE FINAL IMAGE

FIGURE 3.67 The final converted image and the final settings.

For this image, I then used the Targeted Adjustment tool to drive the amount of yellow mix way down to darken the street beyond the woman. If you look at the beginning black-and-white image and then the final one, you can see that it is remarkably different than just a simple conversion to black and white. **Figure 3.67** shows the final result and the final slider settings.

COLOR TONING A BLACK-AND-WHITE IMAGE IN CAMERA RAW OR LIGHTROOM

Because the image is still considered an RGB image, you can apply color toning directly. In the Split Toning panel, I increased the Hue in the shadows. You can adjust the highlights and shadows separately, and use the Balance slider to adjust where the

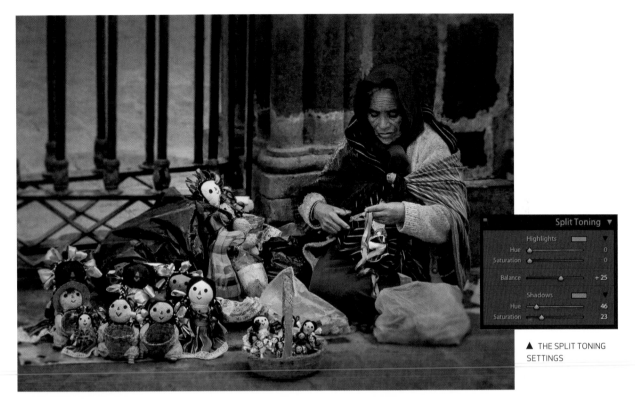

The Split Toning settings panel (right):

Split Toning ▼

Highlights
Hue · · · 0
Saturation · · · 0
Balance · · · + 25
Shadows
Hue · · · 46
Saturation · · · 23

▲ THE SPLIT TONING SETTINGS

▲ THE BROWN-TONED IMAGE

FIGURE 3.68 The result of applying a Split Toning effect intended to replicate a brown tone.

slip points are. I rarely tone things with colors like green or magenta. In this image, I used 46, one of my favorite hues because it approximates the old analog brown toning using chemicals in the darkroom. **Figure 3.68** shows the result of the color toning and the Split Toning settings.

I applied warm toning in the highlights and cool toning in the shadows to replicate the appearance of an analog sepia toning. You can also add a cool toning, adding coolness overall, but restricting it just to actual shadows. **Figure 3.69** shows a variety of Split Toning options.

If you were actually going to print these images, you'd maintain it as an RGB image. If you print using Lightroom or Photoshop, you'd use ICC profile–based color management. You want to print any black-and-white image with a tone as color. (Of course, if you're printing something that is pure black and white, you can print it as grayscale.) I'll cover black-and-white printing options in the next chapter.

FIGURE 3.69 Comparing the results of adjusting the Balance slider when doing a warm highlight and cool shadows Split Tone intended to replicate a sepia toning and a cold tone.

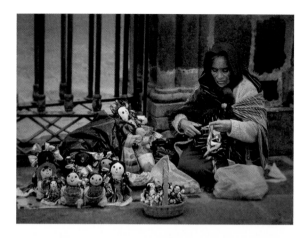

◄ IMAGE WITH WARM HIGHLIGHTS AND COOL SHADOWS WITH THE BALANCE SET TO BIAS THE WARM TONE

▼ THE SPLIT TONING +50 BALANCE SLIDER ADJUSTMENT

◄ THE IMAGE WITH THE BALANCE SLIDER SET TO BIAS THE SHADOWS

▼ THE SPLIT TONING –50 BALANCE SLIDER ADJUSTMENT

◄ THE IMAGE WITH A COLD TONE IN THE SHADOWS

▼ THE SPLIT TONING SHADOWS SET TO HUE 227 AND SATURATION 10

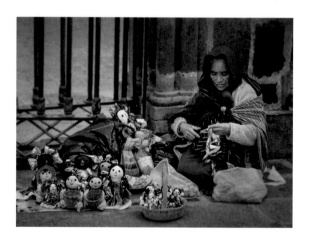

CONVERTING COLOR TO BLACK AND WHITE IN PHOTOSHOP

There are myriad ways of converting to black and white in Photoshop. I'll be using a panoramic shot of the Chicago skyline showing the bend in the Chicago River (**Figure 3.70**). It was shot in seven frames with a Phase One 645 camera, with a 75mm lens and a P65+ camera back.

FIGURE 3.70 The original image in color.

The simplest way to convert to black and white is a mode change to Grayscale. That converts RGB to grayscale settings in color management—either a dot gain or gray gamma (for details, see Chapter 2). **Figure 3.71** shows the result of changing the mode from RGB to Grayscale. You'll note that Photoshop will pop up an info dialog box directing you to use the Black & White adjustment (seems the Photoshop engineers are promoting this tool).

You can also use a Hue/Saturation adjustment and pull Saturation down to 0, removing all saturation from the image. That creates a different flavor of black and white than converting to grayscale. The rendering is different. **Figure 3.72** shows the result of reducing the Saturation slider to zero.

Another method is to change the mode from color to Lab and use the Lightness channel. **Figure 3.73** shows the result of displaying the Lightness channel in Lab mode.

FIGURE 3.71 The results of a
mode change to grayscale.

▲ THE "HELPFUL" INFO DIALOG BOX

▲ THE IMAGE CHANGED TO GRAYSCALE

FIGURE 3.72 Reducing the
Saturation slider to zero.

FIGURE 3.73 The Lightness
channel in Lab mode.

FIGURE 3.74 The result of the Channel Mixer conversion.

FIGURE 3.75 The result of the Black & White adjustment using the Auto button.

You can also use the Channel Mixer, which lets you drive a different mix of red, green, and blue. When you select Monochrome, it does a grayscale conversion for yet another flavor of black and white. For **Figure 3.74**, I used the Monochrome option and set the Red to +110, the Green to 11+, and the Blue to -88. This darkened the sky considerably.

The Photoshop team had a bit of Lightroom envy, so you can also use a Black & White adjustment layer, which lets you adjust the overall mix on a per-color basis, just as you can in Lightroom or Camera Raw. You can adjust six colors instead of eight, but it's essentially the same. **Figure 3.75** shows the result of using the Black & White adjustment and clicking the Auto button.

The Black & White panel also has a Targeted Adjustment tool. This is useful if you want to increase or decrease a certain color in the mix. There are also default settings and different presets so you can approximate a Wratten 25 deep red (a Kodak

filter designation). **Figure 3.76** shows the result of the Red Filter preset in the Black & White adjustment and using the TAT to darken the blue colors.

There are also optional third-party grayscale conversion filters (Photoshop plug-ins) that have a pretty good fan base. I don't use them, but feel free to experiment and see if there's one you like.

FIGURE 3.76 The result of using the Red Filter preset and darkening the blue.

COLOR TONING A BLACK-AND-WHITE IMAGE IN PHOTOSHOP

You can add color toning in Photoshop, too. There's no split-toning adjustment layer, but you can use a Curves adjustment layer and set a per-channel adjustment. In the red channel, I adjusted the highlights to be warmer, and in the blue channel, I adjusted the shadows to be bluer. That gives the effect of a split tone, as shown in **Figure 3.77**.

Another method of doing split toning is using a Color Balance adjustment layer. To be honest, this is the only time I ever use Color Balance. It has a simple UI; just click the highlights for the tone. The result can be the same as using per-channel curves.

You can also apply a color tint using a Photo Filter adjustment layer. It's simple, but not flexible. I use it with a very low Density value because I don't want to go over the top. **Figure 3.78** shows the result of applying an amber tint with a 5% density.

Somewhat to my surprise, I discovered an additional method of adding a color tint to a black-and-white image in Photoshop while writing this book. You'll have to forgive me, because usually I know everything there is to know about Photoshop. Well, I know a lot…but I've never used one function of the Black & White adjustment till now. You can add a tint to the results of the adjustment by clicking on the Tint button and choosing a color to tint the image with. It's limited to a single color, no

FIGURE 3.77 Using Curves on a per–channel basis to do a split tone.

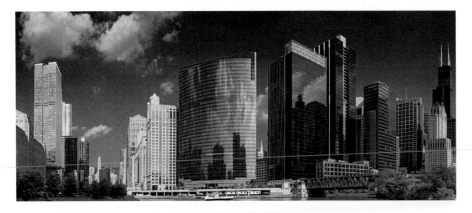

FIGURE 3.78 Adding a tint using the Photo Filter.

split toning, but it's useful, so I'm happy I discovered it and now pass it on to you. **Figure 3.79** shows the Black & White properties and the Tint Color color picker.

A super-geeky color-toning method that I don't personally use is to create duotones or tritones. The downside is that you can't use a duotone or tritone in a 16-bit image, so you have to change the mode to 8-bit, and then convert RGB to Duotone, and then set duotone colors and curve. You can choose Duotone or Tritone from the Type menu and use the presets. **Figure 3.80** shows the result of a tritone adjustment, and **Figure 3.81** shows the Duotone Options with a cool and warm gray preset. If you click on the color swatch, you can choose different colors. Clicking on the ink curve allows you to alter the balance of where the colors blend. Once you arrive at the desired result, I suggest converting back to RGB for printing. If you're going out to prepress, you can keep the image as a duotone—if the printer will be using the specified ink color. Otherwise, convert the duotone to CMYK for reproduction.

FIGURE 3.79 Using the Black & White adjustment to add a color tint to a grayscale image.

▲ THE BLACK & WHITE
ADJUSTMENT PROPERTIES PANEL

▲ THE TINT COLOR COLOR PICKER

FIGURE 3.80 The results of a tritone adjustment.

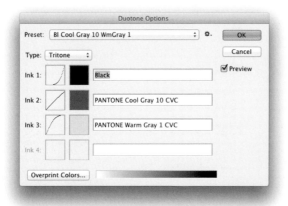

FIGURE 3.81 The Duotone Options dialog box showing a cool gray / warm gray preset.

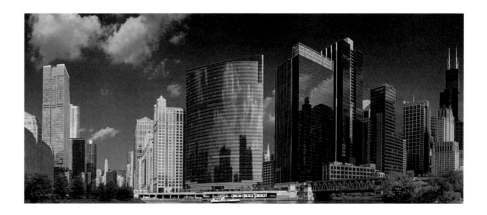

SOFT PROOFING

Soft proofing uses color management to predict how the colors in your image will reproduce based upon the ICC profile of the printer and paper combination. Soft proofing shows you what kind of impact will occur in the gamut reduction (gamut is how much of the range of color the printer can reproduce) and the impact on the dynamic range of the image. One of the problems with computer displays is that they've got a large contrast range because the display makers think that's a good thing. Your display might be set to a 500:1 contrast ratio, but your print might have a contrast ratio of 200:1 or less with a matte paper. That's a pretty severe loss of contrast range and that affects the tone curve of the final image. Colors in the printed image are also affected by the paper color. Some papers have optical brightening agents (OBAs) that tend to make the white appear a little bluish in an attempt to make them appear brighter. Some have no brighteners, so the whites of the paper can appear kind of yellowish, which warms up the colors in your image. All of these are taken into account when you do a soft proof. A soft proof transforms the image colors to the ICC output profile, and then transforms them back to your display profile so you can see an accurate software-based proof.

No matter where you soft proof an image, you need to determine the optimal rendering intent. There is no way to generalize. Use the one that reproduces the image best according to your eyes. You can choose a rendering intent in both Photoshop and Lightroom.

The basic soft-proofing workflow is to view the soft proof, choose the appropriate ICC profile for output, and identify the best rendering intent. You can also view a gamut warning, which is an overlay that shows which colors will be out of gamut for the final print. I would caution that you don't worry too much about the gamut warning or make substantial image adjustments based on it. The gamut warning predates ICC color management. It was originally used to warn people that certain colors were not printable, and that was important in a graphics art workflow. Now, with fine art inkjet printers, a lot of the colors in your images are not going to be out of gamut to the printer. So, it's best to use soft proof to predict the limited contrast range of the print rather than relying on the gamut warning.

SOFT PROOFING IN LIGHTROOM

To soft proof an image in Lightroom, open the Develop module. If the toolbar isn't visible, press the **T** key to show it. Then, on the toolbar, select Soft Proofing. The Lightroom background changes from its usual medium gray to an almost-white color. This is to help you see what your image looks like against the paper you're printing on.

TIP To change the background color, right–click or Control-click the background and choose a new color. The default is the actual paper white, based on your profile. That is useful, as some papers have a cool or warm bias. But you can set it to any luminance output: 100% white, 50% gray, or black. I seriously suggest that you don't show it against black unless you have a real purpose for doing so, such as preparing an image that will be printed with a black background.

One of the advantages of soft proofing in Lightroom is that it automatically changes the background to match the paper color of your ICC profile.

When soft proofing is active, the Soft Proofing panel is open in the upper-right corner. You can select your output profile. The only profiles that appear in the list are RGB profiles, because Lightroom can't soft proof using CMYK, dot gain, or gray gamma profiles.

You can also choose Perceptual or Relative for the rendering intent, which are explained in Chapter 2. **Figure 3.82** shows the original image, and then the soft-proofed image showing Relative Colorimetric rendering and Perceptual rendering. Based on the soft proof, I went with Relative Colorimetric because it retained a better tonality in the colors—particularly in the reds that seemed to die with Perceptual.

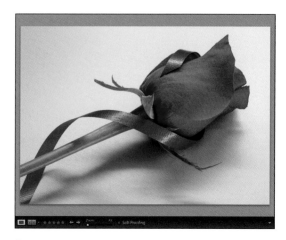

▲ THE ORIGINAL IMAGE

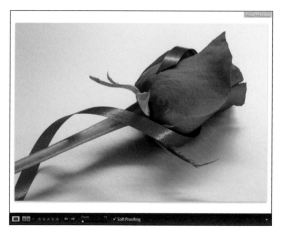

▲ SOFT PROOFED WITH RELATIVE COLORIMETRIC RENDERING

FIGURE 3.82 Comparing the original image and the two soft-proofing rendering intents.

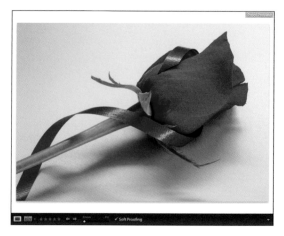

▲ SOFT PROOFED WITH PERCEPTUAL RENDERING

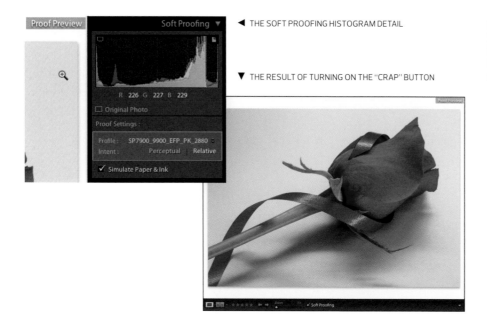

THE SOFT PROOFING HISTOGRAM DETAIL

THE RESULT OF TURNING ON THE "CRAP" BUTTON

FIGURE 3.83 The Soft Proofing histogram, RGB readouts, and the result with the "Make my image look like crap" option selected.

Beneath the Intent menu is the Simulate Paper & Ink option. I call it the "Make my image look like crap" option. With this option selected, instead of using a relative colorimetric, Lightroom uses an absolute colorimetric that shows the maximum black and maximum white of your actual paper. Select that option to see what the impact of your paper color will be on the contrast of the image in the final print form. **Figure 3.83** shows a detail of the Soft Proofing histogram and color readouts with Simulate Paper & Ink checked. The paper white shows a blue tint because Epson Exhibition Fiber paper contains OBAs. I'll need to address this when optimizing the image for printing.

In the histogram there are two gamut warnings. The one in the upper right alerts you to colors outside the gamut of the printer. The one in the upper left alerts you to colors that are outside the gamut of your display. I work in ProPhoto RGB with a larger gamut than you can see on the display, so there are times I may use colors that can be printed but can't be seen on the display. If you have a standard display, it approximates the gamut of sRGB; a pro display approximates Adobe RGB. No display will ever have ProPhoto capabilities. My suggestion is to click on those to become familiar with what they are, and then quit using them because they don't really tell you anything really useful (and at this point are still kind of buggy). **Figure 3.84** shows the display and paper profile gamut warnings.

NOTE Normally in the Develop module, the readouts for Red, Green, and Blue are 0 to 100%, and over the years people have complained that Lightroom doesn't display to 255. But until you designate a color space, Lightroom is using an internal color space with a linear gamma, so you can't really see 0 to 255. However, when you soft proof, you can see red, green, and blue with 0 to 255 values, and that shows up in the histogram.

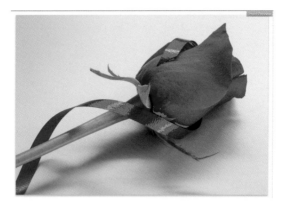

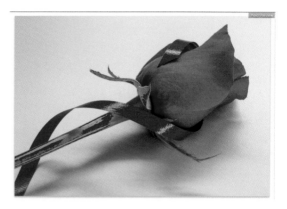

▲ IMAGE SHOWING THE PROFILE GAMUT WARNING FOR COLOR NOT PRINTABLE BY THE PRINTER PAPER PROFILE (PRIMARILY THE BLUES)

▲ IMAGE SHOWING THE COLORS NOT VIEWABLE ON MY NEC WIDE GAMUT DISPLAY (BLUES AND GREENS)

FIGURE 3.84 The result of the paper profile gamut warning and the display gamut warning.

Before you do anything to adjust the image based on the soft proof, I suggest you view the soft-proofed image and the unsoft-proofed image side by side, so you can evaluate what you need to change to make the image look as good as possible after the transform to the final printer profiles. To display the before and after images, click the button to the left of Soft Proofing on the toolbar below the image. **Figure 3.85** shows the Before/After display option and the resulting before and after view set to top and bottom.

Generally speaking, you're going to want to adjust the tone curve, because you're going from 500:1 to 200:1 for a glossy image or 500:1 to an even lower contrast for matte or watercolor. With ICC color management, there's no intelligence during the actual transform into the profile space. It's not image-adaptive. The whole purpose of soft proofing is to see what it will look like, and then take actions to improve the final results. Usually, you'll need to make contrast and hue and saturation adjustments.

If you make a change to any of the sliders in the panels, Lightroom will ask whether you want to create a virtual copy for soft proofing. Making a virtual copy lets you preserve previous settings and create a new virtual copy of your original file with the printer profile included in the virtual copy name. You can set up a master image and do one soft proof for glossy and one for matte. I recommend doing that. The adjustments you make are likely to be different; after you've done that, it's easy to go back to the image that's been optimized for the profile. **Figure 3.86** shows the dialog box that comes up when you change any settings when soft proofing.

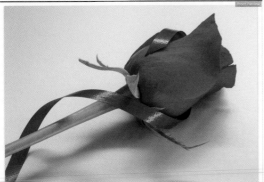

FIGURE 3.85 The Before/After menu options when soft proofing, and the before and after comparison.

▲ BEFORE/AFTER OPTIONS

◀ THE BEFORE AND AFTER SET TO TOP AND BOTTOM

FIGURE 3.86 The dialog box asking whether you want to create a virtual copy for soft proofing. Say yes!

Depending on the image, you may want to lighten up shadows, because printing has the tendency to lose detail in the deep shadows. I suggest adding some Clarity. When you do contrast compression, the white of the paper will still be the white in the image, and the black of the ink is the black of the image; when you reduce contrast range, only the midtones get compressed. Clarity lets you regain some of that apparent loss in the midtones. You can do a side-by-side (or top-and-bottom) comparison to see how much you need to add to preserve texture and detail. The other thing you'll likely need to do is to adjust the HSL of the image. The profile will

do its best to convert the source image profile into the destination profile colors. But sometimes the actual hue will change a little bit, just because of the imperfection of ICC profiles and color transforms. I suggest taking control of how hue and saturation and luminance transform. Use the Targeted Adjustment tool, click Hue, and make the adjustment.

In this image, I'll adjust the hue of this blue ribbon and make it just a little bit less magenta, because in the soft-proof version the blue was turning a little too much to the red. I'll adjust the hue of the green to make it a little more cyan, because the green is starting to look a little yellow. These subtle adjustments will have a big impact on how the final image will appear on paper. **Figure 3.87** shows the final adjusted image in the before/after setup as well as a copy of an actual print I made to prove

FIGURE 3.87 Proof that the soft-proofing effort was worth it!

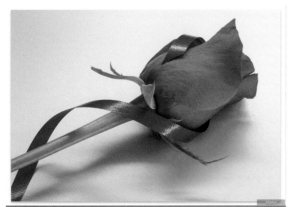

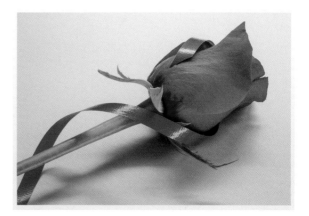

▲ THE ACTUAL PRINT MADE AFTER SOFT PROOFING

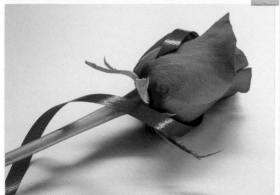

▲ THE TOP/BOTTOM SOFT-PROOFED IMAGE WITH THE ORIGINAL ON TOP
AND THE SOFT-PROOFED IMAGE ON THE BOTTOM

▲ THE SETUP OF THE PRINT IN THE GTI VIEWING BOOTH

soft proofing actually does work. (I know there are doubters out there!) I made the print on an Epson 9900 printer and paper I used for soft proofing. I shot the print in my GTI print-viewing lightbox fitted with D65 color-accurate fluorescent tubes. I included a ColorChecker Passport, so you can see I didn't cheat—although I do admit I needed to add a Gradient Adjustment to lighten the bottom of the print because of light falloff in the viewing booth.

In Lightroom, you can also soft proof an image to see how it will look when you convert it to sRGB or Adobe RGB for export to a service bureau, to the web, or to multimedia. Just choose sRGB or Adobe RGB from the Profile menu. As I mentioned in Chapter 2, unfortunately, a color space-to-color space transform with a working space profile (such as sRGB) does not include rendering intents other than Relative Colorimetric. You can click, but it makes no difference: it'll always be Relative Colorimetric. However, you have the same ability to control contrast and hue, use the targeted adjustment tool, save it as a proof virtual copy, and so on. If you're preparing an image for multimedia, the web, or a service bureau, soft proof in the space you need to provide. You can obtain a beta version of a version 4, sRGB profile that actually *does* let you change the rendering intent between Relative Colorimetric and Perceptual, and it's useful. I use it, and you can obtain it at http://www.color.org.

SOFT PROOFING IN PHOTOSHOP

To soft proof an image in Photoshop, choose View > Proof Setup > Custom, and then choose the profile for your device and a rendering intent (Perceptual or Relative Colorimetric). You can simulate the paper color and ink (that is, you can make your image look like crap), and you can toggle Preview on and off so you can see the image before and after soft proofing. **Figure 3.88** shows the original image on the left and the soft-proofed image on the right after selecting Relative Colorimetric as the best rendering for the image.

I suggest you click Save in the Customize Proof Condition dialog box to save a proof condition, which will then be available in the Proof Setup menu and in the Photoshop Print dialog box.

After you click OK in the Customize Proof Condition dialog box, the image is soft proofed. You can press Ctrl+Y (Windows) or Command+Y (Mac OS) to toggle it on and off. However, there's no built-in ability to display the before and after images in Photoshop. You can open a new window, but anything you do to the image is updated on both windows, and that's not useful for image adjustments for soft proofing. Instead, I recommend duplicating the image, and then choosing Window > Arrange > Tile so you can see what the original looks like on one side and what the soft-proofed image looks like on the other side. By default, Photoshop doesn't use the paper profile's white in the surrounding canvas. Alas, you'll need to do that yourself.

NOTE Don't select Preserve RGB Numbers. If you're curious, you can click it to see how ugly it makes your image look. It shows you how your image would look if you did no color–space conversion, and it's not pretty.

FIGURE 3.88 The image before and after turning soft proofing on.

▲ THE ORIGINAL SCAN OF AN 8 X 10-INCH SHEET OF FILM DONE ON AN EPSON PERFECTION V750-M PRO SCANNER

▲ THE SOFT-PROOFED VERSION AFTER SELECTING RELATIVE COLORIMETRIC RENDERING FOR THE PAPER I WAS USING, EPSON ULTRA PREMIUM PRESENTATION MATTE

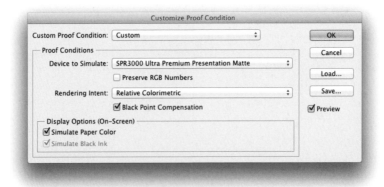

▲ THE CUSTOMIZE PROOF CONDITION DIALOG BOX

Right-click or Control-click the canvas, and choose Select Custom Color. In the Color Picker, select 95% brightness to lower the white of the canvas to a brightness of 95%. It's not an exact match for the paper white of the ICC profile—it's an approximate, a little dingy, a little less than 100% bright. **Figure 3.89** shows the context menu to select a custom canvas color and the Custom Canvas Color color picker.

▲ THE CONTEXT MENU

▶ THE CUSTOM CANVAS COLOR
COLOR PICKER SET TO BRIGHTNESS
OF 95%

FIGURE 3.89 The Custom Canvas Color context menu and color picker.

Using the same philosophy as before and after in Lightroom, you can work on your original image and create a series of adjustment layers relating to contrast, tone curve, and hue and saturation. In this case, I'll do a Curves adjustment and punch up the contrast a little to better match the original, and then I'll add a Hue and Saturation adjustment and punch up the saturation a little bit. The color of the three colors of ink needs a little bit of a hue adjustment. **Figure 3.90** shows the soft proofed before and after, plus the obligatory actual print on the lightbox!

SOFT PROOFING FOR DYNAMIC RANGE IN LIGHTROOM

You can also use soft proofing in either Lightroom or Photoshop to determine the best paper for printing your image. Compare, for example, the results when you use a profile for Epson Exhibition Fiber Paper (EFP), a fiber-based bright white paper, with the results using a profile for Epson Ultrasmooth Fine Art paper using matte ink. The EFP has a cooling effect on the overall image because of the presence of OBAs. In this case, I would make a slight adjustment to the color tint to make it a little warmer and less blue. Toggling between relative and perceptual, there's very little change because this is a monochromatic image (**Figure 3.91**).

FIGURE 3.90 Before and after the Photoshop soft proofing and the resulting print from the Epson R3000 printer with matte paper.

▲ THE BEFORE/AFTER SOFT-PROOFED IMAGE

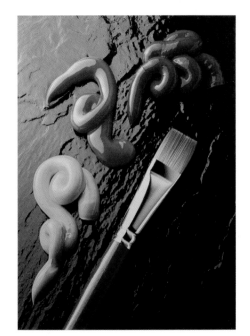

▲ THE FINAL PRINT

▲ THE FINAL PRINT IN THE VIEWING BOOTH

The Ultrasmooth Fine Art paper with matte ink, however, makes the image appear much warmer because of the warmer base and lack of OBAs. In this case, you wouldn't want to warm up the tint, and you might even want to cool it down a bit as I did. Again, you can make contrast adjustments to take the contrast range of the print into consideration. Here, you can see that in a matte watercolor paper the contrast range is much lower than in a glossy paper. So soft proofing is not just useful for determining the colors in the image, but also for the effect of the color of the paper and the contrast range of the final print. Figure 3.91 shows the results of soft proofing for contrast range of Epson Exhibition Fiber Paper and UltraSmooth Fine Art paper. Notice that for both papers, the resulting paper color influenced the image but was dealt with by making image adjustments to reduce the impact of the paper color and contrast range. Yes, Virginia, there is a Santa Claus (and it's called soft proofing—it works)!

FIGURE 3.91 Soft proofing for contrast range and paper color.

▲ SOFT PROOFING THE EPSON EXHIBITION FIBER PAPER *BEFORE* ADJUSTMENTS

▲ SOFT PROOFING THE EPSON ULTRASMOOTH FINE ART PAPER *AFTER* ADJUSTMENTS

▲ SOFT PROOFING THE EPSON EXHIBITION FIBER PAPER *AFTER* ADJUSTMENTS

▲ SOFT PROOFING THE EPSON ULTRASMOOTH FINE ART PAPER *AFTER* ADJUSTMENTS

PREPARING IMAGES FOR HALFTONE REPRODUCTION

I've spent a lot of time over the years preparing images for halftone reproduction for ads, posters, and books. Maybe I've spent too much time—although as a perfectionist, I always want to eke out the most from my images in their final printed form.

To demonstrate the process of preparing an image for halftone reproduction, I'm using the image on the cover of this book. The image was shot with a Canon EOS-1Ds Mark II camera with a 24–70mm lens somewhere in the Bransfield Strait between the South Shetland Islands and Antarctic Peninsula.

The first figure shows the default image in Lightroom. To convert it to black and white, I used the B&W portion of the HSL/Color/B&W panel and added a bit of Split Toning. Rather than keeping the original aspect ratio, I used the Crop tool to arrive at what I thought was an optimal crop, shown in the next figure. Once I was satisfied with the color, tone, and crop, I opened the image in Photoshop to size, soft proof, and fine-tune it before converting to CMYK. **Figure 3.92** shows the original color image and the black-and-white image split toned and cropped in Photoshop. I had to use Photoshop to soft proof the CMYK because, well, Lightroom doesn't support CMYK ICC profiles (sadly).

FIGURE 3.92 The original color image and the converted, cropped image in Photoshop.

▲ THE ORIGINAL COLOR IMAGE

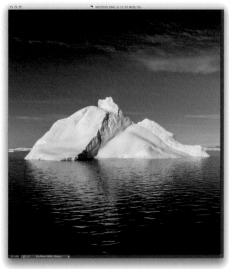

▲ THE CONVERTED AND CROPPED IMAGE IN PHOTOSHOP

The first step was to size the image to the dimensions specified by the book's designer. I set the original dimension of 9.753 x 10.8.77 inches to the 4.8 x 5.353 inches called for in the layout. I could have deferred resizing until the very end, but there's no reason not to start working at the final output size.

I started the process by duplicating the image and choosing Window > Arrange > 2-Up Vertical so I could see both the duplicate on the left and the original on the right. **Figure 3.93** shows the image being soft proofed in Photoshop.

FIGURE 3.93 The soft-proofed image (on the right) and the duplicate RGB image on the left to act as an aim point.

I soft proofed the image, choosing the correct CMYK profile in the Customize Proof Conditions dialog box, and toggling between Perceptual and Relative Colorimetric rendering intents to decide which looked best. For this image, I settled on Relative Colorimetric.

To better judge the final book appearance, I had changed the default canvas background from light gray to a custom background color. Since the image would

be printed on a paper white background, I changed the canvas color to a brightness of 95%. This isn't an exact match for the paper's actual "whiteness," but it's visually close enough that I could judge the overall tone and color better than against a gray background.

In Figure 3.93, you can see the result of changing the canvas color. Now I needed to make specific image adjustments to nudge the soft-proofed image as close as possible in appearance to the unsoft-proofed image on the left. This involved a variety of image tweaks. I could have used a Curves adjustment to adjust the tone, but decided to use another trick to adjust tonality. To darken down the deeper tone in the image, I used Color Range to create a selection of those tones. Then I copied the selected image portion to a new layer with the blending mode set to Multiply. Multiply blending darkens the image by multiplying the upper layer by the contents underneath that layer. I used a layer mask to keep the darkening from occurring in certain areas to maintain detail. The opacity was set to 30%. **Figure 3.94** shows the Color Range dialog box and the Shadow Tweek (sic) layer set to multiply at 30% opacity.

FIGURE 3.94 Using Color Range and a multiply layer (with mask) to darken the shadows.

▲ THE COLOR RANGE SELECTION

▲ THE LAYER STACK SHOWING THE SHADOW TWEEK (SIC) LAYER SET TO MULTIPLY

I used the same process to work on the highlight areas. I again used Color Range to select those tones and copied the pixels of the Background layer to a new layer called Highlight Tweek (sic). Since I wanted to lighten these areas, I used a Screen blending mode. Screen is Multiply's opposite; it lightens the image areas when blending. This layer was also set to 20% opacity. **Figure 3.95** shows the steps.

▲ THE COLOR RANGE SELECTION FOR THE HIGHLIGHTS

▲ THE HIGHLIGHT TWEEK (SIC) LAYER SET TO SCREEN

FIGURE 3.95 Adjusting the highlights in the image.

The tone for the shadows and highlights was improved using these two layers, but the midtones still needed adjusting. To do that, I used a process called Midtone Contrast (or local area contrast) developed by my good friend and colleague Mac Holbert, formerly of Nash Editions: Fine Art Printing. Since conversion from RGB to CMYK compresses the tone curve, steps need to be taken to enhance or adjust the resulting compressed midtones. I merged all the visible layers into a single new layer, leaving the original layers untouched. To do this, press Alt or Option while you choose Merge Visible from the Layers panel menu.

I then double-clicked the image thumbnail in the layer to open the Layer Style dialog box. I chose a blending mode of Overlay, which is like applying a Screen blending mode to portions of the image above middle gray and the Multiple blending mode to areas below middle gray. To concentrate the results to the midtones, I adjusted the Blend If sliders so the top layer would blend at the targeted levels only. No blending would occur above 203 or below 49. The blending would be feathered between 49 and 98 and between 203 and 148. The full effect of the blending would occur between levels 98 and 148. I set the overall opacity of the blending to 35%, which means the effect would be fairly gentle. **Figure 3.96** shows the series of steps needed to make a midtone contrast adjustment.

FIGURE 3.96 Making a midtones contrast layer.

◀ APPLYING A
30–PIXEL RADIUS HIGH
PASS FILTER

▲ THE LAYER STYLE DIALOG BOX WITH SETTINGS

▶ THE LAYER STACK SHOWING THE MIDTONES
CONTRAST LAYER WITH A MASK TO KEEP THE
TOP OF THE ICEBERGS FROM INTRODUCING
AN UNDESIRABLE HALO (WHICH A MIDTONES
CONTRAST EFFECT CAN DO)

After setting the blending options, I used the High Pass filter to find the edges, and I set the Radius to 30 pixels. The High Pass filter finds the edges based on the radius and preserves them while filling the non-edges, the surface areas, with middle gray. Running the High Pass filter on a layer with an Overlay blending mode applies results in a form of sharpening when a small radius is used, or in a local, image-adaptive tone adjustment when a larger radius is used. One downside of using a Midtone Contrast effect can be the creation of undesirable halos. To eliminate the resulting halos, I used a layer mask to cut down on the effect at the top of the iceberg.

At this point, the overall tone was improved, but the soft proofing showed that the conversion from RGB to CMYK was going to make the image too warm. The image is not intended to be a completely neutral black-and-white image, but to have a slight coolness to it. However, in converting to CMYK, the cool tone lost some coolness because the CMYK paper white point is itself warmer. To adjust the color tone, I used a Photo Filter adjustment layer to add a slight degree of overall cooling. When

I say slight, I mean it—the optimal Density was only 3%, but that was enough to cut down on the warming that CMYK conversion would introduce. **Figure 3.97** shows the cooling applied by using the Photo Filter adjustment.

At this stage, the final step before converting to CMYK was to apply output sharpening to the RGB image at the final size and resolution. I used PhotoKit Sharpener 2's Halftone Output Sharpener set to sharpen for 150 LPI Coated 300 PPI. That's a 150-line screen halftone dot that requires an image resolution of 300 pixels per inch. **Figure 3.98** shows the PhotoKit Sharpener settings and the final layer stack.

In the Layers panel, you can see the various adjustments I made and the output sharpening layers at the top. I then converted the RGB image to CMYK using the same output profile I chose in the Customize Proof Condition dialog box, and I used the Relative Colorimetric rendering intent that soft proofing showed worked best for this image. **Figure 3.99** shows the RGB original image on the left and the soft-proofed and adjusted image on the right. Pretty darn close, to my eyes!

FIGURE 3.97 The Photo Filter used to cool the color.

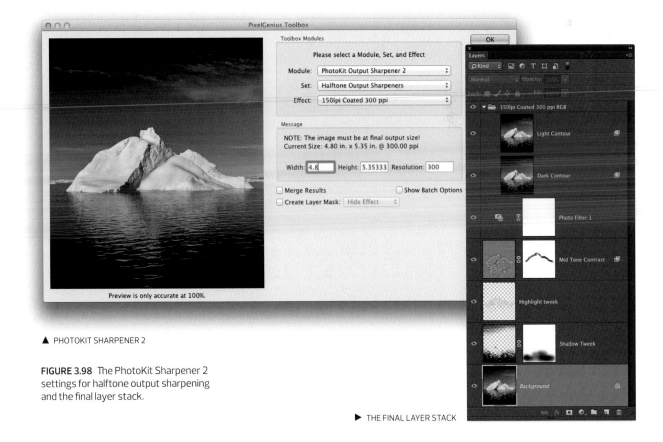

▲ PHOTOKIT SHARPENER 2

FIGURE 3.98 The PhotoKit Sharpener 2 settings for halftone output sharpening and the final layer stack.

▶ THE FINAL LAYER STACK

So, can we all agree that soft proofing can actually work very well if you know how to do it? Please, do yourself a favor and learn how to do it well; it will substantially improve the quality of your final printed image!

FIGURE 3.99 The final side-by-side soft proofing in Photoshop.

FIGURE 3.100 Here are the results of Output Sharpening in Photoshop that I explained starting with Figure 3.52. Prior to the final output sharpening, the image was resized for the book (6" x 6.82" at 300 PPI). The original image was shot with a Sinar 4"x5" camera with a 300mm Rodenstock F9 APO lens on 6" x 7" Ektachrome roll film (using a roll film adapter) and scanned on an Imacon 848 film scanner.

This is one of my oldest images. It was shot in 1976 for a school assignment. I used a Sinar 4x5 camera with a 360mm lens on 4x5 Ektrachrome transparency film, which I processed with one of the first E–6 home processing kits from Kodak. The image was scanned on an Epson Perfection V750–M Pro Scanner at 4800 ppi.

■ CHAPTER 4

MAKING THE PRINT

If you have survived the chapters on color management and preparing your images for printing, you'll find this chapter relatively simple. There's certainly less about theory here, and more about the mechanics. Once you've got your image prepared, and you've soft proofed with the appropriate profiles and tweaked the image just so, it's just a matter of printing them. Of course, as always, there are some potential roadblocks and technical issues (I call them "gotchas") to be aware of. But printing is actually kind of fun. I like making prints—which is a good thing, since I'm writing a book about printing!

BEFORE YOU PRINT

Pay attention to the details as you prepare to print. It's easy to introduce errors that can be frustrating (and time-consuming, and potentially expensive) to troubleshoot and fix.

Before you print, you obviously need to install the printer and printer driver. When you buy a new printer, you might be tempted to pop the CD in the computer's disc drive and double-click the installer to install the printer driver. But ideally, the first thing you should do is read the frigging manual (RTFM). Generally speaking, by default, when you buy a printer, the printer driver on the installation CD is likely to be out of date. It's even likely that there's updated firmware available for the printer. So when I get a new printer, I start by reading the manual. Then I go to the printer manufacturer's Web site and download the most recent printer driver, utilities, and firmware, if an updated version is available.

INSTALLING A PRINTER ON A MAC

Installing a printer on the Mac is relatively simple. You run the installer—ideally the most recent downloaded installer. Then you can plug the printer in. Most printers have multiple methods of connectivity—USB, Ethernet, or FireWire (though FireWire is becoming less and less common). Because I have a lot of printers spread out throughout my studio, I connect most of mine by Ethernet (there are a couple of reasons for the exceptions, which I'll cover later).

After installing the printer driver and connecting the printer on the Mac, open the System Preferences, and then click Print & Scan. Then, click the Plus button at the bottom of the Printers area on the left side of the dialog box. The Add Printer dialog box opens. On the Mac, Bonjour lets your computer find all the printers it can connect with. In my case, a bunch of different printers show up. If you've connected your printer using USB, Ethernet, or FireWire, it should appear. When you see an option of connecting via Bonjour or TCP/IP, I recommend connecting via the manufacturer's Ethernet connection. Click the printer you want to add, as shown in **Figure 4.1**.

Once you've selected the printer, click Add. The printer shows up in the column of installed printers on the left. Now you have some options. You can share the printer on the network. Since I'm the only person using this printer, I don't select that. You can set the default printer. I usually choose Last Printer Used—unless you know you'll usually be printing to a particular printer. In fine art printing you'll always set a specific paper size at the time of printing, so I set the default paper size to US Letter. **Figure 4.2** shows the result of adding the printer.

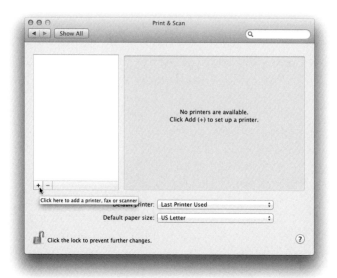

▲ THE MAIN PRINT & SCAN DIALOG BOX SHOWING WHERE TO CLICK TO ADD A PRINTER

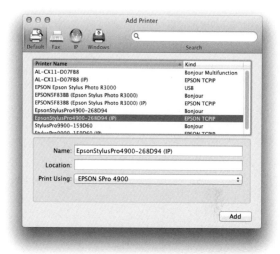

▲ THE ADD PRINTER DIALOG BOX SHOWING THE SELECTION OF THE EPSON STYLUS PRO 4900 CONNECTED VIA TCPIP (NETWORK)

FIGURE 4.1 Adding a new printer to a Mac.

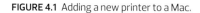

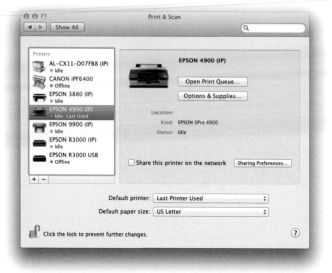

FIGURE 4.2 The result of adding the Epson 4900 (IP) printer.

GOTCHA: USE CAUTION WHEN INSTALLING CONSUMER PRINTERS ON THE MAC

By default, many consumer printers are installed by Mac OS under the Gutenprint open-source printer driver initiative. These are generic versions of printer drivers that may give you different and often fewer options than the manufacturer's printer driver. If you plug in the printer without installing the driver from the manufacturer, the printer shows up and you can print to it, but the options are different or limited because a generic printer driver controls the printer. In cases where what you are seeing is not what you're expecting to see, check to see whether the Gutenprint open-source driver is being used by the system. If it is, remove the printer and install the manufacturer's driver, then add the printer again. **Figure 4.3** shows selecting *Other* in the Add Printer dialog box and the Printer Software dialog box showing the generic Gutenprint drivers that you should try to avoid.

FIGURE 4.3 Adding a printer using generic Gutenprint drivers.

▶ ADDING A PRINTER BY SELECTING OTHER IN THE ADD PRINTER DIALOG BOX

▶ THE PRINTER SOFTWARE DIALOG BOX SHOWING GENERIC GUTENPRINT DRIVERS FOR VARIOUS EPSON PRINTERS

▲ THE PRINT QUEUE DIALOG BOX SHOWING THE PRINTER IS PRINTING

▲ THE PRINT QUEUE GENERAL TAB SHOWING CHANGING THE PRINTER'S NAME

FIGURE 4.4 The Print Queue dialog box showing status and the General tab.

If you click Open Print Queue, it will show you the queue for that printer. In this case, it shows that the printer is printing. If you click Printer Setup, the General tab shows you the printer driver version number; you want to always make sure your driver is up-to-date. This is also where you can change the printer's name. **Figure 4.4** shows the Print Queue dialog box and also the General tab for changing the printer's name.

I like to rename printers; if you have more than one printer, giving them meaningful names is important, even more so if you have multiple printers of the same model. I recommend putting a piece of tape on the printer with its number or specific name, and that way you can be sure you're printing to the correct printer when you select it in the application.

When you click the Supply Levels tab, you can see the ink levels for the printer, if the printer you're using communicates that to the user. If your printer includes it, you can click Utility to open the printer utility, print a test page, and clean the printheads. The options available vary depending on the printer.

If you are having issues when trying to install or use a printer, there are a couple of things to be aware of. Depending on how you may have updated your operating system, you may have accumulated some older out-of-date printer drivers that are not compatible with your current system. If simply deleting the printer and re-adding it doesn't resolve the issue, you may need to totally reset your printing system. **Figure 4.5** shows how to reset the printing system.

▲ CONTROL-CLICKING (RIGHT-CLICK) ON THE MAIN PRINTER PANEL AND SELECTING RESET

▲ THE WARNING DIALOG BOX ASKING IF YOU REALLY WANT TO RESET THE PRINTING SYSTEM

FIGURE 4.5 Resetting your printing system.

After a hard reset, you should download the most recent driver, reinstall it, and then reconnect the printer prior to adding the printer.

INSTALLING A PRINTER ON WINDOWS

When you install a printer on Windows, it's important to download and install the most recent version of the printer driver before you plug in the printer. When you connect the printer, it will announce itself to the computer and usually prompt you to install it. To double-check the information for your installed printer, choose Start > Devices and Printers (which is also in the Control Panel). Installed printers are listed in the Printers and Faxes section of the Devices and Printers control panel. If you right-click an individual printer, you can select a print queue similar to the one on the Mac. It shows you how many documents are in the queue. You can also show the main Printer Properties dialog box (not to be confused with the other Printer Properties you set when printing). **Figure 4.6** shows the main Devices and Printers dialog box as well as the Print Queue and the system-level Printer Properties dialog box.

If you choose Printer > Properties, you can change the name and set other preferences, such as whether or not to share it. You can set up color management, but

▲ THE DEVICES AND PRINTERS DIALOG BOX

▲ THE PRINT QUEUE DIALOG BOX

▲ THE SYSTEM-LEVEL PRINT PROPERTIES DIALOG BOX

FIGURE 4.6 The Devices and Printers, Print Queue, and Printer Properties dialog boxes.

I suggest you not do anything with this here. As I said in Chapter 2, the Windows Color System doesn't really have a direct impact on fine art printing, because you'll use the application's color management features. If you have multiple printers, make sure you give each printer a meaningful name so that when you select a printer in Photoshop or Lightroom, it's the correct one.

If your connected printer is offline, the icon will be dimmed. However, if there are problems with the printer connection or driver, you'll see a yellow warning triangle on the printer, as shown in **Figure 4.7**. Clicking on the warning will bring up a troubleshooting dialog box. You can click the Change Settings button in the Driver Software Installation dialog box and try to walk through the troubleshooting steps in the Device Installation Settings dialog box, but I've found it's better to simply delete the printer, reinstall the driver, and then reconnect the printer.

▲ DETAIL SHOWING THE EPSON STYLUS PRO 4900 PRINTER WITH A WARNING

▲ THE DRIVER SOFTWARE INSTALLATION DIALOG BOX

▲ THE DEVICE INSTALLATION SETTINGS DIALOG BOX

PRINTING FROM PHOTOSHOP

The Photoshop Print Settings dialog box is a relatively complex and powerful print control center. On the left is a preview of your image. On the right are all the settings that you have to master. You have to make absolutely sure you've got each one correctly set; miss one and you've ruined your expensive fine art print.

When I was young, I had an art instructor who said you are embellishing the art of a previous artist whenever you put pencil to paper. What he meant was that someone has put a great deal of time and craftsmanship into creating this great piece of paper, so don't screw it up. Thinking about it that way gives you a healthy degree of respect for the medium and the substrate.

So, how not to screw up? I'll walk you through the dialog box so you know how to get the results you want.

Starting at the top, in the Printer Setup area, it's self-apparent to select the correct printer. Then click the Print Settings button.

THE PHOTOSHOP PRINT SETTINGS DIALOG BOX

Photoshop engineers have done a pretty good job of making the print dialog boxes the same across platforms. In essence, the options are identical on Mac and Windows. It's just the print properties versus print settings that are different. **Figure 4.8** shows the main Photoshop Print Settings dialog. If mine looks a bit different, I suspect it's because of some of the options I've chosen (which I'll highlight later). The dialog box is broken up by the panel areas for the various settings you must select.

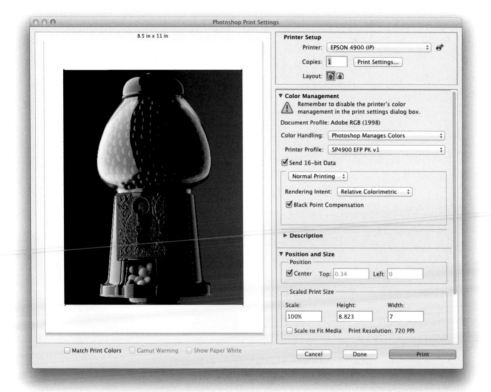

FIGURE 4.8 The Photoshop Print Settings dialog box.

Printer Setup panel

The first step is to select the printer and set up the print settings for your specific printer. The other thing to address in the Printer Setup area of the dialog box is Layout. You must set to print in portrait or landscape mode. Sadly, Photoshop's Print dialog box still can't auto-rotate your image. **Figure 4.9** shows the Printer dropdown menu (notice my nice tidy printer names) and the Print dialog box you get when you click the Print Settings button.

FIGURE 4.9 The Printer dropdown menu and the Print dialog box.

▲ PRINTER DROPDOWN MENU

▶ THE PRINT DIALOG BOX

NOTE Photoshop CS6 started it and Photoshop CC continues with a new behavior of prefiltering your printer profiles to show only the type of output profiles relevant to your chosen printer—meaning if your printer is considered an RGB printer (as most all inkjet printers are, even if they use blends of CMYK inks), only RGB profiles will show up in your profile menu. Yes, it's an attempt by the Photoshop engineers to make selecting profiles "easier," but they should have gone down the route the Lightroom engineers went to allow the user to select which profiles appear in the dropdown menu. Maybe next time!

Color Management panel

In the Color Management area of the dialog box, choose a Color Handling option. You've got two, basically: Printer Manages Colors and Photoshop Manages Colors. Unless you're printing black-and-white images using a special module, which I'll describe later in this chapter, you want Photoshop to manage colors. **Figure 4.10** shows the Color Handling menu and the Printer Profile menu of ICC profiles.

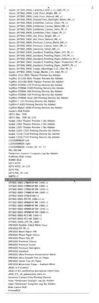

FIGURE 4.10 The Color Handling dropdown menu and the really long Printer Profile menu.

▲ THE COLOR HANDLING MENU

▶ THE REALLY LONG PRINTER PROFILE MENU

After you choose Photoshop Manages Colors, select the appropriate profile. Unfortunately, Photoshop shows you all of your installed profiles—and that list can be overwhelming. Be sure you select the correct printer profile. I'm climbing onto my soapbox for a moment here to say that each color profile should be named usefully, not as a marketing tool. It would be useful if Epson and Canon, for example, understood that creating a profile named Epson Stylus Pro 7900-9900 and then the actual media name is a royal pain in the ass for the user. I'd like to see a naming convention that groups profiles for a single printer together, but also makes it easy to identify the media you're selecting.

You have the option to send 16-bit data. I'll do that.

Next, choose either Normal Printing or Hard Proofing. Choose Hard Proofing when you're doing cross-rendered proofing, especially if you're proofing for halftone reproduction. When you select Hard Proofing, select your saved Proof Setup—or, in this case, I can select Working CMYK. Then select Simulate Paper Color. With that option selected, Photoshop will direct the printer to print a scum dot on the paper to simulate the paper white point that's in the paper profile. **Figure 4.11** shows the dropdown menu and the result of selecting Hard Proofing.

▲ THE PRINTING TYPE MENU

▲ THE HARD PROOFING OPTION

FIGURE 4.11 The printing type menu and the result of selecting Hard Proofing.

BE CAREFUL WITH COLOR MANAGEMENT IN WINDOWS

On the Mac, either the application manages colors or the printer does color management, but not both. If you select Photoshop Manages Color, the printer's own color adjustments are locked out and dimmed. Generally, this is a good thing (which was why Apple insisted applications and printer drivers do this for the Mac). However, it is a rather draconian measure. With Windows, you can have the application manage colors, the printer manage colors, or have both or neither do it. You have more opportunity to screw up in Windows than you do on the Mac. So make sure you choose the correct settings in both the Photoshop Print Settings dialog box and the printer's settings dialog box.

In most cases, you'll choose Normal Printing. The next parameter to select is Rendering Intent. In this case, I'll choose Relative Colorimetric or Perceptual. I'll choose Relative Colorimetric rendering because that was the best intent when soft proofing. Absolute Colorimetric and Saturation aren't good choices for fine art printing. The reason I selected Relative Colorimetric was, of course, because that was the best rendering intent when I was soft proofing the image. Always select Black Point Compensation because it maps the image's black point to paper black, going above and beyond the ICC specification. It's a good thing. **Figure 4.12** shows the Rendering Intent dropdown menu.

FIGURE 4.12 The Rendering Intent dropdown menu.

Description panel

The Description panel is basically a tool tip. As you hover your cursor over different areas of the dialog box, it provides a description of the options. I won't bother with a figure; try it yourself next time you print.

Position and Size panel

In the Position and Size area of the Photoshop Print Settings dialog box, you can choose to center the image. Remember that it will be centered within the printable margins. If you have asymmetrical margins, it will be centered not according to the paper dimensions but relative to the printable margins. You control those printable margins when you set up your custom paper size. **Figure 4.13** shows the Position and Size panel.

As I said in Chapter 3, you want to resize and resample way before you get here—so don't click Scale to Fit Media, or change the height and width. You've already done that. I'll also warn you that trying to move the image within the printable area by grabbing and moving can be problematic, and using the Top and Left text entry

FIGURE 4.13 The Position and Size panel.

FIGURE 4.14 Adjusting the area to print after selecting Print Selected Area option.

boxes is a pain. There needs to be a redesign of this function that makes it easy to accurately position the image on the page (sort of like Lightroom).

If you wanted to print a quick proof of a selected area, you could select Print Selected Area. When you select it, you get little cropping marks in the preview, so you can print a swath. **Figure 4.14** shows the option to print only a selected area if you check the Print Selected Area button.

Printing Marks, Functions, and PostScript Options panels

The options in both the Printing Marks and Functions areas of the dialog box are typically useful only in the graphic arts and not something you would normally use when fine art printing.

If you're using a PostScript printer, there would PostScript options. But most inkjet printers are not PostScript. With a non-PostScript printer selected, those options aren't available. **Figure 4.15** shows the three panels. To be honest, I never use these options, but they could come in handy someday (although I doubt it).

FIGURE 4.15 The Printing Marks, Functions, and PostScript Options panels.

Match Print Colors

There are three options under the image preview: Match Print Colors, Gamut Warning, and Show Paper White. These options essentially allow you to soft proof right in the Photoshop Print Settings dialog box. It's interesting, but not all that useful, because you're not in a position to do anything about it. All the soft proofing should have been done before you choose Print, so I leave those all unchecked. **Figure 4.16** shows before and after selecting the Match Print Colors option. There is one situation where using this option can come in handy, and that is if you have short-term memory loss and you can't remember which rendering intent looked the best for your image. In that case, select the Match Print Colors option and try toggling back and forth through the rendering intents.

FIGURE 4.16 With and without the Match Print Colors options.

▲ BEFORE

▲ AFTER

Customizing the Photoshop Print Settings dialog box

In the beginning of this chapter I mentioned that my Photoshop print dialog box might look different than yours. Here's why: I used the context menu (Control-click on the Mac or right-click in Windows) to change the background display. By default, it has a rather "distracting" diagonal line pattern that I really hate. **Figure 4.17** shows the default display and the context menu to change it. I selected a simple white custom color. I think it makes it look more like a "print"!

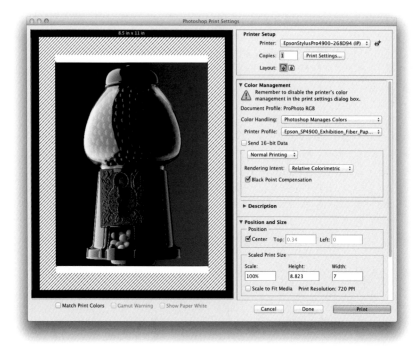

Done or Save buttons

At this stage, you're ready to print or save the print settings for use later. You should realize that clicking Done or Print will actually "dirty" your file. By *dirty* I mean it adds the print settings you've selected into the file, which will require saving it. You can choose to close the file without saving, but I find it useful to store the last print settings in the image. By the way, hitting Cancel will cancel the settings and your file won't be dirtied.

PRINTER-SPECIFIC SETTINGS

When you click the Print Settings button, you leave the Photoshop dialog box and communicate directly with the printer driver. You'll be selecting options that are specific to your printer model.

To my mind, there are really only two fine art printer manufacturers left: Canon and Epson. HP was doing great for a while, but it doesn't seem to be updating its printers nor (I've heard) manufacturing parts for its fine art printers anymore. So, I'll walk through the options for the Epson Stylus Pro 4900 and the Canon iPF6400 printers I have at my disposal. Both are pro-level printers. Consumer-level printers

won't have the exact same sort of options in the printer driver, so you'll have to extrapolate the settings you need for your own printer. I'll talk about the settings on the Mac first and address the differences in Windows a little later.

Epson Stylus Pro 4900 settings

You have the ability to make printer presets. Generally, I consider that useful if you're printing from Photoshop, but it's contraindicated if you're printing from Lightroom. Once we get through this, if you want to create a custom user preset, I'll leave that up to you.

Printing on a Mac. When you click on the Print Settings button, you get a special OS-supplied combination of the old Page Setup and the printer-specific driver functions. **Figure 4.18** shows the initial Print dialog box with the main dropdown menu expanded. The items at the top of the list are from the old Page Setup dialog box, and the ones below the line are from the printer driver itself. The bottom option, Supply Levels, connects to the printer and displays the current ink levels per color.

FIGURE 4.18 The main Print dialog box.

The first step before choosing the printer settings is to select the Paper Size. In this case, I'll select US Letter (Sheet). You can also select US Letter, Roll Paper – Banner, but I'm just going to print on a sheet. The paper you select here will alter the printer driver settings later in the Printer Settings dialog box. The Paper Sizes displayed are specific to the printer selected at the top Printer dropdown menu. **Figure 4.19** shows the selection of the paper size.

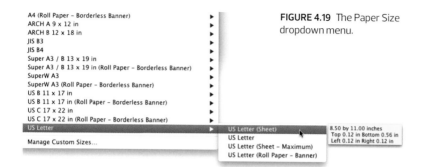

FIGURE 4.19 The Paper Size dropdown menu.

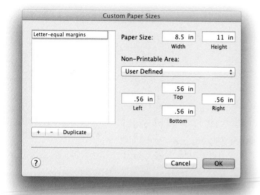

FIGURE 4.20 The Custom Paper Sizes dialog box.

I generally create custom sizes. If you scroll all the way to the bottom of the Paper Size menu for the Epson Stylus Pro 4900, for example, you'll see the Manage Custom Sizes option. In the Custom Paper Sizes dialog box, you can control the height, width, and printable margins. I'll enter 8.5 x 11 inches. Depending on the printer model, you may be able to center the image. Some printers have asymmetrical top and bottom margins. The Epson Stylus Pro 4900 that I'm working with here has a default of 0.56 inches on the bottom and 0.13 inches on the top and sides. So to center my image, I'll change those margins to 0.75 inches all the way around, and then click OK. **Figure 4.20** shows the Custom Paper Sizes dialog box.

Generally, when I print, I want a minimum margin of paper around the printed image for purposes of handling and long-term conservation. You don't want to print all the way to the edge where people will use sticky fingers to hold it. Depending on whether you do an overmat, the margin may not even show. It's a way of being more conservation-minded.

NOTE On the Mac, you can change the units systemwide on the Formats tab of the Language & Text System Preferences. In Windows, you can change the units in the Region and Language control panel; click Additional Settings to see the Measurement System menu.

After you click OK, it's important to make sure the paper size is actually what you selected. Sometimes changes you make in these dialog boxes have unintended consequences. This is a prime opportunity for error. It's been my experience that you need to send the correct paper size to the printer or you won't get the expected results (this is an ironic comment).

Color matching is something you don't need to control. If you've set the color handling in the color management section of Photoshop to Printer Manages Color, those options aren't changeable.

Next, set the printer specifications, such as whether the printout is based on sheet or roll paper. It would be nice if the printer driver would communicate with this dialog box, because it seems like it should pick up the options I already set, but it doesn't. Be careful here. This is another potential gotcha point—if you set it to print to a sheet in one place but not the other, it's a problem. If you've got a paper cassette for the Epson 4900, you can choose manual feed or cassette. **Figure 4.21** shows the options in the Page Setup dropdown menu. Depending on whether or not your page setup indicated sheet or roll, you'll have different options.

Note that, especially for Epson printers, the paper feed path often dictates the choice of media. If you select Paper Cassette, for example, you can't select some of the fine art heavy watercolor papers; to use those, you need to select manual feed. Additionally, different printers, such as the R3000 or 3380, can do a front or back manual feed. Depending on your printer model, selecting a media type is potentially

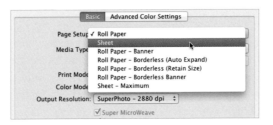

FIGURE 4.21 The Page Setup dropdown menu.

▲ PAGE SETUP OPTIONS WHEN THE PAPER SIZE IS SET TO A SHEET

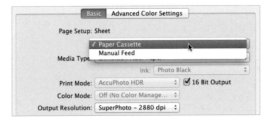

▲ PAGE SETUP WHEN A CUSTOM PAGE SIZE IS SET WITHOUT SPECIFYING SHEET OR ROLL

rather complicated. The Epson Stylus Pro 4900 is compatible with different photo papers, and it's nice that they're organized hierarchically in the file menus. Previously, they were all in one menu, which was even more conducive to user error. I have menus for photo paper, proofing paper, and fine art paper. But in the fine art menu, papers such as velvet fine art or hot and cold press watercolor papers are dimmed because they can't be printed from the paper cassette, which is what I've selected. **Figure 4.22** shows the media options limited by the paper feed path.

If you're using a third-party paper, you should use a media type that is suggested by the manufacturer. You can use the ICC profile supplied by the paper manufacturer, but if you've made a custom profile, you should choose the paper media type that you used when you actually profiled the paper.

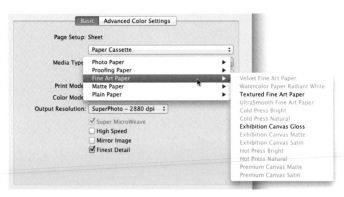

FIGURE 4.22 Comparing media options based on the paper feed path.

▲ MOST FINE ART PAPER OPTIONS ARE DIMMED BECAUSE OF THE PAPER CASSETTE PAGE SETUP SELECTION

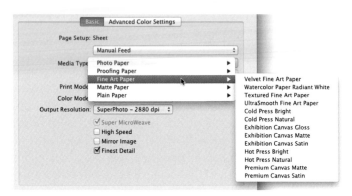

▲ ALL FINE ART PAPER MEDIA OPTIONS ARE AVAILABLE IN MANUAL FEED PAGE SETUP

Below the Media Type menu, the Ink menu is dimmed, and it's set to Photo Black. You can't change it here; you'd have to do a photo black to matte black swap in the print driver or the front panel of the printer.

Because I've chosen Photoshop Manages Colors in the Photoshop Printer Settings dialog box, the Color Mode menu here is automatically dimmed. Color management is off. **Figure 4.23** shows the dimmed Print Mode and Color Mode with the 16-bit option selected. You'll see the 16-bit option available only if you are printing a 16-bit image.

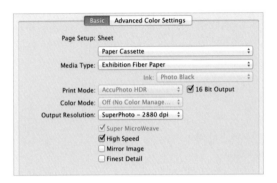

FIGURE 4.23 The dimmed Print Mode and Color Mode options.

TIP For Epson printers, some people ask whether printing to 1440 DPI instead of 2880 DPI would save ink. No. In essence, the ink used by the printer is dictated by the square inches you're printing and the color and density that you're printing. The difference due to resolution is negligible.

The next menu is Output Resolution. I talked about printer resolution in Chapter 3, and this is where you'll set it. I would prefer that menu items were technically accurate and not marketing jargon—SuperPhoto doesn't mean anything, but the resolution numbers do. Keep in mind that these numbers aren't dots per inch, but droplets per inch. Here, I'll select Exhibition Fiber Paper and set the resolution to 2880. **Figure 4.24** shows selecting SuperPhoto 2880 DPI and the final settings, with High Speed selected.

The High Speed option lets the printer heads spread ink bidirectionally, so images print literally twice as fast as they do when that option is off. Depending on your paper type and resolution, this is a good option and saves a lot of time. As I'll explain in a moment, you should deselect High Speed if you select Finest Detail.

The Finest Detail option is unique to Epson (although Canon pro printers also have a high-resolution reporting option as well). Normally, the Epson printer's reported resolution is 360 dots per inch, and the Epson Pro printers actually have 360 nozzles per inch on the printhead. When you select Finest Detail, the driver reports to the print pipeline that the printer is a 720-dots-per-inch device. This is a critical thing to understand. If you were printing a textural fine-detailed image and the native resolution, uninterpolated, is above 360 pixels per inch, you'd want to upsample to 720 and select Finest Detail. In Chapter 5, you'll see proof that printing at 720 is superior to printing at 360, but for now, take my word for it. If you have enough resolution natively, it's worth printing Finest Detail and upsampling to 720 PPI—and if you select Finest Detail, consider deselecting High Speed.

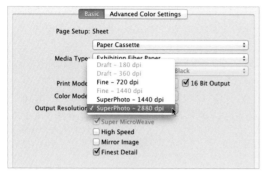

▲ SELECTING SUPERPHOTO – 2880 DPI

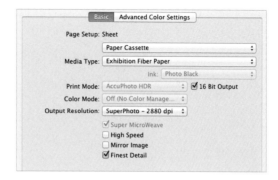

▲ HIGH SPEED DESELECTED AND FINEST DETAIL SELECTED

FIGURE 4.24 Selecting the Output Resolution and the additional High Speed and Finest Detail settings.

The advantage in selecting Finest Detail applies primarily to glossy media. The resolvable detail will vary considerably with matte media. Some matte media, such as Ultrasmooth Fine Art and enhanced matte (or ultrapremium presentation matte), can use a higher resolution, such as 1440 or 2880. If you're printing to canvas, you can set the resolution to 1440 or even down to 720. It all depends on the surface or substrate you're printing to.

You also have a 16-Bit Output option on the Mac. If you've been working in 16 bits, there's no reason to drop down to 8 bits per channel just to make a print. However, it's generally going to make a strong difference only if you're printing images with various complex gradients from Illustrator. It doesn't apply that much when you're printing pixel images from Photoshop. But if you're printing from a Mac, the option is there, so go ahead and use it. Be aware that there have been cases reported where certain printers have a bug with 16-bit output, so double-check that printing with it on or off gives you the results you expect.

So far we've been in the Basic panel. There are other dialog boxes available that may need to be set depending on the media you are printing on. **Figure 4.25** shows the Roll Paper Settings (if you are printing on rolls) and the Advanced Media Control panel with the Platen Gap dropdown menu. Changing these options is needed only if you are setting up and printing out to non-Epson media. Setting the Media Type will set all of these options automatically for Epson media.

Printing in Windows. If you're working in Windows, you'll see the printer driver settings are very similar but in a different configuration. **Figure 4.26** shows the Epson Stylus Pro 4900 Properties dialog box with the Main tab selected. The dialog box in this figure has already been configured for all the standard settings and is ready to click OK.

> **NOTE** Are there any good reasons for making changes in the Advanced Media Control? If you are printing on Epson media, I would say probably not. However, if you are printing to third-party papers or nonstandard substrates, then I would say absolutely yes. Just remember that if you change any of the settings it'll impact the results of ICC paper/printer color profiles. Changing the drying time may eliminate ink pooling. Changing the platen gap may eliminate head strikes. This is something you'll need to test for yourself based on your media choices and the results you achieve.

▲ ROLL PAPER SETTINGS

▲ ADVANCED MEDIA CONTROL

FIGURE 4.25 The Roll Paper and Advanced Media Control options.

FIGURE 4.26 The Epson Stylus Pro 4900 Properties dialog box in Windows.

Select Settings and Media Settings. Starting with the Select Settings menu, select the printing quality (you'll want Highest Quality unless you are printing a draft). In the Media Settings area, select the Media Type (set to Exhibition Fiber Paper). In Media Settings, you have the same choices with the same limitations depending on the paper feed path, as previously mentioned in Figure 4.22. **Figure 4.27** shows each of the Main panel settings for Select Settings and Media Settings.

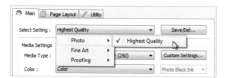

▲ SELECT SETTING MENU FOR HIGHEST QUALITY

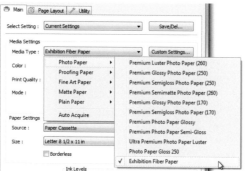

FIGURE 4.27 Selecting the quality and Media settings.

▲ SELECTING THE MEDIA TYPE MENU

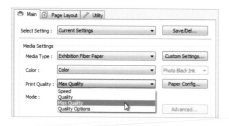

▲ SELECTING THE COLOR MENU

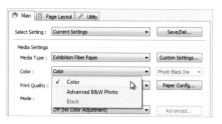

▲ SELECTING THE PRINT QUALITY MENU

▲ SETTING THE QUALITY OPTIONS (ACCESSED FROM THE PRINT QUALITY MENU)

▲ SETTING THE PAPER CONFIGURATION (ACCESSED BY CLICKING THE PAPER CONFIGURATION... BUTTON)

▲ SETTING THE MODE—CLICK CUSTOM AND SELECT OFF (NO COLOR ADJUSTMENT) FROM THE MENU

For color, you can select Color, Advanced B&W Photo. Black is dimmed because the image is in color. Print Quality doesn't give you the same geeky settings you have on the Mac: you have matte quality or quality options. If you select quality options, you can move the slider over to about 5. Just as with the Mac, you can select High Speed or Finest Detail—but you have to dive into the Quality Options area to find the Finest Detail option.

Under Mode, click Custom, and then turn color management off in the expanded options. On the Mac, ColorSync prevents you from doubling up on color management or accidentally turning it all off, but you can screw up more easily in Windows. It's a huge potential gotcha. I suggest turning it off here, and be sure to choose Photoshop Manages Colors in the Photoshop Print Settings dialog box.

Paper Settings. Figure 4.28 shows the Paper Settings section, where you have the Source: Roll Paper, Paper Cassette, or Manual Feed. Depending on the media type you're using, you'll have to select the correct source. I'll select Paper Cassette. That enables a button that allows you to control the printable area, and this is a little different on Windows than it is on the Mac. Standard gives you standard printer margins; Maximum allows you to extend the printer margins but may produce poor quality near the bottom edge. Again, you can center the image within the printable margins.

Down below in the Page Settings you select the paper size. Unfortunately, in Windows, you choose from the A series, B series, Photo series, and others in a more complicated hierarchical display of paper sizes. However, you can also select User-Defined and then create a custom printer size.

Page Layout. Under Page Layout, you can set the orientation and, again, it's important that the printer driver and the printer have the same orientation settings. This is another potential gotcha. You can also enlarge or reduce, but you should already have done that. **Figure 4.29** shows the Page Layout tab. Note that in the Select Setting menu, I've selected a saved setting named 4900 EFP. You can save user-defined settings by clicking the Save/Delete button. It's useful because it allows saving often used settings to help cut down on user error.

FIGURE 4.28 Setting the Paper Settings options.

▲ SETTING THE PAPER SOURCE OPTIONS

▲ THE PRINTABLE AREA SETTINGS (ACCESSED BY CLICKING ON THE PRINTABLE AREA... BUTTON)

▲ THE USER–DEFINED PAPER SIZE DIALOG BOX (ACCESSED BY CLICKING THE USER DEFINED... BUTTON)

▲ SETTING THE PAPER SIZE OPTIONS

FIGURE 4.29 The Page Layout tab.

NOTE If you are wondering what the LFP stands for, it's an acronym for Large Format Printer. So simple it plum evaded me!

Utility. Under the Utility tab, you can do nozzle checks and cleaning. It allows you to alter the groups or the display order of the menu, which might be useful, but it's not necessarily something I would suggest doing willy-nilly. Sometimes Windows allows you to do things maybe you shouldn't be able to do, such as changing the menu order and changing what is or isn't displayed.

You can click the printer-specific utility. In this case, it's the Epson LFP remote panel. (LFP stands for large format printer.) The remote panel allows you to control and update the firmware, monitor and display the printer status, adjust the paper feed to fine-tune the actual speed, and perform other tasks. I'll talk about this more in Chapter 5. **Figure 4.30** shows the main Utility tab and the EPSON LFP Remote Panel 2 dialog box (launched as a separate application by clicking the EPSON LFP button in the Utility tab).

Click OK and you'll go back to the Photoshop Print Settings dialog box.

▲ THE UTILITY TAB OF THE EPSON 4900 PROPERTIES DIALOG BOX

▲ THE EPSON LFP REMOTE PANEL 2 DIALOG BOX

FIGURE 4.30 The Utility tab and the EPSON LFP dialog box.

NOTE If you see banding in the printout, the paper feed adjustment is going too far and the swath of the printhead going back and forth is not lining up. In that case, you want to adjust the paper feed. This is a very deep dive on a printer-specific issue, but you should check the manual for how to do that.

Canon iPF6400 settings

Just like the Epson 4900 driver on the Mac, you start off with the main Print dialog box after clicking the Print Settings button in the Photoshop print dialog box. **Figure 4.31** shows the Main panel of the Print dialog for the Canon iPF6400 printer.

Main panel. In Figure 4.31, I've clicked on the Advanced Settings button to access the more advanced setting options. When you select Photoshop Manages Color, the Easy Settings are dimmed. In the Main dialog box, choose your media type. With Canon printers, you need to set the media type at the printer itself, and that setting has to match the media type you select in the driver. This is a potential gotcha, so make sure you correctly set the media type on the printer and in the Main printer dialog box. **Figure 4.32** shows the Media Type menu for Photo Paper and the "Special" menu. Since I'm printing out to Hahnemühle FineArt Baryta paper, the manufacturer suggests using the Special 5 Media Type settings.

TIP Baryta is a type of coating material used instead of optical brightening agents (OBAs) to brighten the paper without causing any fluorescence. I'll talk about OBAs and Baryta in the next chapter.

FIGURE 4.31 The Main panel of the Canon iPF6400 Print dialog.

▲ MAIN PANEL OF THE PRINT DIALOG BOX SHOWING THE DROPDOWN MENU

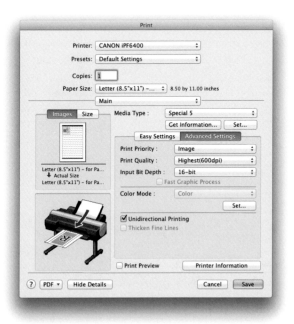

▲ MAIN PANEL SHOWING THE ADVANCED PANEL OPTIONS

▲ THE PHOTO PAPER MENU

▲ THE SPECIAL MENU

FIGURE 4.32 Selecting the Media Type settings.

Advanced settings. The Print Priority can be set to Image or Proof. I've never used the Proof setting. You can change the print resolution and the print quality. The quality is dictated by the media type. You can use Standard(600dpi) or Highest(600dpi), which reports 600 DPI to the operating system and uses a higher number of passes to achieve maximum image detail. If you have a 16-bit image, you can select 8- or 16-bit for the output. You can also choose unidirectional or bidirectional printing.

The color mode options would be enabled only if you chose to have the printer manage color. Those options are dimmed because Photoshop is managing the color. **Figure 4.33** shows the various options in the Advanced tab.

▲ PRINT PRIORITY MENU

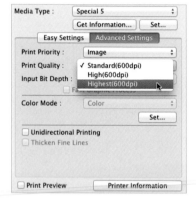

FIGURE 4.33 The Advanced tab options.

▲ PRINT QUALITY MENU

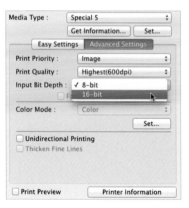

▲ INPUT BIT DEPTH MENU

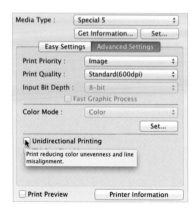

▲ UNIDIRECTIONAL OPTION

Page Setup. Under Page Setup, you have the same essential ability to control the page size and whether to resize to fit the page or to change the scale. Again, you should have made any scaling changes to the image prior to printing. You have the option to print the image centered within the printable margins. **Figure 4.34** shows the Page Setup panel and the Paper Source dropdown menu.

Utility. With the Utility dropdown, you can perform printer maintenance, start the print monitor, or configure the color image runner enlargement copy (don't ask; I have no clue what that is). **Figure 4.35** shows the Utility Panel options.

FIGURE 4.34 The Page Setup panel.

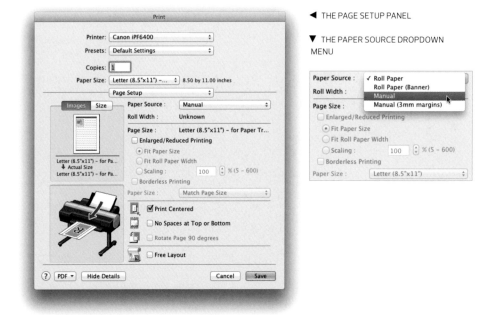

◀ THE PAGE SETUP PANEL

▼ THE PAPER SOURCE DROPDOWN MENU

FIGURE 4.35 The Utility panel (with options I've never used).

Under additional settings, you can specify a data send method, whether to spool or print directly without spooling. If you send directly, it ties up the CPU for your computer; don't know if it's modal or not, but I'd send all print data as a batch to spool it to the printer so the CPU sends only what the printer can grab at a specific time. Since the settings are grayed out, I won't bother to show a figure.

Printing to Windows. Yes, the Canon iPF6400 has a Windows driver. **Figure 4.36** shows the Main panel of the Canon iPF6400 Properties dialog box. If you look closely at the dialog head in Figure 4.36, you'll see a (2) after the printer's name. I inserted the number because I added the printer two ways, once via USB and the other via Ethernet. I won't bother to drill down on the individual panels, but suffice it to say, all the same features for the Mac driver are available for the Windows driver—just in different locations.

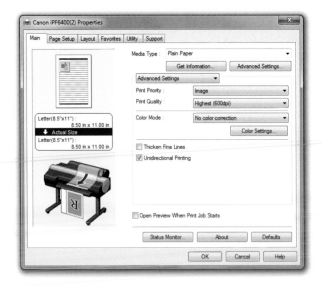

FIGURE 4.36 The Windows printer properties dialog box showing the Main panel.

PRINTING FROM A PHOTOSHOP PRINTER PLUG-IN

The only real print export plug-in that I'm aware of is provided by Canon. At one point, Epson had an excellent plug-in, but the company chose to concentrate on the printer driver and dropped it. To its credit, Canon has developed and maintained its plug-in. To access the Canon print plug-in, choose File > Export > iPF6400 Print Plug-in. **Figure 4.37** shows the imagePROGRAF Plug-In for Photoshop dialog.

FIGURE 4.37 The Canon printer plug–in for Photoshop.

One reason to use the plug-in versus the printer driver is that Canon claims and my tests confirm that the gamut is a little bit bigger under the plug-in than through the printer driver. I will show a 3D gamut plot of the ICC profile I made through the actual application and print pipeline and the ICC profile I made or the Fine Art Baryta paper for the actual plug-in. It's subtle, but it's bigger. In terms of gamut, generally speaking, bigger is better. **Figure 4.38** shows a graph taken from ColorThink showing the gamut differences between the printer driver and the plug-in color gamut.

The plug-in provides a preview and has five main tabs. Under the Main tab, you can select the printer, and since I have just one, it's easy to select. It allows you to set the media type. I've chosen Special 5 because I'm printing out to Hahnemühle FineArt Baryta paper.

The Input Resolution to Plug-In is set to High Accuracy, which is 600 PPI. For the Input Bit Depth to Plug-In, high gradation is 8 bit, and the next highest gradation is 16 bit. The plug-in allows you to control the print mode, which is highest or highest maximum number of passes. You want to print the highest number of passes. That means the printhead passes back and forth more accurately. Under Output Profile, you can select the ICC profile. I'll select the profile I made for the plug-in. You either need to make custom profiles or use the general Canon profiles; they don't offer any

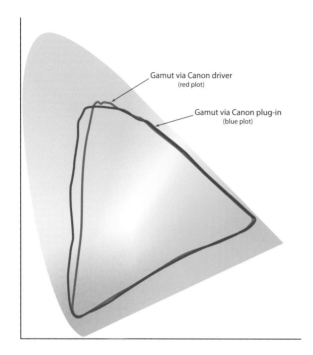

FIGURE 4.38 Gamut plots.

Gamut via Canon driver
(red plot)

Gamut via Canon plug-in
(blue plot)

profiles specific to the plug-in. So, for optimum output quality, you'd want to make your own custom profile.

Under Matching Method, you can select Perceptual Colorimetric or Relative Colorimetric. You could also select Saturation, but it's not optimal. And you can control and change the ICC conversion options. You can use the OS standard (on Mac, that's Apple CCM) or you can choose the Adobe CCM. Currently, the Adobe CCM has not been released as a stand-alone CCM, so even though I was able to choose it, I got a warning that I'm locked into the OS standard. On the Mac, that's Apple CCM; for Windows, it would be the ICM CMM.

You can also set the configuration. You can actually apply sharpening, but you should never do output sharpening here—do it in Photoshop or Lightroom instead. You can also change the image enlargement method, but you should already have your image set to the proper size and PPI. The plug-in lets you perform printing in the background, so you can set it to automatically close the plug-in after printing.

Under the preview, you can view the print area layout or the image. I have it set to view the image. You can quickly see image properties, including height, width, resolution, and color space. If you're doing some pretty extensive work, one advantage of the plug-in is that you can maximize the dialog box and it goes full screen.

Under the Page Setup tab, you can choose the paper size and the layout and the paper source, whether it's roll or manual feed. You can set custom sizes in inches or millimeters. Under the Color Settings tab, you can combine both ICC-based color management plus direct print control of cyan, magenta, and yellow and gray tone, as well as brightness, contrast, and saturation. Since I'm using a custom profile, I don't want to use any of these controls. **Figure 4.39** shows the Color Settings panel and the Adjustment Pattern Settings dialog box. This would be useful if I were using the Monochrome output option to do black-and-white printing using color toning.

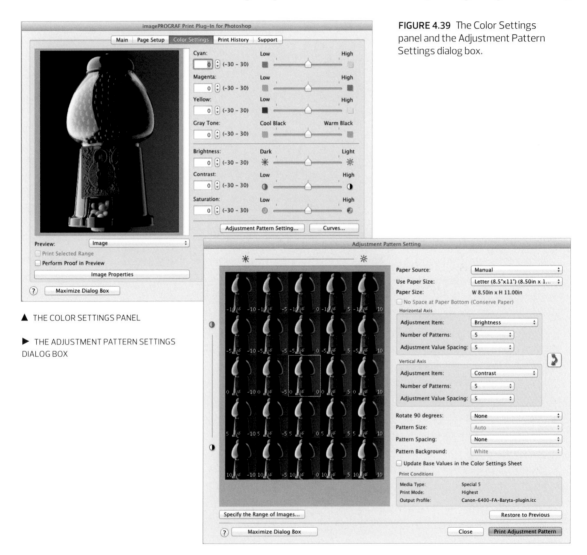

FIGURE 4.39 The Color Settings panel and the Adjustment Pattern Settings dialog box.

▲ THE COLOR SETTINGS PANEL

▶ THE ADJUSTMENT PATTERN SETTINGS DIALOG BOX

If you click the Print Adjustment Pattern button, you see something similar to the old Photoshop Variations interface. You can select the adjustment item—any of the colors, brightness, saturation—the number of patterns (I could set it to between 3 and 7), then adjust the value spacing. You can see how much strength is in the modification. You can even control both the horizontal and vertical axes, which is what makes it look like the old Photoshop Variations option. I don't use this at all for color. I do use it for printing to black and white, which I cover later in the chapter.

Under the Print History tab, you can control whether information is included on the print, such as the printer name, time, or filename. This could be useful if you're doing a myriad of test prints; you could automatically print specific information so you could keep the different prints straight.

The last tab is Support. Click there to go to the Canon support Web page or user manual.

That is it for the plug-in. So, would I use the Canon printer plug-in on a regular basis? Probably not. There are some shortcomings, such as its inability to save settings—every time you print, you would need to go through and set all the settings correctly. I'm a big believer in making printing efficient and error free, which segues nicely to the next section!

AUTOMATED PRINTING USING ACTIONS

I believe the ability to record printing actions started with Photoshop 5, without a great deal of fanfare. Dave, the engineer in charge of the Photoshop Print module, based in Minneapolis, worked very hard to clean out and re-engineer the Print dialog box. He was the one who made it possible to record the Print dialog box as an action.

I won't teach an extensive tutorial on creating actions, but I will show you briefly how to record an action to make a print, and then I'll show you how to use that action to do fast printing in Bridge.

In the Actions panel, click Create New Action. Name it (I'll call it *4900 letter*), select a set to add it to (I'll create a new set called *Printer Actions*), and then click Record.

Now choose File > Print to open the Print dialog box. All the changes you make in the Print dialog box and the print settings will be recorded as a component of the action. I start by setting the printer to the Epson Stylus Pro 4900, click Print Settings, set it to US Letter Sheet, select Paper Cassette, Exhibition Fiber, SuperPhoto 2880, and set Finest Detail to On. There are no more paper settings involved, and I won't alter the advanced media control. Then I click Save.

Back in the Photoshop Print Settings dialog box, choose Photoshop Manages Colors. Select the profile; I'm going to select the Epson – 4900 – FA- Baryta, which uses the Exhibition Fiber paper settings I selected in the printer settings.

Select Normal Printing, then Relative Colorimetric, with Black Point Compensation turned on. For the purposes of this demonstration, I'll select Scale to Fit Media. Then I'll click Print. **Figure 4.40** shows the result of recording the action in Photoshop.

Figure 4.41 shows the expanded display of all the parameters recorded in the action. Notice the print options included in the action: color space, RGB color, the profile, the rendering intent, the printer name—literally everything that was set in both the Photoshop Print dialog box as well as the printer driver. Notice that the Print One Copy is checked in the action steps. If I played that action, it would send the image to the printer and make a print. If you only want to set the settings, uncheck that option. The result will be the same as simply clicking Done in the Photoshop Print dialog box.

Once you've recorded an action, you can close the document without saving and have access to all the settings quickly in any document. For example, when I open a new image that hasn't had any printer settings stored in it, I can just select the 4900 Letter action in the Actions panel and click Play, and all the settings that were recorded in the action have been propagated into the Photoshop Print Settings dialog box: the color handling, printer profile, print settings, size, and position. So once all the settings are propagated, I need only make any changes on a per-image basis and then I can print. The action serves as a print preset so that all the settings are handled and you just need to customize it for your specific image. Sadly, the Canon printer plug-in does not capture all the plug-in settings—a weakness of the plug-in.

You can extend this basic action by incorporating a series of additional actions before you play the print action. For example, you could create actions for sizing, positioning, and output sharpening. You can actually create a multiset action. Then, in Bridge, select the images, choose Photoshop > Photoshop Batch, and set up your Photoshop actions in the Batch dialog box.

FIGURE 4.41 The recorded parameters of the action and unchecking the Print One Copy step.

FIGURE 4.42 The Conditional Action dialog box.

But wait, there's more! With the release of Photoshop CS6.1 (13.1), and continued in Photoshop CC, is the ability to record actions using a Conditional Action step in your actions. After creating a new action, go to the Actions panel flyout menu and select Insert Conditional. **Figure 4.42** shows the Conditional Action dialog box and the If Current menu showing all the possible potential conditional options.

This is a simple if/then set of conditions. If the condition is met, then you can select a previously recorded action to play. If the condition is not met, then you can choose a different action to play. OK, I'll admit this is sort of geeky, but if you are experienced in recording actions, this new functionality is an important feature of Photoshop automation. But if you combine a conditional action step in a series of recorded steps, then you can do a Batch command from Photoshop or Bridge. **Figure 4.43** shows the recording of a simple conditional step to rotate a landscape image to portrait orientation prior to printing.

FIGURE 4.43 Recording a conditional action step.

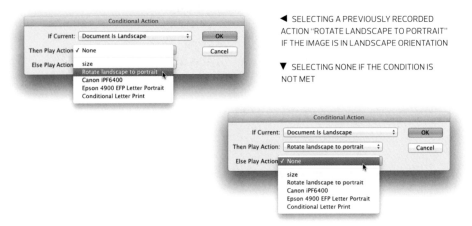

◀ SELECTING A PREVIOUSLY RECORDED ACTION "ROTATE LANDSCAPE TO PORTRAIT" IF THE IMAGE IS IN LANDSCAPE ORIENTATION

▼ SELECTING NONE IF THE CONDITION IS NOT MET

When run on an image, if the orientation is Landscape (meaning wider than taller), the conditional will run the action to rotate the image from landscape to portrait orientation. If the image is not landscape, nothing will be done. If this conditional step is added to additional action steps, then you can use the series of steps to automate the processing of multiple images. **Figure 4.44** shows an action named Conditional Letter Print that contains the previous example conditional step plus the running of an image resize step, a Print Options step, and a Print One Copy step followed by a Close step (without saving).

The conditional action step will rotate landscape images to portrait, but it won't impact square or portrait images. All images will be sized to an 8-inch height and then printed. Since the last step is to close without saving, you don't need to worry about overwriting your original files. Using Bridge you could select a series of images and print them without having to deal with landscape or portrait orientations, then size them and make prints using a Photoshop Batch command.

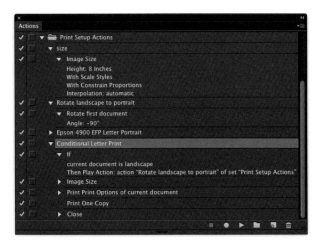

FIGURE 4.44 The Conditional
Letter Print action.

PRINTING FROM LIGHTROOM

Unlike Photoshop, Lightroom is built on the concept of modularity. Different functionality is available in different modules. In the Library module, you can create collections. When you're getting ready to print, create a collection of the images that have been soft proofed and are ready to go. It's best to select an image from a collection when you're in the Print module. You can select a single image from the library and print it, but one of the major benefits of working in the Lightroom is the ability to work with larger volumes of images at a time.

When you've soft proofed and prepared your images, go to the Print module (you can use the Mac keyboard shortcut Command+Option+6 or Control+Alt+6 for Windows). The right side of the Print module has panels that let you set up parameters for printing. The left side has panels for templates and collections. **Figure 4.45** shows an image in the Print module (note I've hidden the top bar and collapsed the Collections panel to save space). Select your collection from the Collections panel on the left. Then select the image you want to work with from the filmstrip at the bottom of the application window.

First, you need to set up a page. Click Page Setup at the bottom of the panel set on the left side. Then select a printer and a paper size. I'm selecting a custom 8.5 x 11 inches with four equal margins of 0.75 inch. Then click OK. Unlike Photoshop, which combines the page setup and printer settings in one dialog box, Lightroom separates them into two. I'll come back to the Print Settings dialog box later. **Figure 4.46** shows my Collections panel with Prints selected and the Page Setup dialog box for the Mac.

FIGURE 4.45 The Lightroom
Print module.

FIGURE 4.46 The Collections
panel and Page Setup dialog box.

▲ COLLECTIONS PANEL

▲ PAGE SETUP DIALOG BOX

In Windows there's a single button named Page Setup that launches the standard Printer Properties dialog box. The reason I suggest starting with selecting the printer and page setup first is that all of the parameters you'll be adjusting in the panels on the right will be set based on the paper and margin sizes. It's more efficient to start with the correct paper size!

FIGURE 4.47 The Layout Style panel.

THE LAYOUT STYLE PANEL

The first panel on the right side is the Layout Style panel. If you're making a single print or a contact sheet, select Single Image/Contact Sheet. **Figure 4.47** shows the Layout Style panel.

Picture Package

Picture Package lets you include different sizes of the same image on a single page. This option is often used for portraits or wedding photos, when a client might order an 8 x 10, a 5 x 7, and a couple of wallet prints. It's useful in a production environment because you can gang multiple images on a sheet, and then cut them into separate images after printing.

▲ TEMPLATE BROWSER SHOWING PREVIEW

If you select Picture Package, you'll usually select a template from the Template Browser panel on the left side of the application window. I chose (1) 7 x 5, (4) 2.5 x 3.5. However, you don't have to use Lightroom templates. When you select Picture Package, a Cells panel appears; in that panel you can create a new page and add preconfigured sizes to it, mixing and matching to suit your needs. Click the triangle next to an option to see more sizes, or choose Edit from the dropdown menu and create a new custom size. **Figure 4.48** shows the Template Browser and Preview as well as the Cells panel. The Height and Width sliders are active because I've selected the 5 x 7 image. Otherwise, if no cell is selected, the sliders are dimmed.

Picture Package always uses a single image in an array of differently sized images. Once the images are arrayed, you can click Auto Layout, which configures and rotates the images for maximum efficiency on the paper. In the Cells panel, you can adjust individual cells to make them bigger or smaller. How the Height and Width sliders affect the cell depends on the options selected in the Image Settings panel. If Zoom to Fill is selected, the image zooms in or out to fit the cell borders. If you want to maintain a specific crop, deselect Zoom to Fill. Rotate to Fit is probably one of the things I like best about the Lightroom Print module, because you can rotate images and not have to worry about the landscape and portrait mode. **Figure 4.49** shows the result of selecting the template with the Zoom to Fill option unchecked.

▲ CELLS PANEL

FIGURE 4.48 The Template Browser and Cells panel.

FIGURE 4.49 The results of selecting the (1) 7 x 5, (4) 2.5 x 3.5 template.

Custom Package

Below Picture Package is Custom Package. Unlike Picture Package, Custom Package allows you to put different images on the same page. You can size and position them however you'd like. **Figure 4.50** shows an example of a really simple one using the template Custom Overlap x3 Border. Click and drag an image from the filmstrip and drop it into the individual cell. Using Custom Package, you can still add individual cells from the Cells panel. Figure 4.50 shows the template, preview, the template browser, and an array of three vertical images.

Photographers might use the custom package to do promotional prints. While Picture Package is often used for customers, Custom Package is often used for self-promotion. But a wedding photographer might have a custom package with a group shot up above and a variety of individual shots below. It's designed as a method of putting multiple images on the page in a somewhat limited layout design. It's certainly not intended to take the place of InDesign.

▲ TEMPLATE PREVIEW

Custom 1 over 2	
Custom 2 over 1	
Custom 4 square	
Custom Centered	
Custom Overlap x 3	
Custom Overlap x3 Border	
Custom Overlap x3 Landscape	
Custom Square + 2	
Fine Art Mat	
Maximize Size	
Triptych	

▲ TEMPLATE BROWSER

▲ THE RESULT OF THE TEMPLATE WITH IMAGES PLACED

FIGURE 4.50 Custom Package.

For both package types, you can add a border and an inner stroke in the Image Settings panel. The border ends up being white; the inner stroke has a custom color—you can select any tone. You can't select a color, but you can select the tone. You can customize and eventually get a spectrum of colors, but generally speaking, my aesthetics are such that I wouldn't want to have a weird color border.

Contact Sheet

The Single Image/Contact Sheet layout style (shown in Figure 4.47) allows you to create traditional multi-image contacts similar to the old analog contact sheets where you would place a page of negatives over photo paper in the darkroom. The Lightroom contact sheet is a lot easier to use. **Figure 4.51** shows the result of selecting the Lightroom 4 x 5 Contact Sheet template and selecting the images in the collection to put into the contact sheet.

In the Page panel, I've selected a couple of options to add to the contact sheet. I'll include page numbers (because the resulting contact sheet will be three pages long) and select the Photo Info option to add the filename under the images. I'll also check the option to Keep Square in the Layout panel. **Figure 4.52** shows the Page panel, the Text Template Editor dialog box, and the Layout panel.

The Text Template Editor allows you to select various options and insert them as "tokens" into the text that will be displayed in the print. For a contact sheet, obviously you would want the filename for identification, but you could also add additional text such as your copyright info. You can't add a hard return (hitting the enter or return key will close the dialog box), but you can add spaces to separate the tokens. The text will wrap to multiple lines, depending on the overall text length. Also note you can simply enter text directly into the editor and not be bound by the tokens. At the top is a menu that allows you to save the text settings as a preset. The ability to add text under the images isn't limited to contact sheets; you can add text to any layout

▲ THE PAGE PANEL

▶ THE TEXT TEMPLATE EDITOR DIALOG

▲ THE LAYOUT PANEL

FIGURE 4.52 The Page Info panel, Text Template Editor dialog, and Layout panel for configuring the contact sheet.

style. The limitation is that you can't alter the font or the color (it's a default sans serif font that will be different on Mac and Windows), but you can alter the font size.

You can change the grid, the cell spacing—vertical and horizontal—and the cell size. For the most part, if you're creating contact sheets, I'd suggest keeping the cells square so that horizontal, vertical, and square images all fit within the same area. That will make your contact sheet more coherent and make it easier to identify image by image. To add pictures to the contact sheet, just select multiple images in the filmstrip. You can see the grid you're using in the Preview panel in the upper-left corner of the application window.

For making contact sheets to send as PDF files, you can select Draft Mode Printing in the Print Job panel to use Draft Mode Printing; this will render the images from Lightroom previews without rendering the full resolution from your original images. This option is really fast. **Figure 4.53** shows the Print Job panel set to Draft Mode Printing, the Print dialog box choosing the Save as PDF option, and the final saved contact sheet PDF (which was a 4 MB file on disk). Note that the Mac Print command includes the ability to print to PDF. For Windows, you'll need to download a utility add-on to print to PDF (do a Google search for "print to PDF on Windows").

FIGURE 4.53 Saving the contact sheet PDF.

▲ THE PRINT JOB PANEL WITH DRAFT MODE PRINTING OPTION SELECTED

▲ THE MAC PRINT COMMAND WITH SAVE AS PDF SELECTED

▲ THE FINAL PDF FILE SAVED ON DISK

THE IMAGE SETTINGS PANEL

As I mentioned in the Picture Package section, you should leave Zoom to Fill unchecked if you want to maintain the crop on your image. That's true no matter which layout style you've selected. I selected Rotate to Fit; in this case, if I deselect it, the image becomes a smaller image in the center of the page, but with Rotate to Fit selected, the same image is rotated to fill the cell size automatically. **Figure 4.54** shows the Image Settings panel with Rotate to Fit checked. It also shows the horizontal image auto rotated, and the unrotated size and position with the Rotate to Fit unchecked.

Depending on how many images you have selected in the filmstrip, you may want to select Repeat One Photo Per Page. Another option is to apply a stroke border. Normally, I wouldn't have a border on anything other than a high-key shot that might have white or very light tones all the way to the edge. I like to use a stroke border as a method of creating a holding rule on the image. **Figure 4.55** shows a high-key image with a 2-pt black stroke around the image. Here, the stroke border will help contain the image and provide a final border around it, giving an indication of where the image ends and the margins start.

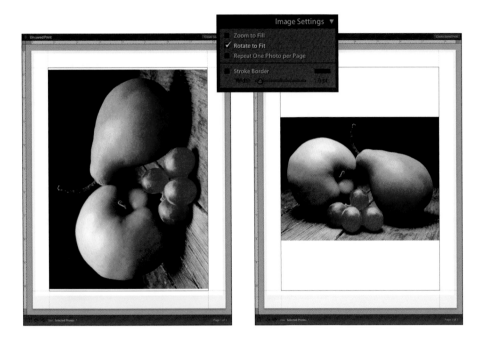

FIGURE 4.54 Using the Rotate to Fit option in the Image Settings panel.

FIGURE 4.55 Using a 2-pt black stroke to contain a high-key image.

THE LAYOUT PANEL

You can choose to use inches, centimeters, points, or picas, but I'll stick with inches. You can independently control the top, left, right, and bottom margins. Use the slider to vary the width. In this case, I'm moving the slider for the left margin to the right; instead of using the slider, you can enter a number, which I find is generally more precise. You can also hover your cursor over the margin in the image window and drag the margin on the page itself. When you do that, the cursor changes from a pointer to a cross with horizontal arrows. **Figure 4.56** shows the Layout panel, using the scrubby slider to adjust a margin or dragging the cursor directly on the print margin guides.

FIGURE 4.56 The Layout panel and margin adjustments.

▲ THE LAYOUT PANEL

▲ ADJUSTING THE LEFT MARGIN WITH THE SCRUBBY SLIDER

▲ ADJUSTING THE LEFT MARGIN BY DRAGGING THE MARGIN GUIDE

While you can make borderless prints, my general recommendation is to print with a margin of some width for conservation purposes. In this case, I've created a ¾-inch margin on all four sides.

If you're printing a single image, the cell size is the equivalent of the image size in Photoshop. It lets you make the image on the print larger or smaller. It will always print only within the margins you set up above, but this allows you to precisely control the size of the printable cell. This is useful, particularly when you're making multiple prints at once. Just set up the cell size and click Print.

THE GUIDES PANEL

If you select Dimensions in the Guides panel, the physical dimensions and the native resolution of the image are displayed in the upper-left corner of the image itself. The width and height are displayed in three-decimal-point precision, because engineers

▲ THE GUIDES PANEL

▲ THE DISPLAY OF DIMENSIONS AND RESOLUTION ON THE PRINT DISPLAY

▲ CHECKING THE PRINT RESOLUTION OPTION IN THE PRINT JOB PANEL

▲ THE DISPLAY OF DIMENSIONS ON THE PRINT DISPLAY

FIGURE 4.57 The Guides panel with the Dimension guide checked.

are nothing if not precise. This image will print at 763 pixels per inch. If I select Print Resolution in the Print Job panel, the image dimensions remain, but the PPI goes away because Print Resolution resamples the image to the resolution entered in the entry field. **Figure 4.57** shows the Guides panel with all the guides checked.

You can deselect Show Guides and they all go away. Then the image preview looks like a print hanging on a wall because it shows the image, the white margin of the paper, and a subtle drop shadow. It looks like a real print. While I'm actually working, though, I find it's useful to keep Show Guides selected so I can see the rulers, margins, image cells, and gutters if the image breaks across two pages. By the way, you can change the background of the area around the print display by right-clicking in Windows (Control-click on the Mac) on the background. **Figure 4.58** shows the context menu.

FIGURE 4.58 The context menu to change the Background Color.

THE PAGE PANEL

In the Page panel, you can change the background color or tone for the page. If you select Page Background Color, the tone or color you select will be printed within the printable margin of the image. The only warning I'd give is that if you're going to print a solid-color background, you'll be using up a lot of ink. Also, if you want an absolute jet black background, it will use an enormous amount of ink and the paper may get a little wavy until the ink is dry.

You can also add an identity plate to the image. When Lightroom was first developed, the Lightroom engineers originally called these *vanity plates*, and the early betas showed your name in an image that looked like a license plate. But by the time they shipped the product, they'd switched to calling them *identity plates*. You can select an existing identity plate from the dropdown menu or click Edit to customize one. In the Identity Plate Editor dialog box, type in text and choose a font. You can also create a graphical identity plate, using an image you copy and paste into this space.

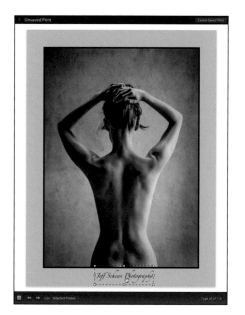

▲ THE PAGE PANEL

▲ THE IDENTITY PLATE EDITOR (ACCESSED FROM THE TRIANGLE DROPDOWN MENU IN THE IDENTITY PLATE PREVIEW)

▲ THE IMAGE WITH THE IDENTITY PLATE BEING POSITIONED

Identity plate images can contain transparency, so you could copy a logo you'd done in Illustrator and saved as a PNG with transparency. (You could also use it anywhere else in Lightroom that uses identity plates, including slideshows and preparing images for the Web.) **Figure 4.59** shows the addition of an Identity Plate to an image.

You can position the identity plate anywhere you want. To resize it, click and drag an edge or a corner and it will keep its proportion. You can override the text color: click Override Color and select a new color. I'll drag my name to the center underneath the image and scale it to 30%. The Identity Plate is giving the appearance of an actual signature (sort of). You can also change the opacity. You can even render it behind the image, which I always thought was a cruel joke, because if it's behind the image, you can't see it, but it could come out from underneath the image depending on the design element you're using.

The Page panel also gives you the option to add a watermark. If you're providing proofs to people that you don't want them to keep, you can add a copyright notice, which is what I have it set to by default. (To get the copyright symbol, press Option+G on the Mac. In Windows, press Alt+0169 on the numeric keyboard.) If you've saved watermarks, you can choose one; otherwise, choose Edit Watermarks from the pop-up menu. In the Watermark Editor, you can create a text watermark,

▲ THE WATERMARK EDITOR

▲ THE WATERMARK ADDED TO THE IMAGE

FIGURE 4.60 Adding and editing a watermark on the image.

customizing text options that include a shadow, radius, and angle, or place a graphic. You can control the watermark effect, including its opacity and size. The anchor point ensures that the watermark stays in the proper position even if you rotate or reposition the image. To save the watermark, click Save, and then name it. **Figure 4.60** shows adding a watermark to the printed image.

You can print page numbers, which would be useful on a multipage contact sheet. If you select Page Info, Lightroom includes the sharpening setup, the profile saved relative to the soft proof, and the printer. You can also print crop marks at the corners. This can be useful with a picture package, especially if you need cutting guides.

The Photo Info option lets you print custom text or multiple metadata fields. The only problem that I have with Photo Info is that you don't have any control over where it prints. It automatically defaults to be centered beneath the image. The only control you have is the font size, not even font colors or the font itself.

THE PRINT JOB PANEL

You can print to a printer or a JPEG file. Printing to a JPEG file lets you set up a custom layout, either a single or multi-image layout, with identity plates and page options, and then save that as a JPEG to send to a third-party printer. When you choose JPEG File from the Print To menu, the Print Job panel changes. You have options for file resolution, print sharpening, JPEG quality, custom file dimensions, and a color management profile, usually set to sRGB because most print labs unfortunately are not color-managed and request sRGB JPEGs. You also have Print Adjustment options, which I'll address later in this section. **Figure 4.61** shows the Print To dropdown menu and the Print Job panel when set to Printer and JPEG File.

When you choose JPEG File from the Print To menu, you have fewer options in the Print Job panel. Let's go through them.

The Draft Mode Printing option uses the saved preview of the image, so printing is very fast. Lightroom already has previews and thumbnails of all the images, so if you print using the existing preview, you don't need to re-rasterize the raw file. This is very useful if you're creating a contact sheet, whether you're printing one or saving it to PDF to send through email. When Draft Mode Printing is selected, the other options in the Print Job panel are dimmed. The contact sheet templates that come with Lightroom all select Draft Mode Printing.

You can use the Print Resolution setting to override the native resolution of the file, and then upsample or downsample. It uses Lightroom's optimized interpolation method, as described in Chapter 3. I feel strongly about interpolation. In the

FIGURE 4.61 The Print Job panel.

▲ THE PRINT JOB PRINT TO MENU

▲ THE PRINT JOB PANEL SET TO PRINTER

▲ THE PRINT JOB PANEL SET TO JPEG FILE

next chapter, I'll demonstrate why you'd want to upsample, which I also talked about in Chapter 3.

Note that when you select Print Resolution, the dimensions in the upper-left corner of the actual image no longer show the native resolution. That's because you're overriding the native resolution and resampling. I'll keep it at 720 PPI, which is the maximum. It comes up with a little warning, and it tells you the higher resolution could cause memory issues on some printers. It's really asking if you know what you're doing. We do, so click OK.

The next option is Print Sharpening. As discussed in Chapter 3, if you know what you're doing in the Develop module, use Standard here. If your sharpening settings were set at the default, use High. If you've oversharpened, use Low. This is something you'll just have to test to convince yourself that this stuff really does work very well.

For Media Type, choose Glossy for anything that has a sheen or is a coated paper. If you're printing to matte, watercolor, or fine art paper, generally speaking, choose Matte. The sharpening is different because the paper itself has an impact on the way detail is rendered. Through testing, the Lightroom engineers and I have optimized this. In fact, Adobe licensed the output sharpening routines from PhotoKit to include in the Lightroom and Camera Raw print modules, so I feel pretty good about them.

On the Mac, you can select 16 Bit Output. In Windows, you cannot. I discussed the benefits earlier so I won't dwell on it here.

In the Color Management section (shown in **Figure 4.62**), if you choose Managed by Printer, Lightroom will just send the data tagged with its internal RGB space—the ProPhoto RGB color coordinates but with linear gamma—to the printer. There are a couple of reasons you may want to use this option. If you're using the Epson Advanced Black & White mode, you want the printer to manage color, because the Advanced Black and White mode is a component of the printer driver and lets you control how the color image is printed in black and white.

However, if you're printing color or a color image with monochromatic toning or split toning, select the profile that is correct for the printer and the paper you're using. In Lightroom, you can control what profiles you actually see in the dropdown menu. To add profiles, click Other, and the Choose Profiles dialog box displays every single RGB color profile that is installed on your system. I have a lot because I've got so many printers. The Choose profiles dialog box shows RGB profiles, but Lightroom won't display or use CMYK profiles or grayscale profiles. If you want to see display profiles, select Include Display Profiles at the bottom of the dialog box, then just click the check box next to each profile you want to display. If you're printing to JPEG, you'll always have the option of selecting your profile, regardless of what is displayed in the main color management dropdown menu.

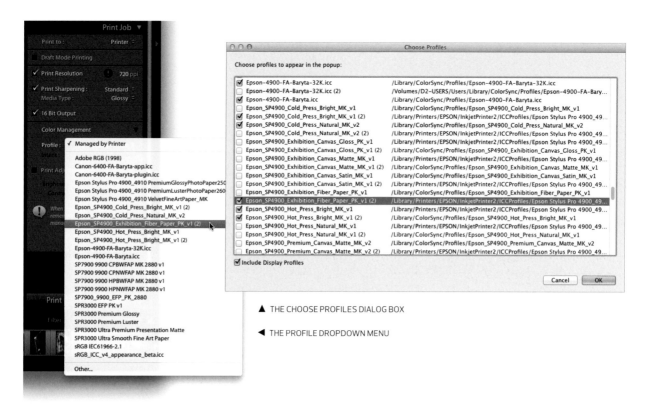

FIGURE 4.62 The Color
Management section.

▲ THE CHOOSE PROFILES DIALOG BOX

◀ THE PROFILE DROPDOWN MENU

Now you can select the rendering intent. This is something you've already determined in the soft proofing. Selecting one or the other will have no impact on the preview in the print module; you should have already determined which will work best for your image.

The last section in the Print Job panel is Print Adjustment, which is Thomas Knoll's answer to the age-old problem "Why do my prints look so dark?" Many people have a problem with a computer display that pumps out 200 cd/m^2 (candelas per meter squared). Computer displays are so bright that the image is brighter on the display than under the viewing light, so your print ends up looking dark. If you have a proper viewing environment, which I talked about in Chapter 2 and showed the results of in Chapter 3, the image on your display and the image on the print should match under the viewing light. However, if you don't have a proper viewing environment, you can adjust Brightness and Contrast here. People were complaining, and Thomas Knoll said, "Let's just put a gamma adjuster in the print module so people can make the changes right there without going back and adjusting image settings." Color management folks were aghast, but this is actually a very elegant solution.

If you have a consistent problem with your images coming out dark, you can use the Brightness slider to adjust how the image is handled without messing around with your profile or image settings. The Brightness slider is literally a gamma adjustment, moving the midpoint lighter or darker. As you move the slider to the plus side, say +50, it's brighter by 50 units, but those units don't translate to anything—it's just an arbitrary unit. The differences are actually quite subtle. Moving the slider to 10 is barely visible, 30 is noticeable, and over 50 it's a strong adjustment. Test your assumptions in print, though, because you get no feedback from these sliders in the preview on the screen.

The Contrast slider gives you a simple S-curve contrast adjustment. You can't decrease it, only increase it. **Figure 4.63** shows the result of modifying the output by altering the Print Adjustment settings.

I recommend setting up your computer display and viewing environment so that the white you see on your computer and on the paper in your print visually match, so you won't have to worry about print adjustments. However, the adjustment sliders are definitely helpful if you know you're printing for a specific condition, such as dim home lighting. This is something to test on your own. If you make prints for sale, you can make prints that are designed for a good viewing environment, such as a proper home display, or for a dim home display. You can use the brightness and contrast adjustments to alter the final output based on the display conditions.

FIGURE 4.63 Comparing results using the Print Adjustment sliders.

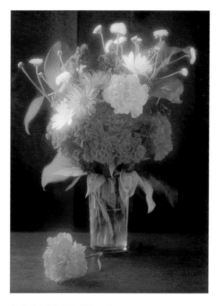

▲ THE IMAGE PRINTED WITHOUT PRINT ADJUSTMENTS

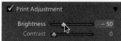

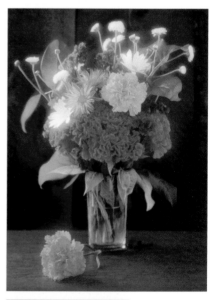

THE PREVIEW PANEL

As I mentioned earlier, the Preview panel shows you the configuration of cells on the page. If you hover your cursor over a template, its configuration shows up in the Preview panel so you can quickly see how it's set up. Since I'm usually working with a single image, I hide the Preview panel so the entire left column is available for the Template Browser and Collections panels. Roll over the Lightroom Templates and see the preview for yourself!

THE TEMPLATE BROWSER PANEL

The Template Browser panel contains a variety of templates that come with Lightroom, as well as any user templates you've created. The use of templates is one of the major reasons I love printing from Lightroom. When, not under pressure, I can create a template for the standard way I like to print, including the margins, sizes, sharpening, print resolution, color management—all captured in the template. That way I can select a template, click Print, and then make the print quickly without worrying about selecting each setting correctly. The other thing that's cool is if you have a bunch of images selected in the film strip, you can just click the template you want to use and click Print. If you have ten images selected, you'll have ten printed. You don't have to open them image by image, or fiddle with dialog boxes for drivers and print setups, as you would in Photoshop, where you have to open each one and set the settings and hit Print ten times. **Figure 4.64** shows my tidy Template Browser with folders of templates for my printers. I don't really like storing a bunch of loose templates in the default User Templates folder.

FIGURE 4.64 The Template Browser panel.

To create a user template, set up the right-panel parameters the way you want them, and also choose your page setup and print settings. Then click the Plus button at the top of the Template Browser panel and give your new template a meaningful name. You can click and hold down the Folder button—either just add it to User Templates or create a new folder. I like to create a new folder for each printer's templates. **Figure 4.65** shows clicking the Create New Preset (meaning template) button, naming a new template, and the New Folder dialog box accessed in the Folder dropdown menu of the New Template dialog box.

When you select a template, the chosen template is highlighted so you know that all of the right-side parameters and the page setup and printer driver settings are as they were when the template was created. You are free to modify any of the settings on the fly. If you do, the template that you started from is dimmed (although any unchanged parameters are still preserved). If you want to change the template to include any newly updated parameters, right-click in Windows (Control-click on

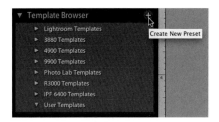

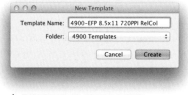

▲ THE CREATE NEW PRESET BUTTON

▲ THE NEW TEMPLATE DIALOG BOX

▲ THE NEW FOLDER DIALOG BOX

FIGURE 4.65 Making a new template.

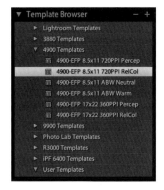

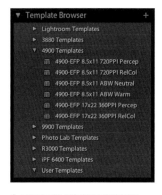

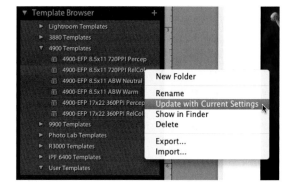

▲ THE ACTIVE TEMPLATE HIGHLIGHTED

▲ THE TEMPLATE WITH CHANGED PARAMETERS

▲ THE CONTEXT MENU TO UPDATE THE TEMPLATE

FIGURE 4.66 Updating a template.

the Mac) the template you want to update. **Figure 4.66** shows the active template highlighted, the template dimmed (because of a changed parameter), and the context menu to update the template.

To update a template, select it and make a change in any of the settings. Once you've made a change from the saved state of the template, the template is dimmed. Right-click (Windows) or Option-click (on the Mac) the template, and then choose Update With Current Settings. The changes you've made are saved in the existing template.

The context menu also lets you rename the template, delete it, or import or export templates. Importing templates is useful if you're updating from an earlier version of Lightroom.

You can make changes without saving them to a template, too. You can use the template as a starting point, and then adjust settings on the fly for an individual print or set of prints. You can also save a new template with the slightly different settings.

THE COLLECTIONS PANEL

The Collections panel lists all your saved collections. You create collections in the main library, which is a great way to collect a bunch of images. I've got a collection called *Prints*, which is inside a Collection Set named *TDP-collection* (the TDP stands for the title of this book). I've got a collection of images that have all been prepared for printing. **Figure 4.67** shows my Prints collection.

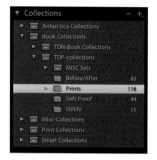

FIGURE 4.67 My Prints collection.

The Collections panel lets you select any of your saved collections from the main part of the library. Note that you'll need to create and save collections in the Library module of Lightroom. All you can do in the Print module is select a collection and an image from the filmstrip. To further extend the usefulness of Collection, you can, however, create what is called a *Saved Print collection* from within your library created collection.

CREATING A SAVED PRINT COLLECTION

Everything I've talked about so far is about printing a single one-off print or contact sheet. You may have noticed the words Unsaved Print in the image window; that indicates it's a single-image print setup with a specific template, but it's not saved anywhere. But Lightroom will create a saved print collection when you click Create Saved Print above the right side of the image window. In the Create Print dialog box, you can name it and control where it appears in a collection. **Figure 4.68** shows the Unsaved Print indicator and the Create Saved Print button.

▲ THE UNSAVED PRINT INDICATOR

▲ THE CREATE SAVED PRINT BUTTON

FIGURE 4.68 The Unsaved Print indicator and the Create Saved Print button.

The Create Print dialog box offers some options to use while making a new creation (**Figure 4.69**). You can choose Make New Virtual Copies. You may want to go in on an image-by-image basis to change things such as cropping, for example, for a specific print show or for standard pre-cut mats. Then you'd definitely want to make new virtual copies. The Include Only Used Photos option is more useful in the Book module. If you select Set As Target Collection, anytime you go to a saved creation in the collections panel, the same group of images will be available automatically.

After selecting the options you want, click Create. Notice that where the Prints name was just a single entry in the Prints collection in Figure 4.67, now it appears as a hierarchical menu (**Figure 4.70**). It shows that 58 of the 116 images were selected as shown in Figure 4.70. If I need to add or subtract images from the Saved Print creation, I can add or delete them from the Library module. The saved creation is really saving a collection of the images and attaching them to a group. It's an enormous time-saver if you have to do this on a regular basis. For example, a photographer can save a print portfolio this way, and then easily add new images to the print show creation or take images out, always ready to print a new portfolio.

> **NOTE** I'm a big fan of "creationism," but it has nothing to do with religion. Creationism is the concept of saving a certain creation so you can always get back to it. All of the Lightroom modules where you "create" things like prints, slideshows, books, or Web galleries have this same "create" capability.

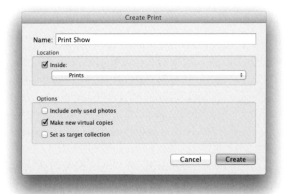

FIGURE 4.69 The Create Print dialog.

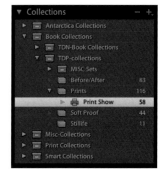

FIGURE 4.70 The saved Print creation.

THE TOOLBAR

Below the image window, you have a toolbar. If you hit the T key, it goes away. From the Use menu, you can choose Selected Photos, All Filmstrip Photos, or Flagged Photos. Be careful that you don't select All Filmstrip Photos unless you absolutely know how many are in the filmstrip and that you want to print them all, or you may end up with hundreds or thousands of photos printed. I always choose Selected Photos so I know I'll get the photos I've chosen. Flagged photos are photos you've marked in the Library. **Figure 4.71** shows the main Toolbar and the Use dropdown menu.

FIGURE 4.71 The Toolbar (upper center) with filmstrip and the Use dropdown menu.

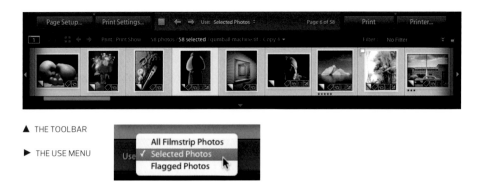

▲ THE TOOLBAR

▶ THE USE MENU

PRINTING

Lightroom for the Mac has two buttons at the bottom of the left pane: Page Setup and Print Settings. We've already looked at the Page Setup dialog box. The Print Settings dialog box gives you the Print dialog box with the same basic options you had in Photoshop. **Figure 4.72** shows the Mac Page Setup and Print dialog boxes.

In Windows, there's just one button: Page Setup. Clicking that button opens the Print dialog box. Click Properties to see printer-specific settings, as shown in **Figure 4.73**.

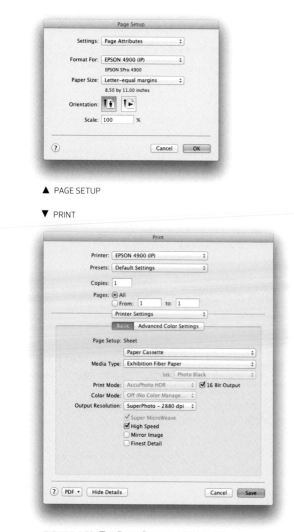

▲ PAGE SETUP

▼ PRINT

FIGURE 4.72 The Page Setup and Print dialog boxes.

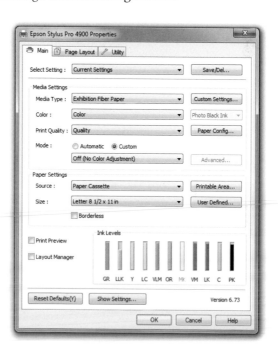

FIGURE 4.73 The Windows printer Properties dialog box.

After you've set everything up, if you click the Print button in the toolbar, Lightroom sends the image to the printer in the configuration you have set up. No additional dialog box is necessary. However, if you click Printer in the toolbar, you'll see the standard operating system Print dialog box so you can control the printer features.

PRINTING A BLACK-AND-WHITE IMAGE

When you print a black-and-white image, approach the process differently than when you're printing color images. I'm using a collection of 27 images called Print Show Sepia. I'll work with an image of driftwood that is sepia-toned, essentially split toned. It's a natural split tone because these are copies of prints that were chemically toned and made in my darkroom (yes, I still have one) that have now been digitized.

PRINTING BLACK-AND-WHITE TONED IMAGES USING ICC-BASED COLOR MANAGEMENT

If your image is black and white with a tone, and you want to maintain the classic split-tone look, print using ICC-based color management. Select the profile for the printer and paper you want to use, then proceed as you would for a color print. **Figure 4.74** shows the image in the Print module and a scan of the final print. You can see that the print maintains the split-toned look of the original image.

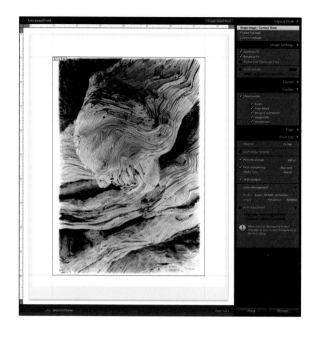

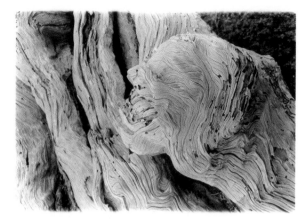

▲ THE SCAN OF THE FINAL PRINT

◀ THE IMAGE IN LIGHTROOM PRIOR TO PRINTING

FIGURE 4.74 The sepia split–tone image in Lightroom and the scan of the final color print.

PRINTING BLACK–AND–WHITE IMAGES USING A SPECIAL BLACK–AND–WHITE MODE

There are some advantages and disadvantages to printing black-and-white images using a normal color-managed workflow. Particularly when printing neutral images, there is a tendency to have the prints contain a slight tint or color cast. This is because ICC output profiles are really designed to handle color appearance, not render neutral black and white. For really neutral black-and-white prints, I would suggest one of the following options.

Epson Advanced B&W Photo mode

The Epson Advanced Black and White (ABW) mode works the same in Photoshop and Lightroom. To print using the Epson ABW mode, choose Managed by Printer, then click Print Settings. In the Print dialog box, choose Advanced Black & White Photo from the Print Mode menu. **Figure 4.75** shows the Epson Stylus Pro 4900 printer driver selecting the Advanced B&W Photo option.

FIGURE 4.75 Selecting the Advanced B&W Photo in the Print Mode menu.

For color toning, you have defaults of natural, warm, cool, and sepia. My preference is to click Advanced Color Settings to open a whole different dialog box that lets you select the tone, brightness, contrast, shadow tonality, highlight tonality, and maximum optical density. I don't adjust any of those. I will only change from Darker, the default, to Dark.

In Advanced Color Settings, if you adjust the brightness, you see the effect on Greg's image, not yours. Neither Mac nor Windows offers a pipeline for interactivity; because the printer driver hasn't gotten the image yet, it can't preview the image you're going to send it. **Figure 4.76** shows the Color Toning menu and the Tone menu in the Advanced Color Settings panel.

The other option I use is the ability to add a color toning. You can select Warm, which isn't too bad and kind of looks like traditional Sepia—but if you select Sepia, it looks kind of like baby-poo brown.

▲ THE COLOR TONING MENU ▲ THE TONING MENU

FIGURE 4.76 The Advanced Color Settings tab for the Advanced B&W Photo option.

The color wheel and a crosshair lets you change the horizontal or vertical numbers to adjust the color tint that's applied. On the side, there's a horizontal and a vertical readout. When you center it up at 0,0, it is intended to be neutral, but I actually think it looks a tiny bit too cool, so I use a horizontal setting of 4 and a vertical setting of 8 to reduce the coolness.

I tend to keep the Optical Point Shift option off. You can turn it on or on full page. It prints a very, very light scum dot over the entire image. The scum dot cuts down on the gloss differential, explained in detail in the next chapter. I keep that at 0. In fact, I use all the controls at 0 because I don't want to fiddle with numbers and sliders when I can't actually see how I'm affecting things.

When you've adjusted your settings, click Save. Also, I suggest creating a new template previously shown in Figure 4.65—then, just make the print. **Figure 4.77** shows scans of prints using each of the default Color Toning settings.

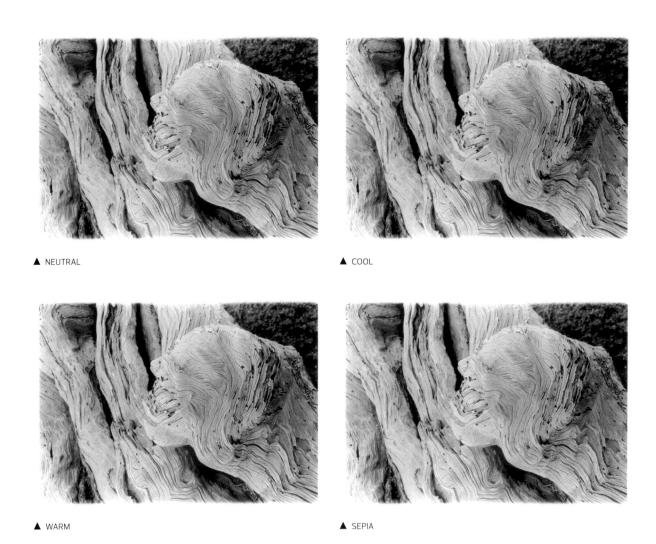

▲ NEUTRAL

▲ COOL

▲ WARM

▲ SEPIA

FIGURE 4.77 Comparing results from the Epson Advanced B&W Photo mode.

Canon Monochrome Photo

In order to print black and white to the Canon, I can print from Photoshop or Lightroom. Printing a black-and-white image using the printer driver is the same. The Canon special Monochrome (Photo) color mode is available in both the printer driver as well as in the Canon Photoshop plug-in (although the plug-in offers some extra functionality). When using Monochrome (Photo) in the printer driver in Photoshop or Lightroom, you must set the color management to be managed by printer on the Mac (in Windows it doesn't matter—yet) **Figure 4.78** shows selecting the Monochrome (Photo) option from the Color Mode menu.

FIGURE 4.78 Selecting the Monochrome (Photo) option in the Color Mode menu.

Once you select Monochrome (Photo), click the Set button to access the special Color Settings option for Monochrome (Photo), as shown in **Figure 4.79.**

To adjust the color balance, select an option from the dropdown menu or drag the color sliders. Below the color balance settings is a Tone menu. You can change it to soft (light) or strong (makes it darker). I'll set it to Medium-hard tone. You can alter the brightness, contrast, highlight, shadow, and tint. In the printer driver version, you don't have access to special curves or a preview of the effect on your image (just like the Epson printer driver), but you do in the Photoshop plug-in version.

▲ COLOR BALANCE MENU SHOWING THREE DEFAULTS

▲ TONE MENU OPTIONS

FIGURE 4.79 The Color Settings options for Canon's Monochrome (Photo) output (via the printer driver).

In the Photoshop plug-in (**Figure 4.80**), below the sliders you can also do a custom curve adjustment by clicking on the Curves button. And since it's monochromatic, you don't do it per color; it's just a grayscale adjustment. If you click Adjust Pattern Settings, you see a preview in a ring-around for the different adjustments for toning, similar to the old Photoshop Variations interface.

Back in the Page Setup area, set up the paper size and orientation, and then click Print. One of the limitations of this plug-in is that you can't capture your settings to use again later. Since you're printing from an export plug-in in Photoshop, all of these image settings are one-off. If you find settings you like, take copious notes on them. **Figure 4.81** shows a comparison of the Pure Neutral Black, Cool Black, and Warm Black options, and a fourth print using the maximum warm and red settings.

So, of all the different outputs, which is my favorite? For this image, I like the results shown in Figure 4.74 using an ICC profile-based color-managed output, because it's the only one that kept the split-toned look of the original chemical sepia toning. For neutral black-and-white output with really subtle color tinting, either the Epson or the Canon output is excellent. However, if you want to really dive into a deeper level of black-and-white printing, I suggest using a special third-party raster image processor (RIP).

FIGURE 4.80 The extended options using the Photoshop plug-in version of Monochromatic (Photo).

▲ THE MAIN COLOR SETTINGS TAB IN THE PLUG-IN

▲ THE CURVES DIALOG BOX

◀ THE ADJUSTMENT PATTERN SETTING DIALOG BOX

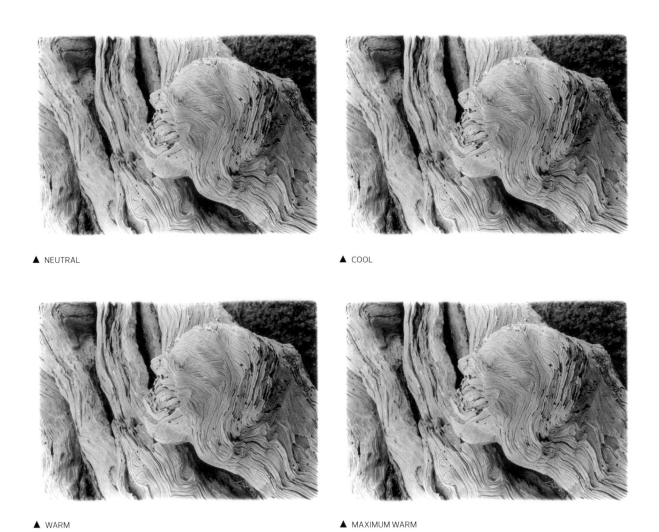

▲ NEUTRAL

▲ COOL

▲ WARM

▲ MAXIMUM WARM

FIGURE 4.81 Comparing the results from the Canon Monochrome (Photo) output.

> **TIP** If I find settings I like when printing from Photoshop, I take a screenshot of them, and then paste them into a hidden layer in the image. You can also use Photoshop's Note tool to write yourself a note. I'll cover other workflow techniques that make life easier in Chapter 6.

PRINTING BLACK-AND-WHITE IMAGES USING A THIRD-PARTY RIP

If you are a hardcore lover of fine black-and-white printing, and you find the manufacturer's printer drivers or plug-ins too limiting, let me point you to an alternative third-party RIP called Quad Tone RIP, developed by an excellent black-and-white photographer named Roy V. Harrington. Quad Tone RIP is a shareware product priced at $50 and available for download at www.quadtonerip.com. A couple of points before I go on: first, it's not really a "plug & play" solution. It's a rather geeky way of creating a pseudo printer driver that can be installed on the Mac and in Windows. Second, it's only for Epson Photo or Pro printers.

> **NOTE** I suggest you visit Roy Harrington's photo Web site (www.harrington.com) to see some excellent black-and-white work. I don't know Roy personally, but I think I'll send him a copy of this book as thanks for creating Quad Tone RIP (and, yes, I paid the shareware price).

With those points out of the way, here's what I really like about Quad Tone RIP: it works like a printer driver allowing you to print out of Photoshop or Lightroom and not from a separate application. The RIP allows you to use up to three curves to achieve a true split-tone look (I always wondered why it was called "quad" when it directly supports only three curves). You can build custom curves and even ICC profiles for use in soft proofing. **Figure 4.82** shows Quad Tone RIP installed as a printer driver on the Mac. It also shows Photoshop Print Settings dialog box set to the QuadR3000 (I installed it on my Epson R3000 because I could connect to that via USB).

In the Print dialog box and with the QuadToneRIP panel selected, you'll see a variety of various settings to choose from. For the Mode, I've selected 16-bit because the image I'm printing is in 16 bit. Currently, I've got a Curve 1 selected that reads "UCpk-raw-neut." This is the curve to use for a neutral output using Photo K ink in the Epson R3000 printer. **Figure 4.83** shows the main QuadToneRIP dialog box with additional sections highlighted.

FIGURE 4.82 The Quad Tone RIP driver selected in Photoshop.

► THE PRINT & FAX DIALOG BOX WITH THE QUADR3000 SELECTED

▼ THE PHOTOSHOP PRINT SETTINGS DIALOG BOX SET TO PRINT TO THE QUADR3000

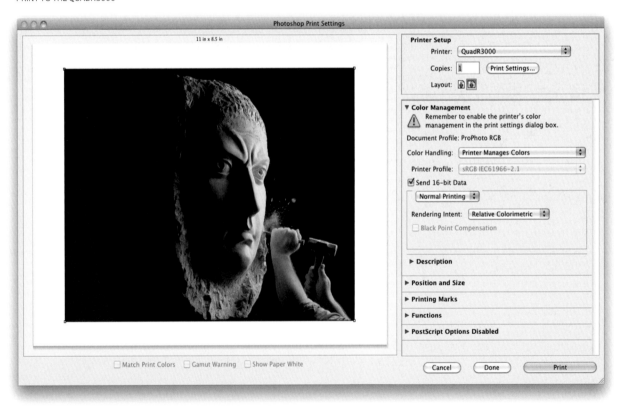

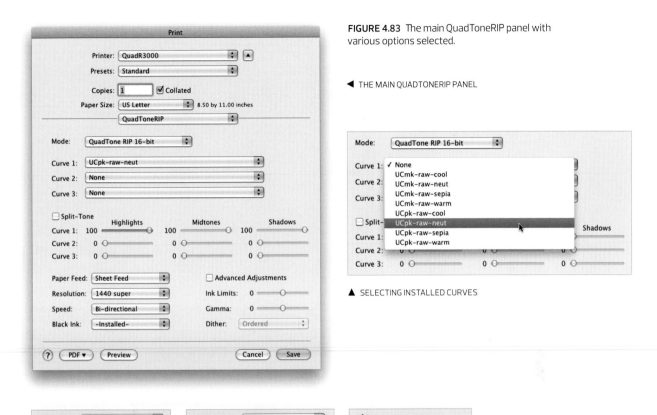

FIGURE 4.83 The main QuadToneRIP panel with various options selected.

◀ THE MAIN QUADTONERIP PANEL

▲ SELECTING INSTALLED CURVES

▲ SELECTING OUTPUT RESOLUTION

▲ SELECTING THE BLACK INK (I USED INSTALLED)

▲ THE ADVANCED ADJUSTMENTS OPTIONS (WHICH I DIDN'T CHANGE)

For the first round of comparisons, I simply printed out each of the basic default curves, starting with cool, neutral, sepia, and then warm. **Figure 4.84** shows scans of the printed output. Yeah, I know, I didn't use the same image I used on the Epson and Canon examples. Sorry, but I was bored printing that same driftwood image and wanted to do something different!

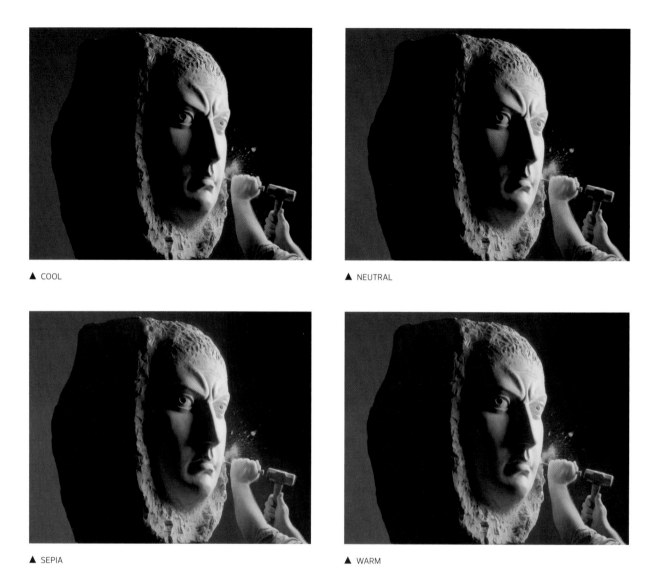

▲ COOL ▲ NEUTRAL

▲ SEPIA ▲ WARM

FIGURE 4.84 Comparing the default curves.

Looking at the results, the neutral is really nice—but the default colorations of cool, sepia, and warm are not really optimal. However, it's really the ability to blend different curves for the highlights, midtones, and shadows that allows Quad Tone RIP to really excel over the printer manufacturers' drivers. **Figure 4.85** shows the result of three different split-tone curve settings.

▲ DUAL CURVE SEPIA AND NEUTRAL (GENTLE SPLIT TONE)

▲ DUAL CURVE SEPIA AND NEUTRAL (STRONG SEPIA SPLIT TONE)

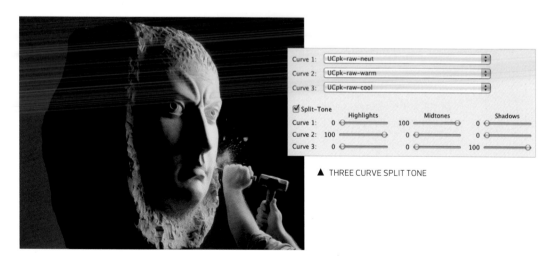

▲ THREE CURVE SPLIT TONE

FIGURE 4.85 Comparing the results of split toning in Quad Tone RIP.

I really like Quad Tone RIP because it's installed as a printer driver. In Lightroom you can capture all the settings in a print template—which is way cool. Sadly, it doesn't seem like the Quad Tone RIP settings can be recorded in an action in Photoshop.

ALTERNATIVE BLACK–AND–WHITE PRINTING

If you try Quad Tone RIP and decide you really want to go down an even deeper rabbit hole of ultimate black-and-white printing, I have a suggestion for you: consider going all the way to a dedicated black-and-white printer with custom inks. Fair warning, it ain't cheap nor easy—but if you love rich black-and-white prints (and don't love color), go for it! The downside is it will require dedicating a printer to special black-and-white inks and use a rather tedious workflow for printing, but I've seen some remarkable prints using the Piezography system (www.piezography.com).

A well-known fine art printer—in printing circles anyway—named Jon Cone (Cone Editions Press, Ltd.) developed a set of special inks that can be loaded into Epson printers and a few select others that use piezo printheads. The special inks replace the standard Cc, Mm, Y & K inks with seven distinct shades of carbon-based pigment ink. There are several different toning options, including Warm Neutral, Selenium, Carbon, Neutral, and Special Edition inks designed for split toning. The upside of the Piezography system is that it works well in an integrated manner with Quad Tone RIP (which makes using the system a lot easier).

In addition to using the Piezography system inks for prints, you might want to look into using inkjet printers for making film positives or negatives for making traditional black-and-white contact prints using silver gelatin or hand-coated platinum papers. One of the leading practitioners of this is a photographer named Dan Burkholder (www.danburkholder.com). The key to this practice is to prepare digital images to print to film. The film positive or negative (depending on the final coated paper) is used in contact with the paper to produce potentially stunning results. Dan has tutorials and offers workshops on the process.

What do I think about all these "alternative" black-and-white processes? Well, I've seen some really excellent prints, but the technical and workflow hurdles are simply too daunting for me. I don't want to dedicate a printer to third-party inks, nor do I want to spend a lot of time in the darkroom hand-coating papers to make platinum prints—been there, done that. It's just not my cup of tea!

But if you want to wander down the path of unusual processes, exotic inks, and spending time in a stinky darkroom, go right ahead! I will commend you, but not follow you.

NOTE When referring to Cc, Mm, Y & K inks, I'm referring to the fact that most of today's pro inkjet printers use two different cyan and magenta inks. There's usually a strong cyan and magenta and a light or weak cyan or magenta. This is done to get better color gradations of the color gamut. I refer to them as C or M for strong (or vivid) and c and m for the light versions of the inks.

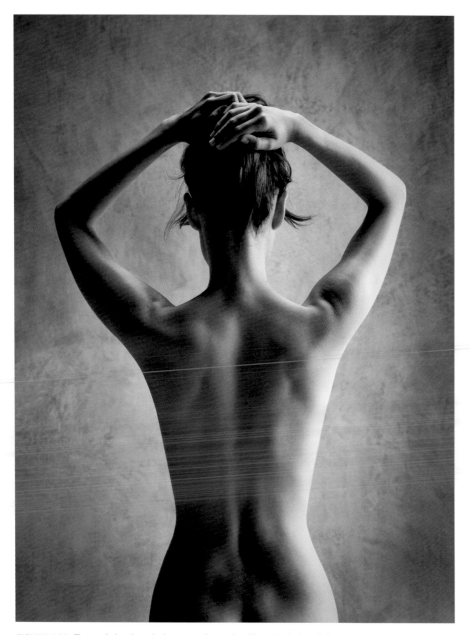

FIGURE 4.86 The nude by the window was shot using filtered window light at Greg Gorman's Mendocino, California studio. The image was shot with a Canon EOS-1Ds Mark III camera with a 24–105mm lens at 65mm and ISO 400. The image was retouched in Photoshop and converted to black-and-white in Lightroom with a slight warming split-tone applied.

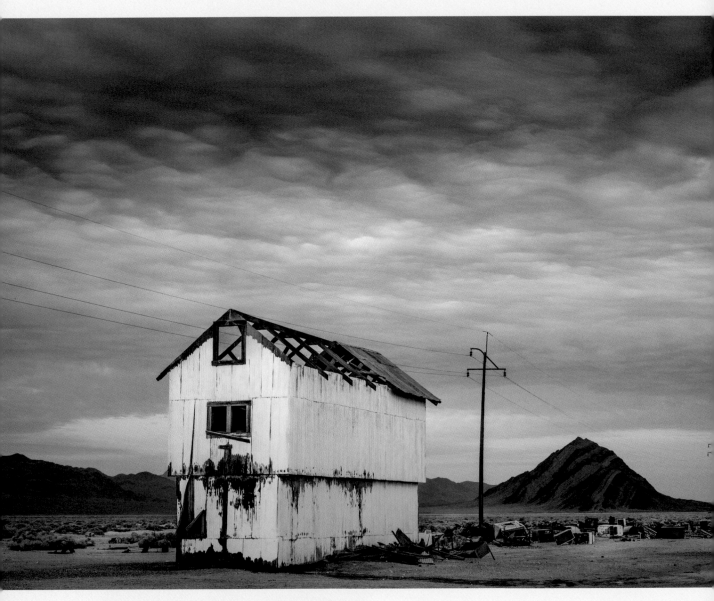

This image was shot at sunrise just outside Death Valley using a Phase One 645DF camera with a 75–150mm lens at ISO 100 using a Phase One P65+ digital back. I retouched it to remove a fellow photographer who happened to get into my shot.

■ CHAPTER 5

ATTRIBUTES OF A PERFECT PRINT

Start with a great image. Then invest the time and effort it takes to fine-tune, caress, and massage it. Pay attention to the details of paper and presentation, and treat your image like the precious object that it is (or should be). If you do all that, you can make the perfect print. Many of the points in this chapter are subtle, but combined they are the gestalt of the craftsmanship of digital fine art printing.

WHAT IS A "PERFECT PRINT"?

A *perfect print* is made from an image that has optimal tone and color, and whose detail has been properly processed to make the image pop off the paper. Perfect prints share some common traits: sharpness, good color and tone, with a feeling of depth. They have a three-dimensional quality that gives the viewer a sense of shape and texture even though a print is limited to two dimensions. A perfect print shows the craft and care of the person making the print. There should be no obvious flaws or defects. A perfect print elevates the printing medium to an art form.

There's a little secret that I've learned in my vast experience of making really great prints: to make a really great print, you really need to start with a great image. A great image printed poorly is still a great image, but a bad image printed well is just a good print. As Ansel Adams said, "There's nothing worse than a really sharp print of a fuzzy concept."

In *The Digital Negative*, I fine-tuned an image of the Courthouse Towers in Arches National Park just outside of Moab, Utah. Now I'll use that great image (in my opinion) to make a great print. **Figure 5.1** shows the image in Lightroom with the default rendering of the raw image at the top and the adjusted raw image at the bottom.

Although I could make a good print directly from the adjusted raw image, to "perfect" the image, I edited it in Photoshop to finesse certain aspects of the image that couldn't be done in Lightroom. **Figure 5.2** shows the final layer stack of the image in Photoshop.

After saving the image from Photoshop back into Lightroom, I used Lightroom's soft proofing to tweak the image to achieve the best possible print match to the image. **Figure 5.3** shows the Master image at the top and the Proof Preview image at the bottom. Yes, the differences are subtle, particularly when being presented in 150 LPI halftones in this book—but take my word for it, every little bit adds up. The primary adjustments made were to the tone curve using the parametric adjustments and some subtle HSL adjustments to adjust the color rendering. The Relative rendering intent produced the best match to the Master image.

I moved to the Print module and set up the Page Setup and Printer Settings to print an image on 17 x 22-inch paper with a minimum 1-inch margin all around the image. That produced a cell size of 20 x 15 inches of printable image area and, due to the image crop, an image size of 15 x 19.645 inches at 424 PPI.

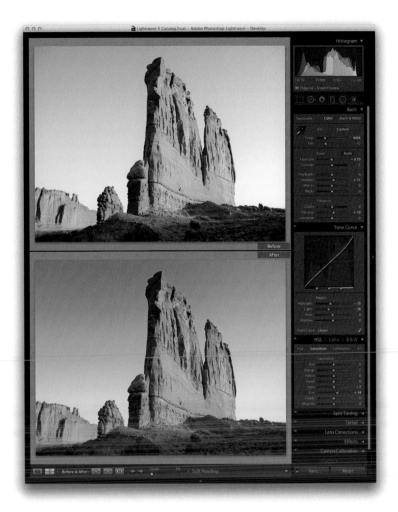

FIGURE 5.1 The Before/After view of the image in Lightroom.

FIGURE 5.2 The final layer stack in Photoshop with layers for Progressive Sharpen, Midtone Contrast, Sculpting, Saturation, and Color adjustments, with a final layer to fix the edges between the blue sky and the rocks.

FIGURE 5.3 Adjusting the image using Soft Proofing in Lightroom.

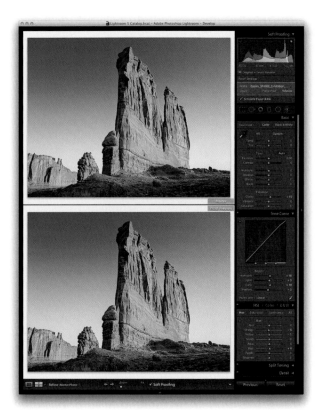

▶ THE MAIN DEVELOP MODULE WITH SOFT PROOFING ON, WITH RELATIVE RENDERING SELECTED, AND THE EPSON EXIHIBITION FIBER PAPER PROFILE FOR THE EPSON 4900 PRINTER

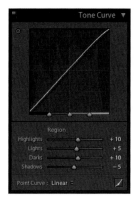

▲ THE TONE CURVE PANEL

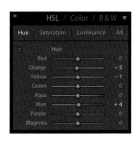

▲ THE HSL PANEL

TIP When is your image "done"? One of the most difficult aspects of digital imaging is knowing when an image is done! To me, it's done when there's nothing left to do, which may seem obvious but really isn't. You must draw a line somewhere. I've recently been introduced to the term *Wabi–sabi* which is a Japanese aesthetic of seeing beauty in transience and imperfection. So, while you strive for perfection, remember imperfection can have beauty, too.

Since the image resolution at that printed size was above 360 PPI, I set the Print Resolution in the Print Job panel to 720 PPI. **Figure 5.4** shows the image in the Print module as well as the Print dialog box settings. Note that the Output Resolution is set to 2880 DPI and that High Speed is unchecked, while Finest Detail is checked. This will produce the best possible final output.

The image printed very well the first time out of the printer! Yes, I would like to say I didn't need to do any changes for the final print after looking at this first print, but, to be honest, I did fiddle with the image a bit before making the final print. Since I was going to recess mat and frame the image, and then place a signature and title on the image, I ended up going back in and adjusting the image crop to eliminate some distracting detail on the far-right side. One frustration I have with Lightroom is that you cannot zoom into the image while cropping. You have to work around this in Lightroom, or take the image to Photoshop for cropping. To make the final crop, I opened the image back into Photoshop so I could zoom in and be more precise in the final crop. **Figure 5.5** shows the final print in the printer and the final framed image.

 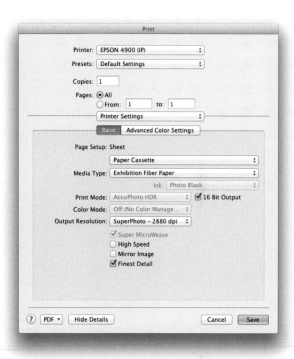

▲ THE IMAGE IN THE PRINT MODULE ▲ THE PRINT DIALOG BOX SETTINGS

FIGURE 5.4 The image in the Print Module and the print driver settings for printing.

FINE PRINTING IS A CRAFT

Photographers spend their lives taking images that may take just a fraction of a second to shoot. As a result, they have a tendency not to dwell on the process of making a print. But I learned the discipline of printing in the chemical darkroom, where you could labor over a single image for hours on end to get the ultimate print. By comparison, the process of making a print these days is much more instanta-neous, but it still requires a degree of craft to arrive at a perfect print. So, I encour-age you to take your time and invest whatever effort may be needed to achieve what you consider a "perfect print."

I would also encourage you to visit galleries and art museums to see for your own eyes, what "perfect" prints actually look like. Unless you have seen really well crafted fine art digital prints, it's tough to really comprehend just how much craft can go into making great prints.

FIGURE 5.5 The final print.

▲ THE FINAL PRINT MATTED AND FRAMED

◄ THE FINAL PRINT IN THE PRINTER

PRINT-VIEWING ENVIRONMENT

When you're processing images for printing, it's important to have a viewing environment in which your computer display and your print evaluation area have some relationship to one another.

In **Figure 5.6**, the image on the second screen from the left is being soft proofed and compared to the print on my GTI lightbox (www.gtilite.com). The environment I work in is not really dim, as you can see. I don't like to work in a cave. In fact, the space is fairly bright, which is one reason I tend to run my computer displays at a higher brightness than some do, generally at about 150 candela per square metre (cd/m^2). The luminance of the computer display should match the luminance of the white paper in the lightbox so that the whites in the display and the surrounding border in soft proofing are the same color white that the final print will have. I use the GTI lightbox (current equivalent model now TRV-1e, available for about $1,230)

FIGURE 5.6 My digital imaging area with display and print-viewing environments.

shown here for doing reduced-size proofing prior to making big prints. I've relamped my GTI lightbox with D65 fluorescent lights because the standard D50 or D55 bulbs were just too warm. The white of the D65 and the white of my display, which is running at D65, provide a much more accurate display-to-print comparison.

To the left of the lightbox is a task lamp with a SoLux daylight bulb (www.solux.net). I use a SoLux task lamp (approximately $150 for the fixture without bulb) with a 50-watt bulb that is 4700° Kelvin (the bulb costs about $16). I find it useful to compare prints under both viewing environments to evaluate a print under cooler daylight and warmer daylight. I also have a SoLux 3500°K bulb that I can pop in the fixture if I need to evaluate a print under lighting that would more closely approximate a gallery condition.

The main image in Figure 5.6 also appeared in *The Digital Negative*. You'll note that in this figure I don't have a print under the SoLux lamp. **Figure 5.7** shows a print of the image under both the SoLux lamp and the GTI lightbox. The print under the GTI is a bit cooler than the print under the SoLux due to the slight differences in the color temperature. But either viewing environment would be appropriate for print evaluation, with the SoLux being the least expensive!

How to judge the tone and color of a print

When you're setting up your viewing environment, there are some things to watch out for. Ideally, you don't want a strong color in your field of vision that will influence the appearance of the image you're examining. The bottom line is that you need a relatively neutral field of vision. In my studio, the wall beyond the computer displays is a medium gray, the floor and cabinets are medium gray. Only the brick isn't medium gray, but it doesn't have any strong vivid color. The neutrality is to cut down on the influence of the environment when you're evaluating the computer display and the proof print.

You may also have to judge the print under alternative display environments. For example, if you know a print will hang in a gallery, the best way to evaluate the print is to hang it in the gallery. Most galleries and museums run relatively dim warm (3200°K or lower) lighting. But there are issues with museum display standards and the amount of light falling on the print. Museums like to keep things dim. In general, museum light levels are kept under 5 foot-candles (50 lux) for light-sensitive materials such as textile dyes, watercolors, and photographs. Less light-sensitive materials such as oil paintings are displayed at levels less than 15 foot-candles (150 lux). If the audience is older, the museum may raise the light levels. When light levels are raised, they must be balanced by decreasing exposure time.

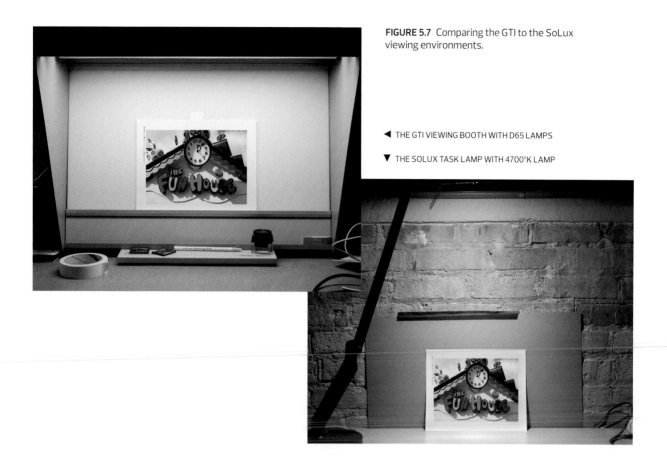

FIGURE 5.7 Comparing the GTI to the SoLux viewing environments.

◄ THE GTI VIEWING BOOTH WITH D65 LAMPS

▼ THE SOLUX TASK LAMP WITH 4700°K LAMP

I saw a photo print show at the Getty Museum in Los Angeles where everything hanging on the wall was lit incredibly dim. In dim lighting, you change the relationship of the tones in the print. So if the print will hang in a dimly lit environment, evaluate the image in light of that. As I covered in Chapter 2, when the amount of illumination drops, human vision becomes less sensitive to color, so you may need to punch up color while increasing lightness of the shadows and overall contrast. **Figure 5.8** shows how the same print will appear under strong and dim home lighting. You'll notice that under the strong display lighting, the image has a lot of snap and contrast with deep blacks and bright lights. The print in the same environment without the display lighting appears lower in contrast and the environment of the room reflects into the glass, killing the snap of the print.

FIGURE 5.8 Comparing the print appearance under strong and dim lighting conditions. Image of Bette Davis courtesy of Greg Gorman.

▶ PRINT DISPLAYED WITH STRONG LIGHTING ON

▶ PRINT DISPLAYED WITH DIM AMBIENT LIGHTING

How to judge the detail in a print

In addition to the lighting of the viewing environment, you need to take the viewing distance into consideration. The standard viewing distance is generally twice the diagonal of a print. If you're looking at a small print, you hold it close; if it's a large print, you back off. You need to be able to evaluate the detail of the print at the standard viewing distance (twice the diagonal) and at the *photographer viewing distance*, which is limited only by the length of the photographer's nose.

You can also evaluate an image under a high-power loupe or a low-power microscope if you want to engage in "pixel-peeping." Michael Reichmann of Luminous-Landscape.com coined that term to refer to people looking at images with far too much magnification, such as 300% in Photoshop. In the final print, you shouldn't see the pixels. **Figure 5.9** shows scans of two prints. The image on the left had a native resolution of 360 PPI, whereas the image on the right was resampled to 150 PPI. Both images were printed on glossy photo paper and scanned at 100% at 1200 PPI. The images were cropped and sized at 75% in Figure 5.9.

At this viewing distance (75% of life-size) both prints appear reasonably good. But the small repro size is hiding how bad the low-resolution image will look when viewed closer. **Figure 5.10** shows the same two images zoomed into 100% in Photoshop. At 100% the reproduction size is approximately three times life-size. The low-resolution print clearly looks terrible.

FIGURE 5.9 Comparing small reproductions at 75% of actual size.

▲ NATIVE RESOLUTION OF 360 PPI

▲ DOWNSAMPLED RESOLUTION OF 150 PPI

FIGURE 5.10 Comparing the higher–resolution and lower–resolution prints at 3x life–size.

▲ 100% VIEW OF THE 360 PPI PRINT SCAN

▲ 100% OF THE 150 PPI PRINT SCAN

Upsampling for maximum image quality

I know that there has been a lot of controversy over the optimal output resolution for inkjet printing, so I wanted to see myself whether the output resolution could have an impact. It can (and does), and here's the proof. **Figure 5.11** shows the full-size image that had native resolution of 235 PPI at the print size of 6 x 9.5 inches. The image was shot with a Canon EOS Digital Rebel XTi with a 10-22mm lens at ISO 200. The perspective correction was done using Lightroom's Upright correction set to Auto. That resulted in a corrected but cropped final image.

I printed out two prints on Epson premium glossy paper; one print was printed with the native resolution and the other print was upsampled to 360 PPI in Lightroom's Print Job panel. The same output sharpening was applied to both. Figure 5.12 shows scans of both prints at an effective magnification of 10.66x, which is life-size.

The results are subtle but visible—particularly in the diagonal lines. The upsampled lines are smoother and show fewer jaggies. This improved result will show more on diagonal lines and circles, and other types of high-frequency textural detail. Figure 5.13 shows the results of doing the same native and upsampled prints on a Canon imagePROGRAF iPF6400 printer using Canon glossy paper.

FIGURE 5.11 The image with a 6 x 9.5–inch output size that provided a native resolution of 235 PPI. The details of the print scans in **Figure 5.12** and **Figure 5.13** show an area on the right side of the image just above the red brick building.

▲ SCAN OF THE NATIVE 235 PPI PRINT ▲ SCAN OF THE UPSAMPLED 360 PPI PRINT

FIGURE 5.12 Comparing the native and upsampled prints from an Epson Stylus Pro 4900 printer.

▲ SCAN OF THE NATIVE 235 PPI PRINT ▲ SCAN OF THE UPSAMPLED 300 PPI PRINT

FIGURE: 5.13 Comparing the native and upsampled prints from a Canon imagePROGRAF iPF6400 printer.

When you're viewing at an extreme magnification, you can see the benefits of upsampling before sending the image to the print. But what if the native resolution is above 360 PPI for Epson or 300 PPI for Canon/HP? Should you downsample? No! Never throw away good pixels if you can avoid it. The magic numbers change to 720 PPI for Epson and 600 PPI for Canon. **Figure 5.14** shows an image shot with a Canon EOS 1Ds Mark III camera with a 100mm macro lens. At the final print size of 6 x 9.5 inches, the native resolution was 432 PPI.

For the Epson scan, the image was upsampled to 720 PPI and the Finest Detail check box was selected, while the High Speed option was unchecked. For the Canon print, the image was upsampled to 600 PPI and the Print Quality was set to Highest (600 DPI). **Figure 5.15** shows the Epson prints, and **Figure 5.16** shows the Canon prints.

The Epson prints show a real benefit in the way diagonal lines are rendered smoother and sharper. The Canon example is a bit less obvious, but the upsampled print shows finer detail compared to the native resolution. The Canon prints appear sharper, while the Epson prints appear smoother. When I did this test, I was expecting the Epson prints to be sharper. But this just goes to show how close the two printing technologies have become.

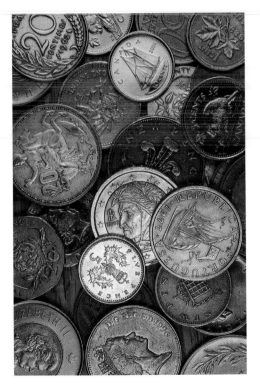

FIGURE 5.14 The image with a 6 x 9.5–inch output size that provided a native resolution of 432 PPI. The detail of the print scans in **Figure 5.15** and **Figure 5.16** shows a detailed look at the five–pence coin's crown.

▲ SCAN OF THE NATIVE 432 PPI PRINT

▲ SCAN OF THE UPSAMPLED 720 PPI PRINT

FIGURE 5.15 Comparing the native and upsampled prints form an Stylus Pro Epson 4900.

▲ SCAN OF THE NATIVE 432 PPI PRINT

▲ SCAN OF THE UPSAMPLED 600 PPI PRINT

FIGURE 5.16 Comparing the native and upsampled prints from the Canon imagePROGRAF iPF6400 printer.

Now, let me reiterate that this example is based on printing to high-gloss paper that can retain an enormous amount of image detail in the print. The results really apply to printing to photo-type paper only, not watercolor papers. For watercolor papers, which have a surface that retains less detail, my experience shows that upsampling to 720 PPI for Epson or 600 PPI for Canon isn't necessary unless you are printing to a really smooth paper. So, I would stop at 360 PPI for Epson and 300 PPI for Canon.

DIGITAL PRINT ARTIFACTS

There are several ways that you may get more than you bargained for—or at least something different than you intended—when you print digital images. Many of these issues are minimal, and most can be worked around in some way, but you'll want to keep an eye out for them. These artifacts are rather difficult to show in the book, so I'll try to describe them fully so you can be on the lookout for them.

Gloss differential

Gloss differential refers to a difference in the reflection coefficient of the paper and the ink on the paper. It's noticeable with really glossy paper where the gloss of the deep black ink will appear to be shinier and more reflective than the gloss of the white paper. Paper manufacturers have tried to minimize the gloss differential with pigment ink, so these days it's not a major problem, but it is a difference between digital prints and photographic prints. The silver coating in an analog chemical print is under the gelatin coating, so as the image is exposed and processed, it sits under the surface of the paper. However, with an inkjet printer, the ink sits on top of the paper, so when the gloss differs, you'll see it. Gloss differential can be a problem if you're holding the page in your hand, but it's not apparent if you mat and frame the image behind glass.

Gray balance failure (not metameric failure)

Gray balance failure occurs if the ink has a different gray balance viewed under two different spectral color curves or different lighting, so that it may appear green under daylight or magenta under tungsten. To avoid gray balance failure, judge the prints in the viewing environment where they'll be displayed. If your printer exhibits a slight degree of gray balance failure, you can compensate for it while you're making the print. If you know you'll view the print under tungsten, you may need to pull out a little bit of magenta or make the image just a little cooler so it appears neutral under tungsten light. One of the hardest things to do is to arrive at an optimal gray balance for absolutely neutral black-and-white prints, as I discussed in Chapter 4.

Bronzing

Bronzing was an issue in the early days of pigment printers, but, for the most part, it's been eliminated now. Bronzing is a function of the way in which the encapsulated pigment ink refracts and alters the appearance of the color. You end up seeing a flash of bronze-like color as you tilt the print back and forth. Generally, bronzing is not a problem when you look at an image straight on; it's only a problem at an angle to the light. There's not much you can do about it except to mat, frame, and put the image behind glass. The angles where you see the bronzing are acute angles, not normal viewing angles.

Outgassing

Outgassing has nothing to do with passing gas or breaking wind. But it is about breaking free. You see, in pigment inks, the ink is suspended in liquid. Glycols are added to keep the ink in suspension and make it more fluid so it can be squirted out of the jet heads. As soon as you print, those glycols start escaping. Many of the glycols evacuate in the first couple of hours, but enough leave over the first 24–36 hours . If you mat a fresh print and hang it behind glass, the glass will become cloudy wherever the ink is the densest.

To avoid outgassing effects, wait before framing. While you wait, Epson has advocated interleaving prints with craft paper or newsprint (obviously without ink on it). It is a matter of patience while waiting out the glycols.

Outgassing is more of an issue when you're printing on resin-coated (RC) paper, because there it creates a nonpermeable barrier blocking the glycols from escaping through the back of the print, which means they have to escape from the front. If you're printing on watercolor paper or paper with a semipermeable barrier, it's less of an issue. The glycols don't care where they go; they just want to escape.

If you're making prints for others, you sure don't want to have those prints matted and framed before the glycols have outgassed. It's not a matter of curing or drying, but of letting them escape.

Pixelation (lack of resolution)

Pixelation—that is, visible pixels—occurs when you print at a resolution that is too low for the print size. If you accurately judge the detail of a print, you should be able to avoid pixelation. Make sure the resolution is appropriate for your print size and the viewing distance. See Figure 5.9 for examples of prints with the correct resolution.

Scratches and abrasions

Inkjet prints, particularly glossy prints, are very susceptible to scratching in the printed area for the first couple of hours until the ink starts to cure and harden. The ink may appear dry, even to the touch (but keep your fingers off your prints!), but stacking prints and dragging corners of the top print over the bottom print will introduce fine scratches. That's another reason that using an interleaf sheet when you're stacking prints can be handy. If you start shuffling glossy prints, you'll introduce scratches.

There's a different problem with matte or watercolor paper. In order to achieve a black that is as dark as possible, a matte black ink actually has a matte surface. It's very sensitive to abrasions and burnishing. If you drag your fingernail across a deep black part of an image, you'll burnish it and see a shiny spot where your fingernail had been dragged. That shiny spot is where you've polished the image, or taken the matte out of the black ink.

The bottom line is to treat your prints with respect. If you've got a nice image, you tend to treat your prints nicer.

PRINT SUBSTRATES (PAPER/MEDIA)

I used to just call the stuff that I made prints on "paper" until my good friend John Paul Caponigro said it's not paper, it's a *substrate*. So I told him I'd quit calling it paper. But regardless of what JP says, it *is* generally paper. Papermaking is really an art form. I'll remind you that my drawing instructor taught us that paper is itself an art, so when you start drawing, don't screw it up. That holds true for making digital prints.

TYPES OF PAPER

Paper is made of cellulose, the fiber that is refined from either wood pulp or cotton, or other natural fibers. Wood-based alpha cellulose has varying degrees of lignin, which is an organic substance binding the cells, fibers, and vessels that constitute wood. It's the lignin that gives craft paper its tan/brown color and makes newsprint yellow with age. Getting rid of the lignin requires a pretty aggressive bleaching process; manufacturers try to remove lignin while maintaining a high level of alpha cellulose. The type of paper we'd use for digital printing, whether it's wood-based or cotton-based, will have a high degree of refinement so that the color of the paper is white and does not yellow with age. Cotton-based cellulose is generally a blend of cellulose types, unless the paper is declared to be 100% cotton cellulose. For the

NOTE In chemistry, pH is the measurement of the activity and concentration of hydrogen ions. Distilled water has a pH of approximately 7 (at 25°C). If the pH is under 7, the pH is acidic, while above 7 is considered alkaline (base). For paper, the ideal pH measurement should be close to pH 7, which is considered neutral. Too much acidity will negatively impact paper permanence. Many people assume that a neutral pH is the same as acid-free. An acid paper with buffers added could still be subject to deterioration or yellowing if the acid remaining in the sheet or formed during aging exceeds the buffering capacity. Ideally, a paper should be acid-free and a neutral pH.

most part, particularly when you're dealing with watercolor paper, the higher the cotton percentage, the better the quality of the paper.

There's nothing inherently wrong with a wood-based alpha cellulose paper; it's just that it has to go through a lot of bleaching and that the end result generally has to be buffered to maintain a neutral pH and eliminate any acidity.

There are other natural fibers that can be used, but those are used for making alternative papers or parchment, and I'll talk about alternative media a little later.

PAPER COATINGS

All papers that are used for traditional digital printing need a coating. If you run an uncoated paper through an inkjet printer, you end up with a mass of ink in blobs on the paper. Depending on the paper and ink combination, if you're using a dye ink as opposed to a pigment ink, you will often need a special coating that will hold the ink. There are two kinds of paper for dye inks: a microporous type and a swellable polymer. One type of paper uses a ceramic microporous coating and the ink is sucked into microporous cavities in the paper. With the swellable polymer type, the polymer itself swells to absorb the ink. Both kinds of paper do a reasonably decent job for dye inks, but neither is particularly useful for pigment inks.

For matte coatings, which would be used for watercolor paper, for example, a variety of different substances (possibly even gelatin, which is old school) act as a sizing. They give a surface for the ink to adhere to, preventing it from being sucked down into the paper. The coating is generally considered a trade secret, so the paper manufacturer may or may not reveal it.

For gloss coatings, the surface is even more relevant. With those papers, you want the surface to have an even and smooth, glossy appearance. It can be high gloss, like a photo-gloss paper, or have a degree of surface texture, which I'll talk about in the photo papers section.

The last kind of paper coating is resin-coated (RC). Those papers start with a paper base but have a plastic or resin-coasted surface bonded to the paper, generally both front and back. Whether it's called *RC paper*, *plastic paper*, or *plasticized paper*, there's nothing inherently negative about it, other than the prints feel kind of plasticky when you hold them. But once you mat and frame them, and hang them on the wall, the odds are you won't be able to tell what the paper was made of.

PAPER ATTRIBUTES

There are various attributes that give different papers a different tactile feel and appearance. As digital printers, we find ourselves with an overabundance of choices. So let me drill down on some of the attributes that may factor into your paper selections.

Surface

Generally speaking, it is the surface of papers that you'll notice first. Some photo papers have a gloss coating. However, some papers have a semi-matte coating, which gives a nonglossy but not 100% matte surface. Surface texture falls into the general categories of glossy, luster, semi-gloss, and semi-matte, though different manufacturers use different terms. The best way to know the surface of a paper is to look at it. The distinctions have a lot to do with how coherent the surface reflection will be.

In the old days, air-dried F-surface was the standard photographic look for the surface of a silver gelatin print. You could ferrotype a glossy paper and make it look hyper-glossy, but I hated the look. Ferrotyping was said to be good for reproduction, but wasn't really needed.

For watercolor papers, the manufacturing process dictates the surface. Matte or watercolor paper can be created with a hot-press surface or a cold-press surface. In the papermaking process, cellulose is in suspension in water and the screen (also called a *deckle*) captures all the cellulose fibers into what will become a sheet of paper. You have to press the paper to get the water out. If you use a hot press to dry and bond the fibers, the paper will have a smooth, even surface. If you use a cold press, the paper will have a very natural surface. It's a matter of how much texture the paper is going to retain.

Surface reflectance and texture is an aspect you learn to love or just accept. I don't particularly like super-glossy paper or semi-glossy paper. I tend to prefer paper that has the best resemblance to silver gelatin paper. Two of my favorites are Epson Exhibition Fiber paper, designed to replicate F-surface photo paper, and Hahnemühle FineArt Baryta. For watercolor papers, I prefer a cold-pressed textured appearance. If you're going to print on watercolor paper, it's the texture that becomes a prime component of surface—so why use a really super smooth watercolor paper?

For really large prints, RC papers provide an advantage because they don't have memory curl. I'll deal with the issues of sheet versus roll paper later, but for now, I'll just note that if you need to make really big prints, RC paper is much easier to handle and mount because it doesn't try to curl up.

Optical brightening agents (OBAs)

Optical brightening agents, sometimes called *fluorescent brightening agents* (FBAs) or *fluorescent whitening agents* (FWAs), take invisible UV light and fluoresce the invisible light into the blue portion of visible light—that's how paper is made whiter and bluer. Some people think OBAs are really bad, and some think they're not so bad. I think they're not necessarily so bad, depending on how they're used and applied.

There are two ways of adding OBAs: in the actual paper base itself, or in the coating. Epson Exhibition Fiber paper has a pretty high level of OBAs in the paper base itself. I think adding OBAs to the coating is a bad idea, because the coating may be uneven and has a much higher risk of aging out or, basically, losing its ability to fluoresce. When it ages, it is possible to see areas of yellowness.

Because OBAs are intended to make paper appear brighter and bluer, when you're printing to a paper with a lot of OBAs, like Epson Exhibition Fiber, you have to compensate for the brightness or blueness of the paper. Hahnemühle FineArt Baryta has some OBAs, but the baryta coating itself is used to make the paper appear brighter. It's still a warmer paper. Generally speaking, you have to look hard to find any photo papers that don't have OBAs, but they are out there.

Remember that OBAs use UV light to excite and fluoresce blue light to make the paper appear whiter. But about 80% of UV light is cut the moment you put the print behind glass. Behind UV-absorbing glass—recommended because UV light is the portion of the spectrum that is the enemy of prints—you don't get to see the OBAs anyway.

Paper brightness

Paper brightness measures how much white light is reflected back to the viewer. The best papers are in the +90s. Papers below 90 aren't as good. Paper brightness is important because it contributes to the contrast range of the prints. An ink that is 100% black will be as black as it's going to be, whereas the whitest anything can be is pure paper white. If that pure paper white is not very bright, it has a negative impact on the contrast range. Don't confuse paper brightness with paper whiteness.

Paper whiteness

Paper whiteness is the measure of the actual color of the paper, and whether it has a cast (generally it's yellow). There are standards for measuring both paper brightness and paper whiteness. When you look at the paper manufacturer's specifications, they'll give paper brightness and possibly paper whiteness. They may also add paper opacity. Since fine art digital printing can be done on relatively thick paper, opacity is less critical, but it's still a factor to consider when buying paper.

EVALUATING PAPER REFLECTANCE

Ernst Dinkla, a fine art printer and paper supplier, has created a program called SpectrumViz that performs a spectral analysis of lots of papers (**Figure 5.17**). I find it interesting to help evaluate papers, see how many OBAs are used, and what their spectral reflectance is. The ideal paper would reflect all qualities of light evenly—some do and some don't. It's easy to see under Ernst's spectral analysis which papers have a high blue reflectance, an indicator of strong OBAs. The software is donationware from Ernst's Web site, http://www.pigment-print.com/spectralplots/spectrumviz_1.htm.

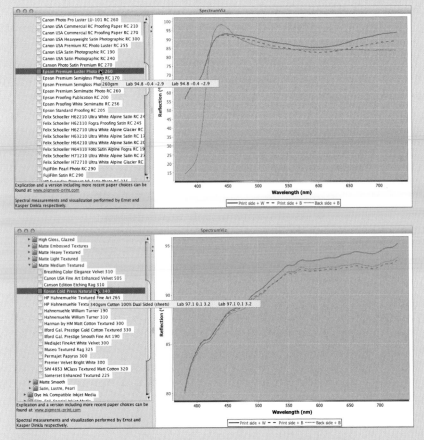

FIGURE 5.17 The SpectrumViz application showing spectrum comparisons of two papers: Epson Premium Luster Photo paper (with the telltale sign of OBAs) and Epson Cold Pressed Natural paper showing no signs of OBAs.

Paper thickness and weight

Owing to different regional standards between Europe and the U.S., paper thickness and weight can be confusing. In the U.S., the weight is often listed as how many pounds a ream of paper weighs, based on a certain size sheet of paper and a ream of 500 pieces. So, 85-pound paper means that 500 sheets weigh 85 pounds. That isn't particularly useful in evaluating the weight of paper.

In Europe, paper is measured in grams per square meter (GSM), and that makes a lot more sense. There you can look at a paper that is 300 GSM and realize a square meter sheet of that paper will weigh 300 grams. The fine art papers range from above 250 GSM and upward to 400 GSM. But that's only half the story.

You also need to consider the paper's thickness, measured by a caliper and usually stated in millimeters. A paper can be thicker but less dense, so that it won't weigh as much but will be stiffer or feel thicker when you pick it up. The best balance is a combination of thickness and weight. When working with very thin paper, particularly with large prints, it's difficult to avoid putting dimples or creases in the paper as you're handling it. When evaluating the paper criteria, check for both paper thickness and weight.

MAXIMUM DENSITY OF INK ON PAPER

D-Max is the maximum density of ink a paper can handle. Photo papers can go up to a D-Max of up to 2.2+. Watercolor paper, even using matte black ink, would struggle to get a 1.7 D-Max.

The D-Max is relevant when you consider the potential contrast range of a print done on photo paper with photo black ink versus done on watercolor with matte black ink.

CONTRAST RANGE OF A PRINT

NOTE I've set the contrast range on my computer displays to 250:1. The screens appear flatter, with less contrast, but give me a better idea of how the images will appear on print. I don't play computer games or watch HDTV on my displays, so there's no disadvantage to a lower contrast.

The contrast range is the calculation of the range between the D-Max and the D-Min (minimum density). Glossy paper can approach a contrast range of 170:1, while watercolor paper may have a contrast range of only 50:1, depending on whether it's got really good matte black ink and a bright white paper. It's useful to know the contrast range of a print so you can compare it to the way the image looks on your computer display, which may have a contrast range of 500:1 or 700:1. That's one of the things you consider when soft proofing, as the printer profile helps you see what kind of contrast range you'll get in the final print.

MEASURING D-MAX AND CALCULATING CONTRAST RANGE

If you have a spectrophotometer and an application that can deliver L*a*b* readouts, you can measure the L* readings and convert the L* into density. The easy way is to go to Bruce Lindloom's Web site (www.brucelindbloom.com), click the Calc tab, and select the Companding Calculator. There, you can enter in the L* readings and convert it to a density. So, if you had an L* reading of 4.92 (as I got from measuring the black ink of a print from Epson Premium Glossy photo paper), the density of that black would be 2.26. That's a pretty dense black when compared to the density of Epson's Enhanced Matte paper, which had an L* of 16.66 and a density of only 1.65.

To calculate the contrast range capable of being printed, you need to measure both the black ink (D-Max) and paper white (D-Min) and use a formula to arrive at the contrast range. The formula is $10 \char`^ (D\text{-}max - D\text{-}min)$ = the contrast range. See **Table 5.1** for a selection of contrast range calculations.

TABLE 5.1 L*, Density and contrast ranges for a selection of papers

PAPER	L* WHITE/DENSITY	L* BLACK/DENSITY	CONTRAST RANGE
Premium Glossy	97.20/0.0318	4.92/2.26	171:1
EFP	96.54/0.039	5.18/2.24	159:1
Luster	94.95/0.058	5.8/2.19	137:1
Enhanced Matte	95.85/0.047	16.66/1.65	40:1
HPB	8.23/0.020	13.39/1.78	59:1
HPN	97.81/0.024	14.08/1.75	54:1

Note: EFP is Exhibition Fiber Paper, HPB is Hot Pressed Bright, and HPN is Hot Pressed Natural. The higher contrast range for HPB and HPN are due to lower D-Min and higher D-Max of these papers compared to the Enhanced Matte paper.

PHOTO PAPERS

Photo papers generally have a higher D-Max and better paper brightness. They're often slightly thinner, and they come with a variety of different surface textures and surface reflectance. **Figure 5.18** shows the surface texture of four Epson papers: Glossy, Luster, Exhibition Fiber, and Semi-gloss.

FIGURE 5.18 Comparing surface texture and reflectance of four papers.

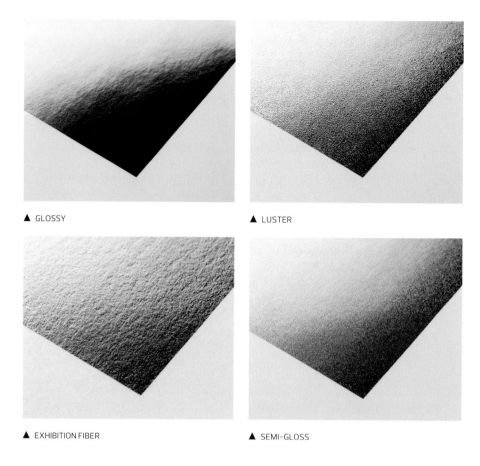

▲ GLOSSY

▲ LUSTER

▲ EXHIBITION FIBER

▲ SEMI-GLOSS

While this example shows Epson papers only, the same types of surfaces are available from a wide variety of third-party paper distributors. For pure detail and contrast range, the glossy paper is a winner, but I personally don't like it for fine art prints. I much prefer the surface of Exhibition Fiber or Luster. The surface texture of the Hahnemühle FineArt Baryta is very close to that of Exhibition Fiber.

MATTE/WATERCOLOR OR FINE ART PAPER

Hot-press papers such as Ultrasmooth Fine Art paper from Epson or third-party papers are very smooth. When you print to them, images retain an enormous amount of textural detail because it's not broken up by the texture of the paper. Cold-press papers often retain the appearance of texture in the paper—not so much the texture of the actual deckle screen, but the natural laying of the paper fibers. But with cold-press papers on small prints, the texture of the paper can compete with the detail

NOTE I don't think watercolor paper is inherently more suited to fine art prints than fine photo papers. Some people think if you don't print on watercolor paper, you're not a fine artist. I take umbrage at that.

of the image; it often depends on the size of the final print and the textural nature of the image detail as to whether or not the cold-press paper will preserve enough image detail in the print.

If you're making a big print out of an image that doesn't have a lot of resolution, using a cold-press paper will give the appearance of a better image. If you get up close and see the texture of the paper, you won't necessarily see the pixelation. That's where a cold-press paper with a very obvious watercolor texture can help, whereas a hot-press smooth watercolor paper won't hide the lack of resolution in the image.

Another factor is whether or not the paper has OBAs. If you really don't want to use OBAs, then you'll be faced with a warmer white paper that will influence the colors of your image. You can make adjustments for the paper color when soft proofing, but paper without a brightening agent of some sort will have a lower contrast range potential. **Figure 5.19** shows hot-press and cold-press texture with and without brighteners. The papers are Epson Hot Press Natural and Bright, and Cold Press Natural and Bright.

> **NOTE** Most paper manufacturers are actually paper distributors. There are only a handful of high-quality paper mills left in the world. St Cuthberts Mill, located in Somerset, England (www.stcuthbertsmill.com), makes Somerset Velvet, one of my favorite watercolor papers. It's a cold-press press paper with nice texture. It has OBAs, so it's very bright. You can't buy it directly from Somerset because the company wholesales, but doesn't distribute. Mitsubishi in Japan is a large RC paper manufacturer (www.mitsubishi-paper.com). Companies such as Epson, Canon, and other paper retailers will get paper that is only slightly different in the original specification. When Epson orders paper, the paper manufacturer makes it to Epson's exact specification (often a trade secret so someone else couldn't buy the exact same thing), but some of it is so similar, it's virtually interchangeable.

▲ HOT PRESS NATURAL (TOP) AND BRIGHT (BOTTOM)

▲ COLD PRESS NATURAL (TOP) AND BRIGHT (BOTTOM)

FIGURE 5.19 Comparing four types of fine art papers.

A lot of the recommendations I give regarding output and printer resolution are aimed at printing to photo papers. They also apply to hot-press, really smooth watercolor papers, but not to cold-press, rough watercolor papers. The reason is that the rough paper surface cannot retain the resolution in a high-resolution image. While I might recommend printing at 720 PPI or 600 PPI to glossy or hot-press papers, I'd lower that to 300 for Canon and 360 for Epson for cold-press paper, since you won't be able to see the detail the higher resolution will contain. When you're printing to an ultrasmooth fine art or hot-press paper, you can see the difference in 2440 PPI and 1480 PPI, but for cold-press or watercolor, there's not much benefit to going above 1480 PPI for Epson or 600 PPI for Canon.

CANVAS

I personally don't like printing on canvas and don't have a lot of experience doing so. I have a good friend and colleague, Henry Domke (www.henrydomke.com), who is an absolute maven when it comes to printing canvas and has a large inventory of canvas prints. I asked Henry for advice on best practices about working with canvas; see the sidebar, "Henry Domke's thoughts on printing canvas."

Making quality canvas prints is much more of a manufacturing process than I'm generally interested in doing. However, the advantage of working with canvas is that it can be stretched on a frame, and it's relatively lightweight and easy to transport. You can roll it up, ship it, unroll it, stretch it, and hang it.

To be honest, one of the reasons I don't use it much is that when I was in school, some people wanted photos to look more like art. Making prints on canvas and passing them off as art doesn't sit well with me, and I have a knee-jerk reaction against it. However, with a print that's big enough and with the viewing distance across the room, the texture of the canvas is not even noticeable or objectionable. So, for really big prints, I may have to get over my prejudices.

NOTE Henry prints canvas on a pair of Epson Stylus Pro 11880 64-inch printers. Unlike most people, who underprint, Henry prints so much he tends to wear out his printers. He is actively testing Epson's Solvent printers in an attempt to eliminate the requirements of spraying the finished canvas. Henry prints using ColorByte's ImagePrint raster image processor (RIP) in part because of its built-in capability to do gallery wraps and the fact that, unlike the Epson print driver, ImagePrint has no maximum print-length limitations.

GALLERY WRAP EXPLAINED

If you are printing on canvas and don't intend to put the stretched canvas in a frame, you'll end up having to wrap a portion of the image around the stretcher boards. Depending on the image details at the edges of your image, this can work fine. But there's an alternative approach called a "gallery wrap" that dresses up the edges of the image. Some software like Image-Print can do this automatically. But if you want to do it manually, you'll need to work in Photoshop.

To make a gallery wrap, you'll need to expand the image using the Image > Canvas Size command. The amount you need to expand will depend on the thickness of your stretcher frames, but it should be at least 1 inch. Using the Marquee tool, select one of the left or right edges in the image and use the command New Layer Via Copy (Command+J for Mac, Ctrl+J for Windows). Take the new layer and use the command Edit > Transform > Flip Horizontal, and then move the layer so it lines up with the original edge of the image. It will produce a mirror reflection of the edge of the image. Do the same thing on the other edge. Once you have the left and right edges done, do the same on the top and bottom edges. Once you've done all four edges, make the canvas print and use the additional gallery wrap to dress up the edges of the stretcher frame and stretch the canvas as you normally would. **Figure 5.20** shows the mains steps to producing a gallery wrap.

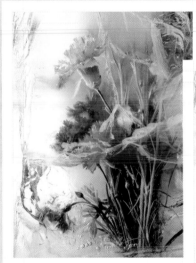

▲ THE IMAGE WITH GUIDES AND THE IMAGE CANVAS EXPANDED BY 1.5 INCHES

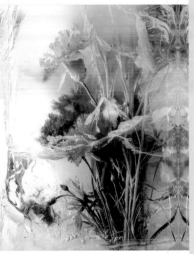

▲ THE RIGHT-SIDE EDGE COPIED AND FLIPPED, AND PUT INTO PLACE

▲ ALL FOUR EDGES MIRRORED TO CREATE A GALLERY WRAP

FIGURE 5.20 Creating a gallery wrap.

HENRY DOMKE'S THOUGHTS ON PRINTING CANVAS

I print about 50% paper, 50% canvas, so I have a lot of experience with both. File prep is almost identical. You just have to make sure you have the right profile. Because canvas has a textured surface, I tend to be a bit more aggressive with sharpening. One of the issues is what resolution to print at. Given the textured surface of canvas, I think that higher-resolution settings are unnecessary.

Canvas is thicker, so most people use something to cut it other than the blade on the printer because the blade wears out so quickly when cutting canvas. I have found that a *very* sharp pair of Messermeister 8-1/2-inch Take-Apart Utility Shears to be perfect. You just push the blades against the canvas as you pinch to hold it steady.

Because canvas is thicker, the rolls are shorter. Often, canvas rolls have something like half the length of a paper roll. That means you are more likely to run out of paper in the middle of a print.

Most people display paper prints with glazing and canvas prints without glazing. That is a huge advantage for canvas over paper. The cost of framing (typically just stretcher bars) is significantly less for canvas. With no glass, canvas prints typically don't have a problem with glare. The weight of the print plus support material is much less for canvas than for paper. This means canvas prints are easier to hang.

Without glazing to protect the prints (at least those made on aqueous printers), most people feel nervous displaying canvas without applying a protective coating. To do that right is a huge pain. I have a dedicated ventilated spray room for it. Solvent printers create prints so durable that they probably don't require coatings.

Coatings have their own impact on the look and feel of the finished print—usually negative. Some coatings (such the popular Glamour II Veneer) make the print look like it's encased in plastic—ugly and hard to work with. I believe that, in a residential setting, applying a coating is unnecessary, but most people believe otherwise. However, many clients like to use a gallery wrap for their canvas prints. "For an in-depth explanation about gallery wraps, see the sidebar "Gallery wrap explained.""

Attaching the canvas print to the stretcher bars is the same process that is used for attaching raw canvas to stretcher bars to create an oil painting. There has been no meaningful change to the process in many years. The process is intimidating at first, but once you've done it a few times, it is no big deal. I'm sure there are many good YouTube videos on stretching canvas.

Personally, I never do any framing or stretching of my canvas or paper prints. I always ship them rolled up. That makes shipping much cheaper and much less prone to damage. My clients get them framed/stretched locally. High-volume frame shops have automated equipment that makes stretching even simpler, so it would be absurd for most individuals to do it themselves.

I do the same extensive testing for my canvas prints that I do for my paper prints. If you have the proper profile for the canvas, then you should have the thing nailed. Sharpening is a different story, but over time (and on thousands of prints), I've learned how much sharpening I like. I have my master file that is all ready to be resized, sharpened, and then printed. No test print is needed at that point.

Regarding handling, once you have a stretched canvas that has gallery wrap, you have to be careful about the corners when transporting it. The corners are prone to hit or rub on things. If enough force is used, then the ink will be rubbed off and white canvas will be revealed. Hence, protection (typically cardboard corners) is used.

Some issues regarding printing on canvas:

Head strikes. These look like dark smudges, and they occur when the print head touches the canvas. You can prevent head strikes by increasing the platen gap.

Flaking of the primer. The canvas is coated with a primer. Canvas primer is thicker than the coating on paper. Sometimes clumps of primer form and can flake off after printing. That leaves little white spots that are usually just a few millimeters across, but sometimes bigger. I use paint to cover these up, but it does not always work. I would assume that brand-name canvas might have fewer problems of this kind than cheaper canvas. I stick with Epson-branded canvas and still see it in perhaps one out of 20 prints.

Drips/drops. Drips are small random spots of ink. The color varies with whatever ink is dripping from the print head. This apparently is not a common problem, but it has been a serious issue for me. Apparently, the pump cap assembly and the associated wiper blades get dirty and wear out over time. Cleaning them and replacing them requires a very expensive service call for the Epson Stylus Pro 11880. Some printers, such as Epson's new Solvent printers, let you buy inexpensive replacement parts. Drips are almost impossible to repair (I've tried the paints I mentioned above) and very hard to prevent. I have found that they tend to occur after I've had the printer for a year or two. Drips tend to occur most often if I am printing more than 10 canvas prints in a row.

Running out of canvas in the middle of a print. Because canvas rolls are much shorter, and because canvas prints are often larger, you will find that you run out of canvas in the middle of prints more often. There is no elegant way to deal with this. Epson tried with things such as barcodes to alert you to how much canvas is left, but I have not found it to be helpful.

ALTERNATIVE SUBSTRATES AND PRINTING PROCESSES

You can print on substrates that are not traditionally prepared inkjet paper. In fact, some of the substrates you can use are not paper at all. With the proper sizing and coating, you could print on papyrus, or parchment, or basically just about anything that you can shove through the inkjet printer. That could include wood—very thin wood, but wood nonetheless. That would have a lot of alpha cellulose and lignan left in it! You can print on metallic paper, which is paper with a metallic or iridescent surface. You can print on metal or aluminum, again with the proper coating preparation. Depending on what you're trying to accomplish, you can end up with pretty interesting pieces of art—but whether they're considered photographic in a classic sense, I'm not sure. A source for a precoating to print on alternative materials is inkAID (www.inkaid.com).

You can also print on film that has been properly coated to hold the ink. Since it is designed for inkjet printing, the material works well and creates an effect similar to a transparency or negative, which can then be used for printing on photosensitive materials such as silver gelatin photo paper on platinum, or palladium-coated paper. Two friends of mine are doing some interesting work in this genre, Dan Burkholder (www.danburkholder.com) and Jill Enfield (http://jillenfield.com). Jill recently released a new book titled *Jill Enfield's Guide to Photographic Alternative Processes: Popular Historical and Contemporary Techniques* (Focal Press, June 2013).

Dan has been doing digital negatives for photosensitive printing for a while. In fact, Dan has an eBook titled *The New Inkjet Negative Companion* available as a download from his Web site that outlines the preparation and making of digital negatives for platinum, silver, cyanotype, and Van Dyke brown prints. He also uses a hybrid combination of the color of inkjet with the blacks of platinum or palladium. He removes the black from an RGB image, prints a color print (getting just color) and then makes a digital negative, and then coats the inkjet print with platinum and contact-prints the negative onto the color print. A new process combines platinum prints made from digital negatives and prints the result over gold leaf for a rich golden-toned print. **Figure 5.21** shows platinum on colored inkjet and the same image printed with platinum over gold leaf.

Jill does similar work, printing palladium (instead of platinum) over colored inkjet prints—printing both the colored inkjet and a digital negative in succession to make sure of size consistency. While Dan likes to print registration marks on his prints and negatives, while Jill prefers hand registration by eye because it makes each print more unique and spontaneous. **Figure 5.22** shows a scan of a colored inkjet with the blacks stripped out prior to coating the paper and printing the palladium.

▲ PLATINUM OVER COLORED INKJET

▲ PLATINUM OVER GOLD LEAF

FIGURE 5.21 Alternative printing by Dan Burkholder.

▲ THE COLORED INKJET PRINT PRIOR TO PALLADIUM PRINTING

▲ THE FINAL PALLADIUM OVER THE COLORED INKJET PRINT WITH THE HAND-COATING BRUSH STROKES RETAINED (SOMETHING JILL LIKES TO DO)

FIGURE 5.22 Jill Enfield's palladium over colored inkjet.

PICKING THE RIGHT PAPER FOR THE IMAGE

Now that we've covered all the paper types, which one do you choose? The decision is somewhat arbitrary, depending on your aesthetics and what you're trying to accomplish with a particular image. It's been my experience that I can look at an image, something with a lot of darks or saturated colors, and know that if I print it on watercolor paper, the image is going to die—it just won't have pop. But there are other images that may be less saturated and have more muted tones, images that don't have a lot of texture and detail in the image itself, that translate to watercolor paper very well. If it's not a high dynamic range image, if it is relatively muted, it doesn't suffer as much being printed on watercolor paper. **Figure 5.23** shows a range of images printed on both hot-press watercolor paper and Exhibition Fiber paper. See if you can determine the best paper for the image.

Generally speaking, the image itself tells me what kind of paper it wants to be printed on. That's kind of airy-fairy, but it's a nonverbal communication or spiritual relationship with the image that tells me which type of paper to use for a particular image. For the images in Figure 5.23, I liked the watercolor paper the best for the house in the desert. For the Cow Canyon Trading Post image, they are close enough that either paper would produce an excellent print. However, for the sculpture image, the weak blacks of the watercolor paper made me choose the Exhibition Fiber paper as the winner!

Rolls or sheets?

My personal preference is to print on sheets of papers rather than on rolls. While roll paper is considerably lower cost per square inch, I simply hate dealing with the paper curl you get with roll paper—particularly fine art watercolor paper.

Paper sheets generally come in thicker millimeters or higher GSM weights than roll paper counterparts. You are somewhat limited to using the available paper sizes that manufacturers provide, but most papers are available in standard sizes.

If you do decide you want to print from rolls versus sheets, you'll need to invest in some sort of anti-curling device. Most of my friends who print on roll paper use a Bienfang De-Roller to flatten the print. The De-Roller is really an expensive rollup window shade, but with some specific features designed for taking the curl out of paper. The De-Roller comes in two standard sizes: a 24-inch width model (and up to 38 inches long) with a 1.5-inch diameter, and a 50-inch model (also with a 1.5-inch or a 2-inch diameter and up to 38 inches long). The 24-inch De-Roller will set you back about $235. The 50-inch width with a 1.5-inch diameter sells for about $265, and the 50-inch model with a 2-inch diameter is priced at about $299. Yes, they are

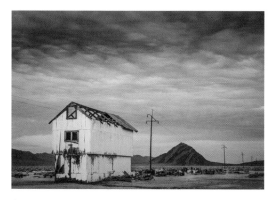

▲ HOT-PRESS BRIGHT

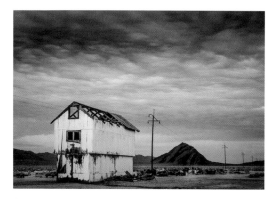

▲ EXHIBITION FIBER PAPER

▲ HOT-PRESS BRIGHT

▲ EXHIBITION FIBER PAPER

▲ HOT-PRESS BRIGHT

▲ EXHIBITION FIBER PAPER

FIGURE 5.23 Comparing paper types with different images to determine which paper is best for the image.

expensive (I warned you about that), but if you do a lot of roll printing, you'll make up the price in reduced paper costs versus sheets.

There is one word of caution: my friend Mac Holbert doesn't think counter rolling is a good way of flattening because the paper fibers are forced into an opposite direction. He feels that counter rolling may have an adverse effect on print longevity. He uses weighted boards and pressure over time to flatten his prints.

Print big or print small?

Back in college at Rochester Institute of Technology (RIT), we had some photo truisms: if you can't print it good, print it big; or the converse, if you can't print it good, print it small! We also had some others: if you can't print it good, print it dark (or light). I come from an analog background where an 8 x 10-inch print from a 35mm negative was good, but an 11 x 14-inch print would sometimes push it. Yes, I shot medium and large format (you could make a really large print from an 8 x 10 chrome if you had an 8 x 10 enlarger). But in general, if you were shooting small format, 11 x 14 was the upward limit. With medium format, 16 x 20 was easy, and with large format, maybe 30 x 40-inch prints were the norm.

In the digital age, all bets are off. Nikon has a 36.3MP small-format DSLR. My Phase One IQ180 camera back is 80MP and even larger if I stitch multiple captures together. So, the barriers for really large prints have come down compared to the old darkroom days, which in some ways is a shame. On one hand, a nice tight print at 5 x 7 or 8 x 10 with a 2-inch mat border can look like a small gem, and it doesn't take a lot of real estate to hang it. Heck, a nice wallet-sized print well matted and framed can be really nice to look at, and done well, it will draw you in. On the other, I have a 44-inch wide printer, so I could easily print out 40 x 60-inch or larger prints, particularly from stitched IQ180 captures—but, just because you can doesn't mean you should. I think there are certain sweet spots for capture size and print size that allow you to maximize the image quality of the final print while having reasonably sized framed prints on the wall.

My two favorite print sizes are 17 x 22 and 24 x 30. Depending on the camera I use, I can get excellent, highly detailed prints at these sizes while maintaining a useful paper margin and still getting an impressive print when framed.

Also understand that printing big comes with big costs for more ink, more paper, and more expensive matting and framing (unless you go canvas). Bigger is not always better. Try to find your own sweet spot.

PRINT FINISHING

Once you've made your print, it's not finished until it's finished. By *finishing*, I mean improving its resistance to abrasions and UV light fading. The natural way to do that is to frame the print behind glass or plastic, or give it a coating.

COATINGS

There are a couple of different ways to coat a digital print. You can just use a can of protective spray, such as Print Shield from Premier Imaging Products (www.premier-art.info). Print Shield protects the surface of the print and ink sitting on the paper, and it adds water resistance and UV-light resistance. That's one that John Paul has used—and if it's good enough for JP, it's good enough for me. The key to spraying a coating is to apply multiple light coats rather than applying it all in one fell swoop. If you're good at spraying, it's not a real problem—just move back and forth and do

even swaths, making sure that you spray from far enough way that you don't create buildup or runs.

If you're coating a lot of images in a production environment, it's expensive to use cans of aerosol spray. In that case, you'd want to contemplate either an HVLP (high-volume, low-pressure) system or an airless sprayer. Most people I know doing production work use an HVLP sprayer.

You can also apply coating with a roller or a foam brush; you can buy the coating and mix it with water. Generally speaking, you want to use water-based acrylic varnish for either an HVLP sprayer or a roller or foam brush. You can order different surface treatments, including glossy, semi-gloss, and matte, and mix the gloss or the matter to get your own custom reflectance. The only roller-based coating I've used is Timeless print varnish from Breathing Color (www.breathingcolor.com). Breathing Color offers training videos and also supplies a wide range of inkjet media, including papers and canvases.

If you're spraying or rolling a coating on watercolor paper, the coating increases the dynamic range on the print, making the blacks a little deeper. It also protects the print from abrasions, and if you're using matte black ink, it keeps the print from being burnished.

Another option is lamination. That is not something you'd want to do on your own because heat-set lamination requires a special machine. You could laminate the front and the back and have a very stiff, very durable, but (to a certain extent) kind of ugly laminated print. However, if you mount the print on a stiff board, you could add a thin film lamination on the top that would make the surface of the print very durable and, depending on the material, it could be incredibly glossy. But if you choose lamination, you want a third party to do it because it does take specialized equipment and skill.

In addition to traditional coatings, there are alternatives. For example, you can add an embellishment to a print. You'd use a clear gesso or a varnish designed for oil or acrylic painting to add a brush texture on the top of the print. I'd advise you to test for your particular ink and paper first to make sure the surface is suitable to accept the embellishment. In some cases, you may have to apply a Print Shield spray first and then apply the varnish or gesso on top of it. That's not traditional, so it's not something that I would be predisposed to do, but it is an option.

MATTING

When you're matting an image, there are generally accepted practices of using acid-free materials to hold the corner of the prints in position on the backing board and using a very accurate overmat, with a bevel cut. The question is whether you want

to do an overmat that goes into the image. If you do, print the image a little larger so the loss of about 1/8 of an inch all around the image is taken into consideration when you're printing. I tend to prefer a recessed mat so that I actually see the surface of the paper.

I don't cut my own mats. I have this really nice scar on my left thumb from trying to use an Xacto knife to cut the mount board with my right hand (I'm left-handed). My thumb got in the way and, fortunately, the bone stopped the blade. I have a constant reminder on my thumb as to why I don't actually want to cut my own mats. Besides, there are some impressive mat-cutting machines that provide incredibly consistent results. Most of my friends who prefer to cut their own mats use an Esterly Standard mat cutter from Speed-Mat (www.speed-mat.com), but it's really expensive (about $3,000 for a 40 x 60 cutter with accessories). A more reasonable professional cutter is a Fletcher 2200 (about $1,250 for a 48-inch cutter).

SIGNING PRINTS

It's an established artistic practice to sign a print to provide authenticity and provenance. If you printed on a watercolor paper, you can sign with a pencil. If you're going to spray it, sign it before you spray so that the coating also protects the signature.

If you're going to sign your prints, don't use your legal signature. I heard about a guy whose identity was stolen because someone who was working for an artist stole some checks and used the signature from his prints to forge checks.

Arriving at your optimal signature takes practice. I learned the hard way—200 signatures within 90 minutes at a trade show—that you want to develop a very quick, fluid, and efficient signature, not something that is difficult to repeat. Practice it until muscle memory takes over and your signature looks both artistic and consistent. **Figure 5.24** shows my print signature in pen (top) and pencil (bottom). I use a pencil for watercolor paper and a permanent pigment pen (available at art stores) for signing photo papers.

I put my signature and date on the lower right underneath the image, and I add the image title (assuming it has a title—often it's simply a location) on the lower left underneath the image.

FIGURE 5.24 Signature in pen for photo paper on top; pencil signature for watercolor paper on bottom.

TO NUMBER OR NOT TO NUMBER

The practice of numbering a print came from stone lithography. I've actually done stone lithography printing, and it's a pain. You have to prepare the stone, get the design and artwork onto the stone, and then go through an incremental process of testing and revising the stone making unnumbered proofs that are considered artist proofs (APs). When the lithographer thought that the stone condition was optimal for making the print, he would start making and numbering them.

When you started making the prints, you could aim for a given number, like 25 or 50, but you wouldn't know how many prints you could make because the stone wore out. The details would diminish to the point so that the later prints no longer looked as good as the beginning prints. In the old days, once the stone had been printed, there was a ceremony of breaking the stone so that no further prints could be made.

Fast-forward into the digital age: With digital printing, you can make as many prints as you want, with each print equal to the previous one. With traditional printing, whether it is stone lithography or silk screening, limiting the number of prints was a matter of economics and scarcity. But the whole concept of a numbered and limited edition with digital printing is an artificial scarcity. If a photographer and artist claims to make only 50 prints, you have to trust that they won't make more prints.

My friend JP has an interesting approach. He numbers prints, but produces an open edition instead of a limited edition. He sets the pricing for the print based on how many he makes. The first prints he makes are less expensive; as he makes more, he increases the price. It's an interesting twist, turning the concept of scarcity on its head.

Matting choices are a matter of taste. I'd caution that you want to use museum-grade mats. The term *museum-grade* is kind of arbitrary and capricious, but I mean that your mats should have the attributes that a museum would expect for conservation and preservation: a mat should be acid-free and not impact the artwork that it was mounted on or matted over.

You could possibly do dry mounting, but for photographic conservation, dry mounting is a one-way street. If you need to replace a backing board after you've permanently mounted and sprayed it, it'll be difficult to replace. Unless you have a compelling reason, any spray mount or dry mount of a print is not a good practice for fine art purposes.

Most prints that are matted are ultimately meant to be framed. If you sell matted prints as opposed to final framed prints, put the matted prints into sleeves to keep the mat boards nice and clean. Get a clear sleeve that is large enough to hold the backing board, print, and overmat.

Sleeves are also useful for dealing with and handing prints through the print finishing process. I use Clear Bags, available from www.clearbag.com. They're acid- and lignin-free, and come in a wide variety of sizes. Basically, you want a bag that is slightly larger than the print. With a clear sleeve, you can handle the print without worrying about getting fingerprints or dirt on it.

FRAMING

How large you print your image and how large your frame needs to be depends on how you approach paper size and image size. For example, if you plan to mat a print, you want to allow an easement of 2–4 inches all the way around the image when you print it. More is better, but if you have more than that, the size of the frame grows, and it's the frame and glazing that can be very costly. An easement of 2–3 inches around the actual opening size for the image would be suitable.

You can get artsy-fartsy and go with a really big setback of 6 or more inches, which can be impressive because the mat and the frame make the image appear more prominent and more important, but that's an aesthetic that is up to the individual. Personally, I think it's kind of bogus.

When it comes to print framing, there are two basic kinds of frames: wooden frames with miter cuts and joinery, and self-assembled metal frames. Wooden frames require a high degree of craftsmanship and carpentry to get the frame to be an exact shape and size. You need skills beyond being a fine artist and a photographer to cut your own mats and do your own framing. If you're in a production environment and you have the equipment for mitering and joinery, there's no reason not to do it. I find it tedious, and it's not really my cup of tea. Self-assembled frames come in a variety of metal rails with different finishes. You can get very nice metal frames, and assembling them is not so difficult that it's beyond anyone's capability, if they are handy with a screwdriver. The frames won't have the same kind of fine-art furniture look of a custom wood frame, but they're certainly a suitable and usable alternative.

You don't want to leave the print surface exposed to the air. So if you mat and frame a print, you want to protect it with either glass or poly, meaning methyl methacrylate, often called acrylic glass or by its brand names of Plexiglass or Lucite.

If you're framing relatively small prints (16 x 20 inches or smaller), there's no reason not to use glass. Which type of glass you want to use is largely dictated by

the environment in which the print is going to be hung. You can use low-UV glass that will aid in UV resistance so that the image lasts longer. You can also get anti-glare glass. I tend to dislike anti-glare glass because in addition to cutting down on the reflection (a good thing), it reduces the detail of the image (a less good thing).

Plastic, including poly, weighs a lot less than glass, so if you're framing a very large print, it'll weigh a lot less. The downsides to plastic are that it attracts dust through static and is more easily scratched or abraded than glass. (You can usually smooth out small scratches or abrasions using a plastic polish.) The upside of plastic is that it's essentially unbreakable. If you drop a print on the edge, glass in the frame can shatter. If you're shipping prints, you have to decide whether it's better to ship the matted, framed print without glass and then have it glazed at the receiving end, or just ship it with plastic. A lot of this depends on ultimately where the print is going to be hanging and how much shipping and handling has to be involved to get it to its final destination.

I don't really do a lot of print framing for galleries since I tend not to try to sell prints (yeah, I know, but I explained this in the introduction). However, I did have a major retrospective print show at the Art Institute of Atlanta in 2005. I say retrospective, but it was only retrospective up till that point—a new show would have a lot of new work! **Figure 5.25** shows some shots I took of the print installation in the Janet S. Day Gallery.

A good practice when framing is to provide additional information about the print on the back of the print or the mat board. It's useful to indicate the type of paper it was printed on, the printer that was used, and possibly the date the print was made. This is to provide information for future conservators, so they do not have to guess when considering how to preserve the print. I've got a standard little label that I print out and stick on the back of the print.

PRINT PRESENTATION

Back in the old days of the last millennium, when I was a working commercial photographer, my representative carried around my print portfolio to show art directors and prospective clients. These days, for showing your work one-on-one, I'd use an Apple iPad. Trying to carry around a print portfolio is pretty old school. Having said that, you just may have a use for print portfolios or folios.

FIGURE 5.25 Various views of my Art Institute of Atlanta retrospective print show.

PORTFOLIOS AND BINDINGS

There are plenty of places to get premade portfolios. You can find them in art stores or just about any place that sells art supplies. For a more artistic touch, you can create a handmade book with custom binding. I made a promotional piece with a series of eight prints, with my own custom handmade binding. I got some interesting handmade paper and found little twigs that I sliced. Then I used leather lashings to bind the twigs as the binding posts. I then put that into a presentation box and used it as a self-promotion vehicle. **Figure 5.26** shows the handmade book.

You can find fine art papers with inkjet coating on both sides that would let you create a post-bound book with images on both sides of the paper. I don't think those kinds of portfolios will last long—but for the short term, I think it's fine.

The other option is to create a photo book online, using a print-on-demand service with an Indigo press, producing a short-run halftone reproduction printing. Obviously those aren't prints that you'll be personally making. But you could put together a book and send it off to Blurb (www.blurb.com) or another online provider. Lightroom has the ability to make photo books. You can also use iPhoto or Aperture to create and order books and note cards from Apple. You can print one or as many as you want. It's an alternative to trying to make inkjet prints into a serviceable book.

FOLIOS

I think of folios as presentation folders or boxes with prints inside. I've got presentation boxes in which you could use a really nice paper (vellum or parchment) as a liner, then put the prints in the box with interleaving so the prints don't rub up

FIGURE 5.26 My handmade self-promotional piece.

▲ THE BOUND BOOKLET IN THE PRESENTATION BOX

▲ THE OPENING PAGE WITH A POEM PRINTED ON VELUM

▲ THIS FIRST IMAGE IN THE SERIES OF EIGHT PRINTS

▲ FOLIO CLOSED

▲ FOLIO SHOWING THE COVER SHEET

▲ FOLIO SHOWING THE PRINTS

FIGURE 5.27 Custom–made folio with a cover sheet and prints.

against one another. I had mine made specially, but you can also buy them. The folios or print boxes are available in museum-grade materials that are acid-free to help preserve the longevity of the print. **Figure 5.27** shows an example of a custom-made folio for prints.

PRINT STORAGE

The optimal way to store images is horizontal and flat, rather than vertically. Over time, the paper gets fatigued if it has to stand up. (You would, too!) A flat file is a good option. **Figure 5.28** shows my flat files for print storage. I really don't remember what I paid for them (two sets of five 30-by-42-inch drawers with base and top), but currently this unit would cost about $1,500 for natural oak.

You can also store smaller prints in photo albums, as long as the album pages won't destroy or stick to the surface of the print. Albums can be a handy way of storing prints, especially heirloom or family prints. If you have to evacuate the house due to fire or any other emergency, an album is easy to grab. So one of the best ways of preserving your images is to make prints. (Epson has a whole section of its Web site dedicated to encouraging people to make prints and put them in albums in order to preserve family heirlooms. Self-serving of Epson, yes, but a good idea nonetheless.) **Figure 5.29** shows a photo album my wife purchased to store prints I made from our Hawaii vacation (lots of shots of rainbows and sunsets).

FIGURE 5.28 My flat files for print storage.

FIGURE 5.29 Photo album of the family vacation (even photographers are entitled to vacations).

▲ THE COVER

▲ THE INSIDE PAGES

PRINT LONGEVITY

When you take the time to make a print of a great image, you want that print to last. The life expectancy of either a photographic (silver gelatin) print or a digital print depends on the process and materials used to create it, and the way it's treated during its life.

We still have original prints and the negatives of photographs that Matthew Brady shot during the Civil War. Black-and-white analog material, as long as it was properly processed, can last for centuries. However, color photographic material that relies on dyes or colorants can be relatively short-lived. The old Kodak Kodachrome film was probably the first best color film with long-term life expectancy. Unfortunately, other photographic processes after Kodachrome—both color negatives and color transparencies—have a much-reduced life expectancy due to a lot of factors.

TIP In terms of standards for digital printing, the term *archival* is meaningless. You need to be concerned about lightfastness and other factors that will impact print longevity and preservation.

VARIABLES THAT AFFECT LONGEVITY

Generally, the successful long-term storage of either photographic or digital prints depends on the following variables: humidity and temperature; light exposure (especially UV light); fire, water, and other causes of physical damage; contact with chemicals in solid and gaseous forms; and the containers in which the prints are stored. There are standards, such as ISO 18916: 2007 (E) for testing practices, for all of these issues related to longevity.

Humidity can cause damage to prints, as can higher temperatures. Fungus and mold are also potential problems. It's a challenge to maintain photographic and digital prints in a tropical environment or any place with high humidity, like Florida. Low temperatures extend the life expectancy of analog photographic materials, too. Humidity and temperature can have such an impact that many important documents, photographic archives, and other materials belonging to the government and to museums are stored in particularly favorable low-temperature conditions, such as Iron Mountain, a huge cave in central Pennsylvania.

UV light, since it's a higher-energy light, is the most destructive light for prints. Sunlight is a great destroyer of prints, causing fading and color changes.

The hazards of fire and water are pretty obvious, but others are a little more subtle. For example, if an earthquake knocks your frame off the wall, breaking the glass, that glass can easily cut the print and destroy it.

Chemicals can have significant effects on printed images. For example, new carpets and certain kinds of paint vapors have an adverse impact that can be shockingly quick.

Of course, the containers or enclosures that you keep prints in have an impact on longevity and long-term conservation and preservation.

NOTE When I shot film, we'd test film in lots. When we got a bunch of film we liked, we'd freeze it to keep the emulsion from changing. Temperature definitely made a difference with film. It's not clear whether low-temperature storage is useful for pigment prints.

LONGEVITY TESTS

You may not be able to know instinctively which paper and ink combinations are going to provide the greatest durability, but there are groups that test the longevity of prints made using specific practices.

The Image Permanence Institute (IPI), a department of RIT's College of Imaging Arts and Sciences, does an enormous amount of work on testing and standards involving all manner of accelerated exposure testing. It tests light exposure as well as the effects of pollution and things such as pH, temperature, and humidity. I'm an alumnus of RIT and I think the people at IPI do some good work, but I have a slight problem with them, in that they do a lot of contract work for companies and corporations but don't necessarily publish their results. It's up to whoever commissions the testing to decide whether to release the results to the public.

At Wilhelm Imaging Research (www.wilhelm-research.com) in Grinell, Iowa, Henry Wilhelm has a long history of longevity testing. Henry tests lightfastness, and he has published the results for various printer, ink, and paper combinations. He's the author of the preeminent book about longevity, *The Permanence and Care of Color Photographs: Traditional and Digital Color Prints, Color Negatives, Slides, and Motion Pictures*. You can purchase the book, and you can also download all 761 pages of it as a PDF file for free from his Web site. Henry is a leading authority, but he primarily performs accelerated light testing. He also does tests for the effects of ozone, humidity, and resistance to water, but the rating is simplistic. However, his information is important and he's shown that the combination of the ink and paper has a major impact on print longevity. Some inks work better with some papers and less well with others. Visit Henry's Web site to see if he's tested your printer. A word of caution, Henry's Web site is, well, a bit cluttered. It can be tedious finding the right printer and paper combinations, but it's worth the effort!

ALL THE VARIABLES MATTER

In the early days of inkjet printing, using photo dye inks, there were lots of questions about lightfastness. Epson commissioned Henry Wilhelm to do some testing with an early dye photo printer and glossy paper. Henry was finding in excess of 50 years of lightfastness—which was true—however, if you made a print and it was exposed to ozone, it would start fading in a matter of days. You really have to factor in all the variables. Now Henry does tests for resistance to ozone!

In Chapter 4, I talked about using the Advanced Black and White Mode of the Epson driver. If you use this mode, you can get extended lightfastness because it uses less of the color inks. A fine art printer has between 10 and 12 colors of ink, and not all inks age equally.

The Aardenburg Imaging and Archives (AaI&A) (www.aardenburg-imaging.com), founded by Mark McCormick-Goodhart, is a collaboration between the AaI&A research program and the general digital printing community. Mark solicits prints from the community and tests them for lightfastness, durability, and longevity. AaI&A is a grassroots effort; to get the test results, you have to register for free, but donations to the cause are welcome. While Henry has tested an enormous number of printer and paper combinations for lightfastness, Mark has tested a smaller subset (currently 288 lightfastness tests are available), but because they've been contributed by avid digital printers, they feature the papers and printers digital printers tend to gravitate toward. The printer, paper, and ink combinations they test are relevant for anyone doing digital printing.

There are also institutes in Europe that are engaged in longevity testing, and the National Gallery and the museums and galleries in England are also contributing. But it's challenging to get useful information as an individual unless you're a professional conservator or curator.

FINAL THOUGHTS ABOUT LONGEVITY

In the grand scheme of things, I'd like my prints to outlive me. I don't know that I'll produce enough work that is important enough to warrant society's interest into the next century or three, but if there are relatively simple and easy steps to ensuring greater print longevity, you owe it to your work to take them. If you take the time and make the effort to produce really nice prints of really good images, you might as well engage in practices that will ensure those prints stick around a while. If you're concerned, it's incumbent upon individuals to do the appropriate research. It's good to be familiar with the principles and the concepts, and then pick and choose what is relevant to your own work.

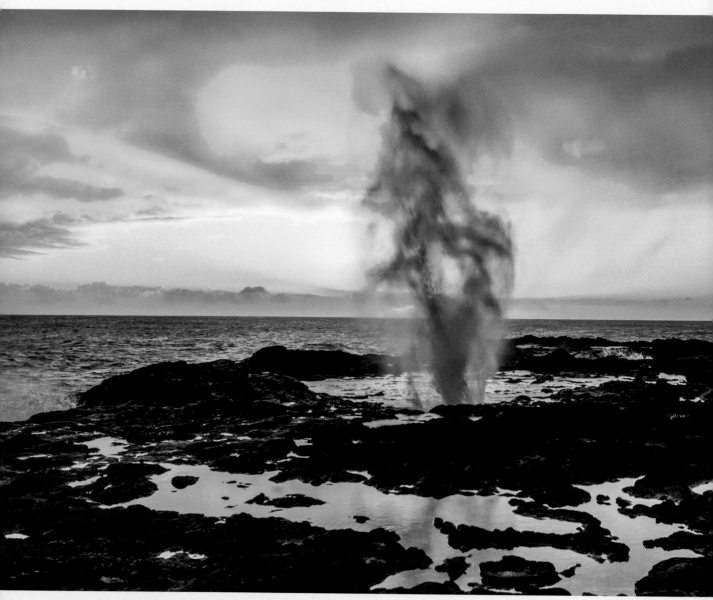

Spouting Horn blowhole in Poipu, Kauai, Hawaii, at sunset. The image was shot with a Canon EOS REBEL T4i with a 10–22mm lens at ISO 100.

CHAPTER 6

DEVELOPING A PRINTING WORKFLOW

A workflow is a logical series of steps that one takes from point A (the start) to point B (the destination). In this case, point B is hopefully a really nice print that will make you happy. A refined workflow is important because working through a well-thought-out series of steps prevents the sort of randomness, inconsistency, and errors that can interfere with you getting from point A to point B efficiently. Generally speaking, the goals of a printing workflow are to perform the steps in a logical order and to maintain a degree of consistency. The more consistent you are in your approach to making a print, the better the final results will be.

AN EXAMPLE FINE ART PRINT WORKFLOW

Mac Holbert has made a career out of making really great prints for other people (as well as for himself). This is his step-by-step workflow for arriving at the best possible final output. While Mac developed this workflow using Photoshop, it's not difficult to transfer the fundamentals of the concept (and the steps) to incorporate Lightroom. This is actually what Mac has done, because he really appreciates the many workflow benefits that Lightroom offers. By the way, while the step-by-step workflow is presented courtesy of Mac, the explanations are from me—so, any errors or omissions are mine!

1. CONFIRM SETTINGS AND SPECIFICATIONS

The first thing to do when you launch Photoshop is to double-check that the color settings in the color management section are correct and that you're starting from a known beginning point.

Any time you start making changes, you need to be able to get back to a known starting point. This issue is less relevant in Lightroom because, honestly, the Lightroom workflow is so much more efficient than Photoshop's, and there are fewer settings to worry about. **Figure 6.1** shows the Photoshop Color Settings dialog box as well as a series of actions I've created to set the Color Settings preferences. It also shows a way of letting Photoshop make sure your settings are correct every time you launch the application.

I recorded a series of actions to change the Photoshop Color Settings. I've assigned function keys so that at a click of a button, I can set my Color Settings for Printing, Screenshots, or the proper Color Settings I used when creating this book. A further extension of the automation of Color Settings is the ability to use the Script Events Manager (found in the File > Scripts menu) to automatically set the proper Color Settings every time Photoshop is launched. One caution I would mention is that once you do this, every time Photoshop launches this action, Color Settings for Printing will be applied. You should only do this if this is really what you want (it is what I want).

2. CROPPING (NONDESTRUCTIVE, IF POSSIBLE)

When you start working on an image, you might as well work on the crop you'll ultimately want to produce. The crop could be dictated by the paper and image size you want (for example, if you're fitting an image into a precut mat), but I like to set

◀ ACTIONS CREATED TO MAKE SURE MY COLOR SETTINGS ARE CORRECT

▲ THE PHOTOSHOP COLOR SETTINGS DIALOG BOX

▲ USING THE SCRIPT EVENTS MANAGER TO AUTOMATICALLY SET YOUR PHOTOSHOP COLOR SETTINGS

FIGURE 6.1 Making sure your Photoshop Color Settings are correct.

the crop based on what's optimal for the image. I don't care too much about fitting to an existing proportion. I crop out everything that doesn't help the image. While you're cropping, make sure you've got the correct rotation so that the image is level.

For the purposes of flexibility down the road, I suggest using nondestructive cropping. That's easy to do in Lightroom because you can always go back and re-crop anything. In Photoshop, it's a little trickier to crop nondestructively, but starting in Photoshop CS6, you can do it. When you're using the Cropping tool, deselect Delete Cropped Pixels in the options bar to retain the entire image. Then you'll have a visual crop, and you can see the whole thing again if you choose Image > Reveal All. **Figure 6.2** shows the option to uncheck Delete Cropped Pixels.

FIGURE 6.2 Unchecking the Delete Cropped Pixels option in the Crop tool options.

FIGURE 6.3 Configuring the Crop Guide Overlay options

▲ THE CROP GUIDE OVERLAY OPTIONS

▶ THE CHOOSE ASPECT RATIOS DIALOG BOX

▲ USING THE CROP GUIDE OVERLAY WHILE CROPPING

Cropping is an important aesthetic, which is one of the reasons that Lightroom has such a wide variety of different cropping overlays. In Lightroom, when in Develop, you can choose the Crop Guide Overlay to include a variety of options. New to Lightroom 5 is the ability to use Aspect Ratios as an overlay. **Figure 6.3** shows the Lightroom Crop Guide Overlay options.

In essence, try to keep the cropping nondestructive, because you might end up wanting to change your mind down the road. If you delete the pixels, you lose the flexibility to change your mind.

3. CLEANING AND SPOTTING

I like to really get to know my image. The way to do that is to go through the image zoomed way in, at a minimum of 100% and sometimes at 200%. In Photoshop, you

can see two different views at once—one where you can see the full image, and one where you can see the zoomed-in portion. You can also keep the Navigator panel open, so that when you're working zoomed in, you can see where you are relative to the image. Of course, when you're zoomed in to 100% to 200%, you're engaging in pixel-peeping—but you want to make sure you don't have any sensor spots. If you're working with film scans, you want to get rid of all the dust and scratches that may be apparent on the film. Generally speaking, I'll use the Spot Healing Brush or Healing Brush to remove dust and scratches directly on the background layer unless there's some compelling reason to do it on a separate layer.

You can do the same thing in Lightroom, working zoomed in. If you zoom in to 100% and press the Home key, Lightroom takes you to the upper-left corner of the image. As you click Page Down, it moves one screen down at a time, so you can scroll down and view the image systematically. When you get down to the bottom of the screen, if you press Page Down again, Lightroom goes up and over to the right so you can continue viewing the next section of the image.

In Photoshop, you can use the Home and Page Down keys to move down the image. To move sideways, you need to press Command+Page Up or Control+Page Up.

It's important to examine the image closely for any defects or dust or scratches. This careful inspection will also give you a clue as to what kinds of things you may need to do farther down the road.

4. GLOBAL NOISE REDUCTION AND SHARPENING

After everything is cropped and cleaned, apply noise reduction. In Photoshop, apply noise reduction on a separate layer so you have greater control, then apply sharpening on its own layer. In Lightroom and Camera Raw, global noise reduction is part of the whole processing component, so it doesn't matter when you do it—but you might as well do it in the beginning when you're doing the sharpening.

5. SHADOW AND HIGHLIGHT RECOVERY

Mac includes this step because he's often working on film scans, as opposed to digital captures. If you're dealing with film scans, it makes sense to use the shadow and highlight recovery feature in Photoshop to adjust the tone curve, if needed and appropriate. The tone curve is different from Levels or Curves.

If you're working in Lightroom, shadow and highlight recovery is, in essence, part of the global tone and correction you'll perform in step 6.

6. GLOBAL TONE AND COLOR CORRECTION

As you make these changes, you want to maintain maximum flexibility. In Photoshop, I tend to make tone adjustments first, and then where possible, adjust tone and color together. For example, you can use a Curves adjustment to adjust both tone and color, removing color casts. Particularly if you're working in 16-bit, though, there's no reason not to have multiple tone or color corrections, just as I did with the scan of the roll of film in Chapter 3. (See Figure 3.25.)

7. MAJOR IMAGE EDITING AND RETOUCHING

If you're going to composite images, you may have tone and color corrections that are specific to the composite. So if you combine multiple images, you'd want to maintain discrete tone and color corrections. If you're doing substantial retouching—for example, getting rid of a photographer who happened to end up in your photograph—you'd want to do that in a separate layer. If you keep the retouching on a separate layer, you can turn it on or off or modify it down the road if need be.

8. REGIONAL TONE AND COLOR CORRECTION

Mac refers to regional corrections; I think of these more as local tone and color corrections. Either way, these are the changes you make to specific areas of your image after you've made your global changes. Tone and color corrections are distinct from hue and saturation adjustments.

Keep in mind that the steps in this workflow are in reverse order of the layers you'll end up with in Photoshop. **Figure 6.4** shows an image with the final Layers panel after retouching and color correcting.

9. REGIONAL HUE AND SATURATION CORRECTION

After correction tone and color in localized areas, adjust the hue and saturation where needed. To see how you can selectively localize hue and saturation correction by color, check out the Chapter 3 section "Adjusting tone and color in Photoshop," starting with Figure 3.16.

FIGURE 6.4 A retouched and color-corrected image showing the final layer stack.

▲ THE FINAL IMAGE

▶ THE FINAL LAYERS STACK

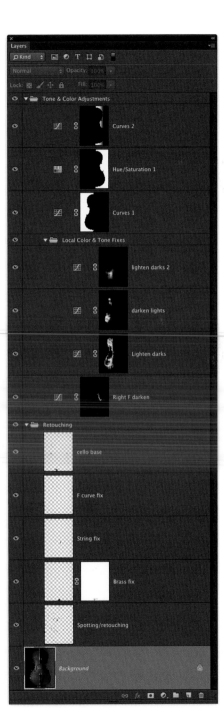

10. CREATIVE SHARPENING, BLURRING, NOISE

This is the creative component of the sharpening workflow: sharpening, blurring, and adding noise or grain. These tasks are separate in Photoshop, but in Lightroom they're kind of all together in one workflow. However, even in Lightroom, you probably want to perform the tasks in the same kind of order in terms of the adjustment panels, but it's less critical that you do them in a specific order.

Remember that layers in Photoshop have a very specific relationship to each other based on their stacking order. You can't change the order easily, so performing steps in a specific order and maintaining consistency is important.

11. BURNING, DODGING, SCULPTING, AND MIDTONE ENHANCEMENT

At this point, you add localized enhancements for texture and shape, just as I did with *The Digital Print* cover image in Chapter 3. These are an extension of the local tone correction, but they're sitting on top. This is where you might do a midtone contrast adjustment, add a sculpting layer, or do some dodging and burning. (See the sidebar "Dodging and burning" in Chapter 3.)

SCULPTING

Sculpting is essentially like a freehand application of midtone contrast enhancements. You create a 50% gray fill layer, apply the Overlay blending mode, and then paint on the layer. Where you paint in white or any color lighter than middle gray, it lightens the image; where you paint in a darker color, it darkens the image. Sculpting is similar in concept to dodging and burning but combines both effects in a single toning layer and allows for a very interactive method of adjusting an image. Sculpting is covered more extensively in *The Digital Negative*.

12. OUTPUT SHARPENING

The final stage of the sharpening workflow is output sharpening, which can be done only once you've arrived at the final image dimensions and final resolution. Output sharpening is built into the printing process in Lightroom, which is a real improvement in the Lightroom workflow, but it's a separate step in Photoshop.

13. FINAL IMAGE CHECK

At this stage, go back and do a close inspection, again zoomed in to 100%, and make sure you didn't overlook anything. In particular, double-check the crop to make sure it's set up the way you want it and that you don't have any extraneous detail that you're not going to want on the print. Also double-check the rotation of the image, making sure it's level.

14. PROOFING WITH BAT AND ANNOTATED PRINTING

In Chapter 4, I went to great lengths to talk about the importance of soft proofing so you have a good prediction of what an image looks like before ink hits the paper. It's also important to do hard proofing. You can hard proof either in strips or chunks. If you're trying to figure out how much of an adjustment you'll need for a final print, you can apply a gradient adjustment for contrast, hue, and saturation, or whatever you need, and then choose the adjustment strength based on the hard proof. (This trick comes from my friend JP.)

Soft proofing works up to the point where you have to evaluate ink on paper. Hard proofing allows you to confirm print settings. It's often called BAT, which is short for *bon à tirer*, a French term for a final proof; it literally means "the best pull."

When you make the final proof before you make the final print, you'll want to make notations about what you're doing. You can take screen shots of print settings and store them in the Photoshop file, or you could use the Note tool in Photoshop. In Lightroom, every time you make a print, your settings are stored in the history; if you've made changes to the images during the course of making multiple prints, you can go back and see what the settings were just by clicking on the previous history state. **Figure 6.5** shows the History panel in Lightroom showing the creation of a proof copy as well as the changes made and the date and times the image was printed.

If you're printing from Lightroom, make a soft-proofing virtual copy so you can always be working on a virtual copy instead of the original image. The ability to always go back to how you made the final proof is important, because if you have to make multiple prints over a period of time and you want to keep the prints consistent, you want to make sure that you keep notes and keep track of everything you did in making the print.

You can make hard proofs that are reduced in size, but then you can print tone and color but not the actual final resolution. However, you can print a strip using the Photoshop command to print only a section of an image. If you print a section at 100% size, you can check the noise reduction and sharpening before making the

FIGURE 6.5 The History panel in Lightroom showing the history of changes and prints made.

final print. One problem to be aware of with reduced-size proofing is that when you make a large print, the large print is often a little less contrasty because of the size and the fact that you're looking at it from a distance. So you may need to punch up the contrast a little bit if you're doing reduced-size proofs. Just understand that there may not be a direct relationship between a small proof and the large final print.

15. FINAL OUTPUT AND EVALUATION

Before you make the final output, make sure the print settings are correct. In Lightroom, check that the output template is active and that you're printing to the correct printer on the correct paper that is correctly loaded into the printer. All these things are obvious, but they are all things that you have to check.

Make sure the paper is properly loaded, and inspect it before you load it. If you're working on watercolor paper, it's handy to use a can of compressed air to make sure there's nothing hanging on to the surface of the paper. Make sure you clean off any small piece of paper or speck before you make the print, because the printer will print over it and, if you blow it off later, you'll leave a little white spot on the print. One of the reasons I like to print with a fairly large margin is because you have to handle the paper when you're loading it.

Paper handling itself is quite the art form. When I'm making a big print, I don't like to use the baskets of the printer's print-catching system. Instead, I attach a piece of foam core to the printer so that as the paper comes out of the printer, it slides down onto the foam core. It's much easier to carry the print when I can keep it on the form core. **Figure 6.6** shows a large panoramic print coming out of my Epson 9900 printer.

FIGURE 6.6 Using Foam core to catch a large print coming out of a printer.

When evaluating the image after it's printed, everybody has his or her own criteria for what constitutes a perfect print. For me, it's a print that is free of any defects. When I load paper, I double-check the paper to make sure there aren't any defects. After I've made the print, I check that there aren't any defects introduced by the printer; in other words, no ink spatters or scratches.

Finally, after you've made the print, you'll want to go through the whole process of outgassing, eliminating the glycols. (See Chapter 5, "Digital Print Artifacts.")

WHEN TO PRINT IN PHOTOSHOP VS. LIGHTROOM—THE BEST WORKFLOW

I have and use both Lightroom and Photoshop. I've been directly involved in the development of Lightroom and in particular working with the engineers on the development of the print module in Lightroom. I'll say it very simply: I'd much rather print out of Lightroom than Photoshop. As I said previously, if you're making a lot of prints, Lightroom's workflow for printing is superior to Photoshop's.

PHOTOSHOP AND LIGHTROOM WORKFLOWS

To print from Photoshop, you have to open the image and set up the Photoshop Print Settings dialog box, including the Page Setup or Print Properties and the print settings. Each one of those settings—every dropdown menu and check box—has to be accurately set. You then have to actually click Print. In contrast, in Lightroom, you simply select the image, select the saved preset and be assured that all the settings will be correct, and click Print.

If you want to make ten prints from Lightroom, you select the ten images, select the template, and click the Print button once. In Photoshop, you have to open each of the ten images, correctly set the printer settings and the print dialog box, and click the Print button in Photoshop ten times. Personally, I think that sucks. It leaves a lot of room for user error.

If you have both Photoshop and Lightroom, use each for its strengths. I think most images will need to go to Photoshop for the kind of image corrections that Lightroom is not really designed to do. If you need to do substantial retouching, or combine multiple images to replace a sky or swap heads in a group photo, you have to do that in Photoshop. You can go as far as you can in Lightroom, but I've found that it's often the case that I just plan on going into Photoshop for the retouching, and then save the image and go back into Lightroom for the final printing.

JEFF'S PRINT WORKFLOW

For my workflow, I incorporate Mac's, going through and making the global and local adjustments to the image in Lightroom, right up to the point where I decide I need to go into Photoshop. Then I'll go into Photoshop for retouching and compositing. I then save the image, go back to Lightroom, do the soft proofing there and make a virtual copy, and then use the print module in Lightroom for the final printing.

When you work this way, note that you want to open the original image, not a copy. It's one of the advantages of working on a Photoshop (PSD) file or a TIFF. Working on the original means that you can retain all of the layers of the original file. Even if you've made tone and color corrections in Lightroom on top of the actual Photoshop file, you'd want to make sure you open the original image to make sure you keep all of your original layers. That's one of the big advantages of a combined Lightroom-Photoshop workflow: You can adjust the layered image and then go back into Lightroom, and it preserves all the Lightroom adjustments on top of the original Photoshop file. **Figure 6.7** shows the Edit Photo with Photoshop CC dialog box showing the edit options.

FIGURE 6.7 Selecting the Edit Original option in the Edit Photo with Photoshop dialog box.

PRINT TROUBLESHOOTING

Have you every heard of Murphy's Law? It's an adage that says: "Anything that can go wrong will go wrong" (and usually at the least convenient moment). This is particularly relevant when it comes to digital fine art printing. Between user error when setting print driver dialog boxes to loading the wrong paper (or the wrong side of the paper) to getting clogged inkjet nozzles, there are a lot of opportunities for things going wrong!

TOP PRINTING PROBLEMS

The biggest problem that can crop into a printing session is either no color management being applied or double color management. However, Adobe, Apple, Microsoft, and the print driver makers have severely reduced the possibility of either of these problems occurring. Generally, no color management means that neither the application nor the print driver is being used to apply color profile transforms when sending the image to the printer. The result will be something dark and greenish. Double color management—meaning both the application and the print driver are applying color profile transforms—will result in a print that is too light and magenta or reddish. **Figure 6.8** shows examples.

The next likely undesirable result relates to either the wrong printer profile being selected or the wrong media settings being applied. Compared to the previous problems, these issues can be rather subtle and more difficult to diagnose. Selecting a profile for Premium Glossy paper when you are actually printing on Luster isn't going to look terrible, it just won't be optimal. That's why it's so important to develop a workflow that minimizes the risk of improper settings being applied. This is another reason why I prefer the Lightroom approach, with saved presets that minimize the risk of user error.

NOTE For the author's insights on printer maintenance, download the free PDF at peachpit. com. Just create a free peachpit.com account and register this book so it appears on your Account page. Then you'll have access to the bonus content.

▲ NORMAL COLOR-MANAGED RESULT

▲ DOUBLE COLOR MANAGEMENT (LIGHT AND MAGENTA)

▲ NO COLOR MANAGEMENT (DARK AND GREEN)

FIGURE 6.8 Comparing expected and unexpected output results.

PREPARING AN IMAGE FOR PRINTING BY A SERVICE BUREAU OR PHOTO LAB

While it's not advisable to work on JPEG files while you're editing images, it's the format I recommend for images that you're preparing for a service bureau or photo lab. You can use either Lightroom or Photoshop to save the JPEG file, but Lightroom has some built-in features that make it easier to include margins, identity plates, and other custom information.

PREPARING AN IMAGE IN LIGHTROOM

In the Lightroom Print module, you can set up the margins, cell size, and paper size the way you want to output, along with any identity plates. I want to add my stylized identity plates—a script font of my name—to my image, for example. If you export the image, you can't include the page and margin information, and the identity plate, on the image. So if you're sending an image to a service bureau or photo lab, and you want to maintain the signature and margins exactly, print to JPEG instead of exporting the image from Lightroom. JPEG isn't a good file format for editing, but it's perfectly fine for output, as long as no one's going to do any image editing or color transforms after the fact. **Figure 6.9** shows the relatively simple process of preparing an image for output to JPEG.

When you choose JPEG File from the Print To menu in the Print Job panel, the job options change. Make sure to select Print Sharpening, and set it to Standard. Set the JPEG Quality to 100. You can set up custom file dimensions; in this case, I'm printing a 13 x 18-inch image centered on 17 x 22-inch paper. For color management, use an ICC profile for your service bureau if you have one. Some require sRGB (simple RGB, I call it); others let you choose Adobe RGB. If you're sending to a service bureau for output on an inkjet printer, you can specify the paper and ink that the lab is using. In this case, I'll assume sRGB and glossy media. My service bureau is using a Noritsu (www.noritsu.com) chromogenic printer, which requires a resolution of 300 PPI. When it's all set up, click Print to File. Your JPEG file will be saved in the color space you chose with your page margins and identity plate or any other information you have set up in the print. If you're using Picture Package or Custom Package to set up a multi-image array, it's particularly useful to be able to print to JPEG.

If you don't need to retain specific margins, identity plates, or similar information, you can simply export the image. In the Export module, set the size, resolution, and output profile, and then export it.

▲ SELECTING JPEG FILE IN THE PRINT TO MENU IN THE PRINT JOB PANEL

▲ SETTING UP PRINT SHARPENING, CUSTOM FILE DIMENSIONS, AND THE COLOR MANAGEMENT PROFILE (SET TO USE THE SRGB ICC V4 APPEARANCE BETA WITH PERCEPTUAL RENDERING)

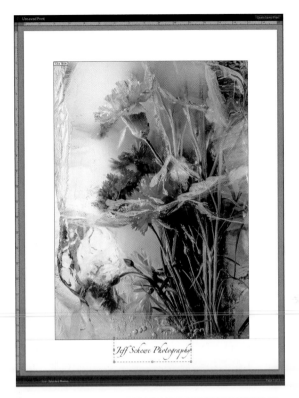

FIGURE 6.9 Setting up to print to a JPEG file.

▲ THE IMAGE LAID OUT IN THE PRINT MODULE WITH THE ADDITION OF AN IDENTITY PLATE AT THE BOTTOM

PREPARING FOR THIRD-PARTY PRINTING IN PHOTOSHOP

To prepare an image in Photoshop, set the image size and resolution. In this case, the resolution is 300 PPI and the height and width are set to 13 x 18 inches; I won't alter that. I'll add a margin around the image by increasing the canvas size: choose Image > Canvas Size, and enter the total width and height you want to add; I set the canvas to 17 x 22 inches. I also ran PhotoKit Sharpener 2, selecting Contone 300 for output sharpening. If you were doing the output sharpening manually, you would do so at this step. **Figure 6.10** shows the series of steps needed to prepare the image size, sharpening, and output dimensions.

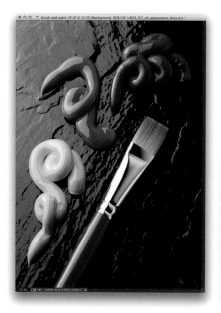

FIGURE 6.10 Preparing the image size, sharpening, and final output dimensions.

◀ THE IMAGE FOR PRINTING

▼ THE IMAGE SIZE DIALOG BOX

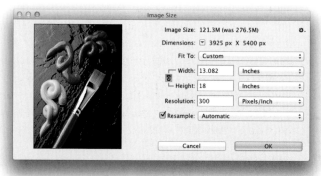

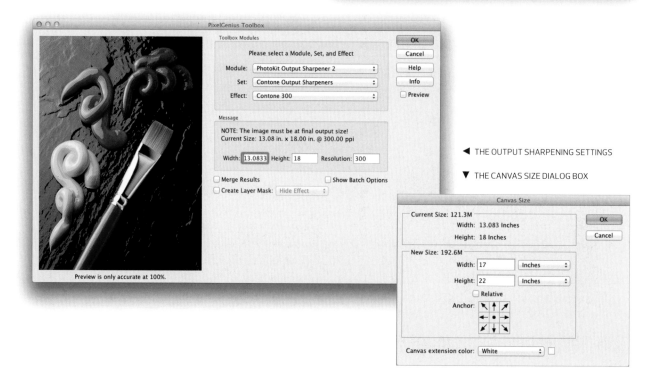

◀ THE OUTPUT SHARPENING SETTINGS

▼ THE CANVAS SIZE DIALOG BOX

To add a signature in Photoshop, I'd have to copy and paste my signature onto the image. In lieu of that, I simply added a text layer with a script font. In this case, my provider requires sRGB, and I'll use the beta sRGB profile so I can choose Perceptual for the rendering intent. Then, choose Edit > Convert to Profile, and choose the destination profile you used to soft proof. I'll caution you that, whenever you do a color space transform, you should try to do it in 16 bits. In this case, I changed the mode from 16 bits to 8 bits, but not before transforming the color space. **Figure 6.11** shows the image with text and the Convert to Profile dialog box.

Finally, choose File > Save As, and choose JPEG from the Format menu. My preference is to embed ICC profiles when you're dealing with RGB images, because RGB images with no profile are akin to mystery meat. So embed the profile, and click Save. In the JPEG Options dialog box, I suggest you always use Baseline because some third-party printers choke on progressive JPEGs, and progressive JPEGs are useful only on the Web anyway. Set the Quality to maximum, and click OK. At that point, your image is ready for the service bureau.

FIGURE 6.11 The image with a text layer and the Convert to Profile dialog box.

▲ THE IMAGE WITH TEXT

▼ THE CONVERT TO PROFILE DIALOG BOX SHOWING THE SRGB ICC V4 APPEARANCE BETA PROFILE

USING A THIRD-PARTY RIP

RIP stands for "raster image processor." RIPs were once used to rasterize vector artwork into pixels, as when printing PostScript. In fine art digital printing, you're turning pixels into dots of ink, and RIPs can enhance your workflow options. Whether or not a RIP is relevant to you depends on what you're trying to accomplish. In general, you probably don't need a RIP unless you're using it for workflow or doing cross-rendered proofing for halftone reproduction. Some RIPs are bundled with printers, particularly Epson printers. There are some excellent fine art printing RIPs that I think are useful. I'll briefly cover the ones I'm familiar with.

IMAGEPRINT FROM COLORBYTE

Epson only; Mac and Windows; http://colorbytesoftware.com

ImagePrint is probably one of the most popular of the third-party fine art printing RIPs. **Figure 6.12** shows the basic ImagePrint application environment.

You can gang multiple images up efficiently to get as many images as possible on a sheet or roll of paper. The page layout allows you to combine multiple images, similar to Picture Package in Lightroom. ImagePrint also allows you to create gallery wraps directly in the RIP. This is something that Henry Domke appreciates and uses. **Figure 6.13** shows the multi-image packing ability as well as the gallery wrap feature.

ImagePrint also gives you access to its entire inventory of custom profiles, which is quite impressive. In some cases, there are even multiple profiles for the same paper—for daylight and tungsten, as well as other light sources. **Figure 6.14** shows the ImagePrint Profile Manager with profiles for virtually every third-party paper distributor and multiple profiles for different print-viewing light sources.

ImagePrint has direct print head control, bypassing the print driver itself. Fans claim that ImagePrint has better shadow detail and can print more neutral black-and-white images.

NOTE On the Mac, the Epson driver has a hard limit on the total length that you can print from the driver. The maximum length is about 93 inches, which isn't an issue for most people. But if you are making really big prints or printing long panoramic images, it can be a problem. ImagePrint (as well as most other RIPs) can blow past the built-in length limitation.

FIGURE 6.12 The basic ImagePrint application environment.

If you were used to the tedious process of printing out of Photoshop, you would find the workflow offered by ImagePrint to be particularly useful. However, if you typically print out of Lightroom, it's not as beneficial. I would argue that Lightroom's printing workflow is very competitive to ImagePrint's.

There are a couple of limitations with the ImagePrint RIP. They drive only Epson printers, and you have to pay for them on a per-carriage-width basis. I bought ImagePrint for my Epson 4900, which has a 17-inch carriage. I can't use ImagePrint on my 9900 unless I buy a separate license, and it is expensive.

FIGURE 6.13 The multi-image package and gallery wrap abilities of ImagePrint.

▲ MULTIPLE IMAGES ARRANGED ON A PAGE

▲ AN IMAGE SET UP TO PROVIDE A GALLERY WRAP (WHERE THE OUTER EDGES ARE MIRRORED TO PROVIDE A MORE PLEASANT WRAP AROUND CANVAS STRETCHERS)

FIGURE 6.14 The ImagePrint Profile Manager.

▶ THE MAIN IMAGEPRINT PROFILE MANAGER DIALOG BOX

▼ A DETAIL OF PROFILES FOR HAHNEMÜHLE PAPERS

QIMAGE ULTIMATE FROM DDI SOFTWARE INC.

Windows only; http://ddisoftware.com

Qimage Ultimate is a favorite of many who print from Windows, but it's not technically a RIP because it relies upon the print driver to send the image data to the printer. It's a front end to the print driver that basically controls the printer, but not at the print head. It has a lot of workflow advantages. It also provides really smart upsampling and output sharpening. Advocates of Qimage claim it's superior to Lightroom. I don't necessarily agree with that, but I understand why it has a lot of fans. **Figure 6.15** shows the main Qimage Ultimate application UI and some of the detailed settings available for interpolation and output sharpening.

NOTE The only problem I have with Qimage is that it's Windows only, and my main workflow is on the Mac.

FIGURE 6.15 The main Qimage Ultimate application UI and options for interpolation and output sharpening.

◀ THE MAIN QIMAGE ULTIMATE APPLICATION

▼ THE INTERPOLATION OPTIONS MENU

◀ THE INTERPOLATION DIALOG BOX SHOWING INTERPOLATION TYPE AS WELL AS FINAL OUPUT SHARPENING OPTIONS

INDEX

Q

Qimage Ultimate RIP, 315
Quad Tone RIP, using, 237–242

R

raw captures, converting with DNG
 profiles, 67–69
raw image processing, color
 management for, 71
red, green, blue additive primaries, 25
Reduce Noise filter, using in
 Photoshop, 113–114
Reichmann, Michael, 255
Relative Colorimetric Intent, 44
renaming profiles on Macintosh, 49
Rendering Intents
 Absolute Colorimetric, 44
 choosing, 43–45
 Perceptual, 43
 Relative Colorimetric, 44
 Saturation, 44
resampling algorithm
 in Lightroom, 132
 in Photoshop, 132
resampling plug-ins, 133–135
resolution
 amount needed, 128–129
 for Canon printers, 8, 129–130
 comparing, 256
 for Epson printers, 8, 129–130
 for HP printers, 8
 image vs. printer, 130–131
 of printed size, 127–128
 resolvable printed, 129
 seen by eye, 129
RGB (red, green, blue)
 vs. CMY, 25
 Melissa, 36
 rose, leaves, and ribbon, 21–22
RGB master image
 correcting color cast, 82
 global adjustments, 81–82
 local adjustments, 81–82
 optimizing tone, 83
 preparing, 80–82

RGB printer profilers, 73
RIPs (raster image processors)
 ImagePrint, 312–314
 Qimage Ultimate, 315
 third-party, 234, 237–242, 312–315
Rodney, Andrew, 73

S

Saturation Intent, 44
scanner profiles
 basICColor GmbH software, 65
 converting to ProPhoto RGB, 66
 creating, 64, 66
 LaserSoft Imaging software, 65
 Profile Prism software, 65
 software, 65
 TGLC Color Management software,
 65
 using, 64–67
 X-Ritei1Profiler software, 65
scans, processing, 92
scratches, explained, 263
service bureaus, using for printing, 15
sharpening. *See also* capture
 sharpening; noise reduction
 applying local blur, 120
 applying locally, 106
 in Camera Raw, 118–121
 combining with noise reduction,
 106
 comparing, 103
 edges, 113, 115–116
 in Lightroom, 118–121
 local and global, 106–107
 performing, 101
 PhotoKit Sharpener 2, 116–118
 in Photoshop, 121
 previews available, 104
 third-party products, 118
signing prints, 283
Smart Sharpen, using in Photoshop,
 115
soft proofing
 changing background color, 147
 for contrast range, 157

 for dynamic range in Lightroom,
 155–157
 explained, 147
 in Lightroom, 147–153, 155
 for paper color, 157
 in Photoshop, 153–155
 and virtual copy, 221
 workflow, 147
SoLux daylight bulb, using, 252
solvent inks, 9–10
SPDs (spectral power distributions) of
 daylight, 19–21
spectrophotometer
 explained, 28
 getting printer with, 14
 purpose of, 28
SpectrumViz application, 267
specular highlights, clipping in, 85
storing prints, 289–290
substrates. *See* print substrates
subtractive primary colors, 24–25

T

task lamp, using, 252
Texaco image
 color corrections, 87
 daylight settings, 83
 global tone adjustments, 86
 local adjustments, 87
 tone corrections, 87
 white balance, 83–84
TGLC Color Management software, 65
thermal print heads, 8–10
thermal radiation, 20
Thompson, William, 20
Tint, explained, 20
tone
 adjusting for lava rock image, 88
 adjusting in Photoshop, 92–98
tone and color, judging in prints,
 252–254
tone curve
 applying to lava rock image, 89
 vs. Basic panel, 83
tone mapping, adjusting, 85–86

WATCH READ CREATE

Unlimited online access to all Peachpit, Adobe Press, Apple Training and New Riders videos and books, as well as content from other leading publishers including: O'Reilly Media, Focal Press, Sams, Que, Total Training, John Wiley & Sons, Course Technology PTR, Class on Demand, VTC and more.

No time commitment or contract required! Sign up for one month or a year. All for $19.99 a month

SIGN UP TODAY
peachpit.com/creativeedge

creative edge